MW00611470

serious
PLAY

serious
PLAY

DESIGN IN MIDCENTURY AMERICA

edited by

MONICA OBNISKI and DARRIN ALFRED

MILWAUKEE ART MUSEUM DENVER ART MUSEUM

YALE UNIVERSITY PRESS New Haven and London

DIRECTORS' FOREWORD

Welcoming and engaging the broadest spectrum of our communities, the Milwaukee Art Museum and the Denver Art Museum celebrate the best of human creativity and strive to inspire greater understanding and connection with the world we live in. We are delighted to present *Serious Play: Design in Midcentury America*, a project that suggests that our current appreciation for design may be traced to the emergence of play as a "serious" form of experimentation that led to innovation. The exhibition and publication explore, through the lens of playfulness and whimsy, the process and aesthetic of midcentury designers practicing in the United States. Broadening how creativity is defined, *Serious Play* reveals the historical underpinnings of play as a type of problem solving that was inquisitive and fun. With an openness to new ideas, serious play could be as enriching for the designers (and other adults) as it was vital for children.

We were fortunate to have two curators whose own "serious play" provided the spark for this ambitious undertaking. Monica Obniski, Demmer Curator of Twentieth and Twenty-First Century Design at the Milwaukee Art Museum, and Darrin Alfred, Curator of Architecture, Design, and Graphics at the Denver Art Museum, conceived of and worked collaboratively for several years on the exhibition and publication. They identified themes and designers to focus on, found authors to tell these stories in an engaging manner, and sourced objects and images from archives and public and private collections. At each institution, at every level, colleagues pooled their talents to do what was necessary to bring the project to successful completion.

With *Serious Play*, the Milwaukee Art Museum and Denver Art Museum have produced an exhibition that reinforces an ongoing commitment to design at both institutions. Our two museums have strong holdings in design, but an exhibition of this scale would not be possible without loans. We are profoundly indebted to the institutional and private lenders who agreed to participate in this project.

We would also like to thank the National Endowment for the Arts for granting this project an Art Works award. In Denver, we thank the Annual Fund Leadership Campaign and the citizens who support the Scientific and Cultural Facilities District (SCFD) for helping to make the exhibition possible.

Marcelle Polednik
Donna and Donald Baumgartner Director
Milwaukee Art Museum

Christoph Heinrich
Frederick and Jan Mayer Director
Denver Art Museum

ACKNOWLEDGMENTS

It is with great pleasure that we offer our deepest gratitude to the countless individuals who contributed to the realization of this project. Their generous assistance, patience, advice, and enthusiasm were crucial. Most importantly, we would like to express our respect, admiration, and gratitude to the designers represented in the exhibition and publication for their sense of fun and playfulness, which encouraged us to explore the topic further. May they continue to inspire many others.

We are deeply grateful to the institutions and individuals that have generously loaned works to the exhibition and have assisted us with innumerable inquiries. Without their commitment to sharing these objects with the public, this exhibition would not have been possible. Special thanks are due to the following individuals, as well as their colleagues: James Rondeau, Sarah Kelly Oehler, and Kathleen Kiefer, Art Institute of Chicago; Merrill C. Berman; Anne Pasternak and Barry R. Harwood, Brooklyn Museum; Steve Cabella; Lynn Zelevansky and Rachel Delphia, Carnegie Museum of Art, Pittsburgh; Tom Clark and Martha Torno; Lawrence Converso; Caroline Baumann, Susan Brown, Caitlin Condell, and Cara McCarty, Cooper Hewitt, Smithsonian Design Museum, New York; Sally Sheimo, Damon Liss Design; Jay Dandy and Melissa Weber; William and Annette Dorsey; Eames Demetrios, Llisa Demetrios, Carla Hartman, Lucia Atwood, and Byron Atwood, and also Genevieve Fong and David Hertsgaard at the Eames Office, Los Angeles; Jody and Dick Goisman; Andy Masich and Courtney Keel Becraft, Senator John Heinz History Center, Pittsburgh; Steven Heller; Amy Auscherman, Gloria Jacobs, and Linda Baron, Herman Miller Archives, Zeeland, Michigan; Adam Strohm and Ralph Pugh, Paul V. Galvin Library and IIT Archives at the Illinois Institute of Technology; Michael Jefferson and Heidi Mucha; Hugh A. Grant and Christopher Herron, Kirkland Museum of Fine & Decorative Art, Denver; John Kishel; George R. Kravis II and Alana Emery at the Kravis Design Center, Tulsa, Oklahoma; Danny Lewandowski; Barbara Bair, Margaret McAleer, Mari Nakahara, and Rachel Waldron, Library of Congress, Washington, DC; Michael Govan and Wendy Kaplan, Los Angeles County Museum of Art; Mark McDonald; Kaywin Feldman, Jennifer Komar Olivarez, and Ghenete Zelleke, Minneapolis Institute of Art; Khristaan Villela, Laura Addison, and Amy Groleau, Museum of International Folk Art, Santa Fe, New Mexico; Andrew Neuhart; Dung Ngo; Jenny Dixon and Dakin Hart, The Isamu Noguchi Foundation and Garden Museum, New York; Edgar Orlaineta; Zesty Meyers and Evan Snyderman, R & Company, New York; Jean Richards and Brent Brolin; Randy P. Roberts; Steven K. Galbraith and Amelia Hegel-Fontanel, Melbert B. Cary Jr. Graphic Arts Collection, Rochester Institute of Technology; Ruth Adler Schnee; Benjamin Storck; Waverly B. Lowell and Chris Marino, Environmental Design Archives, University of California, Berkeley; William Whitaker and Heather Isbell Schumacher, Architectural Archives, University of Pennsylvania, Philadelphia; Scott Vermillion; Marc Zehntner, Matteo Kreis, Jochen Eisenbrand, and Andreas Nutz, Vitra Design Museum, Weil am Rhein, Germany; William Whitaker and Shilpa Mehta; and Jill A. Wiltse and H. Kirk Brown III.

We owe enormous thanks to the outstanding teams at the Milwaukee Art Museum and the Denver Art Museum for their close collaboration and enthusiastic support in realizing this presentation. We are extremely grateful to Marcelle Polednik, Donna and Donald Baumgartner Director of the Milwaukee Art Museum, and Christoph Heinrich, Frederick and Jan Mayer Director of the Denver Art Museum, for their encouragement

and commitment to the project from its initial stages. We are greatly indebted to Curatorial Assistant Hannah Pivo in Milwaukee and Senior Curatorial Assistant Kati Woock in Denver, who were fundamental to all aspects of the exhibition and catalog planning. They mastered the many details of the project with patience, thoroughness, and dedication.

At the Milwaukee Art Museum, planning and implementation of the exhibition were skillfully carried out by staff in many departments: Curatorial Department Administrator Liz Flaig managed the timeline and project budget, with oversight by Interim Chief Curator Margaret Andera; Senior Registrar Dawn Gorman Frank, assisted by Associate Registrar for Exhibitions and Loans Lydelle Abbott Janes, oversaw and performed the myriad tasks associated with shipping, crating, and other logistics for the exhibition and its tour; Rebekah Morin, Rights and Reproductions, coordinated photography requests for this catalog; Heather Winter, Librarian and Archivist, provided research tools at every step of the project; Jim DeYoung, Senior Conservator, with Terri White, Associate Conservator of Objects, managed the robust conservation schedule, assisted by Framer/Mountmaker Richard Knight and Chris Niver, Assistant Conservator. The museum's multifaceted preparators, led by Chief Preparator Joe Kavanaugh, installed the exhibition in Milwaukee with aplomb, according to the exhibition design created by the inimitable Chief Designer David Russick, who was assisted by Jessica Steeber, Design Coordinator. Fundraising for the exhibition was managed by Senior Director of Development Mary Albrecht, who was assisted by her extraordinary team: Therese Palazzari, Kathy Emery, and Sara Tomilin. We also thank Barbara Brown Lee Senior Director of Education and Programs Brigid Globensky; Casie Simpson, Creative Director; and Amanda Peterson, Director of Marketing and Communications, as well as their devoted teams.

At the Denver Art Museum, the exhibition benefitted from the enlightened oversight of Lori Iliff, Chief of Exhibition and Collection Services. Her colleagues Jill Desmond, Director of Exhibitions, Strategies, and Gallery Design, and Jennifer Pray, Senior Project Manager, executed the exhibition and offered important advice with support from Laura Bennison, Design Coordinator/Assistant Project Manager. Sarah Cucinella-McDaniel, Chief Registrar, and Jamie Grandinetti, Assistant Registrar, managed the complex care and handling of the art with poise. The installation was coordinated by Kevin Hester, Manager of Exhibition Installations, with the talented team of Mitchell Broadbent, Chief Preparator; David Griesheimer, Manager of Exhibition Production; and Ethan Tuers, Associate Manager of Exhibition Installations. Sarah Melching, Silber Director of Conservation, along with Kate Moomaw, Associate Conservator of Modern and Contemporary Art, and Steve Osborne, Conservation Technician and Mountmaker, helped ensure the objects appeared at their best. Fundraising was skillfully managed by Arpie Chucovich, Chief Development Officer, and Chiara Robinson, Director of Institutional Giving. Ann Baier Lambson, Interpretive Specialist for Architecture, Design, and Graphics, provided invaluable insight into the exhibition's interpretation. Additional thanks are owed to Nancy Blomberg, Chief Curator and Curator of Native Arts; Melora McDermott-Lewis, Chief Learning and Engagement Officer; Andrea Kalivas Fulton, Deputy Director and Chief Marketing Officer; Katie Ross, Director of Marketing; and their dedicated teams.

We are truly appreciative of Denver's talented publications team. Laura Caruso, Director of Publications, expertly supervised many aspects of catalog production,

coordinated the responsibilities of curators and authors, and edited the manuscript with remarkable precision. Renée B. Miller, Rights and Reproductions Coordinator, provided outstanding assistance in coordinating image rights and photography requests. Jeff Wells, Manager of Photographic Services, in tandem with Christina Jackson, Assistant Photographer, carefully documented many of the works in the exhibition.

This publication has been produced in collaboration with Yale University Press. We value the contributions of Katherine Boller, Raychel Rapazza, Mary Mayer, and Alison Haage. The book has been beautifully designed by Jena Sher.

Yale joins us in thanking the authors who have enhanced this publication with their thoughtful and illuminating contributions: Amy Auscherman, Steven Heller, Pat Kirkham, and Alexandra Lange.

Other individuals provided assistance with loans, access to archives or collections, research assistance, or valued professional advice. We are pleased to thank W. Douglas McCombs, Albany Institute of History & Art, New York; Gillion Carrara; Emily M. Orr, Cooper Hewitt, Smithsonian Design Museum, New York; Leslie S. Edwards, Cranbrook Center for Collections and Research, Bloomfield Hills, Michigan; Jim Drobka; Martin Eidelberg; Laura Fisch; Susan Skarsgard and Wayne Morrical, GM Design Archive and Special Collections, Detroit, Michigan; Rick Gallagher; Tricia Gilson; Aleishall and Kori Girard; David A. Hanks; Sierra Green, Senator John Heinz History Center, Pittsburgh; Michael Kraszynski; Liz Arenaro, the Costume Institute at the Metropolitan Museum of Art, New York; Pat Moore; Bill Stern, Museum of California Design, Los Angeles; Caroline Dechert, Museum of International Folk Art, Santa Fe, New Mexico; Janine Biunno, The Noguchi Museum, New York, New York; Daniel Ostroff; J. Dorothy and Gilbert Palay; James Zemaitis, R & Company, New York; Shanna Shelby; Tim Noakes, Stanford University; Marc Treib, University of California, Berkeley; Jamie Lausch VanderBroek, University of Michigan Library, Ann Arbor; Mo Zell, University of Wisconsin, Milwaukee; Jeff Winter; and Michael Jefferson, Wright, Chicago.

Key supporters have helped make this exhibition and catalog possible. We are enormously grateful to the National Endowment for the Arts for an Art Works award in support of the exhibition. We also thank Furthermore, a program of the J. M. Kaplan Fund, for assistance with publishing the catalog.

Finally, this project has reaffirmed and renewed for us the power of collaboration. Joshua Shenk's recent book *Powers of Two* (2014) conveys the iterative process undertaken by collaborative pairs to generate creativity. We believe that the most successful projects benefit from a mutual admiration of one another and a reciprocal dedication to the project, and we are grateful to one another for sharing these goals.

Monica Obniski
Demmer Curator of Twentieth and
Twenty-First Century Design
Milwaukee Art Museum

Darrin Alfred
Curator of Architecture, Design,
and Graphics
Denver Art Museum

INTRODUCTION

MONICA OBNISKI AND **DARRIN ALFRED**

The transformative power of play, and its link to creativity, is well known and widely accepted today as important in learning and childhood development and as a tool that spurs economic development. In the early twentieth century, Dutch historian Johan Huizinga noted that play is a free and self-motivated activity that is "not serious, but at the same time absorbing the player intensely and utterly"; he also argued that play expanded the "fruitful avenues of research and reflection."[1] Huizinga claimed that play may be viewed as the basis of culture,[2] and two decades later, the French sociologist Roger Caillois acknowledged this keystone, writing, "The spirit of play is essential to culture."[3] In other words, play is a type of learning; taking it seriously is a part of culture.

Serious Play: Design in Midcentury America explores the concept of playfulness in mid-twentieth-century American design as a catalyst for creativity and innovation and argues that play can be serious. Play is also not a luxury—it should be available to all. Furthermore, if we believe Huizinga and Caillois, our examination of the playful expression of midcentury designers reveals elements of the larger cultural milieu. Postwar designers (and their work) were notable witnesses to a period that experienced a growing pursuit of pleasure through consumption. As author Steven Johnson recently noted, "The pleasure of play is understandable. The *productivity* of play is harder to explain."[4] The works in this exhibition, and the essays in this publication, help elucidate this point.

In the postwar period, a bias against playfulness existed that has not entirely disappeared. And in the context of the twentieth century, the streamlined, austere aesthetic of the modern movement in architecture and design, with its rigorous rejection of individual expression, might seem like the last place in which playfulness would play a significant role. But many designers, including Charles and Ray Eames, Alexander Girard, Eva Zeisel, and Paul Rand, rejected a dogmatic modernism and hungered for something beyond rational and utilitarian motives. They pursued an alternative approach, effectively blurring the boundaries between work and whimsy. Charles Eames's statement, "Toys are not

Fig. 1 Charles Eames with House of Cards construction, 1952. [CAT. 68]

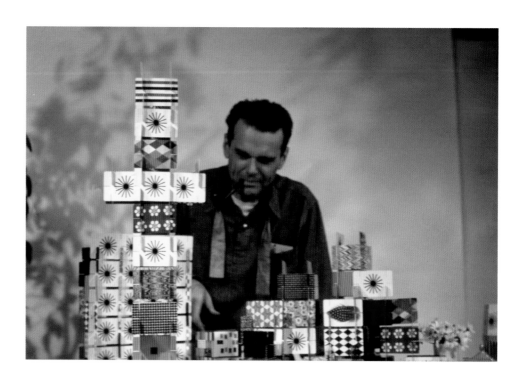

Fig. 2 Irving Harper, Marshmallow sofa, for Herman Miller, 1956. Milwaukee Art Museum. [CAT. 75]

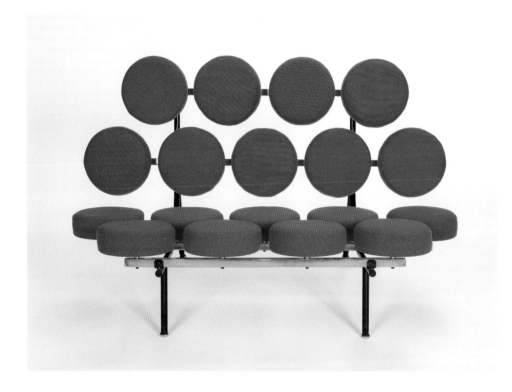

really as innocent as they look. Toys and games are preludes to serious ideas," is a useful way to frame an argument for surveying midcentury design from this perspective (fig. 1).[5] Writing about the Eameses' House of Cards in the *New York Times*, Aline Louchheim (soon to be Saarinen) noted that she "sat there, rapt and delighted as a child in a Chardin painting, building a 'House of Cards,' easily interlocking them to make a towering structure." By writing about House of Cards and The Little Toy (also designed by the Eameses) in the newspaper's art pages, Louchheim argued for taking the toys seriously. "Art is not just painting and sculpture," she stated. "Art is also any object of beauty whose form, color, texture and relationships give us visual and tactile delight."[6]

THE AMERICAN HOME

After World War II, the American home emerged as a site for architectural discourse, as architects and designers explored new ways of living (fig. 2). Due to a booming postwar economy, it was possible to accumulate more goods; in combination with the popularity of do-it-yourself culture, this meant many Americans began decorating their homes in less traditional ways than had previously been the case. In her essay defining this new channel of creativity, which is titled "Playful Domesticity," Monica Obniski explores the development of the storage wall. The ultimate object of customization and consumption, the storage wall was intended for display as well as storage: a functional and decorative piece of mass-produced furniture with multiple shelves for showing off one's accumulated objects. Such objects were often handmade, providing a contrast with the sleek industrial look of the storage unit. George Nelson introduced his Storagewall in the mid-1940s, and Charles and Ray Eames designed their own version, the Eames Storage Unit (ESU), in 1950. Completely customizable and flexible, the ESU and its various configurations functioned as a device for expressing one's personal creativity (fig. 3).

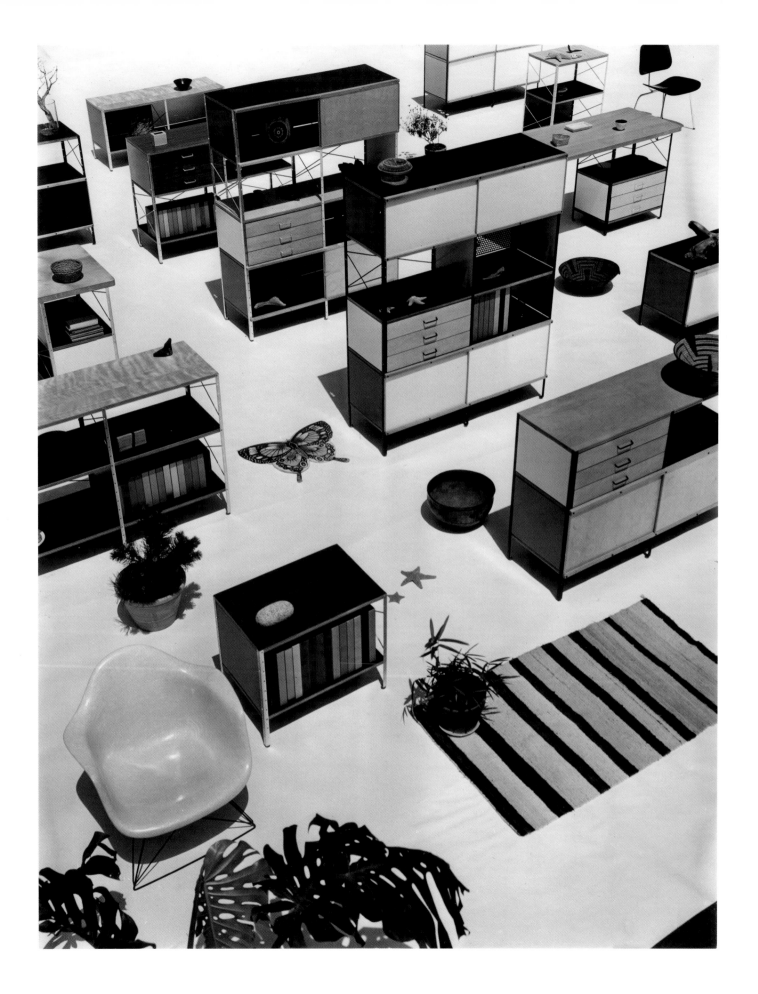

opposite

Fig. 3 Eames Storage Unit (ESU) variations
designed by Charles and Ray Eames for
Herman Miller, 1951

right

Fig. 4 Family portrait of Alexander and
Susan Girard with their children, Marshall
and Sansi, 1952

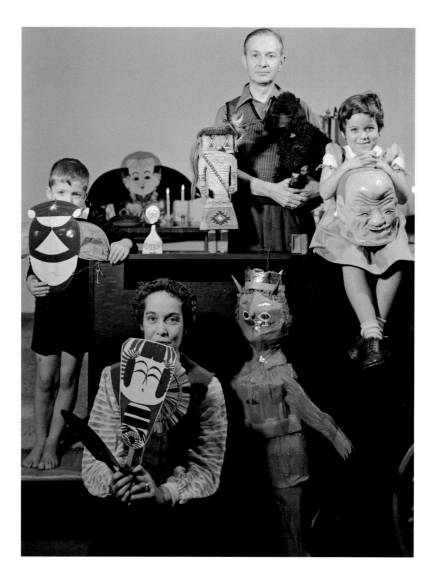

Fig. 5 Charles and Ray Eames
wearing horse masks for an impromptu
performance, 1948

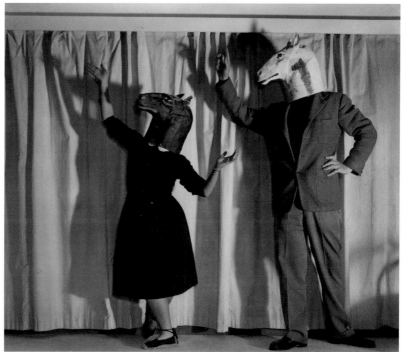

Fig. 6 Carton City built by Charles and
Ray Eames from Eames Storage Unit (ESU)
boxes, 1951

Fig. 7 Irving Harper, Platter clock, for Howard Miller Clock Company, 1959. Collection of William and Annette Dorsey. [CAT. 90]

During an era of increased air travel and leisure time, the domestic interior was further enlivened by collections of folk art alongside ornaments such as kites, masks, and various trinkets. The make-believe quality of masks was embraced by Alexander and Susan Girard (fig. 4) and Charles and Ray Eames (fig. 5). The Eameses, who, like the Girards, collected folk art, are discussed in an essay by Pat Kirkham that considers the pivotal place that play occupied in their design practice and the childlike aspects of their personalities in both their adult identities and their work (fig. 6). Amy Auscherman focuses on the clever work of Irving Harper, a designer at George Nelson & Associates for many years. Harper's archive was recently acquired by Herman Miller and provides the foundation for her inquiry into Harper's experimentation with form and materials for some of the most innovative and whimsical clock designs of the twentieth century (fig. 7). Kirkham's second essay in this volume looks at Eva Zeisel's "playful search for beauty." Zeisel harmoniously linked past and present, creating something fresh and fun in the process.

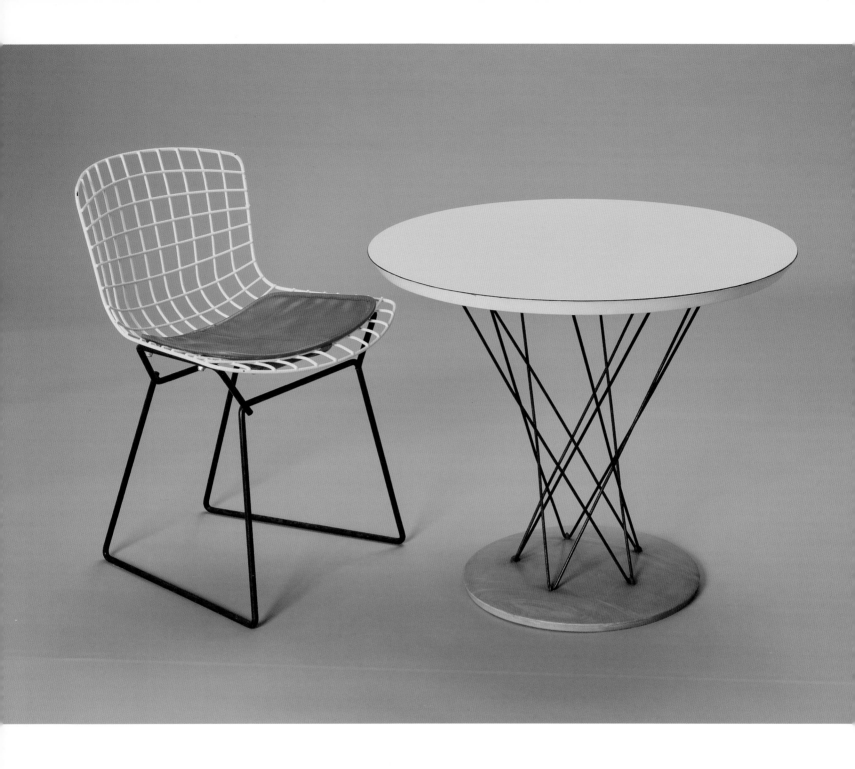

Fig. 8 Harry Bertoia, child's chair, 1955, with Isamu Noguchi, child's table (model 87), 1953, both for Knoll. Collection of Jody and Dick Goisman; Collection Milwaukee Art Museum. [CATS. 43, 150]

CHILD'S PLAY

Charles and Ray Eames, Isamu Noguchi, and Harry Bertoia were among the many designers who created child-scaled furniture (figs. 8–9), but designers also eagerly conceived new furnishings that were not just smaller, but stimulated a child's imagination. Designer Ruth Adler Schnee created many textile designs for domestic settings, but her pattern Humpty Dumpty was made specifically for children's rooms (fig. 10). In her essay, Alexandra Lange traces the idea of toys as furniture and its corollary—furniture as toys—which includes Henry P. Glass's brightly colored Swing-Line, which developed from the Nursery-Line (fig. 11). Lange begins her essay with a discussion of architect

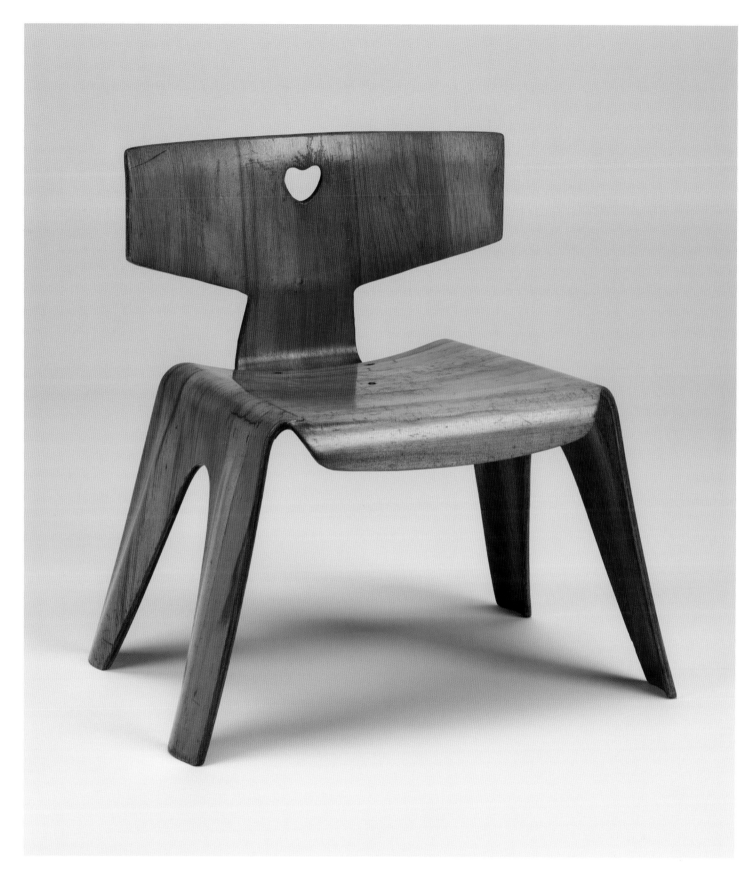

Fig. 9 Charles and Ray Eames, child's chair
for Evans Products Company, c. 1944.
Denver Art Museum. [CAT. 58]

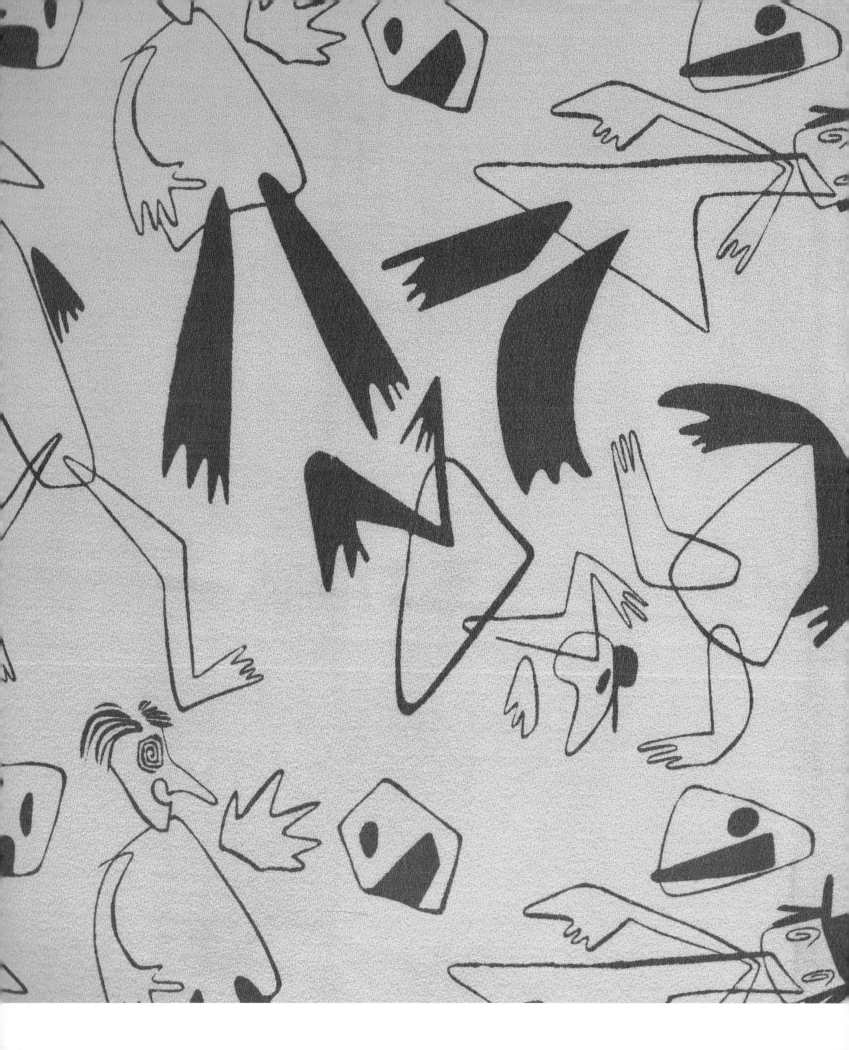

Fig. 10 Ruth Adler Schnee, Humpty Dumpty furnishing fabric for Adler-Schnee Associates, 1949 (detail). Collection of Ruth Adler Schnee. [CAT. 168]

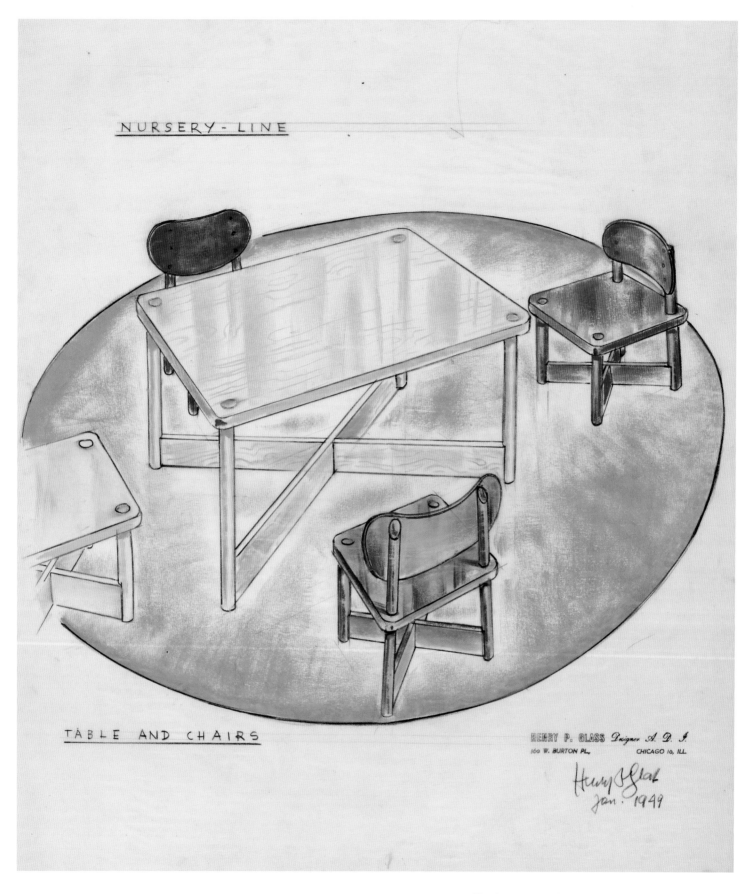

NURSERY - LINE

TABLE AND CHAIRS

HENRY P. GLASS Designer A. D. I.
160 W. BURTON PL. CHICAGO 10, ILL

Fig. 11 Henry P. Glass, drawing of child's table and chairs, 1949. Milwaukee Art Museum. [CAT. 116]

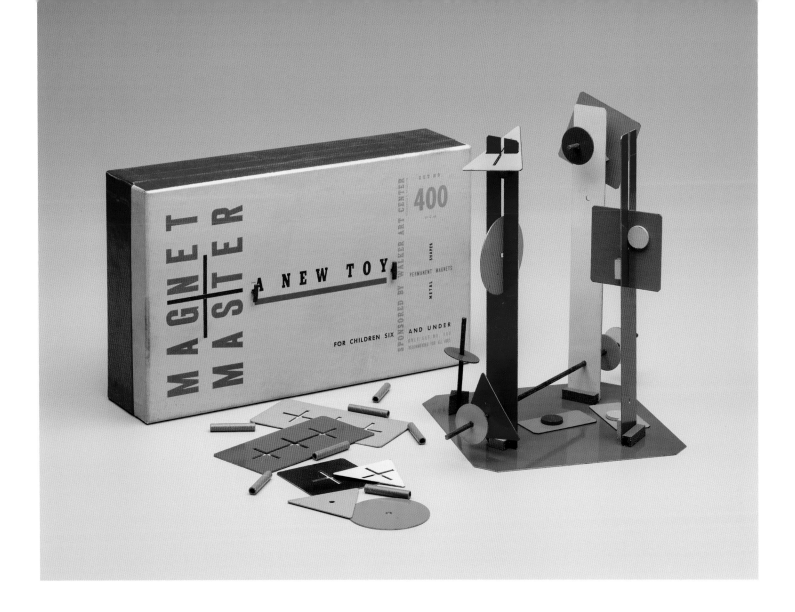

Fig. 12 Arthur A. Carrara, Magnet Master 400, 1947. Milwaukee Art Museum. [CAT. 45]

Anne Tyng's toy (known as the Tyng Toy), one of the architect-designed toys that manifested the desire among midcentury architects to create experimental toys. Another was architect Arthur A. Carrara's Magnet Master, which encouraged children (and adults) to construct architectural models out of colorful geometric shapes composed of steel that were joined by chunky wedge magnets and magnetic rods (fig. 12). Carrara claimed that the Magnet Master "helps children realize their potentialities, develops their imagination, and places a new creative tool at their disposal."[7] Victor D'Amico, director of education at the Museum of Modern Art, noted that "creative play with everyday materials is fun for children and will make them aware of colors, textures, shapes, and relationships."[8]

Ideas about children's development in the context of play extended to the outdoors as well. The hallmark playgrounds prior to midcentury were regularized designs with mass-produced equipment based on turn-of-the-century standards. By the 1930s and 1940s, new discussions on the design and function of playgrounds were taking place, primarily in architectural journals. Postwar designers and architects created play spaces and play sculptures that were less prescriptive and more open, playful, and imaginative.

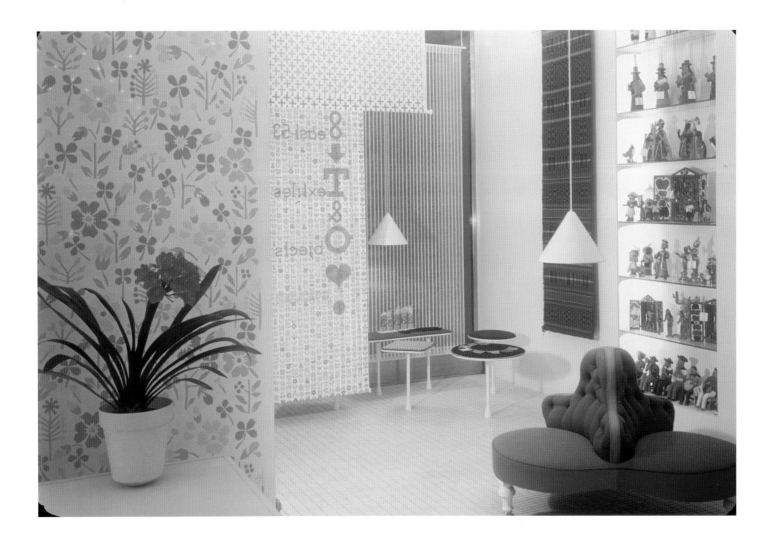

opposite

Fig. 13 Isamu Noguchi, models for play equipment, c. 1965–68. The Noguchi Museum, New York. [CATS. 143, 144, 145, 146]

above

Fig. 14 Alexander Girard, interior for Textiles & Objects shop, 1961

During this time, Isamu Noguchi created playgrounds and play structures to stimulate creative activity as a way of learning about and participating in the world (fig. 13). Recognizing the need for creative playscapes where freedom and play are encouraged, David Aaron, a consultant and designer of play materials and playgrounds for children, wondered, "Play, what does it mean? One thing it means is the same sense of inspecting, turning, holding to the light, examining all the possibilities of. We speak of playing with an idea, meaning that we look at it every which way."[9]

CORPORATE APPROACHES

Play was not relegated to domestic settings. Ideas about play also permeated the corporate world, as designers explored new avenues for companies aiming to cultivate distinctive brand identities. In the mid-1960s, Alexander Girard juxtaposed Latin American folk art with a gridded modular system for the Braniff International VIP lounge to create a complex corporate identity that mixed luxury with playfulness. Monica Obniski addresses this project, along with Herman Miller's Textiles & Objects shop in New York City (fig. 14), in an essay that examines the playful image of business in two corporate environments designed by Girard. Part of Girard's contribution to this period was the insertion of folk art into modern interiors. Similarly, architect Victor Gruen asserted in 1952 that "store design is taking itself too seriously," and therefore, according to *Architectural*

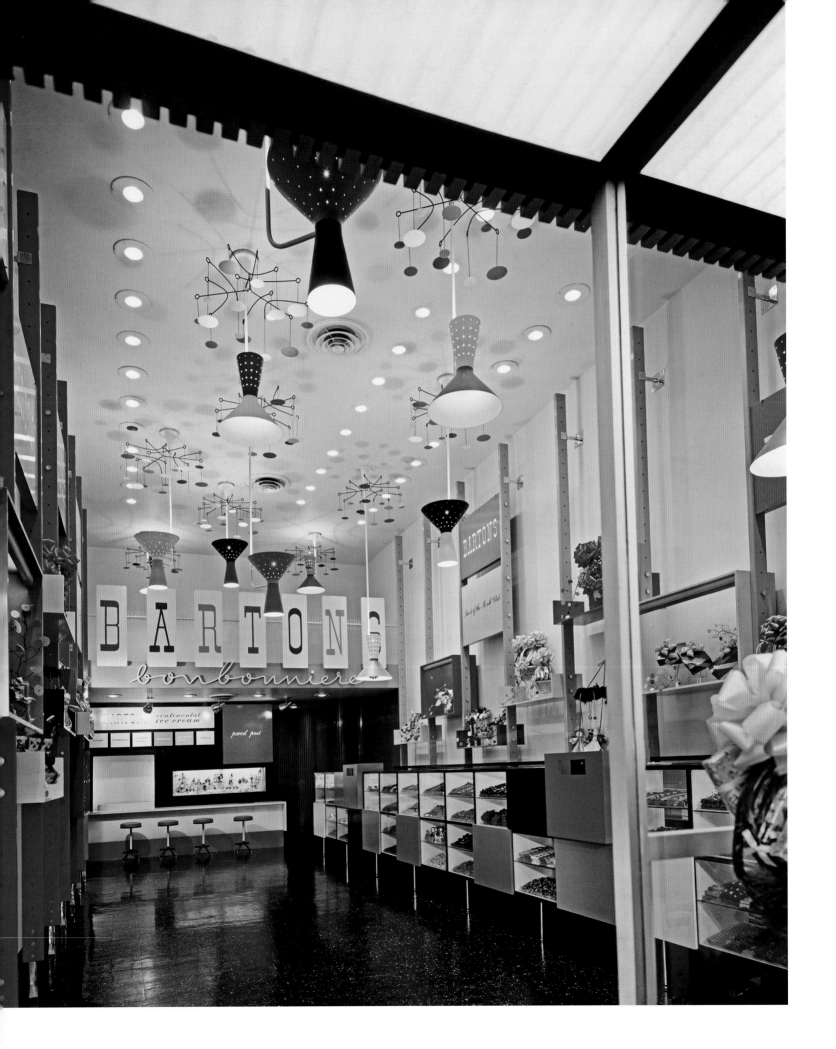

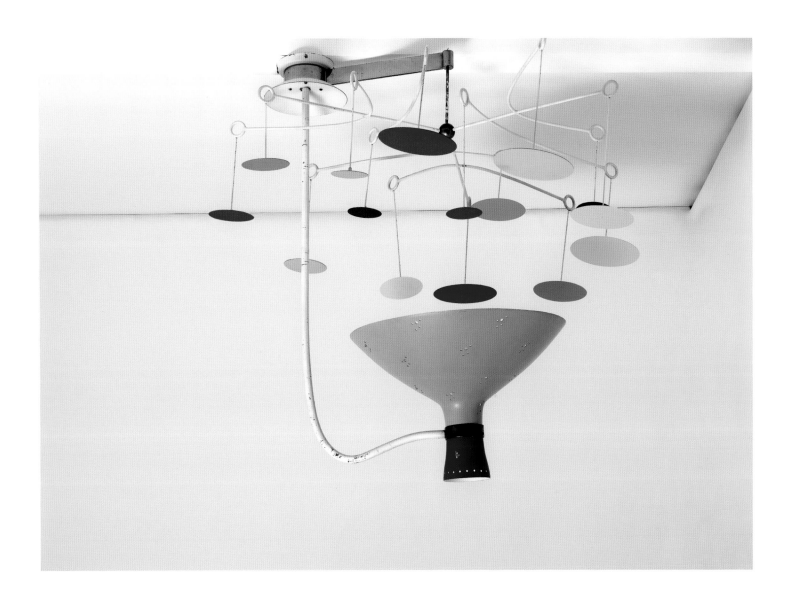

opposite

Fig. 15 Victor Gruen with Alvin Lustig,
interior for Barton's Bonbonniere, 1952

above

Fig. 16 Victor Gruen, ceiling light for
Barton's Bonbonniere, c. 1952. Brooklyn
Museum. [CAT. 124]

Fig. 17 Eileen J. Aureli, rendering for Monsanto House of the Future, c. 1958. Collection of Jill A. Wiltse and H. Kirk Brown III. [CAT. 34]

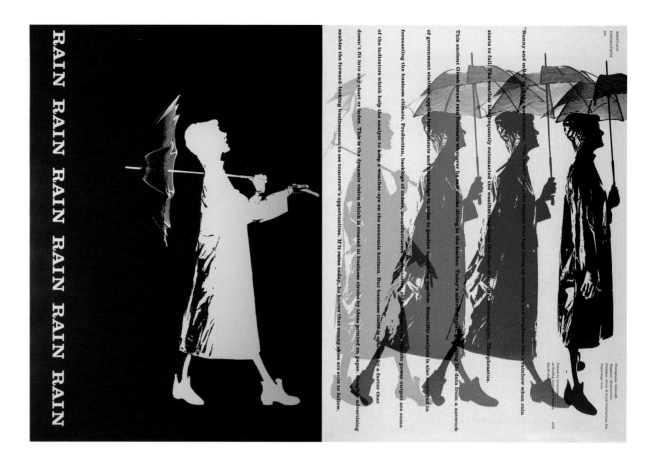

Fig. 18 Bradbury Thompson, *Rain Rain Rain* spread, from the periodical *Westvaco Inspiration for Printers* 210, 1958. Rochester Institute of Technology. [CAT. 179]

Forum, he sought to "induce a playful state of mind" in his design for Barton's Bonbonniere, a delightful candy shop that was like a "toyshop for adults" (figs. 15 and 16).[10]

Darrin Alfred explores the Alcoa Forecast Program, which was conceived as a catalyst to "inspire and stimulate the minds of men."[11] Forecast featured original prototypes by many notable designers, including David Aaron, Marianne Strengell, and Don Wallance, and utilized aluminum in imaginative and whimsical ways. In a similar vein, Monsanto executives authorized their House of the Future project to establish the universality of plastics as among the wonders of the future, and the unlimited vision of the company as a leader in the plastics industry. Opened to the public in 1957, the space-age dream house interior was renovated several times during its existence; many designers created alternate interior plans (including the one shown here) that were never executed (fig. 17).

Graphic design was likewise conceived in and exuded a sense of playfulness. Steven Heller pays homage to designer Paul Rand and like-minded colleagues in his essay, which examines the "play principle" in graphic design (fig. 18). As Rand quipped, "Without play, there would be no Picasso. Without play, there is no experimentation. Experimentation is the quest for answers."[12]

Play is a free, experimental activity that has been traditionally associated with children. This project, while acknowledging the importance of children's spaces, moves the concept out of the realm of childhood and into the studios, workshops, factories, residences, and businesses of adults. Architects and designers shaped culture through play and through a playful state of mind. By assembling and calling attention to their work, we hope that the value of play will be recognized. In short, it is past time to take play seriously.

NOTES

1 Johan Huizinga, *Homo Ludens: A Study of the Play-Element in Culture* (London: Routledge and Kegan Paul, 1980), 13. His comment about "fruitful avenues" is from a lecture he gave in 1938, "The Cultural Limits of Play and the Serious," quoted in Roger Caillois, *Man, Play and Games*, trans. Meyer Barash, first published in 1958; first English translation, 1961 (Urbana: University of Illinois Press, 2001), 3.

2 Huizinga, *Homo Ludens*, 5.

3 Caillois, *Man, Play and Games*, 58.

4 Steven Johnson, *Wonderland: How Play Made the Modern World* (New York: Riverhead, 2016), 280.

5 James B. O'Connell, "A Visit with Charles Eames," *Think* 27, no. 4 (April 1961): 7–9. Reproduced in *An Eames Anthology: Articles, Film Scripts, Interviews, Letters, Notes, Speeches*, ed. Daniel Ostroff (New Haven, CT: Yale University Press, 2015), 218–219.

6 Aline B. Louchheim, "Of Toys and Art: Eames' Cards Call Forth Child's Creativeness," *New York Times*, July 26, 1953.

7 "Magnet Master," *Everyday Art Quarterly* (Walker Art Center) 8 (Summer 1948): 4.

8 Victor D'Amico, "Help Your Child Develop a Seeing Eye," *House Beautiful*, January 1958, 90.

9 David Aaron, undated draft copy [interview by Oscar Shefler] for "Why Is a Tree?" Oscar Shefler Papers. Oscar Shefler was an account supervisor at the advertising and public relations agency Ketchum, MacLeod & Grove in Pittsburgh.

10 "Playful Chocolate Shop," *Architectural Forum*, August 1952, 101–102. See also http://gruenassociates.com/project/bartons-bonbonniere (accessed January 5, 2018).

11 Ketchum, MacLeod & Grove, Forecast Program report/scrapbook, 1959, on loan from Torrence Hunt, Acct. #L98.011, Alcoa Archives, Library and Archives Division, Historical Society of Western Pennsylvania, Pittsburgh.

12 Steven Heller, "Paul Rand: The Play Instinct," in Steven Heller and Gail Anderson, *Graphic Wit: The Art of Humor in Design* (New York: Watson-Guptill, 1991), 122.

PLAYFUL DOMESTICITY

MONICA OBNISKI

The home has often functioned as a showcase for culture. At the turn of the twentieth century, economist-sociologist Thorstein Veblen wrote about the leisure class's conspicuous consumption of goods. Half a century later, social critic Vance Packard updated Veblen's theories in a book called *The Status Seekers* (1959), which suggested that merchandising and advertising to specific social classes contributed to the idea of goods as status symbols.[1] Packard recognized that "status seekers" in the mid-twentieth century decorated their homes with handmade goods as symbols of value. This practice emerged during an era in which creativity began to be heralded as a desirable character trait,[2] and in the same year that Packard's book was published, journalist and critic Aline Saarinen noticed "another kind of art that is now beginning to be found in American homes represents a fairly new trend: small objects of various kinds."[3] These objects were often playful in appearance and prized for their unique charm, and their display in the midcentury home became a demonstration of the owners' creativity and individuality. This essay examines this new channel of creativity—playful domesticity, let's call it—especially as it relates to decor and design in midcentury America.

STORAGE AS ARCHITECTURE

In the years following World War II, increased leisure time and expendable income within the growing middle class translated to an accumulation of goods—from stereo systems and books to home furnishings and knickknacks. This, in combination with the popularity of do-it-yourself culture, resulted in many Americans decorating their homes in new and interesting ways. One of the period's most iconic design objects, the storage wall, was marketed as a product to hold newly purchased consumer goods. An object of aggressive consumption, the storage wall was given pride of place in many domestic (and corporate) interiors. Storage walls could be composed of stacked shelves, both open and closed, with drawers or other specialized functions, and could stand in the middle of the room as a divider or against the wall.

While the concept of storage was not new, many architects and designers showed a devotion to its development that signaled the significance of the trend. Critic and philosopher Arthur Danto understood furnishings as a system of signs, that is, the objects that we select underscore who we are and how we fit into the world.[4] Architectural critic Lewis Mumford wrote that the purpose of storage involved the "preservation of a surplus of goods, physical and spiritual, above the requirements of daily use, as a way of confronting unexpected emergencies, of meeting seasonal changes . . . of serving as a connecting link between the past and the future."[5] He also believed that storage provided the present with freedom from the burdens of the past, without destroying it. Storage walls became one of the prevailing elements of domestic architecture and design of the postwar house.

So what does the storage unit, and the objects that filled its spaces, tell us about the mid-twentieth century? For architect-designer George Nelson, storage design was inextricably linked with basic issues of modern architectural interiors. In discussing modern furniture in 1949, Nelson declared that storage was disappearing into the wall or becoming a partition—effectively becoming architecture.[6] For Nelson, the house essentially became a storage area for all the things associated with daily life and leisure. Nelson himself was instrumental in effecting this change with the introduction of the Storagewall, which he and Henry Wright designed in the mid-1940s. In his book on storage, Nelson

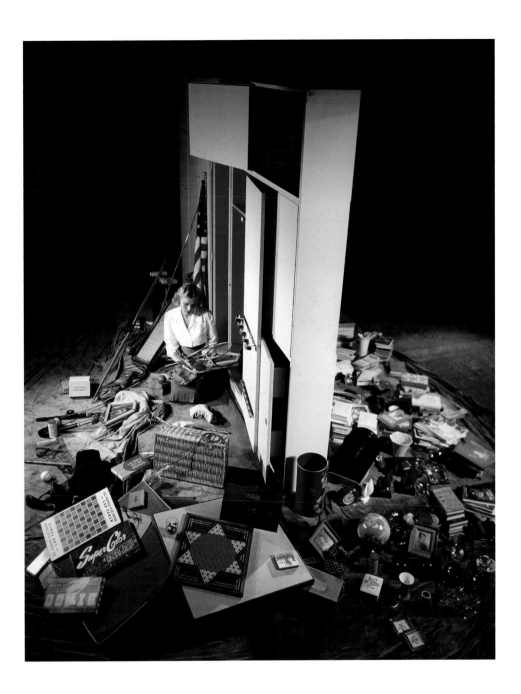

rhetorically asked the reader to consider "where to keep the toasters, barbecue sets, mixmasters, record albums, games, tricycles, skis — the list was endless and it kept growing."[7] One solution was to build differentiated storage — closets, space dividers, utility rooms, unit furniture, and, of course, storage walls — within the home.

An outgrowth of built-in and modular furnishings of the early twentieth century, the Storagewall consisted of prefabricated units that could be mass-produced, creating a fundamentally new piece of furniture that partitioned rooms. The Storagewall was introduced to architects in the November 1944 issue of *Architectural Forum*; in January 1945, *Life* magazine announced it to a broader American public (fig. 19).[8]

As an "adaptable, imaginative, ingenious, inventive, and resourceful" architect, Nelson believed the Storagewall to be one of the most important achievements of his career.[9] Editors of magazines such as *House & Home* exclaimed that the major problem facing

the American homeowner was the lack of adequate storage space for their possessions. The article "You Can't Have Too Much Storage!" tackled the proposed new Federal Housing Administration (FHA) guidelines on Minimum Property Standards (MPS), which would raise previous general storage requirements in new housing built in the United States.[10] Although the government codes were primarily focused on health and safety, the MPS for one and two living units released in 1958 underscored the need for national standards for storage space in kitchens, closets, and other dwelling areas, decreeing this a key issue of the time.[11] The storage wall offered infinite possibilities with its variable drawer, open shelving, and closet configurations, rendering it both functional and flexible. For example, for a cramped New York City apartment, Nelson designed four separate storage units (for the foyer, nursery, kitchen, and living room).[12]

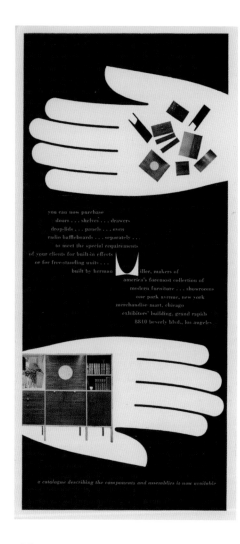

right

Fig. 20 Ernest Farmer, Basic Storage Components (BSC) system in the Herman Miller Merchandise Mart showroom, Chicago, c. 1949

above

Fig. 21 Basic Storage Components (BSC) system, shown in an advertisement designed by Irving Harper, c. 1949

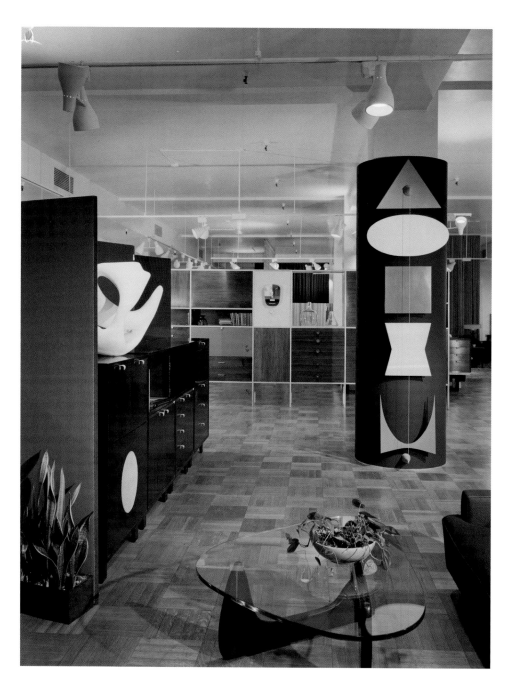

Fig. 22 Irving Harper, Herman Miller
advertisement, c. 1948

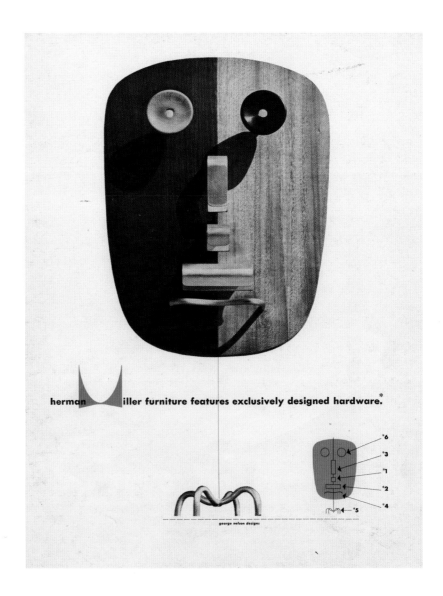

Nelson and his team designed several modular storage units composed of standard-ized elements — all of architectural quality — for Herman Miller. Regarding the Herman Miller unit designed for the Detroit Institute of Arts' *An Exhibition for Modern Living* (1949), Nelson believed that "built-in facilities need not duplicate . . . the forms of existing furniture."[13] For this piece of furniture, called the Basic Storage Components (BSC) system, Ernest Farmer (a designer working for George Nelson & Associates) used components from storage furniture already in production and applied them to this grid-like room divider (fig. 20).[14] An advertisement presents the storage wall components within the palm of one hand and the completed BSC in another hand, suggesting the unit's flexibil-ity; the "hands" also obliquely participate in the do-it-yourself ideal (fig. 21).

As seen inside Herman Miller's Chicago (Merchandise Mart) showroom, the BSC system featured a curious touch — a masklike face.[15] The "mask" served a function — to articulate the various types of wood finishes (primavera, bittersweet red, walnut, oak, ebonized wood, forest green) and hardware available to outfit the storage wall. Designed by Irving Harper (another designer for Nelson Associates), the curious "face" was also featured in an advertisement for Herman Miller furniture (fig. 22). On the surface, the

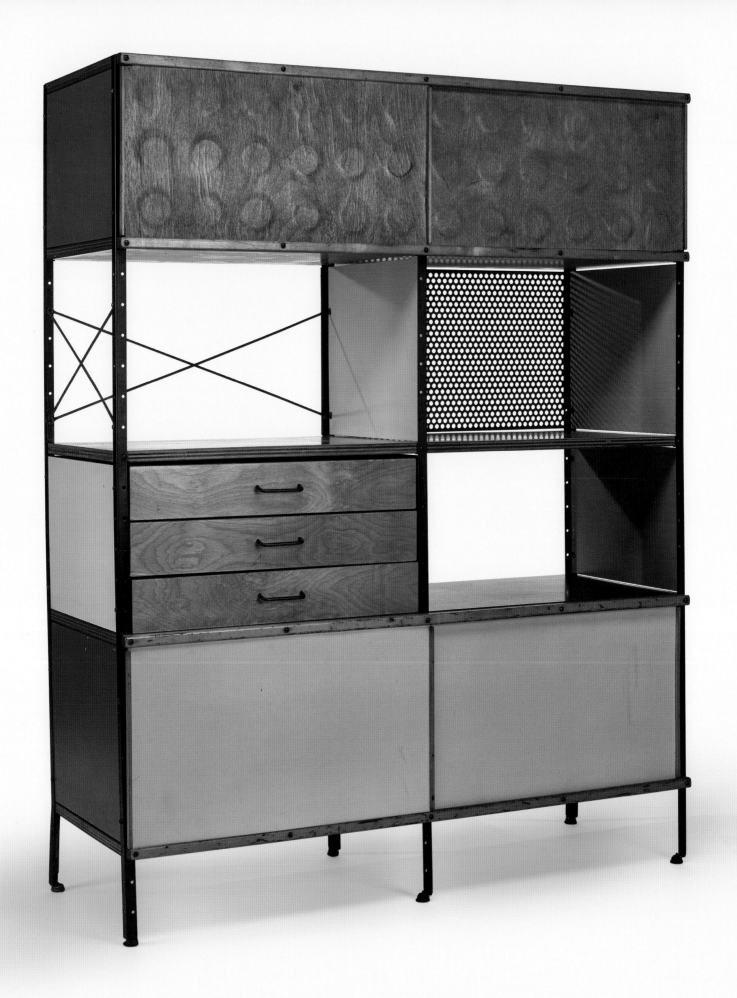

advertisement playfully articulates the choices available by fashioning a visage out of different woods and hardware to create parts of a face. Harper took the ploy one step further by using a red line (the same color as the distinctive Herman Miller logo that Harper also designed) to connect the mask with a piece of hardware (an x-pull) that, in this context, becomes a spider-like creature. By anthropomorphizing the hardware and finishes, Harper humanized banal furniture details and rendered them lighthearted (see "What is a clock, anyway?" in this volume). A playful touch for a serious piece of furniture—and emblematic of an item (the mask) that would become important to many midcentury designers, including Alexander Girard and Charles and Ray Eames (see figs. 4 and 5).

For Nelson and his associates, the architectural approach to storage units involved making objects disappear. In contrast, for Charles and Ray Eames, the storage unit was a form of expression—an architectural structure to inspire creativity. The Eames Storage Unit (ESU) was an "inventive system of construction as simple and as openly engineered as a bridge," according to Charles Eames, and could be used in the living room, dining room, or bedroom, or as a room divider (fig. 23).[16] This storage system was developed while they were working on their own home, Case Study House No. 8 (also known as the "Eames House"), and was ultimately employed in that Pacific Palisades dwelling.[17] Constructed of glass and steel and replete with the Eameses' collections of furniture and objects, the Eames House was a physical embodiment of the designers' approach to modern domestic life. Similar to their home, the ESU used an exposed structural frame to articulate the construction of the case. The industrial language of a steel structure became appropriate for the domestic landscape within the context of the Eames House. Designer Don Wallance noted that the Eameses used their California workshop for design and experimental fabrication of metal, plastic, and plywood furniture, primarily as a "design laboratory for the Herman Miller Furniture Company."[18] The ESU should be understood on these terms: a product of experimentation and free play.

Through play, children acquire skills and learn about relationships and ways to communicate. Of course, this approach is not relegated to children—for the Eameses, toys were a starting point for discovery (see "Charles and Ray Eames" in this volume). Thinking about modular storage systems as "tinker toys to play with" directly connects the kit-of-parts concept from the architecture of the Eames House to the ESU.[19] Designed with standardized parts, this versatile piece of equipment incorporates bright colors (blue, red, or yellow) alongside neutral tones and wood (birch or walnut). Various models provided alternative configurations—drawers, sliding doors, panels, metal cross-braces. The series offered everything from a small table and bookshelves to a large storage wall, and the system was intended to work well with all of the different configurations—the 100, 200, 400 series units and multiple desk units—encouraging consumers to mix and match (fig. 24).

The ESU also developed out of experimental shelving that the Eameses designed for a model room setting in the Detroit Institute of Arts exhibition (fig. 25).[20] For this exhibition, the Eameses did not choose to explore a specific room typology. Instead, they proposed a way of living, one that embraced an "*attitude* toward the space and objects with which one lives."[21] This attitude was shaped by individuality and the freedom to play with objects in a space.

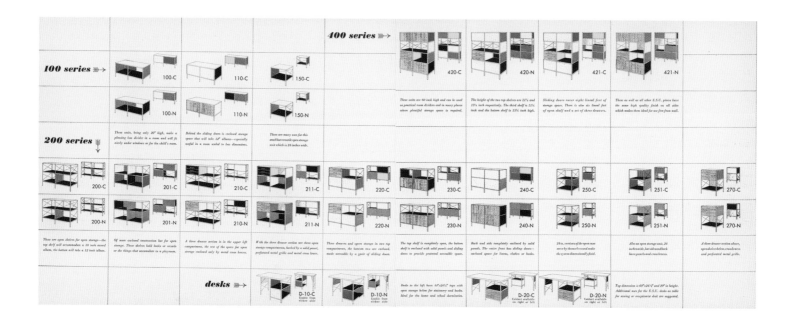

Fig. 24 Eames Storage Unit (ESU) brochure, 1951

Certain unconventional objects, like kites, made their way into room settings because they were objects that the Eameses lived with (fig. 26)—and therefore worked with. Objects like butterfly or box kites, which are structured yet colorful, demonstrate possibilities and offer an embodiment of a flight of fancy. The Eameses appreciated the way these objects looked, but they also wanted to question their role as objects of design. *Life* magazine noted about Charles Eames that "to feed an insatiable interest in the looks of things, he and his wife take frequent sleeping-bag trips into the surrounding seaside and desert areas collecting weeds, rocks and driftwood whose appearance they want to study. They decorate their home with Chinese fans, Indian blankets and golden eggs for the same reason."[22] Just as variety existed in the types of modular storage solutions available—from highbrow to mass-market—ideas for display trickled down to a popular audience through items like Peg-Boards, which were advertised in the 1950s to give walls "true functional beauty" (fig. 27). While the materials were different, the idea was the same—the homeowner could arrange objects and artwork as he or she pleased, in the same vein as an Eames interior.

Elizabeth Gordon observed a new trend in the October 1952 issue of *House Beautiful*: "Watch how people are exercising free taste, mixing good things regardless of the rules. They are bringing together things they like from all periods, all countries and all cultures."[23] The use of non-Western objects became popular during the 1950s, and magazines such as *House & Garden* presented articles like "Going Places, Finding Things in Brazil," which provided readers with suggestions for cheerful, ornamental folk art to bring back home from vacation.[24] When chosen by designers, these objects contributed to a type of humane modernism, a narrative found in postwar America that was embraced by the Eameses and fellow Herman Miller designer (and friend) Alexander Girard, as Pat Kirkham has demonstrated. Kirkham also discusses the practice of "functioning decoration," which incorporated groups of varied objects, including handcrafted toys and folk art, carefully arranged to create "extra-cultural surprise," an aesthetic of plenty, addition, accretions, excess, juxtaposition, layering—basically, an antiminimal approach.[25]

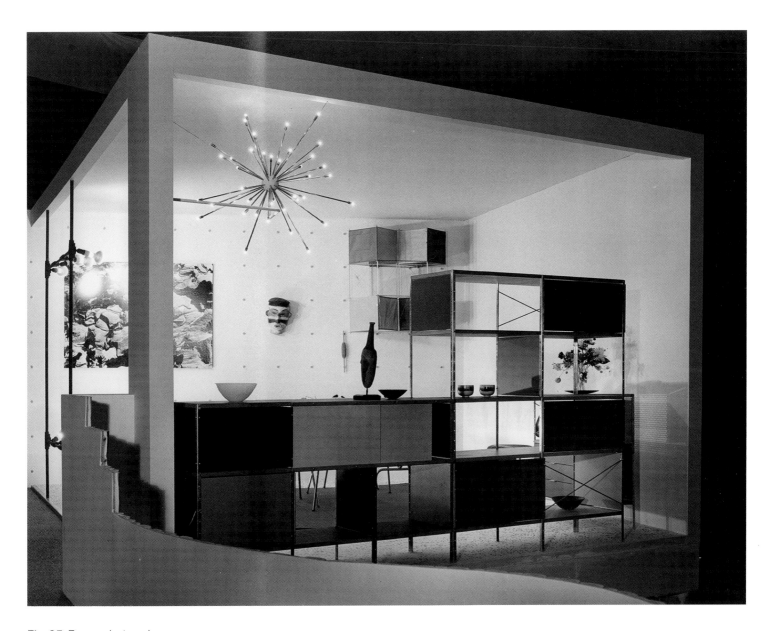

Fig. 25 Eames-designed room
in *An Exhibition for Modern Living,*
Detroit Institute of Arts, 1949

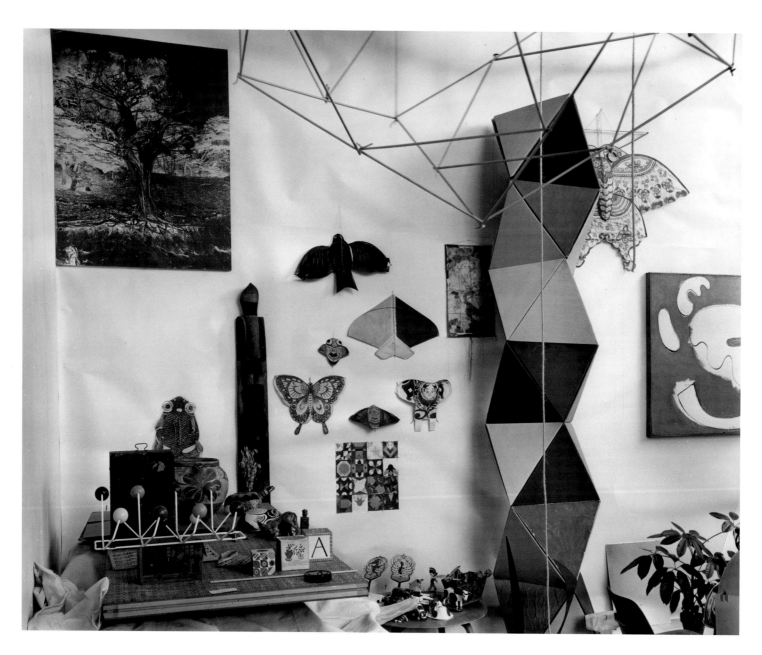

Fig. 26 Butterfly kites mounted on the wall in the Eames House Studio, 1952

opposite
Fig. 27 Advertisement for Peg-Board fixtures in *Interiors*, October 1953

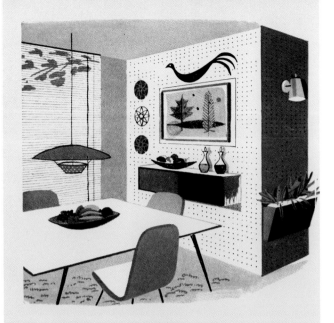

give your walls true

FUNCTIONAL BEAUTY

"PEG-BOARD" perforated hardboard panels provide a **new** texture . . . a smart new treatment for your rooms. Used with "PEG-BOARD" interchangeable fixtures . . . such as shelf brackets, magazine racks, hooks, etc. . . . they give your rooms "WORKING WALLS."

WRITE TODAY for new booklet "Home Decorating Ideas with 'PEG-BOARD' WORKING WALLS", prices and sample kit on request.

Copyright 1953 by

B. B. BUTLER MFG. CO., INC.
3152 Randolph Street • Bellwood, Illinois

"PEG-BOARD" is the Reg. T.M. of B. B. Butler Mfg. Co., Inc., used to identify its products.

PEG·BOARD

PANELS AND FIXTURES

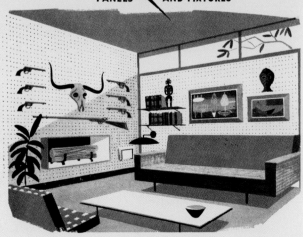

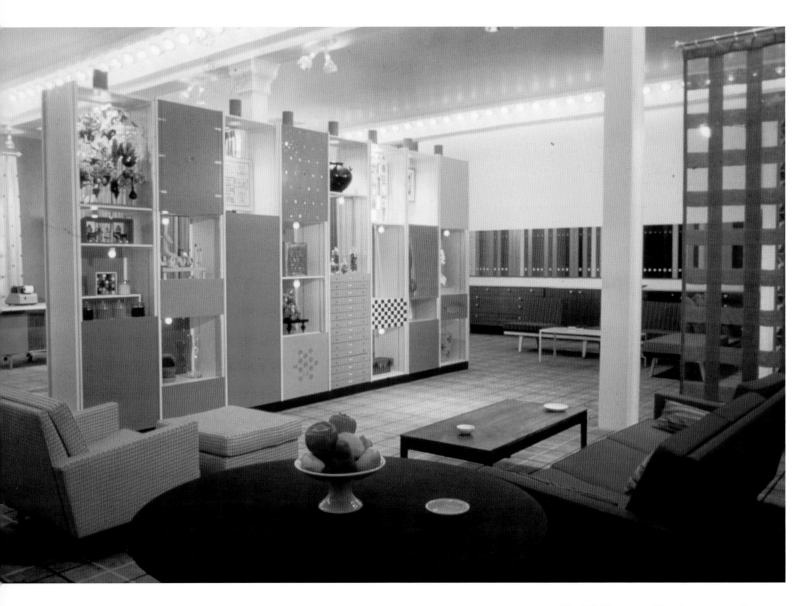

Fig. 28 Alexander Girard, storage wall,
Herman Miller San Francisco showroom, 1959

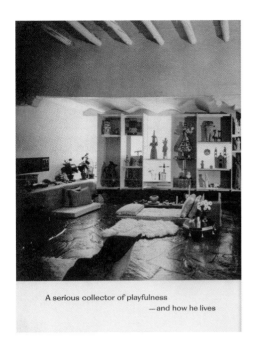

A serious collector of playfulness
—and how he lives

Fig. 29 Alexander Girard's Santa Fe home in *House Beautiful*, April 1963

Alongside the Eameses, Alexander Girard also exemplified a penchant for displaying objects in storage walls—an architectural feature that became a Girard hallmark in his designs for domestic and corporate interiors. Girard adapted Nelson and Wright's concept by moving the storage wall away from the edge of the room, transforming it into free-standing shelving for displays and room dividing. Nelson may have promoted the storage wall widely, but Girard suggested how to *use* it in a dynamic way. For Girard, the storage wall's decorative purpose was critical, while its functional use as storage was secondary; this was antithetical to Nelson's viewpoint. The other distinguishing element of Girard's storage walls is the deliberate act of decorating with folk art and other objects (similar to the approach of the Eameses); this aspect of Girard's artistic practice is prevalent in many of his projects (see "Alexander Girard and Play in the Corporate Environment" in this volume).

Girard considered the storage wall to be the fundamental furniture object of his era. *Interiors* effusively admired this feature in Girard's design of Herman Miller's San Francisco showroom (fig. 28), noting, "Designer Girard's partitioning system is a triumph, simultaneously achieving a mysteriously weightless airiness while organizing the space and setting off the Herman Miller fabric line, designed by Girard himself, with the most alluring display on record."[26] Using backgrounds and multitudinous panels of color, Girard installed a varied mixture of "tourist-type" objects, from a Native American basket and Mexican doll to African prints. The divider was intended to store things, but it also visually cataloged them through delightful arrangements. Similarly, in the April 1963 pages of *House Beautiful* (fig. 29), alongside photographs of storage apparatuses in Girard's Santa Fe home, the writer suggested a reason for Girard's success: due to his architectural training, he was able to order these units in a strong geometric fashion, with an eye toward "strict organization."[27] In other words, on this occasion he was commended to the extent that his work accorded with the principles of modernist "rational" design, but he was also labeled in the magazine as a "serious collector of playfulness."

When, in 1956, the industrial aluminum company Alcoa contracted Girard and other notable designers to fashion a new image for aluminum through a design prototype and advertising campaign called the Forecast Program, he contributed an aluminum room divider (fig. 30) (see "Serious Business" in this volume). For this speculative work, Girard desired an object that "would impart on its own merits a maximum sense of quality and elegance."[28] He strived to create a system that would not compete with the objects on display, so the "character of the design aims to be restrained and anonymous without being uninteresting."[29] As *Interiors* commented, the room divider was to function as a "playful foil to the dolls, primitive toys, artifacts, and curios which collector Girard has spaced within the structure."[30]

As Edgar Kaufmann Jr. noted, "clearly, Girard's modern cannot be accused of coldness," and it is, in fact, a reminder of the humane modernism some recognized as prevalent in midcentury American design.[31] Girard created an accessible way to install, view, and interpret objects within shelves that formed grids. He acknowledged his interest in the idea of souvenirs and the construction of memory through these objects, writing that "in most of us there is a tendency to try to halt time, to relive the past through the accumulation of souvenirs."[32] The meaning of, and interest in, authenticity has evolved over time, but for Girard, the objects were authentic because they were procured on his varied

Forecast:

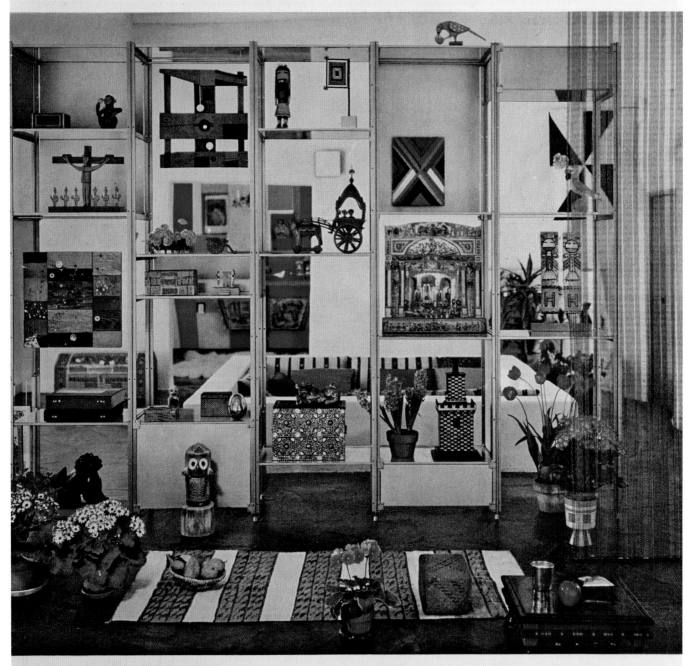

Aluminum shelving unit designed for the Alcoa collection by Alexander Girard. Photographed in Santa Fe by Charles Eames.

There's a world of aluminum in the wonderful world of tomorrow . . . where beautiful things will find their perfect setting in endlessly variable interiors of aluminum . . . made from strong aluminum honeycomb . . . aluminum sheet . . . aluminum shapes . . . in a spectrum of tones and textures to line your walls or divide your rooms with pure enchantment.

ALUMINUM COMPANY OF AMERICA, PITTSBURGH

ALCOA ALUMINUM

opposite

Fig. 30 Alcoa Forecast Program advertisement featuring Alexander Girard's shelving unit, 1956. Photographed by Charles Eames. [CAT. 22]

right

Fig. 31 Herón Martínez Mendoza, candlesticks, c. 1960. Museum of International Folk Art, Santa Fe. [CAT. 219]

touristic journeys (fig. 31); once objects became manipulated in his design projects, they still carried meaning, but their original meaning was altered. Simply put by historian Silvia Spitta, "when things move, things change."[33] For Girard, the rational grid-like system of the storage wall provided the systematic organization to contain his folk art, and could function to create a connection between identity, things, and memory.

Using the design for Alcoa, Girard approached Herman Miller to manufacture his modular shelving system. Gardner Displays (of Pittsburgh) had built the prototype to Girard's specifications in late 1956. Hugh De Pree (president of Herman Miller) sent a memo in 1957 asking for figures to assess whether the company could produce the room divider.[34] Initially, Alcoa gave its consent (as well as exclusive use of the dies) to Herman Miller to manufacture the Girard shelving unit, but Alcoa requested that "a tag designating that the room divider came from the Alcoa Forecast Collection be placed on each divider."[35] After studying the plans and Girard's proposal, the firm was ready to proceed with a Herman Miller prototype of the storage wall.[36] Girard desired one for the San Francisco showroom, which was debuting in October 1958, but there was not enough time to manufacture one before opening. Furthermore, the connecting elements that Girard designed required expensive custom tooling; Herman Miller did not want to support this endeavor, and Alcoa was then reluctant to provide the die and to anodize the aluminum. Ultimately, Herman Miller never manufactured the Girard storage wall, nor was an Alcoa-Girard film by the Eameses ever produced. The film script is revelatory because it proposes that "there is perhaps no designer of our time more concerned with the selection of beautiful things, and their relation to our environment, than Alexander Girard."[37]

Fig. 32 Storage wall decorated in the manner of Alexander Girard, in *House & Garden*, January 1961

Writing about the shelving unit that he designed for Alcoa, Girard commented that people live in "containers within containers," but there is hope for people living in a house that was "a container of divisible spaces."[38] Girard's way of arranging the home forced people to be more discriminating in their selection of objects and more playful in displaying them. He argued, "What folly to gather objects because the sight of them pleases us, because the contemplation of them enriches us, or because they stimulate recollection of good times and places—and then to conceal them."[39] Fundamentally, display in a storage wall was an essential component of his strategy for living playfully in the postwar era. In fact, in their spare time, Girard and his wife, Susan, liked to "raze and reconstruct the room divider," constantly adding variety for their own viewing and contemplation of objects.[40]

Girard, like the Eameses, was part of an influential group of designers whose ideas and vision were available to a popular audience through his wide media coverage; his projects were well publicized in home decorating magazines, architecture and design journals, and newspapers. Girard believed the collections he assembled were "no more varied than the objects found in many American homes."[41] Girard, who, like many at the time, viewed women as the primary homemakers, sought to teach them (via magazines) methods of arrangements; he commented, "Bring it together in a wall and, while arranging it, you will improve your taste by testing sizes, proportions, colors and materials and how they blend in what becomes one large painting."[42] For example, in the pages of *House & Garden,* editors featured several Girard folk art vignettes alongside his commission for the New York restaurant La Fonda del Sol. Employing this stirring material, the magazine illustrated an adaptation of folk art niches for the home (fig. 32)—a display wall that homeowners, participating in the postwar do-it-yourself trend, could build and decorate themselves.[43] And, according to sociologist Herbert Gans, these homemaking magazines provided "not only a legitimation of her [the homeowner's] own striving toward individual self-expression but an array of solutions from various taste cultures from which she can begin to develop her own."[44] It was through such magazines that Girard's taste for well-stocked storage walls penetrated the cultural milieu. Despite these efforts, non-functional decoration was marginalized as whimsical and unnecessary in much of the elite design discourse of the period.

PLAYFUL TABLE ARRANGEMENTS

Just as Girard shared advice on how to decorate one's storage wall, he and Susan also created artistic table arrangements and disseminated that knowledge to others. The Girards followed the ideas established by Mary and Russel Wright's *Guide to Easier Living* (1951), which suggested that modern design assisted in fashioning a simple and flexible domestic lifestyle.[45] For the Girards, appealing table settings were not just for special occasions—they added delight to daily life. The couple was known as "skillful performers in this art of artistic playfulness" because they collected with a purpose—to decorate well.[46] The same principles from storage wall decorating can be extended to table settings— the bold use of color and arrangement as an expression of individuality. *House Beautiful* tried to convince the average American to forgo dogmatic table settings and instead to engage in lively collecting that will yield "inspiration in nature forms—stones, driftwood, fossilized wood, shells, ad infinitum—as well as in man-made objects."[47] Taking cues from Ray Eames's floral and weed arrangements or Girard's use of driftwood, magazines

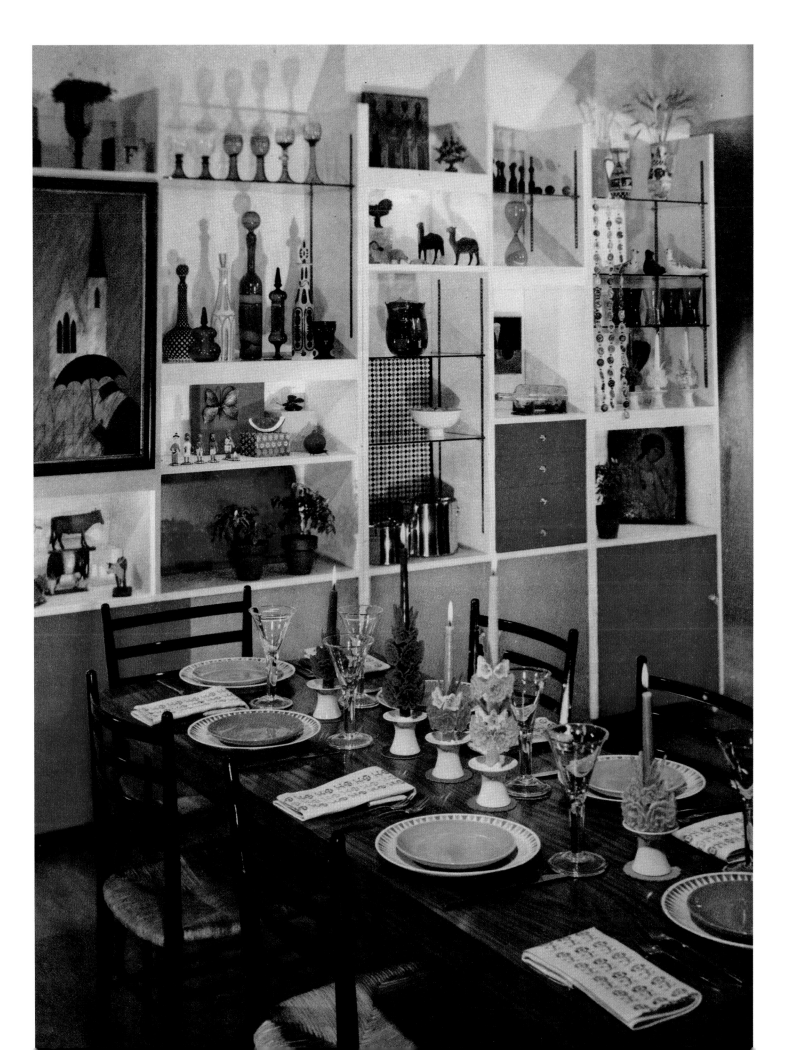

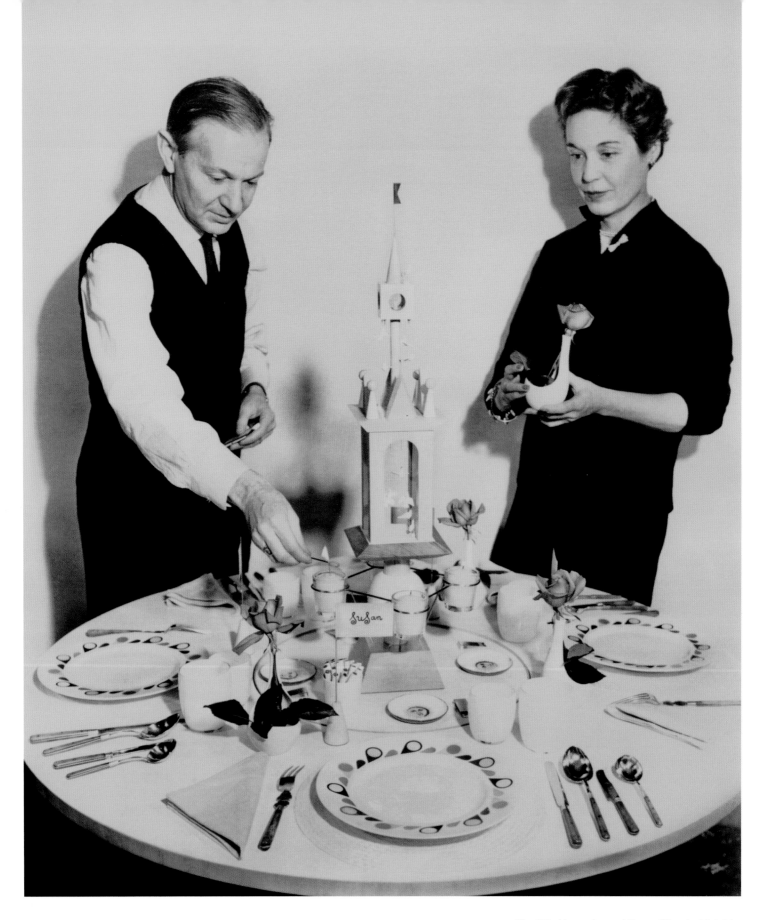

Fig. 33 Alexander and Susan Girard with table
settings designed for Georg Jensen, 1956

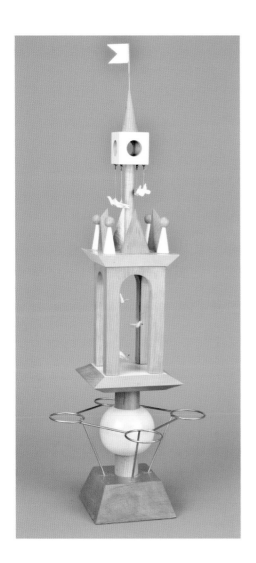

above right

Fig. 34 Alexander Girard, Carolus Magnus plate for Hutschenreuther, c. 1956. Denver Art Museum. [CAT. 106]

above

Fig. 35 Alexander Girard, centerpiece for Georg Jensen, 1955–56. Museum of International Folk Art, Santa Fe. [CAT. 93]

showed Americans how to arrange accessories, including "free-for-the-gathering forms from the world of nature," like rocks and shells.[48] Collecting things for the table could contribute to a better quality of life: another journalist observed that Americans eat three meals a day—and one of those could be visually exciting by indulging in the "most amusing creative playfulness."[49] The article was the first of a *House Beautiful* series about people (like cosmetics entrepreneur Helena Rubinstein, also profiled in the article) who collect interesting table appointments.

Due to his reputation as a tastemaker, Girard was commissioned by Just Lunning of Georg Jensen, the luxury retailer on New York's Madison Avenue, to create eight table settings as part of an exhibit that opened in April 1956 within the store (fig. 33). He also designed oversize color-blocked placemats that were sold at Georg Jensen, as well as new dinnerware patterns that debuted during the exhibition (fig. 34). Girard broke the conventions of more traditional table settings and mixed such unrelated objects as Thai bronze flatware, a handmade wood and tin spice chest, a Mexican wine decanter, and an Italian glass vase in a single setting, suggesting the "happy relationship of good friends who get along well together despite many differences of character."[50] Girard advocated for playful collecting in this exhibit—which also drew international coverage in Italy (*Domus*) and Norway (*Bonytt*)—by mixing tableware that could be purchased at Georg Jensen with his personal "inexhaustible collection of bright discoveries" and objects he made expressly for the exhibition (fig. 35).[51] About the exhibit, Girard said that "it was

not our intention to revolutionize the food we eat or how we eat it, but rather to emphasize some of the things useful, playful or ceremonial that can create various pervading moods at meal times."[52] Table settings emphasize the importance of imagination, exploration, and inventiveness, and can be viewed as vehicles of serious play.

Luxury retailer and fellow collector Stanley Marcus (of Neiman Marcus) claimed that Girard was the first to incorporate folk art into interiors, and that he made folk art more accessible to a wide public through exhibitions and various corporate commissions.[53] While certainly not the first, Girard may have been the highest-profile individual to publicly proclaim folk art as fashionable for decorating postwar modern interiors. Girard defied a modern architecture that dictated that only essentials should be incorporated; instead of an uncluttered and pristine setting, Girard created an "environment of contrasts" in which objects collected from around the world were positioned for contemplation and amusement. In his words, "we should preserve evidence of the past, not as a pattern for sentimental imitation, but as nourishment of the creative spirit of the present."[54] In Girard's work, these two contrasting trajectories—folk art and modern design—are inseparable; for Girard, his contributions to modern design would not have been possible without collecting indigenous folk art. As a corollary, the reception of postwar modern architecture (that is, the kind, like the Eames House, that attracted international attention) flourished through photographs displaying the softening properties of folk art and other "extra-cultural surprises."[55]

WHIMSICAL PRODUCT DESIGNS

Other designers chose to embrace whimsy in their product designs during this period. Trained as painters at the Art Students League, Estelle and Erwine Laverne began working together in 1934—the same year that they married. The playful logo of the Lavernes' firm—a spirited horse with banner featuring lowercase cursive script proclaiming Laverne Originals (also known as Laverne Inc., and later, by the early 1960s, as Laverne International)—telegraphs the approach of the earliest years of their practice (fig. 36). Initially focusing on hand-printed wallpapers in the 1930s, the firm produced widely popular printed textiles and wallpapers by the mid-1940s, designed by leading architects, artists, and designers as part of the Contempora Series.[56] Textiles by Alexander Calder, Juliet and Gyorgy Kepes, Alvin Lustig, and Oscar Niemeyer not only added prestige to the series, but the approach—asking nontextile designers to contribute—announced the firm's openness to creative experimentation. Estelle Laverne's Fun to Run (fig. 37) shows a playful arrangement of overlapping abstract figures running across the textile. For the same series, Laverne Originals commissioned Ray Komai, a Japanese-American designer, to design textiles. In an advertisement for this line, Fun to Run and Komai's The Big Catch are composed to dynamically suggest a mobile in motion (see fig. 36). Another Komai textile, Masks (fig. 38), depicts African masks, or, more accurately, caricatures of geometric faces with a touch of humor. Contemporary critics described the textile as having a "primitive feeling," and Komai identified cubist painters and the African tribal masks that they studied as influences on his work.[57] The textile also made an appearance on the Spring 1949 cover of Craft Horizons (cat. 130). Around the same time, Komai designed his best-known work, a one-piece molded plywood side chair with a vaguely anthropomorphic appearance (fig. 39).

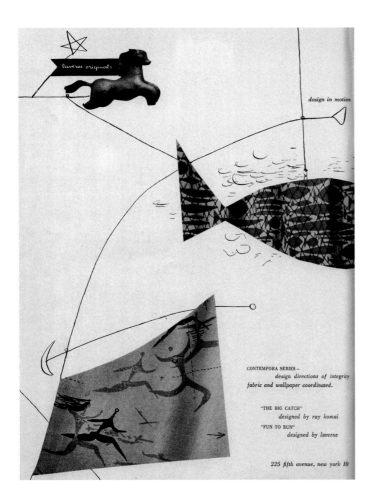

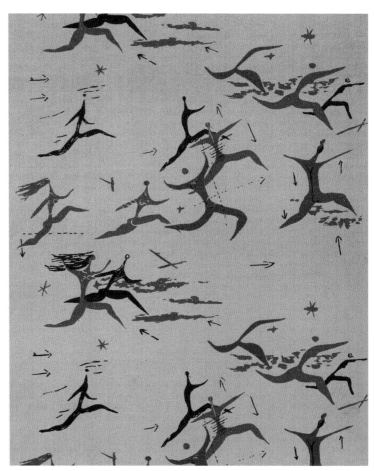

CONTEMPORA SERIES —
design directions of integrity
fabric and wallpaper coordinated.

"THE BIG CATCH"
designed by ray komai
"FUN TO RUN"
designed by laverne

225 fifth avenue, new york 10

Fig. 36 Early Laverne Originals advertisement, 1948

Fig. 37 Estelle Laverne, Fun to Run textile for Laverne Originals, 1947. Art Institute of Chicago. [CAT. 138]

Laverne Originals produced playful objects beyond textiles and wallpaper, such as transparent chairs. Announced by the *New York Times* as a whimsical work, the chairs were made of transparent molded plastic and designed in the shape of flowers (first buttercup and lily; later daffodil and jonquil; fig. 40).[58] Estelle Laverne explained, "We need something in our homes that represents an imaginative solution to a problem," and transparent furniture presented an element of contrast in the American interior.[59] Taking a cue from Eero Saarinen, who desired to "clear up the slum of legs," the Lavernes took the concept one step further — they made the entire object disappear.[60]

After the "serious experimental" work of the Invisible chairs, two years later the Lavernes designed a series, called Golliwogs, as a "fun project" (fig. 41).[61] These painted metal sculptures with humorous faces were named Golliwogs after whimsical doll-like people in turn-of-the-twentieth-century children's books — an unfortunate association because the dolls and the name *golliwog* have been roundly denounced as racist and offensive.[62] In contrast, the Lavernes' hand-painted figures resemble totem poles or giant salt and pepper shakers, and can hold fruit or flowers or serve as floor lamps.[63] Intended to add humor to decor, they could be used in foyers, family rooms, bachelors' flats, or children's rooms. Despite the furniture industry being a "deadly serious business," some designers, like the Lavernes, offered products that were delightfully lighthearted, according to one journalist.[64] Described by the Lavernes as "pure fun," the Golliwogs won the American Institute of Decorators 1961 International Design Award.[65]

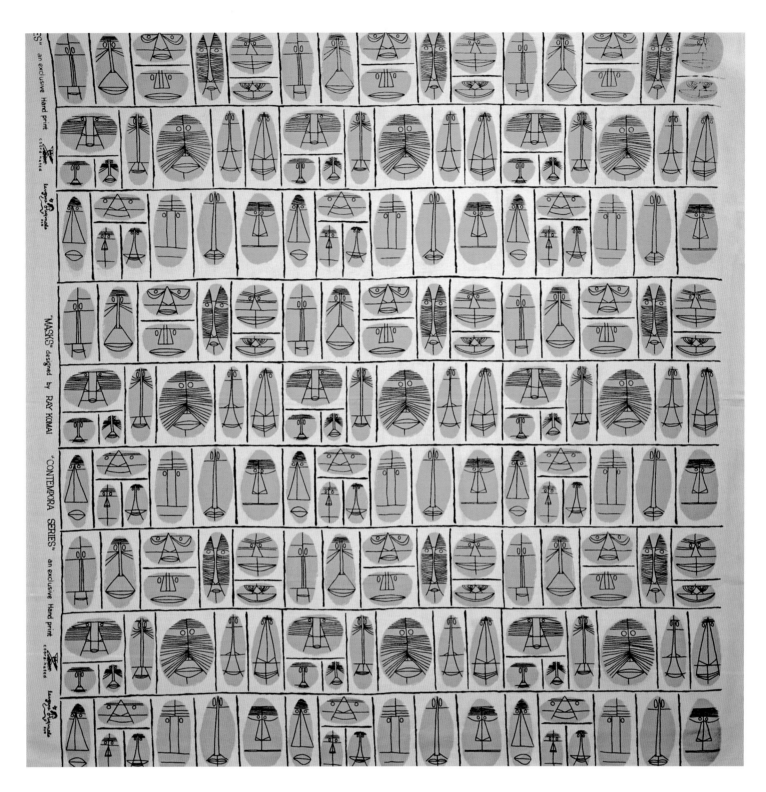

Fig. 38 Ray Komai, Masks textile for Laverne Originals, 1948–49. Collection of Edgar Orlaineta. [CAT. 131]

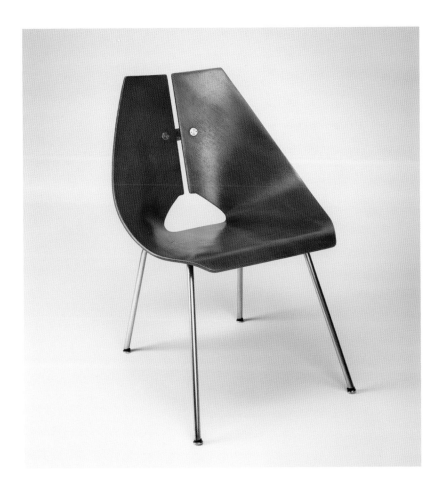

Fig. 39 Ray Komai, side chair for JG Furniture Company, 1949. Denver Art Museum. [CAT. 132]

Fig. 40 Erwine and Estelle Laverne, Jonquil chair for Laverne Originals, 1960. Private collection. [CAT. 134]

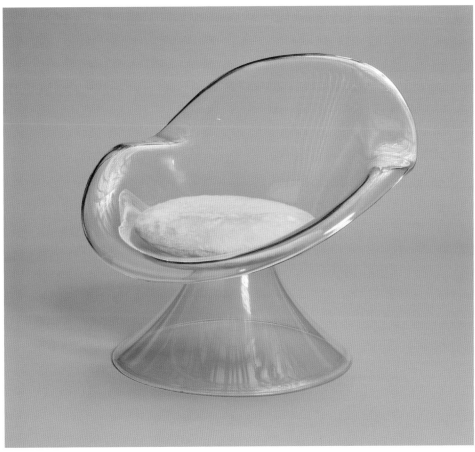

Fig. 41 Erwine and Estelle Laverne,
Golliwogs for Laverne Originals,
1961. Collection of Benjamin Storck,
Galerie XX, Los Angeles. [CATS. 136, 137]

opposite

Fig. 42 Alcoa Forecast Program
advertisement featuring Jay Doblin's
Fun Furniture, 1960. Photographed
by Lester Bookbinder. [CAT. 19]

The Lavernes also designed a group of portrait chairs — seating that depicts a caricature of a person sitting. The first portrait chairs — freely drawn, hand-painted human figures for amusement — were created in 1959. This impetus is reminiscent of the spirit behind the People chairs designed by Jay Doblin (fig. 42) for Alcoa's Forecast Fun Furniture (for more on Alcoa projects, see "Serious Business" in this volume).[66] The Lavernes also designed the Tulip chair in 1959; one rare surviving example includes a portrait of a young woman painted on the chair (fig. 43).[67] Perhaps an experimental gesture? Or painted just for fun? These experiments in seating speak to a desire for unconventionality as well as humanity.

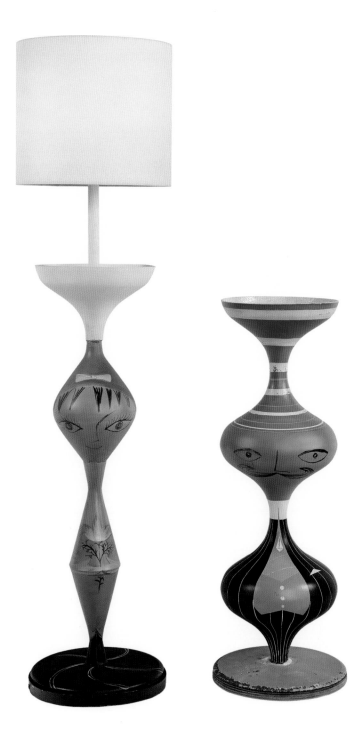

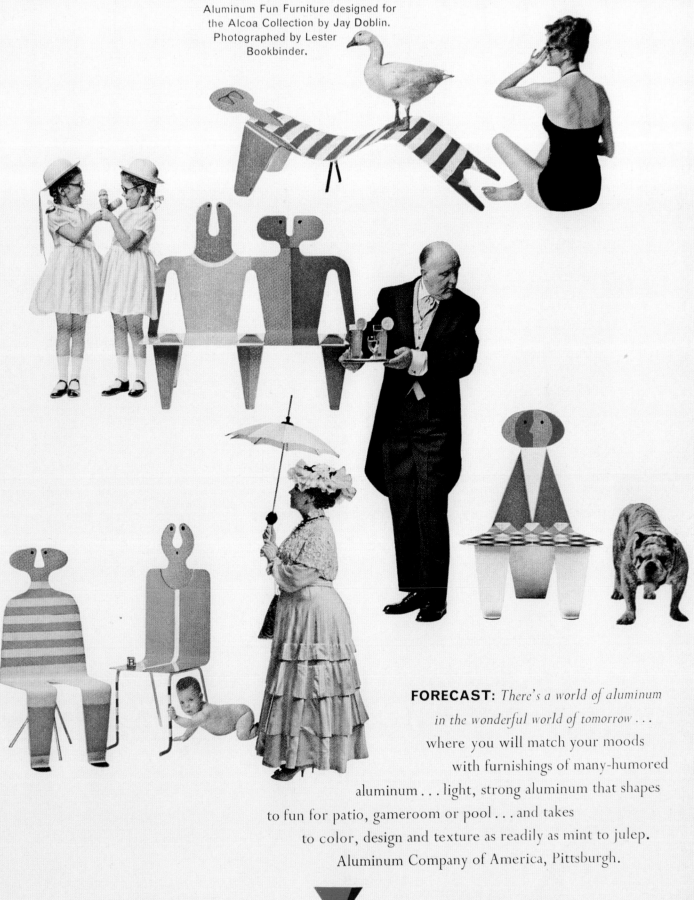

Aluminum Fun Furniture designed for the Alcoa Collection by Jay Doblin. Photographed by Lester Bookbinder.

FORECAST: *There's a world of aluminum in the wonderful world of tomorrow . . .* where you will match your moods with furnishings of many-humored aluminum . . . light, strong aluminum that shapes to fun for patio, gameroom or pool . . . and takes to color, design and texture as readily as mint to julep. Aluminum Company of America, Pittsburgh.

ALCOA ALUMINUM

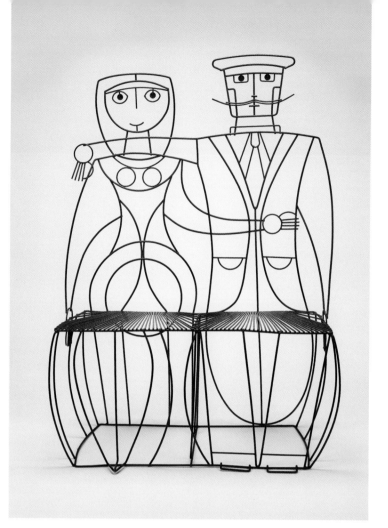

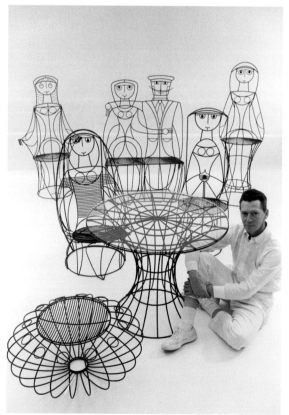

Another designer interested in human figures was John Risley, who trained as a sculptor at the Rhode Island School of Design and Cranbrook Academy of Art before a long career teaching sculpture and design at Wesleyan University. He created his first "person chair" in 1959 by cutting, bending, and welding cold-rolled steel strips. While many examples of Risley's animal- and human-shaped furniture were made by hand, the black metal chairs and benches (fig. 44) were also commercially produced in the 1960s and sold by Raymor (also known as Richards Morgenthau & Company).[68] Risley's figurative steel furniture was introduced to a wider audience through photographs published in *Look* magazine in 1963 (fig. 45). His chairs displayed humanity and humor in equal parts, and, with their seeming carelessness about comfort, are antithetical to the efforts of ergonomic furniture of the period.

In a 1957 interview, Charles Eames claimed that play was becoming a "rare thing" for adults because they were too self-conscious, missing opportunities to have fun while solving problems, which could include decorating the home.[69] Whimsical product designs such as those discussed in this essay, including anthropomorphic and transparent chairs, were the equivalent of the kites that hung on walls, driftwood that decorated a dining table, or folk art that adorned a storage unit—they provided levity and opportunities for playful interludes. Historian Jackson Lears has written that "only by detaching ideas of abundance from material goods and by looking to satisfy demand through play and self-cultivation as much as through accumulation, will human beings alter long-standing frustrations with a consumer society that eternally promises but never fulfills."[70] This is a stirring commentary, as the gathering of goods was certainly possible in an affluent postwar society in the United States, but these things were not the means to an end. New ways of living, which valued whimsy, the handcrafted, and even the theatrical, provided Americans with the potential to develop individuality and free thinking. More broadly, domestic creativity engendered solutions to problems. The storage wall, born of a central domestic dilemma, provided the opportunity not only to store objects, but to play with purpose.

NOTES

1 Vance Packard, *The Status Seekers* (New York: David McKay, 1959), 4–9.

2 The connection between experimentation and creativity is a recurring theme in books from, and about, the mid-twentieth century. In particular, David Aaron and Bonnie P. Winawer, *Child's Play: A Creative Approach to Play-spaces for Today's Children* (New York: Harper & Row, 1965); Richard Caplan, "Designs by Saul Bass," *Industrial Design* 5 (October 1958): 88–95; Amy F. Ogata, *Designing the Creative Child: Playthings and Places in Mid-century America* (Minneapolis: University of Minnesota Press, 2013); and, to a lesser extent, Pierluigi Serraino, *The Creative Architect: Inside the Great Midcentury Personality Study* (New York: Monacelli, 2016).

3 Aline B. Saarinen, "Everybody's a Collector," *New York Times*, March 8, 1959.

4 Arthur C. Danto, "The Seat of the Soul: Three Chairs," in Danto, *Philosophizing Art: Selected Essays* (Berkeley: University of California Press, 1999), 144–163.

5 Lewis Mumford, "The Philosophy of Storage," *House Beautiful*, August 1954, 112.

6 George Nelson, "Modern Furniture," *Interiors*, July 1949, 77–117.

7 George Nelson, *Storage* (New York: Whitney, 1954), 9.

8 The concept was derived from George Nelson and Henry Wright's popular book *Tomorrow's House: A Complete Guide for the Home-Builder* (New York: Simon & Schuster, 1945). The Storagewall was featured in an article commissioned by *Life* for its January 22, 1945, issue.

9 Serraino, *The Creative Architect*, 184.

10 "You Can't Have Too Much Storage!" *House & Home*, June 1957, 152–161.

11 *Minimum Property Standards for One and Two Living Units* (Washington, DC: US Government Printing Office, November 1, 1958); http://hdl.handle.net/2027/mdp.39015027963845 (accessed January 6, 2018).

12 "Strapped for Space: An Apartment by George Nelson," *Interiors*, February 1962, 104–105.

13 Edgar Kaufmann Jr., "The Exhibition Rooms," in *An Exhibition for Modern Living*, ed. Alexander Girard and William D. Laurie Jr. (Detroit: Detroit Institute of Arts, 1949), 83.

14 Design credited to Ernest Farmer in *George Nelson: Architect, Writer, Designer, Teacher*, ed. Jochen Eisenbrand and Alexander von Vegesack (Weil am Rhein, Germany: Vitra Design Museum, 2008), 244.

15 For more on this showroom (and others), see Margaret Maile Petty, "Attitudes Toward Modern Living: The Mid-Century Showrooms of Herman Miller and Knoll Associates," *Journal of Design History* 29, no. 2 (2016): 180–199.

16 Charles Eames, "A New Series of Storage Units Designed by Charles Eames," *Arts & Architecture* 67 (April 1950): 35.

17 For more information on the Case Study houses, see Elizabeth A. T. Smith, *Blueprints for Modern Living: History and Legacy of the Case Study Houses* (Cambridge, MA: MIT Press, 1989).

18 Don Wallance, "The Craftsman's Role in Industry," *Craft Horizons* 12 (January 1952): 31.

19 Olga Gueft, "Ten Tinker Toys to Play With," *Interiors*, December 1950, 100–115.

20 Pat Kirkham, *Charles and Ray Eames: Designers of the Twentieth Century* (Cambridge, MA: MIT Press, 1995), 256. For more on this exhibition, see Monica Obniski, "The Theatrical Art of Displaying 'Good Design,'" in *Alexander Girard: A Designer's Universe*, ed. Mateo Kries and Jochen Eisenbrand (Weil am Rhein, Germany: Vitra Design Museum, 2016), 202–231.

21 Kaufmann, "Exhibition Rooms," 80.

22 "A Designer's Home of His Own," *Life*, September 11, 1950, 152.

23 Elizabeth Gordon, "The New Taste Trend," *House Beautiful*, October 1952, 175.

24 Denise Otis, "Going Places, Finding Things in Brazil," *House & Garden*, October 1959, 172–178. The article is part of Alexander Girard's archive at the Museum of International Folk Art, Santa Fe.

25 Kirkham, *Charles and Ray Eames*, 164. See also Pat Kirkham, "Humanizing Modernism: The Crafts, 'Functioning Decoration' and the Eameses," *Journal of Design History* 11, no. 1 (1998): 15–29.

26 "Barbary Coast," *Interiors*, February 1959, 89. For more on the San Francisco showroom, see Monica Obniski, "Selling Folk Art and Modern Design: Alexander Girard and Herman Miller's Textiles and Objects Shop (1961–1967)," *Journal of Design History* 28, no. 3 (September 2015): 254–274.

27 "A Serious Collector of Playfulness— and How He Lives," *House Beautiful*, April 1963, 135.

28 Memo, "Modular Shelving System Designed by Alexander Girard for the Herman Miller Furniture Co.," March 14, 1958, ACCN 292, Box 27, Folder 3, Herman Miller Archives, Zeeland, Michigan.

29 Ibid.

30 "Room Divider: Girard's Forecast for Alcoa," *Interiors*, July 1957, 67.

31 Edgar Kaufmann Jr., "Alexander Girard's Architecture," *Monthly Bulletin, Michigan Society of Architects* 27 (January 1953): 19.

32 Alexander Girard, *El Encanto de un Pueblo; The Magic of a People: Folk Art and Toys from the Collection of the Girard Foundation* (New York: Viking, 1968), n.p. He does this most notably in the Girard Wing of the Museum of International Folk Art, Santa Fe.

33 Silvia Spitta, *Misplaced Objects: Migrating Collections and Recollections in Europe and the Americas* (Houston: University of Texas Press, 2009), 3.

34 Hugh De Pree to Max De Pree, Jim Witty, and Bob Tanis, "Girard Storage Wall," September 24, 1957, ACCN 292, Box 27, Folder 3, Herman Miller Archives.

35 C. Cudllipp Jr. to Hugh De Pree, October 24, 1957, ACCN 292, Box 8, Folder 4, Herman Miller Archives.

36 Max De Pree to Alexander Girard, March 27, 1958, ACCN 292, Box 8, Folder 4, Herman Miller Archives.

37 "Sketch Prologue to Alcoa-Girard Film," dated to July 17, 1957. Charles Eames and Ray Eames Papers, Library of Congress Manuscript Division, Washington, DC. The film was intended to capture the places that teach

about display (from the humble market to the great museums), different display techniques, and the various reasons for display.

38 Alexander Girard, "The Containers We Live In: The Pungent Designer," *Design Forecast 2* (Pittsburgh, PA: Aluminum Company of America, 1960), 51.

39 Ibid.

40 Rita Reif, "Bric-a-Brac Gets Setting in a Divider," *New York Times,* December 6, 1958.

41 Ibid.

42 Ibid.

43 "Daring Colors, Piquant Food," *House & Garden,* January 1961, 94–99.

44 Herbert J. Gans, *Popular Culture and High Culture: An Analysis and Evaluation of Taste,* rev. ed. (1974; repr., New York: Basic Books, 1999), 73.

45 Mary and Russel Wright, *Guide to Easier Living* (New York: Simon & Schuster, 1951).

46 "The Playful Possibilities of Setting a Table," *House Beautiful,* August 1956, 62.

47 Ibid., 67.

48 John deKoven Hill, "How to Arrange Accessories," *House Beautiful,* February 1958, 72.

49 Laura Tanner, "Collecting—with a Purpose," *House Beautiful,* October 1960, 222.

50 Quoted in Betty Pepis, "Settings for Spring," *New York Times,* April 1, 1956.

51 "Playful Possibilities," 62–67, 113. *House Beautiful* noted that the table settings exhibit could be viewed at the National Home Furnishings Exposition in New York's Coliseum, August 25–September 19, expanding the life of the exhibition beyond Georg Jensen.

52 "Imagination Sets the Table," undated clipping from unidentified publication (perhaps *China, Glass, and Tablewares* magazine) found in scrapbooks, Estate of Alexander Girard, Vitra Design Museum, Weil am Rhein, Germany.

53 Stanley Marcus, introduction to *The Spirit of Folk Art: The Girard Collection at the Museum of International Folk Art* (New York: Abrams; in association with the Museum of New Mexico, Santa Fe, 1989).

54 Girard, *El Encanto de un Pueblo,* n.p.

55 The term "extra-cultural surprise" was used by Alison and Peter Smithson to describe an aesthetic of deliberate juxtapositions

during the 1960s; Pat Kirkham uses it in relation to the Eameses in Kirkham, *Charles and Ray Eames,* 181.

56 Laverne Originals catalog (New York, 1949?). Courtesy of the Hagley Museum and Library, Wilmington, DE.

57 "New Talents Used in Show of Fabrics," *New York Times,* August 16, 1948.

58 Rita Reif, "Invisible Chairs Among New Whimsical Pieces," *New York Times,* June 13, 1959, 18.

59 Clipping dated March 18, 1962, from unidentified newspaper (perhaps the *New York World-Telegram),* Laverne scrapbooks, New York. The author would like to thank Rick Gallagher for sharing the press clippings from the Laverne scrapbooks.

60 Reif, "Invisible Chairs among New Whimsical Pieces." Saarinen was quoted in "Product Reports: Saarinen Places Furniture on a Pedestal," *Architectural Record,* July 1957, 284.

61 Shirley Catter, "Humor and Good Design," undated clipping from unidentified newspaper (probably the *Dallas Times Herald),* Laverne scrapbooks.

62 Cartoonist Florence Kate Upton created the golliwog—a black fictional character— for a series of children's books popular in the United Kingdom and elsewhere. By the 1960s, the term was under attack. It is not known how the Lavernes felt about these rag dolls, which were black caricatures. For more information about these figures, see the Jim Crow Museum of Racist Memorabilia, https://ferris.edu/jimcrow/golliwog/ (accessed January 6, 2018).

63 Marilyn Milow, "Brighten Décor with Greenery," *New York World-Telegram,* February 18, 1961. Press clippings, Laverne scrapbooks.

64 Anne Hannan, "'61 Furnishings Go Frivolous in Chicago," *Newsday,* January 10, 1961, 33. Press clippings, Laverne scrapbooks.

65 Ibid.

66 Sally Haskins, "New Items," *Peoria Journal Star,* June 12, 1959. Press clippings, Laverne scrapbooks.

67 This unique example was acquired from an auction in upstate New York with several other Laverne works that purportedly came from the Laverne Estate.

68 Elizabeth Sanger, "This Is No Joke: Sculptor Picked for Humor Fest," *Hartford Courant,* April 23, 1981.

69 Quoted in "St. Louis Train Station 1957," *An Eames Anthology: Articles, Film Scripts, Interviews, Letters, Notes, Speeches,* ed. Daniel Ostroff (New Haven, CT: Yale University Press, 2015), 163.

70 Jackson Lears, "Reconsidering Abundance: A Plea for Ambiguity," in *Getting and Spending: European and American Consumer Societies in the Twentieth Century*, ed. Susan Strasser, Charles McGovern, and Matthias Judt (Cambridge, UK: Cambridge University Press, 1998), 411.

CHARLES AND RAY EAMES

SERIOUS PLAY, SERIOUS PLEASURE

PAT KIRKHAM

Playfulness and seriousness of intent, and the dialectic between them, were central to the complex mix of shared and complementary talents and interests at the heart of the enormously creative collaborations in life, design, film, and multimedia between Charles Eames (1907–1978) and his wife, Ray Kaiser Eames (1912–1988). He trained as an architect; she studied fine art. They met in 1940 at the Cranbrook Academy of Art, Michigan, where Charles headed a new department of industrial design and Ray was auditing classes such as weaving in order to improve her craft skills. Their professional and personal partnership lasted from their marriage in 1941 until Charles's death.

During their lifetimes they were best known for their furniture in plywood, plastic, wire mesh, and aluminum, and for their home—the modular steel-framed and glass Eames House (1949) in Pacific Palisades, California, that was made from prefabricated parts. But they also designed many other things, most notably toys, exhibitions, interiors, and room settings, and directed and produced more than one hundred short films as well as a series of multiscreen and multimedia presentations.

In this essay, I introduce the Eameses' serious approach to play and the pleasures to be found in play and creativity, especially the creativity of children, and contextualize the Eameses' ideas about, and approaches to, their work within the framework of the Progressive Education Movement. It is not possible in one short essay to cover every aspect of either the Eameses' idiosyncratic combination of the playful and the serious or the various ways in which they drew upon and/or represented aspects of the world of childhood (or their versions of it) in their projects. In the latter part of the essay, therefore, I focus on examples from four different aspects of their work: room settings in the Herman Miller Furniture Company showroom in Los Angeles (a building they designed in 1949), their exhibition *Mathematica: A World of Numbers . . . and Beyond* (1961), the toys they designed, and their films that featured toys.

PLAY AND PLEASURE AS PRELUDE TO SERIOUS IDEAS

Both Charles and Ray had a strong sense of fun and play, an openness to new ideas, a contagious enthusiasm for life, and an immense curiosity about the world around them.

Fig. 46 Ray and Charles Eames drawing their initials with illuminated yo-yos, 1973

Some people regarded the Eameses' playfulness, unbridled passions, and endless delight in toys as "childlike" and unsophisticated (fig. 46). But, in fact, Charles and Ray matched the utmost adult seriousness of purpose with a full embrace of the "inner child." What is refreshing about their work (and so appealing to many designers and filmmakers today) is their seemingly complete lack of embarrassment about expressing the childlike aspects of their personalities in both their adult personae and their work.

The couple believed in getting much of one's fulfillment in life from work — in "taking pleasure seriously in one's everyday work."[1] For the Eameses, work *was* pleasure, and they happily blurred boundaries between the two. When asked if designers should involve themselves "in the creation of works reserved solely for pleasure," Charles famously replied, "Who would say that pleasure is not useful?"[2] Perhaps more than any other design and filmmaking collaborators, the Eameses (and their work) epitomized the notion of serious play and serious pleasure (figs. 47 and 48).

Along with many modern artists and designers of their generation, the Eameses were fascinated by the so-called primitive, especially as manifested in the art, design, and material culture of Japanese, Indian, Mexican, and Native American societies, on the one hand, and children's art, on the other. The Eameses accepted the view of progressive

Fig. 49 Froebel-style Cutting Papers, The Milton Bradley Company, c. 1920. Museum of Modern Art, New York

educationalists and primitivists alike, which claimed that children's creativity, like that of members of "preindustrial" cultures, was innate and hampered only by "civilization."[3] While postwar modernists of many hues admired the simplicity, directness, and supposed spontaneity and freedom from societal conventions and representational codes in children's art, few captured the spirit of it so well in their own work as the Eameses.

The couple actively sought out and collected drawings and paintings by children, especially in the 1950s, when they began designing toys and making films that featured toys in action. A lecture for a course they jointly taught in the early 1950s to architecture students at the University of California, Berkeley, illustrates the Eameses' belief, first, that "children are naturally uninhibited and see everything as new and interesting; they are observing and associating all the time," and, second, that "there are great truths in things done unconsciously by children."[4]

Around the same time as Charles and Ray were discussing children's "unconscious" creativity with Berkeley students, Charles raised the notion of unselfconscious attitudes toward work during a talk at a meeting of the American Institute of Architects. Arguing for a radical widening of horizons, and that architects should know about many more fields and issues than was conventional, he commented that "the world of toys [was] the one field in which man works unselfconsciously and unembarrassed."[5] He was probably thinking of "preindustrial" toy making, but, whatever the case, this rather romantic view of toy production tells us as much, if not more, about the Eameses' approach to their own work as it does about how toys were made.

Linking toys and play with important discoveries, Charles went on to ask, "Where would electricity be if some architect-type maniac hadn't played with electricity for a long time just as a toy?"[6] He used the same example on another occasion when explaining how toys and games are "preludes to serious ideas."[7] Given that he and Ray believed play was a key source of creativity, it is not surprising that they embedded this notion into their own process. They set aside a period at the beginning of each project for playing around with ideas, materials, and media and for contemplating and exploring. Working alone, without staff members offering ideas and free from the financial pressure of paying for staff time, the Eameses created a space in which there was no obligation to come up with solutions. This preparatory part of their work relates to a quotation from the Hindu scripture the Bhagavad Gita, which the Eameses cited in their *India Report* (1958): "Work done with anxiety about results is far inferior to work done without such anxiety, in the calm of self-surrender."[8]

When Charles and Ray were growing up (in St. Louis, Missouri, and Sacramento, California, respectively), the Progressive Education Movement greatly influenced theories of child development and elementary education in many American schools.[9] Influential American education reformers like John Dewey (1859–1952) believed in learning by doing, and the Eames Office was as much a workshop as a design studio.[10] American reformers drew upon the work of Swiss educator Johann Pestalozzi (1746–1827) and German philosopher Friedrich Froebel (1782–1852), both of whom sought to educate the whole child through play. Pestalozzi focused on object teaching, with teachers using objects related to a child's world in order to initiate that child into the wider world. Froebel argued for kindergartens (literally, "gardens for children" in German) where children's impulse to activity, investigation, and creative work was encouraged and developed through play.

Froebel and his followers believed that by playing with blocks, balls, and other objects; participating in handicrafts such as paper cutting and folding (fig. 49), modeling, and sewing; and engaging in activities, including music, dance, storytelling, games, and gardening, children would learn about the natural world.[11]

Like architect-designer Frank Lloyd Wright, Charles Eames encountered Froebel's methods as an elementary school student. He later expressed his gratitude for their adoption within the St. Louis schools. He described it as having "to do with elementary blocks of spheres and cones and pyramids and different kinds of exercises."[12] This surely helped develop his interest in structure, his excellent craft skills, and his hands-on approach to design through prototyping. His holistic approach to life and design aligned well with the approach of Froebel and other progressive education theorists. "Charles never made any distinction between fun and education and play," Ray said.[13]

Whether Ray played with Froebel blocks is not known, but the Progressive Education Movement was so strong in American cities when she was young that she may well have done so. At the very least it is likely that her schooling was influenced by the movement's objectives. Like Charles, she was fascinated by structure, a topic she explored in the 1930s when studying fine art with German émigré painter Hans Hofmann and modern dance with pioneering choreographers Martha Graham and Hanya Holm.[14] She also had an inclusive view of life and work: both she and Charles saw everything as interconnected.[15] Her holistic approach to art and design in the broadest sense is evident in the ease with which she moved from one medium to another, from fine art to design in 1941 and adding film and multimedia a decade later.[16]

Throughout her partnership with Charles, she used Froebel-like packs of colored papers and crayons. Together with her penchant for paper cutting, this suggests that as a schoolgirl she had experienced play- and handicrafts-centered learning (fig. 50). Her grandson Eames Demetrios links her childhood love of cutting out and coloring paper dolls with her and Charles's later modes of working: "they would photograph models and ask friends and their staff to line up and be photographed in various outfits, and they'd cut them up" to use them in mock-ups, models, and catalogs.[17]

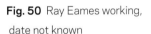

Fig. 50 Ray Eames working, date not known

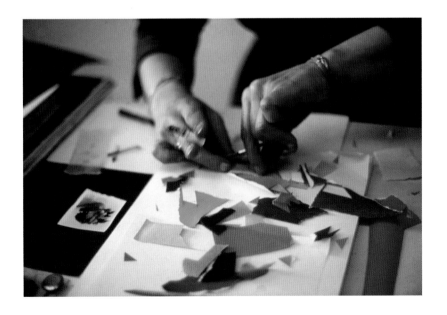

SHOWROOM SETTINGS

The Eameses made choosing furniture fun at the Los Angeles showroom of the Herman Miller Furniture Company, which from the 1950s onward manufactured their furniture. The room settings that they created within the showroom illustrate their idiosyncratic blend of the serious and the playful.[18] For its opening in 1950, Charles and Ray designed the Los Angeles showroom as a series of room settings, as was then the practice with top-end retailers. They decorated the rooms with a range of culturally diverse items from their own collection of toys and folk objects, as well as items (including a radar antenna) from dime stores, ethnic groceries, and war-surplus stores, objects from the collections of friends, and even desert tumbleweeds. Placed in unusual arrangements alongside one another, these disparate groupings created what British architect Peter Smithson called "extra-cultural surprise" and a "wide-eyed wonder of seeing culturally diverse collections so happy with each other."[19]

For the 1952 showroom opening, featuring the new Eames Wire Chair, the Eameses were even more adventurous with the mix of objects they included in their room settings. The items placed alongside the Herman Miller furniture (by the Eameses and other designers such as George Nelson) ranged from colorful Mexican piñatas and Indian kites to a wall covered with small seed packets from a local garden shop to a wooden whale sculpture from the Pacific Northwest (fig. 51). Perhaps the most playful prop created by the Eameses for a Herman Miller room setting was a fake tree, in 1959, when the company was seeking to highlight indoor/outdoor living in general and Eames Aluminum Group furniture in particular. The shrubs in large planters selected by the Eameses to demarcate the boundary between the living and dining areas of the main open-plan domestic space paled into insignificance against the full-size papier-mâché tree in the center of the showroom, complete with fake birds and decorated trunk (fig. 52).

Fig. 51 Charles and Ray Eames, Herman Miller Los Angeles showroom, 1952

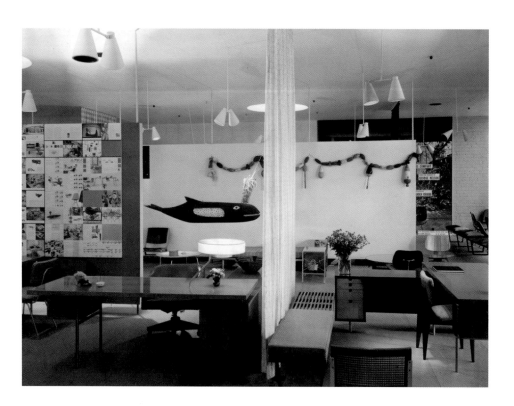

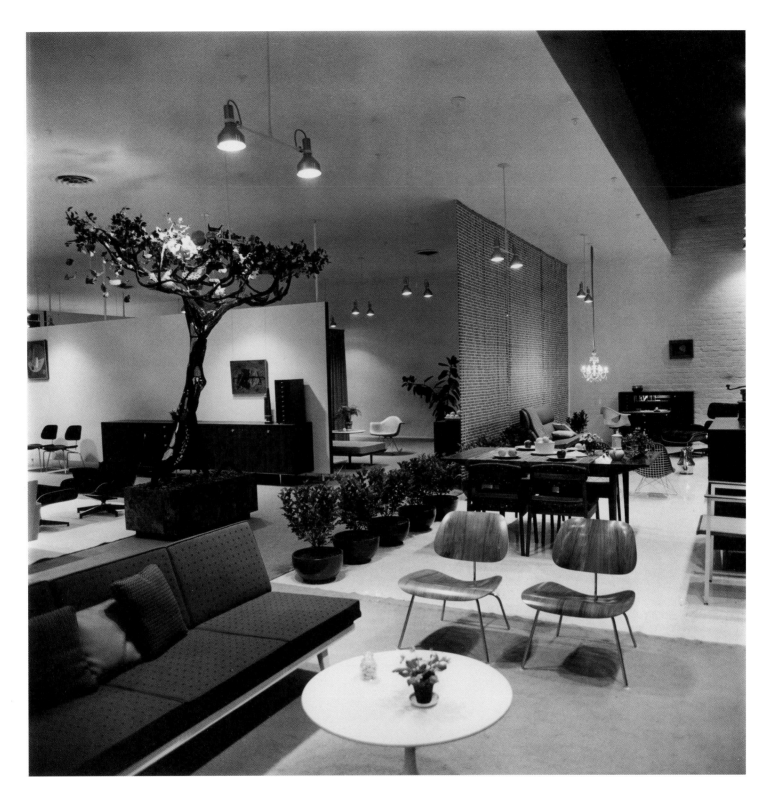

Fig. 52 Charles and Ray Eames, Herman
Miller Los Angeles showroom, 1959

MATHEMATICA

Ray recalled Charles expressing the approach to the 1961 exhibition *Mathematica: A World of Numbers . . . and Beyond* as lifting "the corner of the tent"—itself a playful concept—in order "to let visitors know the pleasure and the joy that mathematicians had in their work."[20] Charles, who remembered physics experiments at school being conducted "almost as parlour tricks" and mathematics taught "through magic squares," stated in 1961 that "much of mathematics has the appeal of magic, and some of it really is—pure magic."[21] In *Mathematica,* Charles and Ray created an aura of magic akin to what Charles remembered from certain school lessons. Funded by IBM for a new science wing at the California Museum of Science and Industry in Los Angeles, the exhibition was intended to teach visitors about mathematics "in a non-mathematical way" as closely linked with the natural world—from sunflowers and the "mirrored parity" of snowflakes to "the logarithmic spiral of a nautilus shell."[22]

The most playful aspect of the show was the group of sophisticated mechanical inter-active games; one commentator called them "serious toys."[23] In the tradition of the English scientist Sir Isaac Newton, they help observers come to an understanding of various mathematical processes by demonstrations.[24] Among these demonstration games were the Probability Machine, which "dropped thirty thousand plastic balls to demonstrate a bell curve, a Celestial Mechanics device that put small metal balls on trajectories that mimic the elliptical orbits of planets, and a Minimal Surface[s] Machine that created elaborate soap bubbles to visualize complex geometry."[25] Another means of engaging visitors were up-to-date versions of "peep shows," a popular form of entertainment and learning in the nineteenth century.[26] The *Mathematica* peep shows offered viewers yet another means of amassing greater mathematical understanding. Charles and Ray hoped that this major museum installation would be followed by "a traveling show of magic acts, displays, and peep shows" that would reach "an even wider audience."[27] What a delight that would have been!

TOYS AND MASKS

Although toys were not a major part of the total output of the Eames Office, Charles and Ray took the design of toys as seriously as any other project, perhaps more so since they shared a strong affection for toys. Eames toys were fun. They also fell into the category of "educational toy," a concept that dates back approximately three hundred years and has consistently remained associated with "early learning as a form of social and societal improvement."[28] In the wake of World War II, there was a strong determination in the United States, as elsewhere, to create a better world for all and for children in particular. As the birthrate boomed along with the economy, demand escalated for toys that could facilitate this vision.[29] Great gift-givers, the Eameses began thinking of toys they would like to give as gifts, first for the children of friends and then for their grandchildren. Some of the toys they designed grew out of existing projects; their plywood animals (1945), for example, developed out of their molded plywood furniture.[30]

In 1950, the Eameses began working on a series of inexpensive masks for children and adults. It was the first toy project they developed with production in mind. There was widespread appreciation of masks within the modern art, design, and performance communities, and the Eameses were no exception. Fascinated by transformation and

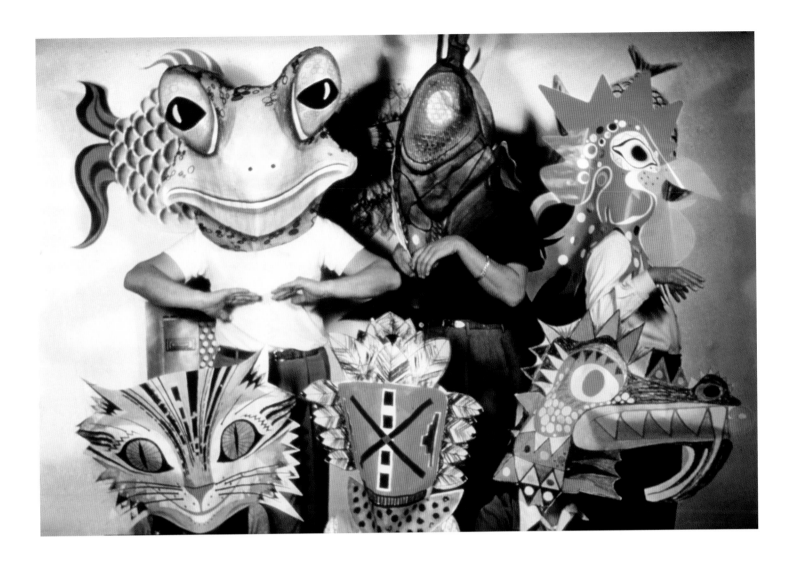

Fig. 53 Eames Office staff wearing
prototype masks, 1950

masquerade, Charles and Ray had begun collecting colorful masks from all over the world in the 1940s, and Ray began drawing, painting, and modeling masks that were used for "impromptu" home theatricals as well as props to decorate their apartment and Eames Office exhibitions, room settings, and photographic shoots.[31]

Figure 53 shows some of the colorful mock-ups of head and body masks in the form of birds, fish, and other animals made by the Eameses and their small band of employees in 1950. One of the challenges facing Charles and Ray, however, was how to create a fun product for mass production and distribution that would store and transport easily. To this end, they decided upon a self-assembly flat pack of die-cut parts in cardboard and paper that could be put together and colored in by those making them.[32] Unfortunately, this project never made it to the production stage.

The Eameses drew on their own childhood play experiences when designing The Toy (fig. 54), their first toy to be produced. Described on the box as "Large ▪ Colorful ▪ Easy to Assemble ▪ For Creating a Light, Bright Expandable World Large Enough to Play in and Around," The Toy encouraged construction and spatial skills as well as color selection and placement.[33] "We talked about hiding under the table as children and having a world to play in. The cloth over the table became such a world," Ray said.[34] She also recalled their specific educational aim of communicating something about "the idea of structure"

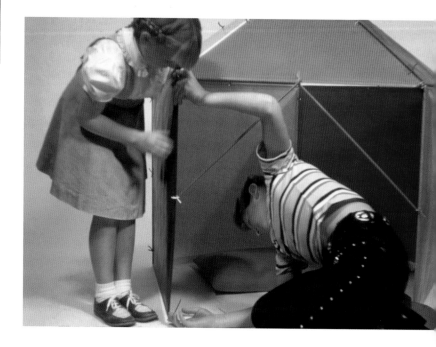

and likened the design process to that for the Eames House: "to make a structure—create a large form with large volume, with a series of materials that could be then contained in a small box."[35]

In August 1950, Charles told friends that he and Ray were working on a toy that was "large, colorful and cheap enough to be expendable" and mentioned triangles and squares that "go together to form columns, blocks, huts, solids—all Bucky Fuller-like stuff."[36] The Eameses greatly admired the American polymath Buckminster Fuller, and the influence of Fuller's famous geodesic dome is evident in both the prototypes and promotional material for The Toy (fig. 55). The prototypes also included a tall column that referred back to one created from blocks of brightly colored triangles for the Eameses' room setting at the 1949 *An Exhibition for Modern Living* in Detroit (fig. 56).[37] The bold

opposite

Fig. 54 Charles and Ray Eames, The Toy, Tigrett Enterprises, publicity photos, introduced in 1951. [CAT. 67]

right

Fig. 55 Ray Eames with the first prototype of The Toy, 1950

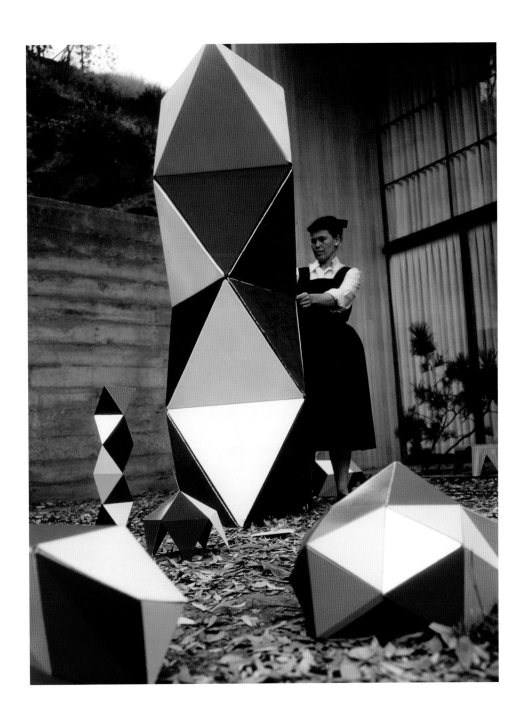

Fig. 56 Ray Eames, collage for Eames room,
An Exhibition for Modern Living, 1949

colorful panels on the sides of the Eames House and the Eames Storage Units (see fig. 23) also highlight the links between the bright colors of the Eameses' toys and their designs in other media at that time.

In its final form, The Toy consisted of four 30-inch squares and four 30-inch triangles of a "recently developed plastic-coated, moisture-resistant paper" in vibrant colors, with thin wooden dowels to stiffen the shapes (they slide into narrow sleeves on each square and triangle) and pipe cleaners to join the shapes together.[38] The manufacturer, Tigrett Enterprises, recommended reducing the size of the container, originally a large, flat box 30 × 50 inches. The resulting hexagonal tube measured only 3 1/2 inches in diameter while remaining 30 inches long. The reduction in size was achieved by rolling the triangles and squares; the only downside was that, if stored in this manner, the panels became harder for young children to keep flat while attaching the dowels.

The Toy was designed to provide "many colorful hours of fun for the whole family" and the instruction sheet set out how various age groups might use it:

> The baby as a bright world to grow in . . .
> the small child as houses and tunnels and tents to play in . . .
> the boys and girls as towers, puppet theaters, large and exciting structures . . .
> the high school age as brilliant party decorations, plays and pageant sets . . .
> in college as campus and house decorations, fantastic and brilliant hanging objects to hover above a junior prom . . .
> young men and women, clubs, civic organisations [sic], floats and festivals . . .

Competitively priced at $3.50 in 1951, The Toy was but one of several products born out of the Eameses' determination at that time to focus on low-cost products, including their plywood, plastic, and metal furniture. But Charles's comment about developing a toy that was not only cheap but expendable does not sit easily with Charles and Ray's emphasis on quality production and dislike of consciously designed obsolescence. They may have been working with less robust materials during the early planning stages of the project, and it should be remembered that Vance Packard's critiques of planned obsolescence and manipulative advertising had yet to be published.[39] In any case, The Toy appears to have sold fairly well for a while (it was included in the Sears, Roebuck and Company mail-order catalog for several seasons), but the manufacturer halted production in 1959.[40]

The Little Toy (fig. 57), another modular construction kit, was promoted as a way to build small-scale tents, houses, and other structures that adults and children could play with (rather than in).[41] The Little Toy's 9-inch tekwood squares and triangles came with pierced corners that facilitated joining the pieces together with coated wires supplied in the kit. Some of the panels came in bright solid colors, while others were perforated or featured checkerboard patterns. The Little Toy sold well enough to remain in production from 1952 until Tigrett Enterprises closed in 1961.

With The Coloring Toy (1955; reintroduced in 2017), Charles and Ray sought to re-create "a kind of fun that children have enjoyed for a long time."[42] Similar to the unrealized mask project, The Coloring Toy encouraged children to use the provided crayons to color the die-cut shapes (fig. 58). They could then use butterfly clips (also provided)

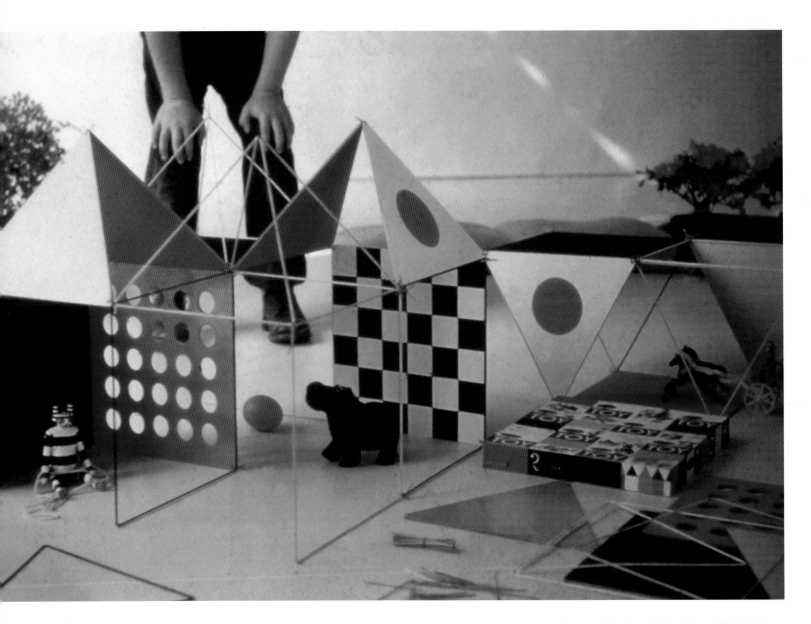

Fig. 57 Charles and Ray Eames, The Little Toy, Tigrett Enterprises, publicity photo, 1952. [CAT. 70]

Fig. 58 Charles and Ray Eames, The Coloring Toy, Tigrett Enterprises, 1955. Eames Collection, LLC. [CAT. 73]

to combine the separate shapes in any way they wished. The instructions encouraged those putting together the pieces to imagine themselves "a magician who can change a girl into a mermaid, a butterfly into a swan, a boy into a monkey, who can make a bird swim and a fish fly."[43]

"Notes to Parents" stated that this toy was meant to "provide a sort of jet assist into a world of color, drawing, shapes, and play. This is a world discovered and rediscovered by all children and is their own creation," and stressed that the toy was not intended "to make artists out of children or to teach them how to play." The notes further expressed the hope that The Coloring Toy would "stimulate the use of these and other materials in an ever-expanding variety of ways."[44]

Like The Toy, the idea for House of Cards (1952) came from things Ray and Charles had played with as children. "Everyone had built a house of cards," Ray said, and she and Charles liked the idea "of using something that exists."[45] They used the traditional number of cards, fifty-four (a standard deck of fifty-two plus two wild cards or jokers), but they devised a way of building a structure that could stand more securely than the house of cards of old (fig. 59). Each Eames card had six slots for ease of interlocking and stability, and each featured an asterisk on one side. In the first set (known as the pattern deck), the other sides of the cards were decorated with a variety of patterns. The front sides of a second pack (known as the picture deck) featured images of familiar and nostalgic objects, from toys and crayons to tape measures, thimbles, and flowers. House of Cards proved popular, especially with adults, and remained in production until Tigrett Enterprises closed its doors.

In 1953 a large-scale version went on the market with twenty 11 × 7-inch cards made of eight-ply cardboard (fig. 60). Easier to slot together, the larger, thicker pieces meant that bigger structures could be built—but with far fewer permutations of images than in the original House of Cards. The images were different, too. The container

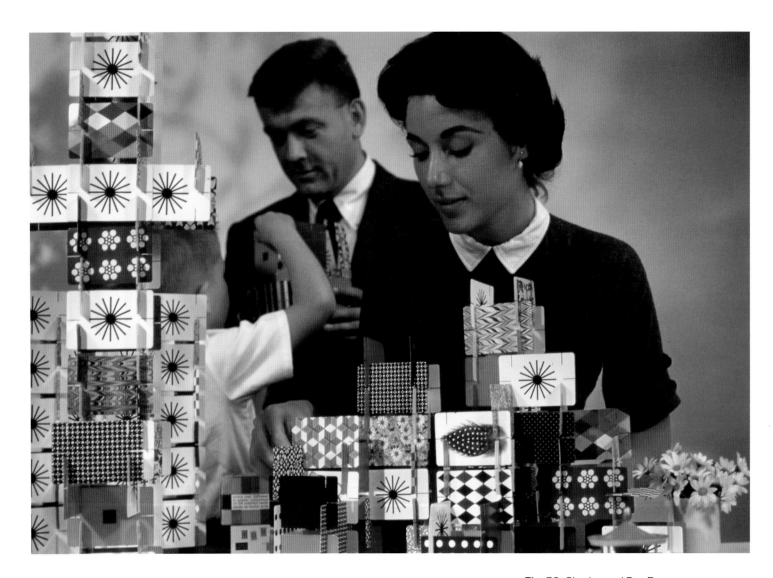

Fig. 59 Charles and Ray Eames,
House of Cards, Tigrett Enterprises,
publicity photo, 1952

Fig. 60 Charles and Ray Eames, Giant House of Cards, Tigrett Enterprises, publicity photo, 1953. [CAT. 72]

described the contents as "Colorful Panels to Build With ▪ Each with a Graphic Design Taken from the Arts ▪ The Sciences ▪ The World around Us." Ranging from an enlarged colored photograph of snow crystals to a mathematical model, these visually compelling images were selected by the Eameses in consultation with architect and designer Alexander Girard, who also helped to select the large squares of various solid colors on the reverse sides.[46] The ability to build structures and juxtapose colors and images in multiple ways is reminiscent of the manner in which the Eameses arranged objects in their own home and images in their films, slide shows, and multimedia presentations.

Sometimes regarded as a toy, largely because it is small, bright, and colorful, the Hang-It-All was designed as an engaging object for children to hang belongings on (fig. 61). The underlying structure for the Hang-It-All grew out of the Eameses' experiments with welded metal rods for chairs and other objects, while the wooden balls suggest the generic ball so beloved by children as well as Froebel wooden balls. In its suggestion of an atomic diagram, the Hang-It-All offered a friendly version of the atomic imagery then pervasive throughout the United States. For a photographic session, Ray dressed a Hang-It-All with a roller skate, kachina, petticoat, and ribbon bow to show how the product provided a physical framework for those trying to achieve Eames-style decorative

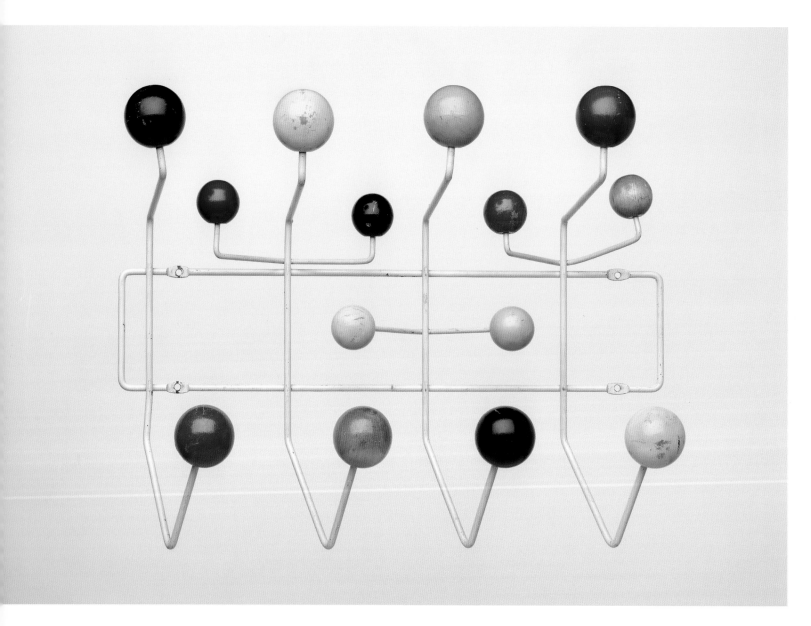

Fig. 61 Charles and Ray Eames, Hang-It-All, Tigrett Enterprises, 1953. Milwaukee Art Museum. [CAT. 71]

Fig. 62 Hang-It-All dressed by
Ray Eames, 1953

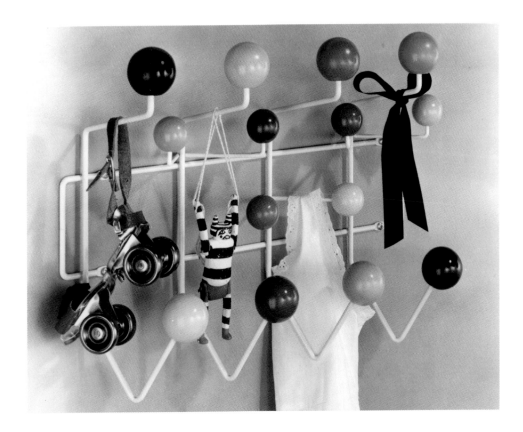

arrangements of diverse objects (fig. 62).[47] Like the House of Cards, the product was popular with adults and remained in production until Tigrett Enterprises closed.

TOYS IN MOTION

The Eameses made more than one hundred short films about things in which they took serious pleasure, from toys to mathematics and science. So great was their fascination with toys that they elected to feature them in their early films. These self-funded labors of love were created in their home studio during nights and weekends.

The Eameses were greatly interested in old toys, and their films that featured them grew out of, and tapped into, a mood of nostalgia in the postwar United States that looked back to a supposedly halcyon period stretching from the second half of the 1800s to the beginning of World War I.[48] For the most part, the toys featured were no longer in production, and the Eameses used close-up shots so that viewers "could see them again up close" and be reminded of past pleasures.[49] Other pleasures came from the movement of toys set to music.

Their first film, *Traveling Boy* (1950), follows the journey of a Japanese wind-up toy who embarks on a voyage with suitcase in hand.[50] Viewers experience a dazzling array of toys in tight close-up as they move against a background of drawings by Saul Steinberg and sets full of objects. *Parade* (1952) is a pageant of moving toys (some mechanical, some animated by hidden hands) set to lively band music (fig. 63). Against a background of toy buildings and drawings by five-year-old Sansi Girard (daughter of the Eameses' friends Alexander and Susan Girard), a variety of toys from human figures to elephants and horses enjoy a town parade "while brilliant Japanese paper flowers and balloons burst in the air over their heads."[51]

Fig. 64 Charles and Ray Eames, stills from *Toccata for Toy Trains*, 1957. Eames Collection, LLC. [CAT. 56]

The close-ups favored in these films helped viewers understand the importance of the concept of "truth to materials." In the opening voice-over for *Toccata for Toy Trains* (1957), Charles explains that "in a good old toy there is apt to be nothing self-conscious about the use of materials. What is wood is wood; what is tin is tin; and what is cast is beautifully cast. . . . It is possible that somewhere in all this is a clue to what sets the creative climate of any time, including our own."[52]

The joy of "good old" toys (as opposed to scale models) is everywhere apparent in all the Eameses' toy films, but nowhere more so than in *Toccata for Toy Trains* (fig. 64). Trains and passengers follow the rapid runs and cascading descents of the score by Elmer Bernstein in a film that captures the joy of toy trains and evokes nostalgia for the heyday of the railroads.[53]

Like several of the Eameses' toys, the film *Tops* (1969), a development in color of a short segment that the Eameses made in black and white for a television show in 1957, was also inspired by the types of toys that Charles and Ray played with as youngsters (fig. 65). One hundred twenty-three tops from all over the world are wound up, spin, and wind down to an Elmer Bernstein score.[54] There is no narration and, as with all films, viewers read it differently. Tony Benn, the British socialist and member of Parliament who was a friend of Charles, observed that it "shows mankind of all races, and from all over the world, and every culture, playing with a single simple toy. The unity of humanity comes through in a way that is utterly pleasurable and absolutely unforgettable."[55] Others were more struck by *Tops* conveying an understanding of principles; indeed, there is a wonderful elucidating moment when a simple tack is thrown onto a drawing board and spins, thus revealing it, too, as a top. As director/screenwriter Paul Schrader (then a young film critic) put it in 1970, "All the complexity and variation of tops have resolved into the basic form of two planes, one of them suspended by the balanced forces of gravity and gyroscopic momentum."[56] Physics professor Philip Morrison felt that the film illustrated his astronomical theory about spinning objects in the galaxy, and he used it to illustrate the applicability of science to all aspects of life and to show that through play

Fig. 65 Charles and Ray Eames, stills from *Tops*, 1969. Eames Collection, LLC. [CAT. 57]

children learn an understanding of scientific laws that can be built upon in later years.[57] This is serious play indeed, and *Tops* brings us back to the Progressive Education Movement and its emphasis on serious play.

The examples discussed herein highlight how important play and playing around with ideas, materials, media, forms, and other design features were to the Eameses. The examples also show just how staggeringly fresh, visually stimulating, and intellectually lucid the results were. In a world where modernists of many hues admired the simplicity and directness of children's views of the world, the Eameses perhaps came closest to inhabiting the world of the child in adulthood in ways that were extremely serious in final intent but full of playfulness along the way.

People often ask what the Eameses would be doing were they alive today. At one level it is difficult to say because their joint interests were so wide-ranging, and because they never specialized in just one medium or genre. One can point to their interest in the environment and interactive presentations now considered precursors of interactive video games and music videos, their near all-encompassing curiosity about methods of communications, their fascination with objects and practices with roots in the past, and their insistence on quality and integrity, but most assuredly their sense of fun was such that they would be playing around with ideas, playing in the sense of exploration and experimentation, and enjoying themselves as they did so. As Eames Demetrios put it, "They would have *played*. And they would have invited others to play. And then, Charles and Ray would have played some more."[58] And, given that they took their pleasures seriously and encouraged others to do the same, they would have played seriously, just as they did in the postwar period when to do so was part and parcel of a progressive and holistic view of education, life, and work.

NOTES

1 Charles Eames, notes for Penrose Memorial Lectures, American Philosophical Society, Philadelphia, April 1974. Charles and Ray Eames Papers, Manuscript Division, Library of Congress, Washington, DC.

2 *Qu'est ce que le design?* [What is design?] questionnaire, 1969, conducted in conjunction with the exhibition of the same name, Musée des Arts Décoratifs, Paris, 1969. Eames Office; http://www.eamesoffice.com/the-work/design-q-a (accessed January 4, 2018).

3 Amy F. Ogata, *Designing the Creative Child: Playthings and Places in Midcentury America* (Minneapolis: University of Minnesota Press, 2013), xiv–xv, 86, 149; and Juliet Kinchin, "Hide and Seek: Remapping Modern Design and Childhood," in *Century of the Child: Growing by Design, 1900–2000,* ed. Juliet Kinchin and Aidan O'Connor (New York: Museum of Modern Art, 2012), 17–18.

4 Charles Eames, Lecture No. 1, September 23, 1953, Architecture 1 and 2, University of California, Berkeley. Reproduced in *An Eames Anthology: Articles, Film Scripts, Interviews, Letters, Notes, Speeches,* ed. Daniel Ostroff (New Haven, CT: Yale University Press, 2015), 121. For the lecture course (1953–54), see John Neuhart, Marilyn Neuhart, and Ray Eames, *Eames Design: The Work of the Office of Charles and Ray Eames* (New York: Abrams, 1989), 185.

5 Charles Eames, Speech to American Institute of Architects, October 10, 1952, Kansas City, MO. Reproduced in Ostroff, *Eames Anthology,* 106.

6 Ibid.

7 James B. O'Connell, "A Visit with Charles Eames," *Think* 27, no. 4 (April 1961): 9. Reprinted in Ostroff, *Eames Anthology,* 219.

8 In 1957, the Indian government commissioned Charles Eames to report on the impact of Western technology and design on Indian production and consumption and to consider the future of design and production in independent, modern India. Charles and Ray spent three months in India and collaborated on *The India Report*, in which they recommended establishing a National Institute of Design, which India did in 1961. See Neuhart, Neuhart, and Eames, *Eames Design,* 232–233, and Charles Eames and Ray Eames, *The India Report* (Ahmedabad, India: National Institute of Design, 1997), 5; http://nid.edu/Userfiles/Eames__India_Report.pdf (accessed January 4, 2018).

9 For the Progressive Education Movement, see Lawrence Cremin, *The Transformation of the School: Progressivism in American Education, 1876–1957* (New York: Knopf, 1961).

10 British architect Geoffrey Holroyd noted a parallel between John Dewey's notion of the school as a miniature community and workshop, and the Eameses' understanding of what a design laboratory-cum-workshop should be. Geoffrey Holroyd, "Architecture Creating Relaxed Intensity," *Architectural Design* 36 (September 1966): 458–470. See also Pat Kirkham, *Charles and Ray Eames: Designers of the Twentieth Century* (Cambridge, MA: MIT Press, 1995), 147–148.

11 Juliet Kinchin, "The Kindergarten Movement: Building Blocks of Modern Design," in Kinchin and O'Connor, *Century of the Child,* 30–35.

12 For Wright and Froebel, see Frank Lloyd Wright, *An Autobiography* (Petaluma, CA: Pomegranate, 2005), 14. For Eames and Froebel, see Charles Eames, interview by Virginia Stith, October 13, 1977, in Ostroff, *Eames Anthology,* 367.

13 Ray Eames, interview by Ruth Bowman, July 28–August 20, 1980, Archives of American Art, Smithsonian Institution; https://www.aaa.si.edu/collections/interviews/oral-history-interview-ray-eames-12821 (accessed January 4, 2018).

14 Kirkham, *Charles and Ray Eames,* 35; and Eames, interview by Bowman.

15 Charles and Ray Eames were so well known for saying that everything (people, ideas, designs, objects, and so forth) connects that the retrospective exhibition of their work curated by John and Marilyn Neuhart in 1976 was titled *Connections: The Work of Charles and Ray Eames*. For Charles referring to connections several times in his last public talk (at the International Design Conference in Aspen, June 1978), see Marilyn Neuhart with John Neuhart, *The Story of Eames Furniture,* vol. 1 (Berlin: Gestalten, 2010), 50.

16 Grandson Eames Demetrios noted the following conversation that took place in about 1982: Young woman: "Mrs. Eames, how did it feel to give up your painting?"

Ray Eames: "I never gave up painting, I just changed my palette." See the catalog *Changing Her Palette: Paintings by Ray Eames* (Los Angeles: Eames Office, 2000). I am grateful to the Eames Office for providing this source.

17 Quoted in Margaret Rhodes, "Three of Ray Eames's Unsung Influences on Modern Design," *Fast Company,* May 12, 2014; https://www.fastcodesign.com/3030451/3-of-ray-eamess-unsung-influences-on-modern-design (accessed January 4, 2018).

18 For the 1950, 1952, and 1959 showrooms discussed in this section, see Neuhart, Neuhart, and Eames, *Eames Design,* 146–147, 167, and 242–243, respectively.

19 Peter Smithson, "Just a Few Chairs and a House," in "Eames Celebration," ed. Peter Smithson and Alison Smithson, special issue, *Architectural Design* 36 (September 1966): 443.

20 Eames, interview by Bowman.

21 For "parlour [sic] tricks" and "magic squares," see Charles Eames, "Language of Vision: The Nuts and Bolts," *Bulletin of the American Academy of Arts and Sciences* 28, no. 1 (October 1974): 20; http://www.eamesoffice.com/the-work/language-of-vision/ (accessed January 4, 2018). For "appeal of magic," see O'Connell, "Visit with Charles Eames," 9.

22 Kristen Gallerneaux, "Squaring the Hypothetical Circle: Getting around *Mathematica*," in *The World of Charles and Ray Eames,* ed. Catherine Ince (London: Thames and Hudson, 2015), 277. See also Eric Schuldenfrei, *The Films of Charles and Ray Eames: A Universal Sense of Expectation* (London: Routledge, 2015), 103–114.

23 O'Connell, "Visit with Charles Eames," 9.

24 Gallerneaux, "Squaring the Hypothetical Circle," 277.

25 Schuldenfrei, *Films of Charles and Ray Eames,* 105. In September 2017, a version of the exhibition went on permanent display at the Henry Ford Museum of American Innovation, Dearborn, Michigan.

26 Amy F. Ogata, "Viewing Souvenirs: Peepshows and the International Expositions," *Journal of Design History* 15, no. 2 (2001): 69–82; see also Katharine Schwab, "Paper Peep Shows Were the Virtual Reality of the 19th Century," *Fast Company,* August 4, 2016; https://www.fastcodesign.com/3062465/paper-peepshows-were-the-virtual-reality-of-the-19th-century (accessed January 4, 2018).

27 O'Connell, "Visit with Charles Eames," 9.

28 Ogata, *Designing the Creative Child,* 36.

29 Ibid., 42–70.

30 Kirkham, *Charles and Ray Eames,* 146.

31 Ibid., 150, 155–159.

32 Neuhart, Neuhart, and Eames, *Eames Design,* 144–145.

33 The Toy was reintroduced in fall 2017.

34 Eames, interview by Bowman.

35 Ibid.

36 Charles Eames to Eero and Lily Saarinen, August 29, 1950. Cited in Ince, *World of Charles and Ray Eames,* 122.

37 Neuhart, Neuhart, and Eames, *Eames Design,* 124–125.

38 Ibid., 157.

39 These include *The Hidden Persuaders* (1957), *The Status Seekers* (1959), and *The Waste Makers* (1960).

40 Neuhart, Neuhart, and Eames, *Eames Design,* 157.

41 Ibid., 161.

42 For The Coloring Toy, see Neuhart, Neuhart, and Eames, *Eames Design,* 204–205.

43 Kirkham, *Charles and Ray Eames,* 150.

44 Neuhart, Neuhart, and Eames, *Eames Design,* 205.

45 Eames, interview by Bowman.

46 Neuhart, Neuhart, and Eames, *Eames Design,* 181.

47 For the Hang-It-All, see Neuhart, Neuhart, and Eames, *Eames Design,* 184. For the Eameses' decorative arrangements, see Kirkham, *Charles and Ray Eames,* 164–199;

Pat Kirkham, "Humanizing Modernism: The Crafts, 'Functioning Decoration,' and the Eameses," *Journal of Design History* 11, no. 1 (1998), 15–29.

48 Pat Kirkham, Christian A. Larsen, Sarah A. Lichtman, Tom Tredway, and Catherine Whalen, section "'Victorian' and 'Edwardian' Influences," in "Europe and North America, 1945–2000," in *History of Design, Decorative Arts, and Material Culture, 1400–2000,* ed. Pat Kirkham and Susan Weber (New Haven, CT: Yale University Press, 2013), 629–630.

49 Eames, interview by Bowman.

50 Neuhart, Neuhart, and Eames, *Eames Design,* 134–135. The date of *Traveling Boy* is usually given as 1950, but screenwriter/director Philip Dunne recalls lending the Eameses a 16mm film editing machine when he went on a location shoot in Argentina in 1951, calling this the "tiny nudge" they needed "to blossom as makers of delightful short films." Philip Dunne, *Take Two: A Life in Movies and Politics,* rev. ed. (New York: Limelight, 1990), 224.

51 Kirkham, *Charles and Ray Eames,* 332. For quotation, see "A Sampling of Eames Films Available from Pyramid" (undated publicity brochure, Pyramid Films, Santa Monica, CA).

52 Neuhart, Neuhart, and Eames, *Eames Design,* 215. In 1980, Ray commented that this "simple little statement" was sometimes omitted when the film was screened, adding, "It breaks my heart." Eames, interview by Bowman.

53 By 1957, the heyday of the railroads was over. When the Eameses were growing up, however, the railroad was the primary mode of long-distance transportation in the United States. Trains were particularly special for Charles, whose father worked on the railroad as a detective for Pinkerton in the early twentieth century.

54 Neuhart, Neuhart, and Eames, *Eames Design,* 347.

55 Tony Benn, "A Tribute to Charles Eames," speech made at US Embassy, London, 1978. Copy sent to author in the 1980s by Tony Benn.

56 Paul Schrader, "Poetry of Ideas: The Films of Charles Eames," *Film Quarterly* 23, no. 3 (Spring 1970): 9.

57 Kirkham, *Charles and Ray Eames,* 336.

58 Eames Demetrios, "A Contemporary Practice: The Eameses in the 1940s," in Ince, *World of Charles and Ray Eames,* 23.

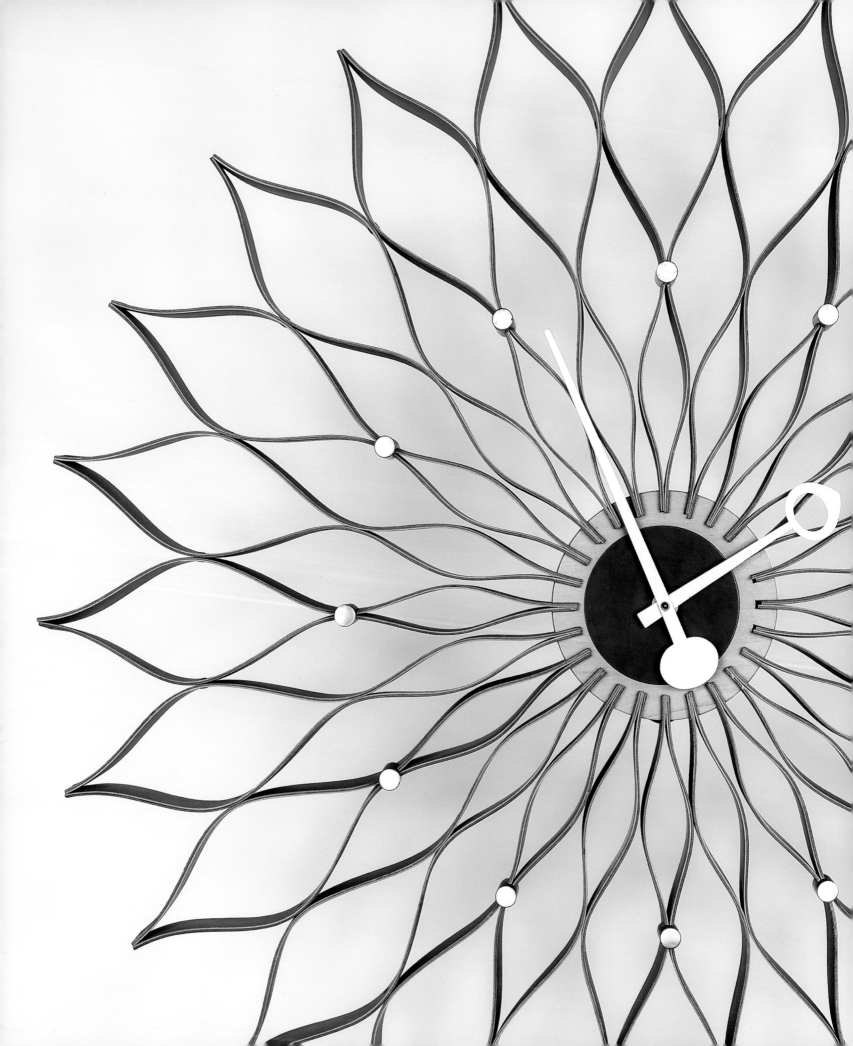

"WHAT IS A CLOCK, ANYWAY?"

AMY AUSCHERMAN

In the introduction to the 1948 catalog for his first collection for furniture manufacturer Herman Miller, George Nelson persuasively noted, "There is a market for good design."[1] Nelson was largely responsible for creating and shaping that market in postwar America. With a stable of designers that included Irving Harper, Lucia DeRespinis, and Charles Pollock, George Nelson & Associates generated some of the most exuberant and iconic home furnishings of the twentieth century. Industrial designs developed at the firm changed how consumers thought objects could look and function within their domestic landscapes. Along with the Marshmallow sofa (1956; see fig. 2), Coconut chair (1955), and Bubble lamp (1952), the line of timepieces designed for the Howard Miller Clock Company harnessed material and manufacturing innovations to create an entirely new and playful design language for common household objects.

Nelson's relationship with Howard Miller began in 1947, two years after he was minted the director of design at Herman Miller.[2] His initial years at Herman Miller were busy and yielded an overhaul of the furniture line previously designed by Gilbert Rohde; a new logomark designed by Irving Harper that is still in use by the company today; and the aforementioned 1948 catalog, which included product photography by Ezra Stoller and texts explaining to designers and consumers how to use the furniture (fig. 66). George Nelson operated like a brand—he was the face, name, and voice of his office. Understanding the notoriety brought to Herman Miller by the Nelson brand, the Howard Miller Clock Company tapped the office to reinvigorate its business after it had been shuttered during wartime.[3] Before the war, the company had also worked with Rohde and produced a series of modern clocks for the 1933 Chicago World's Fair. It was through this experience that Howard Miller learned the value in attaching a known designer to its product line.[4] An added convenience: both Miller headquarters were located across the street from one another in Zeeland, Michigan, making it easy for Nelson to tend to his biggest clients at the time.

Fig. 66 Irving Harper, catalog cover for the Herman Miller Collection, 1948

Fig. 67 Chronopak advertisement,
c. 1951

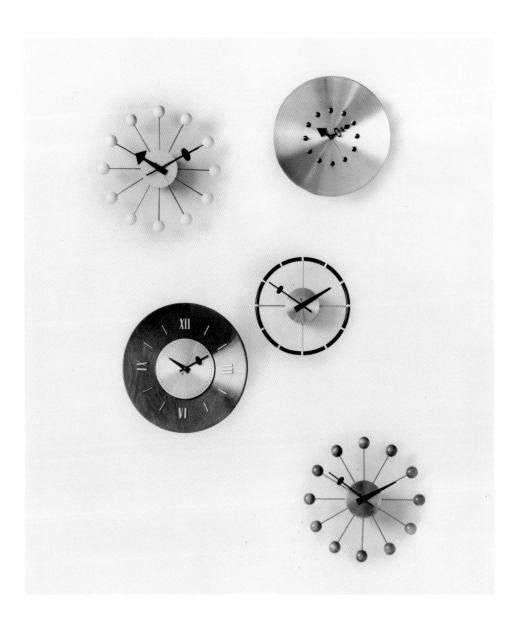

After surveying the current market, Nelson learned that a few large manufacturers with significant investments in tooling dominated the clock business. Howard Miller was a small company that imported its clock movements—which created a cost disadvantage—and couldn't afford to make large investments in production equipment. Working within these constraints, Nelson realized that Howard Miller had to create an entirely new market for the company's modern designs. This was achieved with a distinct series of "radically modern clocks" that were innovative in both appearance and functionality.[5] Nelson ensured cheap overhead by utilizing many of the same components for the construction of the clocks and counted on the whimsical appearance of the designs to generate press, and thus, free advertising.[6] In addition to their "entirely new silhouettes," the clocks utilized a new technology developed by Howard Miller named Chronopak, which eliminated unsightly electrical cords.[7] It touted a two-part arrangement where an outlet plate could be wired into a wall's surface (female) to accommodate a plug (male) attached to the back of the clock. Nelson also knew this would be a selling point that would generate buzz in the market (fig. 67).[8]

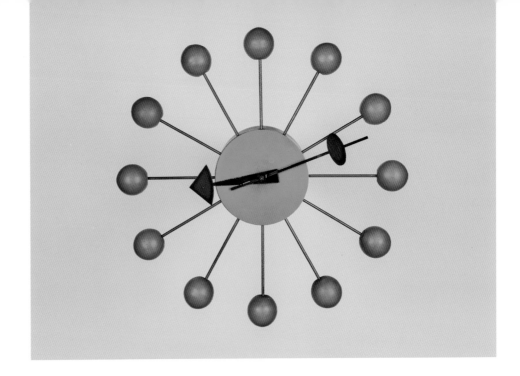

Fig. 68 Irving Harper, Ball clock, for Howard Miller Clock Company, 1949. Collection of Jody and Dick Goisman. [CAT. 77]

Irving Harper led the Howard Miller account and was given carte blanche in the design process for the first collection. According to blueprints from Harper's own archive, now housed at Herman Miller, he started to design the first series in 1947, with revisions taking place between then and the release date of 1949. In an unpublished manuscript found in Harper's archive, he details his process over a series of interviews. Given the opportunity to create an entirely new look, Harper's approach included "playing with" basic clock components—a case that held the motor, hands, face—and reducing them to their basic, geometric forms. He also observed that instead of reading time by looking at the hour numerals (as dictated by traditional clock design), people told time by the position of the clock hands and their relation to one another.[9] Harper said in a 2001 interview, "To omit numbers and have an abstract object that moved on the wall was something no one was doing at the time."[10] This resulted in the elimination of numerals in most of the clock designs generated by the Nelson office. Harper abstracted the form of the clock in the language of modern art of the time—for example, Alexander Calder's mobiles and Joan Miró's paintings—and would continue to look to the art world for inspiration in his designs.[11]

The Ball clock (model 4755) was part of the first Chronopak series introduced in 1949 and is arguably the most famous of Harper's clock designs (fig. 68). The clock was immediately recognized as successful by his design-world peers and was included in the Detroit Institute of Arts' 1949 *An Exhibition for Modern Living,* curated by Alexander Girard. In the exhibition catalog, Edgar Kaufmann Jr. described the objects in the show as having been "selected as symbols of a good life."[12] Nelson recognized that the Ball clock was showing up mostly in kitchens, where art critic Edward Lucie-Smith later said modernism first entered the American home.[13] Nelson may have initiated this trend—he included the clock in the kitchen of the Holiday House in Quogue, New York, commissioned by *Holiday* magazine in 1950 and designed by Nelson and Gordon Chadwick (figs. 69 and 70).[14]

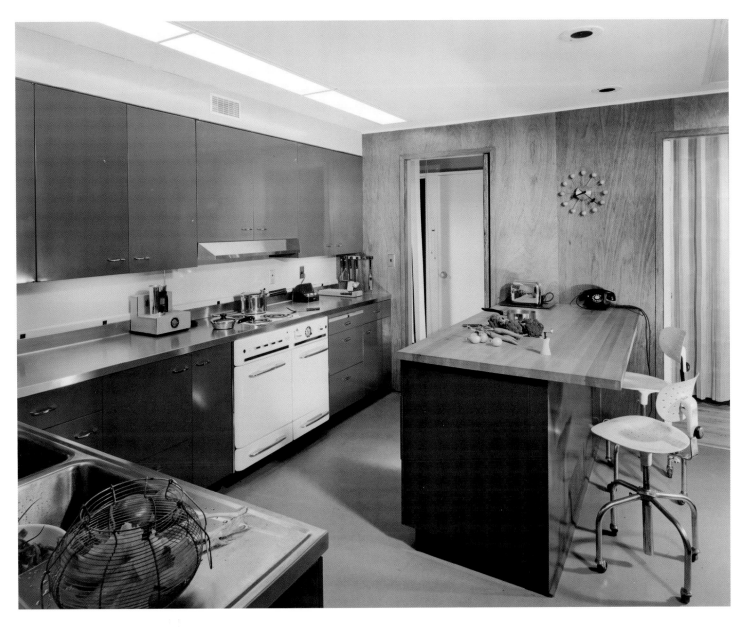

a clock by Howard Miller—ideal gift for the modern home

Fig. 69 Irving Harper's Ball clock in the kitchen of George Nelson and Gordon Chadwick's Holiday House, Quogue, NY, 1950

Fig. 70 Ball clock, Howard Miller Clock Company brochure, c. 1951

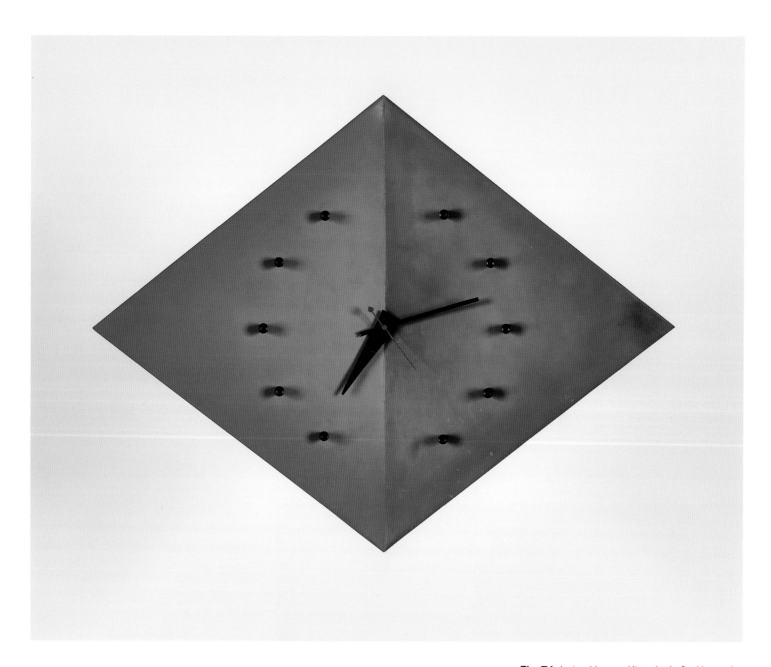

Fig. 71 Irving Harper, Kite clock, for Howard Miller Clock Company, 1953. Collection of Jay Dandy and Melissa Weber. [CAT. 84]

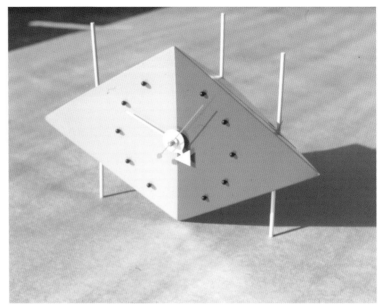

Fig. 72 Pablo Picasso, *Three Musicians,* 1921. Museum of Modern Art, New York

Fig. 73 Irving Harper, Kite table clock, for Howard Miller Clock Company, photograph c. 1954

In a 1981 oral history from the Herman Miller Archives, George Nelson—known for embellishing his stories—told design writer Ralph Caplan that the Ball clock was conceived one night after he, Harper, Isamu Noguchi, and Buckminster Fuller drank too much, asked "What is a clock, anyway?," pontificated about the essential elements of a clock, and doodled possible designs for clocks until they passed out. Nelson recounted on tape, "The next morning I came back and here was this [paper] roll and Irving and I looked at it, and somewhere in this roll there was the Ball clock. I don't know to this day who cooked it up. I know it wasn't me. It might have been Irving, but he didn't think so. And, we both guessed that Isamu had probably done it because Isamu had a genius for doing two stupid things and making something extraordinary out of it."[15] During a visit to his home in Rye, New York, during the summer of 2014, I naively asked Harper to confirm the origin story of the Ball clock's design. "It's bullshit," Harper said to me. "I designed it."[16]

From 1951 to 1956, Harper continued to experiment with form and materials in his clock designs and created the first set of clocks with names that were intentional and explanatory. The Kite wall clock (model 2201), designed between 1952 and 1953, was Harper's first departure from the traditional circular form of the clock and the first time he didn't include twelve hour markers on the face itself (fig. 71). Instead the points where the bi-color triangles meet—the face came in several colorways: black/white, black/gray, orange/purple, and yellow/olive green—acted as the markers for 12 and 6, with ten wooden tabs marking the hours in between. Harper said the harlequinesque colors were inspired by Pablo Picasso's painting *Three Musicians* at the Museum of Modern Art (fig. 72).[17] The Kite design was modified a year later, in 1954—Harper shrunk it down to about half the size to create a tabletop version (fig. 73). The tabletop series also included shapes named Watermelon, Pill, and Cone, all of which also went on to become recognizable classics. The most famous clocks designed during this era included the Spike wall clock (model 2202), which utilized twelve differently colored wooden spokes to indicate hours, and the Asterisk clock (model 2213), which is shaped exactly like its namesake (fig. 74).

Found in Harper's own archive were two design drawings from this era for clocks that were never produced but contain design elements of clocks that did make it into the line. The pencil renderings, dated 1955, are labeled "Sunburst #1" and "Sunburst #2" (figs. 75 and 76). They are similar in appearance to the Flock of Butterflies clock (model 2226), which went into production in 1955 (fig. 77). The design features scored metal pieces attached to twelve spines that, along with dots, act as hour markers and extend out from the motor case. The drawing for Sunburst #1 shows a clock face on a central motor case as well, but this time with dashes indicating hours. This was necessary, as the pieces that fanned out from the central case were numerous and unordered. The design maintains a circular form, but there is no symmetry to the wavy, sunray-like pieces that encircle the clock case. In Sunburst #2 the scored pieces again extend from a central clock face, but this time in an ordered, symmetrical arrangement. The clock face has no hour markers, but instead relies on the position of the scored pieces fanning out from the center to indicate the twelve points. Based on how Harper renders the scored pieces on the paper, which look similar to those used in Flock of Butterflies, one can assume that these unrealized clock designs also were meant to be created in metal. While no explanation exists as to why they weren't produced, they may have been too heavy to make as wall clocks, in either metal or wood. These accordion-like design elements are also incorporated into the Fan (model 2223) and Pleated Star (model 2224) clocks (fig. 78), both of which were meant to be interpreted in metal but were ultimately produced in wood.[18]

Fig. 74 Irving Harper, Asterisk clock advertisement, c. 1953

Fig. 75 Irving Harper, Sunburst #1 drawing, 1955. Herman Miller Archives. [CAT. 79]

Fig. 76 Irving Harper, Sunburst #2 drawing,
1955. Herman Miller Archives. [CAT. 80]

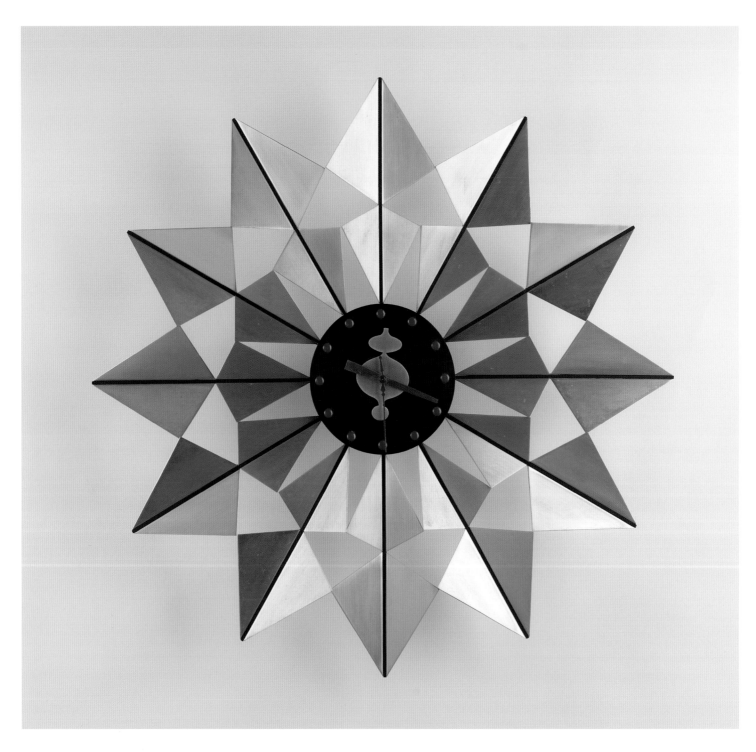

Fig. 77 Irving Harper, Flock of Butterflies clock, for Howard Miller Clock Company, photograph c. 1955

opposite

Fig. 78 Irving Harper, Pleated Star clock, for Howard Miller Clock Company, 1955. Collection of Jay Dandy and Melissa Weber. [CAT. 85]

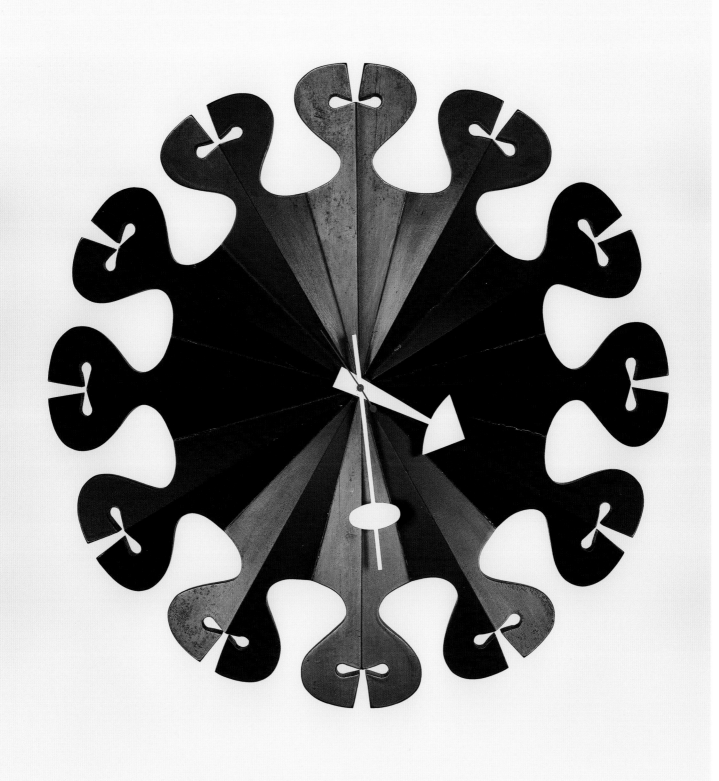

Fig. 79 Lucia DeRespinis, Eye clock, for Howard Miller Clock Company, 1957. Collection of Jay Dandy and Melissa Weber. [CAT. 76]

opposite

Fig. 80 Irving Harper, Paddle clock, for Howard Miller Clock Company, 1957. Collection of Jay Dandy and Melissa Weber. [CAT. 86]

The year 1957 was a prolific one for clocks at the Nelson office. The firm produced approximately twenty-six designs; this was also the first time that Harper enlisted other designers to help with the account. Lucia DeRespinis and Charles Pollock are credited for clock designs that year. "What I remember is Irv calling out, 'Who wants to design a clock?' I leapt at the chance and started working by taking home a stack of newsprint and then just drew clocks—lots of clocks. Then Irv and I sat down to look over my work. He'd point out details, say, this is good, develop that, and we'd continue until we had the finished designs," said DeRespinis.[19] She is credited for five designs, but one in particular became recognizable and famous: the Eye clock (model 2238) (fig. 79). As the name suggests, the clock looks like an eye. The clock face is created with two curved brass bars that make a void around the clock motor, which is suspended in between by a straight bar of wood. The clock motor case creates the iris, the curved bars are the eyelids, the hour markers on the curved bars are the eyelashes, and the void within is the white of the eye. DeRespinis remembered about the design, "The curves were right, the whole thing held together beautifully, and it made a statement."[20]

Another design released that year that relied on voids to communicate was the Paddle clock (model 7513) (fig. 80). Designed by Harper, the face is divided into four petal-like pieces, each made from a different color of lacquered Masonite. (Designed two decades later, the 1978 electronic memory game Simon resembles the clock face.) The voids created where the petals meet serve as hour markers for 3, 6, 9, and 12, with wood dots marking the hours in between. The Paddle clock was part of the Meridian series, a line encouraged by distributor Richards Morgenthau that was intended to be lower-priced.

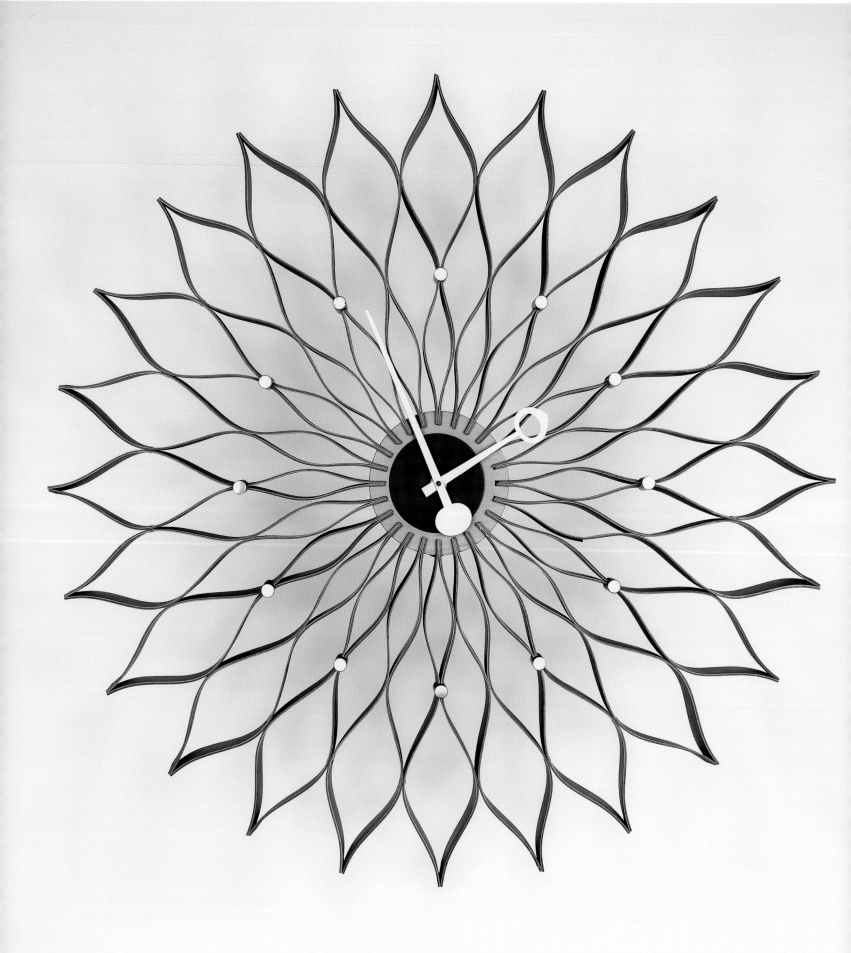

opposite

Fig. 81 Irving Harper, Sunflower clock,
for Howard Miller Clock Company, 1958.
Collection of William and Annette Dorsey.
[CAT. 87]

above

Fig. 82 Irving Harper, design drawing for
Ophelia's Hair clock, 1959. Herman Miller
Archives. [CAT. 82]

Although plywood was a ubiquitous material for furniture at the time, due partly to
Charles and Ray Eames, Harper's Sunflower clock (model 2261) (fig. 81) from 1958
and Ophelia's Hair clock (model 2269) (fig. 82) from 1959 mark the first, and only, times
plywood is used in a clock design for Howard Miller.[21] Both clock designs were massive —
the Sunflower clock measures 30 inches in diameter; Ophelia's Hair measures 26
inches — and create sculptural, three-dimensional effects. Harper cites the Sunflower
clock as the first time he attempted to incorporate time itself as a design feature: the
undulating veneered plywood pieces represent the constant motion of time.[22] The Sun-
flower clock became one of the most popular and best-selling designs and is once again
in production today. Other than the design drawing in Harper's archive, documentation
of Ophelia's Hair is more scarce. It does, however, appear in a May 1960 feature on
Nelson in *Look* magazine and in a spring 1960 Howard Miller catalog supplement.[23]

The 1960s began on a high note for the Nelson office. On January 1, 1960, the
New York Times announced the release of the psychedelic Motion Notion series (fig. 83) with
the headline "Designer of Fanciful Clock Does Not Waste Second." The article marks the
first time Irving Harper is publicly credited as designer of the clocks. With the Motion
Notion series, Harper revisited the idea that he first explored with the Sunflower clock
and Ophelia's Hair — using time itself as a design element. In the Platter clock (model 2274)
(see fig. 7) and the Compass clock (model 2278) (fig. 84), Harper employs an entirely new
clock hand design that was developed specifically for the series. The support for the hands

Fig. 83 Motion Notion advertisement,
c. 1960

is hidden, therefore creating a floating effect as they rotate around the clock faces, which were decorated with screen-printed designs. In the Platter clock, twelve brass dots circle the enameled aluminum concave dish. Harper uses the negative space in the dish to weave string between the hour markers, creating a geometric design. For the Kaleidoscope clock (model 2277) (fig. 85), hour and minute hands are represented by a red circle and short black line that are attached to a spinning disc. Harper then surrounded the polygonal face with six mirrors positioned outward at an angle to reflect the constant motion of the spinning second hand, giving the timepiece the effect of a kaleidoscope and, therefore, its name.

Introduced at the Chicago Merchandise Mart in 1962, the Clocks Ahead of Time series marks the beginning of the end of the Nelson clock line. Harper would leave the office in 1964, and clock design from then on was never as innovative or dynamic. The Nelson office continued to design institutional clocks for Howard Miller, but the office was no longer producing groundbreaking work. In his last series, Harper revisited ideas

Fig. 84 Irving Harper, Compass clock,
for Howard Miller Clock Company,
1959. Collection of William and Annette
Dorsey. [CAT. 88]

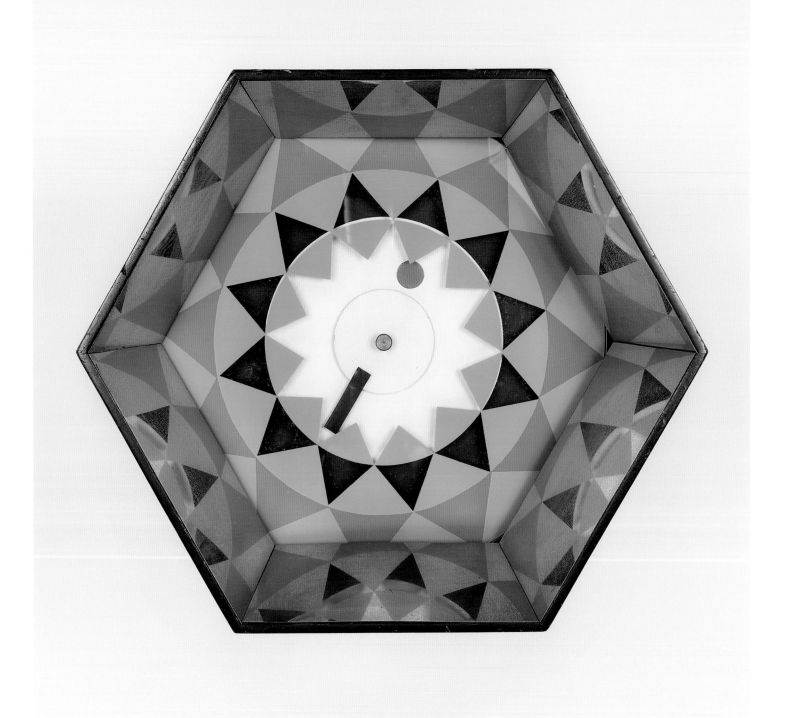

Fig. 85 Irving Harper, Kaleidoscope clock, for Howard Miller Clock Company, 1959. Collection of William and Annette Dorsey. [CAT. 89]

opposite
Fig. 86 Irving Harper, Birdcage clock, for Howard Miller Clock Company, 1961. Collection of Jay Dandy and Melissa Weber. [CAT. 91]

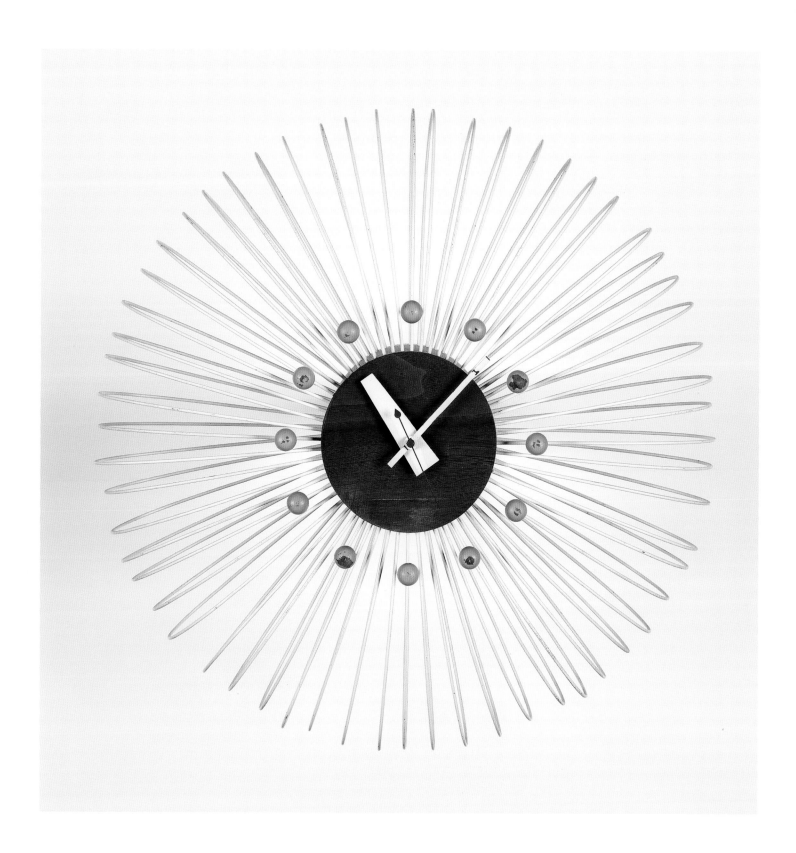

and forms from previous clock collections, but he was also able to drum up a few more unique and original designs. The Birdcage clock (model 2292) utilized the wire from the newly introduced Bubble lamp—a cross-pollination between projects for Howard Miller that developed concurrently (fig. 86). The bent wire is attached to a central wooden clock case to create a cage-like, three-dimensional clock face. Hours are punctuated by wooden dots affixed to the cage and create a mini Ball clock effect.

With Irving Harper at the helm, the clocks designed for Howard Miller constitute a body of work that was the most imaginative and creatively diverse to come out of the Nelson office. By playing with the different elements that make up a clock, Harper extended the form more than any industrial designer had done before. The volume of the work is astounding—more than 130 clocks were designed during his tenure. "They kept coming out of me; I never went dry," Harper said of his process.[24] "He was like a motor— he just created," DeRespinis remembered of his work ethic.[25] Another example of Harper's prolific creative output: from the end of his time in the Nelson office in 1964 until the early 2000s, he created more than three hundred sculptures by hand from construction paper and glue.[26] Many of those sculptures are evocative of the clocks he spent so much time creating during his time in the Nelson office, with some even using leftover parts and clock housings. Harper recycled prototypes from a series of ceramic table clocks (fig. 87) that Howard Miller never put into production and turned them into a group of sculptures that resemble African masks (fig. 88). In his 1934 book *Technics and Civilization,* Lewis Mumford argued that the clock—not the steam engine—is the most important invention of the modern industrial age.[27] The relationship between the Howard Miller Clock Company and the George Nelson office—with the direction and vision of Irving Harper—produced the most important, recognizable, and playful clock designs of the twentieth century.

Fig. 87 Irving Harper, ceramic table clock prototypes, c. 1953

Fig. 88 Irving Harper, paper sculptures, dates not known

NOTES

1 George Nelson, "The Herman Miller Collection," 1948 catalog introduction, Herman Miller Archives, Zeeland, Michigan.

2 Based on dates of design drawings in the Irving Harper Collection, which begin in 1947. Irving Harper Collection, Herman Miller Archives. D. J. De Pree, founder of Herman Miller, also founded the Herman Miller Clock Company in 1927. The clock and furniture companies were separate. The clock company offered traditional-style and modern clocks designed by Gilbert Rohde, who also designed for the Herman Miller Furniture Company. De Pree ran the company until 1937, when he turned it over to Howard Miller, his brother-in-law and son of Herman Miller. At that time the name was changed to Howard Miller Clock Company.

3 Barbara Fitton Hauss, "Consumer Products for a 'Kleenex Culture': Home Accessories by George Nelson," in *George Nelson: Architect, Writer, Designer, Teacher,* ed. Jochen Eisenbrand and Alexander von Vegesack (Weil am Rhein, Germany: Vitra Design Museum, 2008), 112.

4 Ted Rogers, "Howard Miller Clocks," 2002, unpublished manuscript, Irving Harper Collection, Herman Miller Archives.

5 George Nelson, "Planned Expansion," *Industrial Design* 1 (February 1954): 108.

6 Howard Miller Clock Company, letter from Howard Miller to George Nelson, November 28, 1953, #10937, Vitra Design Museum Archives (George Nelson Archive), Weil am Rhein, Germany.

7 Howard Miller Clock Company brochure, 1951.8, Herman Miller Archives.

8 Rogers, "Howard Miller Clocks."

9 Ibid.

10 Quoted in Paul Makovsky, "Vintage Modern," *Metropolis*, June 2001, 117, 120.

11 Irving Harper's library was acquired by Herman Miller Archives in 2014. It contained numerous exhibition catalogs from shows at the Museum of Modern Art, Metropolitan Museum of Art, Guggenheim Museum, and others. He referenced modern art in many of the paper sculptures he started to create in 1964, and even re-created the horse from Picasso's *Guernica* out of folded paper and Elmer's glue.

12 Edgar Kaufmann Jr., "Modern Design in America Now," in *An Exhibition for Modern Living,* ed. Alexander Girard and William D. Laurie Jr. (Detroit: Detroit Institute of Arts, 1949), 40.

13 Edward Lucie-Smith, *A History of Industrial Design* (Oxford: Phaidon, 1983), 176.

14 Carl L. Biemiller, "Holiday House," *Holiday*, May 1951, 106.

15 George Nelson, oral history interview by Ralph Caplan, August 8, 1981, Herman Miller Archives.

16 I visited Irving Harper multiple times between 2013 and 2015 while arranging to acquire his archive for Herman Miller.

17 Rogers, "Howard Miller Clocks."

18 Ibid.

19 Ibid.

20 Phone interview with Lucia DeRespinis, September 6, 2017.

21 Hauss, "Consumer Products," 117.

22 Rogers, "Howard Miller Clocks."

23 Hauss, "Consumer Products," 117. Photocopy of spring 1960 Howard Miller catalog supplement, Irving Harper Collection, Herman Miller Archives.

24 Quoted in Julie Lasky, "Irving Harper's World," in *Irving Harper: Works in Paper,* ed. Michael Maharam (New York: Rizzoli, 2013), 25.

25 Phone interview with Lucia DeRespinis, September 6, 2017.

26 Cited in Lasky, "Irving Harper's World," 13.

27 Lewis Mumford, *Technics and Civilization* (New York: Harcourt, Brace, Jovanovich, 1934).

EVA ZEISEL

THE "MERRY-SOULED" DESIGNER'S PLAYFUL SEARCH FOR BEAUTY

PAT KIRKHAM

Play and creativity were central to the education, early formation, design thinking, and creative practice of Hungarian-born designer Eva Zeisel (1906–2011). (Although she did not take the name Zeisel until she married Hans Zeisel in 1938, for clarity and convenience she is referred to as Zeisel throughout this chapter.) A major figure in twentieth-century design, Zeisel worked in Hungary, Germany, and the Soviet Union in the interwar years and became the preeminent designer of mass-produced ceramic tableware in the postwar United States.[1]

According to her mother, Laura Polanyi Stricker, playfulness was Zeisel's most dominant characteristic as a person, and Zeisel thought her strong sense of fun and play may have been inherited from her grandmother Cecile Polanyi, a radical and bohemian who hosted a famous salon in Budapest.[2] Zeisel's other dominant characteristics were a seemingly endless curiosity and a dogged determination; the former fed into her playfulness, while the latter underpinned the serious manner in which she oversaw the translation of her designs into production. Her daughter, Jean Richards, commented on the playful and serious aspects of her mother's work (fig. 89):

> One of the most curious people I have known, Eva had an approach to designing that was completely playful, and always undertaken with a variety of possible solutions. She sketched curves and shapes with joy, and refined them until she hit upon what she felt was the right design for the project. When designing, there was no seriousness, only play and pleasure. Once she decided on a design, however, she got *very* serious; *very* exacting; *very* precise. She did not allow even a sixteenth-of-an-inch change to her designs in the manufacturing process, after she had worked with modelers and others to achieve exactly what she wanted. She felt that even the slightest change would make too great a difference. Thus, she started with play and ended with seriousness.[3]

After becoming acquainted with the ideas of Cyril Stanley Smith, a Massachusetts Institute of Technology metallurgist who wrote about the technologies associated with early metalwork and ceramics, especially Chinese ceramics, Zeisel summed up her own approach to design as a "playful search for beauty."[4] Smith's studies led him to conclude that playfulness was a key feature in the creative process. He argued that, from the earliest times until the twentieth century, people who engaged in play fueled by aesthetically motivated curiosity were those most likely to make important discoveries.[5]

Zeisel's playfulness and pleasure in amusing people shone through her talks, Q&A sessions, and conversations. Two examples stick in my mind. When asked whether the fact that she designed so many teapots meant that she was particularly fond of tea, she replied in a teasing tone, "I have also designed many saltshakers, and yet I do not particularly love salt."[6] The whole audience laughed. On a more personal level, when she was in her ninety-eighth year, and I was worried about her stamina, I asked if she had taken a nap between a morning spent teaching and a screening of a film about her life and work, followed by a Q&A session. She joked, "At my age I can't afford to take a nap; I might not wake up. . . . I don't want to miss having fun this evening."[7]

Many items designed by Zeisel indicate the ways in which her playfulness and sense of humor fed into her desire to design objects that established "soul contact" with those

Fig. 89 Eva Zeisel with her children,
Jean and John, developing patterns,
c. 1949

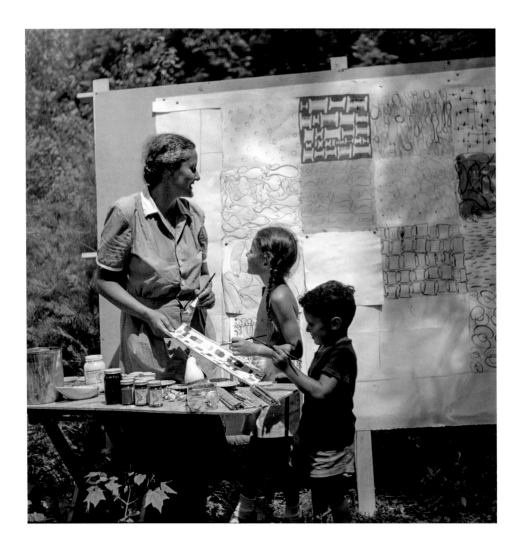

using them.[8] Before discussing these, however, I would like to consider how the strong
emphasis on play and creativity during her formative years helped shape and encourage
the playfulness evident in her professional work.

EARLY LIFE AND WORK

Born Eva Amalia Stricker on November 13, 1906, Zeisel enjoyed a privileged haute-
bourgeois upbringing in Budapest, Hungary, the twin capital (along with Vienna) of
the Austro-Hungarian Empire. She belonged to an extended family of distinguished,
freethinking intellectuals, and her mother and maternal grandmother, both committed
feminists, provided strong female role models while encouraging her to pursue her own
path through life.[9]

Playing and creating art featured among Zeisel's earliest memories. In 1911, the
year in which she and her brother Michael turned five and six, respectively, their mother
opened a progressive kindergarten so that they could receive what she felt was the
best early education then available. Popular across Europe and North America in the late
nineteenth and early twentieth centuries, the kindergarten movement drew ideas from a
variety of sources, from the philosopher Jean-Jacques Rousseau, who believed that the
best early education for "uncivilized" children was one without book learning or interference

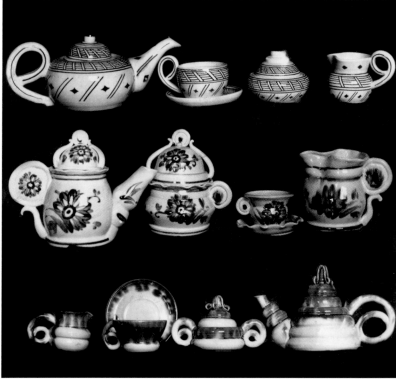

Fig. 90 Eva Zeisel with a "blown-up" paper
cutout, date not known

Fig. 91 Eva Zeisel, shapes and patterns,
for Kispester-Granit, 1926

from adults and adult conventions, to educational theorists such as Friedrich Froebel and Johann Pestalozzi, who argued for education rooted in play and the development of the "whole child."[10] Laura Stricker, a noted scholar with an interest in history (she was the first woman to receive a doctorate in history at the University of Budapest), the social sciences, progressive education, and Freudian psychoanalysis, played an active role in her kindergarten but brought in specialists to teach art, music, and eurythmics (the expression of music and sound through body movement) in order to ensure that the children's creativity and self-expression were developed to the fullest. Learning to be at one with nature was considered vital, and when exercising, dancing, and playing outdoors, children at the Stricker school wore simple gym suits or went naked.[11] Zeisel recalled enjoying the freedom of nudity (it shocked some family friends and acquaintances), and her deep love of nature, evident throughout her work, went back to her early childhood.

The curvaceous forms and playful spirit of Baroque architecture were everywhere apparent in Central Europe when Zeisel was growing up, and they informed much of her later work. When she was about eleven years old and living in Vienna, she studied the Baroque in "spirit and details" with her art history tutor, the young Friedrich Antal (later a leading Marxist art historian).[12]

"Mad about art," she decided as a teenager to make her career as a painter, studying with private tutors and at the Hungarian Royal Academy of Fine Arts. In order to support herself (rather than be "starving in a garret," as she put it), Zeisel decided to make pottery as a financial backup and began a six-month craft apprenticeship with a master potter in fall 1924.[13] She learned a great deal but never mastered making repeated uniform shapes by hand on a wheel; this, however, led her to focus on design. Zeisel's tacit under-standing of clay — akin to her maternal uncle Michael Polanyi's understanding of the wider importance of tacit (as opposed to explicit) knowledge — was evident throughout her career, and she continued modeling forms in clay and plasticine, just as she had done in her childhood.[14] Similarly, she continued her childhood "play" of cutting paper forms and then using them to shape clay. She did this when she worked for the Kispester-Granit factory in Hungary in the early 1980s, likening this manner of working to blowing up a balloon and then manipulating it into playful forms (fig. 90).[15]

After her apprenticeship, Zeisel created handmade pottery in her studio and kiln in the family garden. Bold and quirky, the pieces were influenced by Hungarian peasant wares. In 1926, she designed a range of equally bold and quirky teapots, sugar bowls, and creamers for Kispester-Granit. Faux-naïf in form and decoration, the items featured exaggeratedly large and elaborate handles and lids (fig. 91). Zeisel later described this work as "rather inarticulate" and "disorganized spontaneity," influenced by the haphazard-ness she then admired in paintings by artists such as Oskar Kokoschka.[16]

The examples cited show that play was central to Zeisel's approach to pottery throughout her extensive career, and that this was the case long before she emigrated to the United States in 1938. Although she had designed for production on a huge scale when working in the Soviet Union from 1932 to 1936, it was only in the postwar years in the United States that she became famous as a designer and achieved consid-erable commercial success.[17] She continued to approach design in a playful manner while drawing upon aspects of her childhood approach to play and her lifelong love of the natural world.

ANIMALS AND "AMINALS"

Zeisel's penchant for whimsical animal forms is evident in her first professional engagement as a designer. In 1926, at the Kispester-Granit factory, she modeled clay prototypes by hand for small, serially produced items, including ashtrays in the shape of unicorns that successfully sold in the United States.[18] Surviving pieces and archival photographs show something of the lightheartedness of these objects, which included birds, bulls, horses, rams, and rhinos (fig. 92).[19] In the 1940s and 1950s, Zeisel, like many designers, created with her own children in mind and/or drew upon her experiences as a parent. Her wooden "aminals" amuse not only by the animal forms themselves but also by the "trick" of appearing to be one creature on one side and another on the reverse. Her name for these simple but engaging creatures shows her love of playing with words. She made up similar words that sound like children's mispronunciations to amuse her own children.[20]

Other children's items designed when her children were young include her 1949 range of children's toiletry containers in the form of birds and animals for Ohio Potteries. The line was not produced, nor was her children's service (plate with handle and spoon, porringer-style bowl with spoon rest, and two-handled cup). The latter set, with whimsical decal designs added, was produced by the Goss China Company as Wee Modern (fig. 93). While the decals are a good example of the popularity of playful graphics in the 1950s, and indeed of whimsical design in general at the time, Zeisel's preference in this instance was for solid pastel colors.[21]

BIRDS

Zeisel loved birds, the animal class that featured most in her postwar work: "When you have clay in your hands, it's hard to avoid making birds."[22] She considered bird dishes "entertaining," and her comment in the early 1950s that for "thousands of years, potters have used bird shapes for humorous expression, as relief from routine and severe functional design" reveals something of her own aesthetic preferences (fig. 94).[23] Her earliest bird designs include faux-naïf bird-on-branch decoration in 1926 for Kispester-Granit and, in the following year, another faux-naïf design, a clay lantern featuring a bird with open mouth feeding on a worm, for Hansa Kunstkeramik in Germany (fig. 95). For the latter design, she drew on the paper pattern-cutting play of her childhood and cut the bird-branch-leaf pattern out of a flat strip of clay.

Fig. 92 Eva Zeisel, rhinoceros dish, for Kispester-Granit, c. 1926

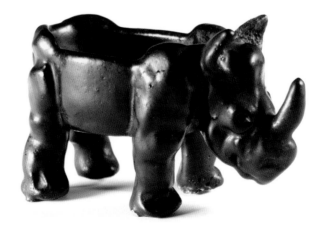

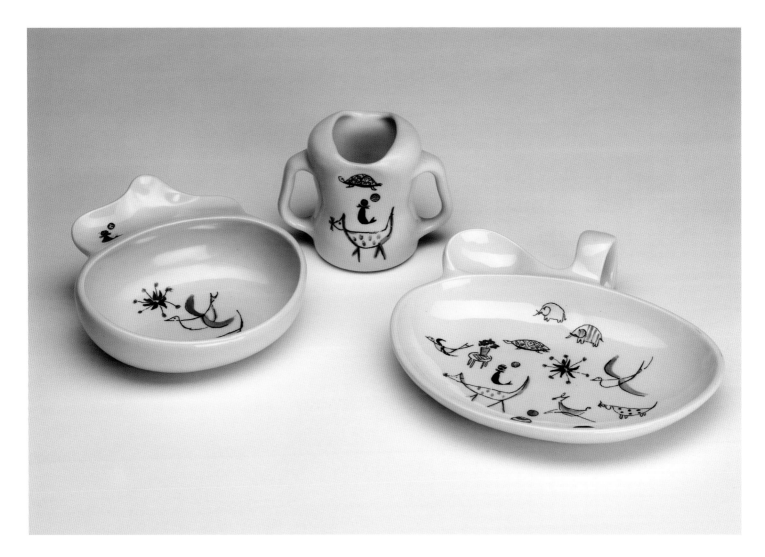

Fig. 93 Eva Zeisel, Wee Modern children's
service, for Goss China Company, 1953.
Denver Art Museum. [CATS. 189, 190, 191]

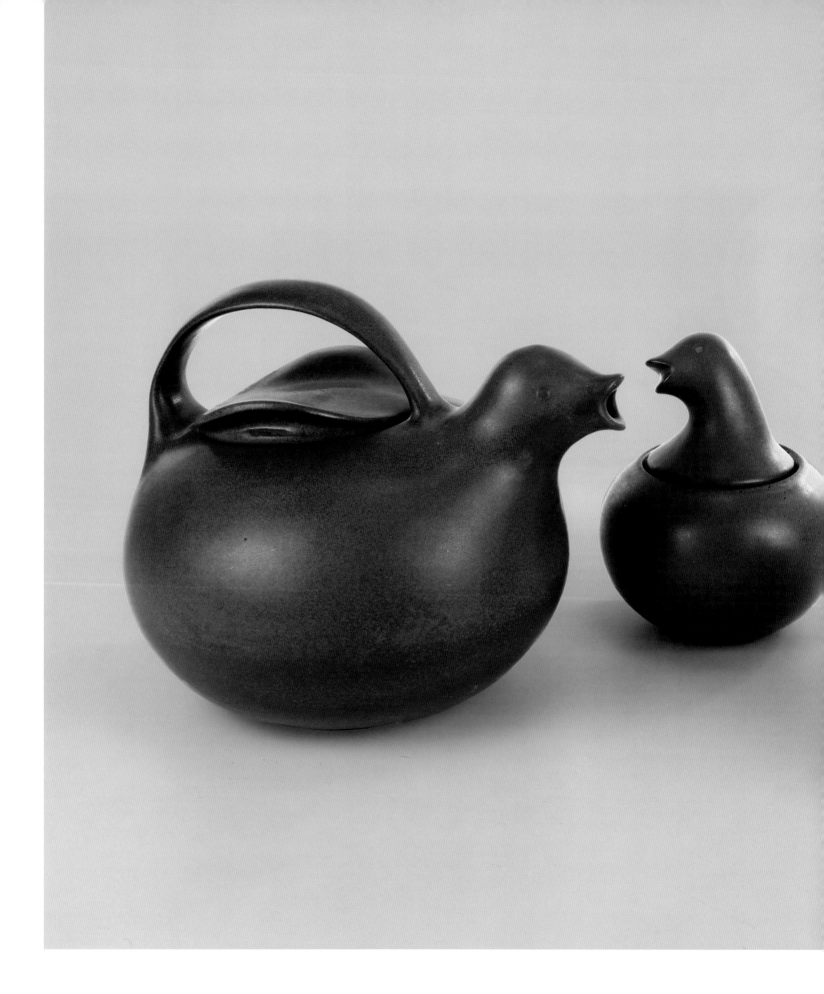

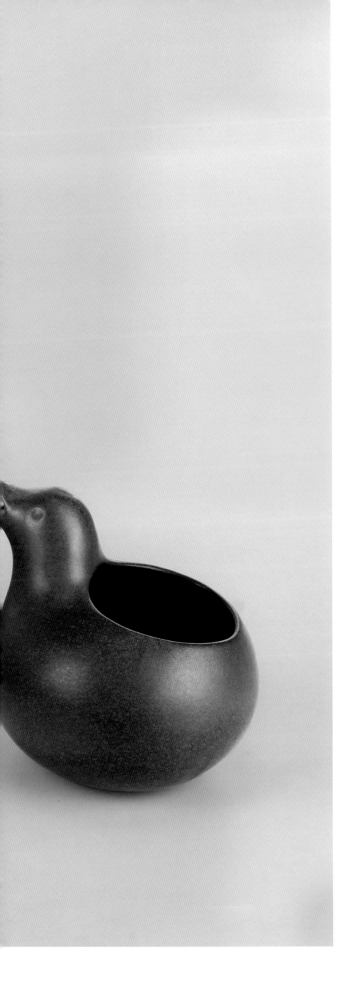

Fig. 94 Eva Zeisel, teapot, creamer,
and sugar, for Monmouth Pottery,
1953. Collection of Scott Vermillion.
[CAT. 197]

Fig. 95 Eva Zeisel, lantern, for
Hansa Kunstkeramik, 1927

Fig. 96 Eva Zeisel, Cloverware serving pieces, for Clover Box and Manufacturing Company, 1947

In the postwar United States, Zeisel focused on three-dimensional bird forms, beginning in 1947 with Town and Country luncheon ware and the plastic Cloverware line. The spouts of the pitchers and creamers for Town and Country open up like birds seeking food, while the bowls of the Cloverware salad servers resemble birds' heads with open beaks (fig. 96). Zeisel's most birdlike forms appear in Eva Zeisel Fine Stoneware, for Monmouth Pottery (a division of Western Stoneware Company), and Schmid Ironstone (fig. 97). In the former, the neck and head of a bird with parted beak extends from the lids of the sugar and marmite bowls, and the bird heads on the salt and pepper also have open beaks. Together, the casserole and lid resemble a duck, while the open vegetable dish is more swanlike (fig. 98). Designed in 1964, the Schmid Ironstone line was aimed at the North American market but made by Nihon Koshitsu Toki Company in Japan; the dishes for vegetables, oil/vinegar, and relish were all in the form of birds, some with open beaks. In the 1980s, her stackable flowerpots for Schramberger Majolikafabrik in Germany alluded to birds or ducks (fig. 99), while the spouts of teapots she designed in 2006, when she was one hundred years old, pick up on beak forms. Birdlike forms also feature in a beautiful, freely sketched design for a centerpiece from the early 2000s influenced by Central European Baroque forms (fig. 100).[24]

Fig. 97 Eva Zeisel, marmite bowl, salt, and pepper in the Colonial pattern, for Monmouth Pottery, 1953; and oil/vinegar bottle and gravy boat with ladle in the Stratford pattern for Nihon Koshitsu Toki Company, 1964. Collection of Scott Vermillion. [CATS. 198, 199, 200, 201]

Fig. 98 Eva Zeisel, vegetable dish and spoon in the Pals pattern, for Monmouth Pottery, 1953. Collection of Scott Vermillion

HUMOR

Humor also figured into Zeisel's work. One of the most amusing uses of human features is a "belly button" form or dimple-like effect that she used, in conjunction with curves that evoked those of a voluptuous woman's body, in her 1958 glazed ceramic wall and space dividers (fig. 101). The "belly button" also featured in vases, a rug, bowls, and teapot lids.[25]

When writing about Zeisel's popular, informal Town and Country luncheon ware, a journalist commented that "*dishes* with humor make mood," and these show Zeisel at her most playful.[26] Town and Country had the largest number of individual playful pieces of any Zeisel tableware line. There was no single colorway: thirty-four different pieces came in twenty-three different color combinations, and the opportunity to mix and match added to the fun for consumers.[27] Zeisel further added to the merriment of the Town and Country line by lightheartedly challenging conventional notions of certain object types, as she did in the same year (1947) by subtly rounding the bottoms of porcelain wares designed for Riverside China so that they rocked gently when touched, just for fun (fig. 102).[28]

Zeisel often spoke of the various pieces in her individual lines as in familial relation-ships to each other. The best example of this is the "mother and daughter" salt and pepper duo in the Town and Country line (fig. 103). She likened the relationship between the shakers to how she related to her daughter at the time, but these cute forms and faces, complete with eyes and mouth formed by the holes for the salt or pepper, go beyond allusions to humans. Some see these popular pieces as seals, others as the forerunner of the Li'l Abner comic strip character "the Shmoo," which first appeared in print in 1948. One journalist likened them to "ghosts — gay and usable . . . the trademark of a merry-souled designer," the latter an apt description of Zeisel.[29] The shakers for her Century

Fig. 99 Eva Zeisel holding a stackable flowerpot at Schramberger Majolikafabrik, Germany, c. 1988

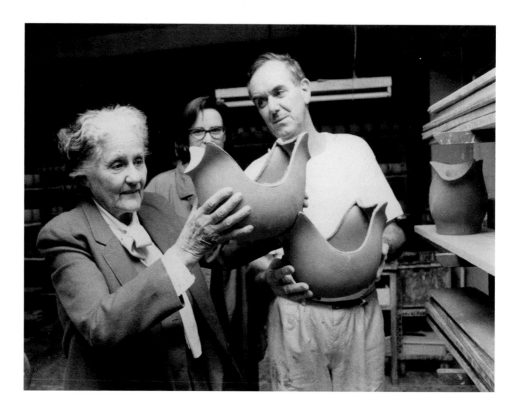

Fig. 100 Eva Zeisel, sketch for a
centerpiece, early 2000s

Fig. 101 Eva Zeisel, prototypes for room
divider modules, for Mancioli, 1958

Fig. 102 Eva Zeisel, rocking tableware, for Riverside China, 1947. Collection of Scott Vermillion

Fig. 103 Eva Zeisel, salt and pepper in the Town and Country line, for Red Wing Potteries, 1947. Collection of Jody and Dick Goisman. [CAT. 202]

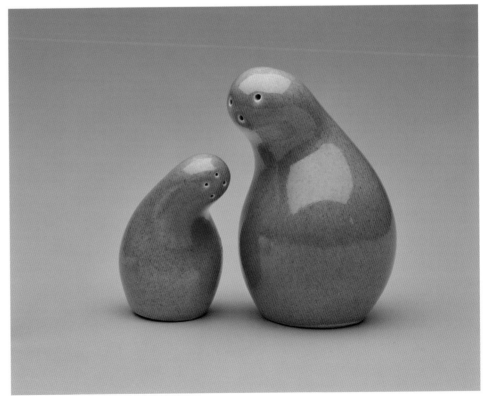

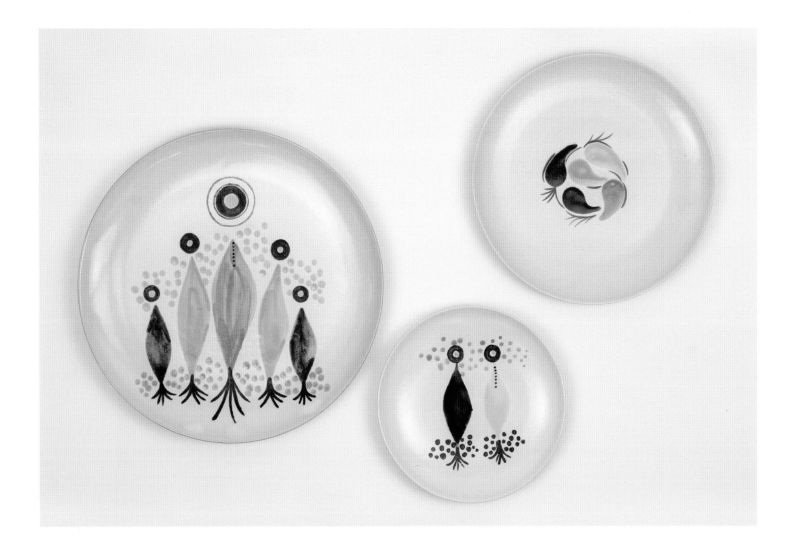

Fig. 104 Eva Zeisel, dinner plate and salad plate in the Pals pattern with dinner plate in the Feathered Friends pattern, all for Monmouth Pottery, 1953. Collection of Scott Vermillion. [CATS. 193, 194, 195]

line (1957) also reference small humans, but their sleek stylized forms hint at ghostlike, even alien figures. The playful shapes made these amusing conversation pieces.

For Town and Country, Zeisel came up with off-center plates and bowls with one side higher than the other, and platters and relish dishes in a teardrop shape (a form reworked elegantly for her 1952 Tomorrow's Classic platters). The unconventional salt and pepper shakers, and the anthropomorphic oil and vinegar pourers, snuggle up together when used as a pair, while the pitcher and creamer evoke the wide-open mouth of a bird or a fanciful sea creature. For the most part, the distinctive pieces in Town and Country have a less close relationship to one another than items in her other lines, but Zeisel noted that "they make love to each other and engage us in their unique interactions."[30] Especially when one factors in the color combinations, the ways in which the pieces interacted depended on how consumers, rather than the designer, arranged them. Zeisel's Town and Country put playfulness back into the hands of the user. Pals, designed in 1953 for Monmouth Pottery, was another example of Zeisel having fun with form. The line featured what she called "turnip people" (figs. 104 and 105).[31] Other objects designed by Zeisel to amuse the beholder by their reference to things in the natural world include her "fishtail" candlestick (1947) for Riverside China and ceramic tiles in the shape of a fish (1997) for the Orange Chicken Gallery.

Zeisel offered consumers not only amusing objects but also more playful ways of engaging with objects in the postwar period when, after the Great Depression and World War II, a greater degree of fun and whimsicality was welcome. Play was clearly central to Zeisel's approach to pottery long before World War II, but it was only with the widespread prosperity and greatly increased and deferred consumption of the postwar period that this aspect of her work met with broad commercial success. She referred to herself as a "modernist with a small *m*" and found orthodox modernism too limiting and overly dogmatic.[32] Not surprisingly, for a woman who defined her approach to design as a "playful search for beauty," she welcomed the greater playfulness, whimsicality, delight, and what she experienced as a greater "thirst for beauty, freedom, aesthetic exuberances, elegance, refinement and light-heartedness" in the later twentieth century, during the movement that many refer to as postmodernism.[33] Play and playfulness remained hallmarks of Zeisel's work until her death in 2011.

Fig. 105 Eva Zeisel with a plate decorated in the Pals pattern, for Monmouth Pottery (lower left), 1953

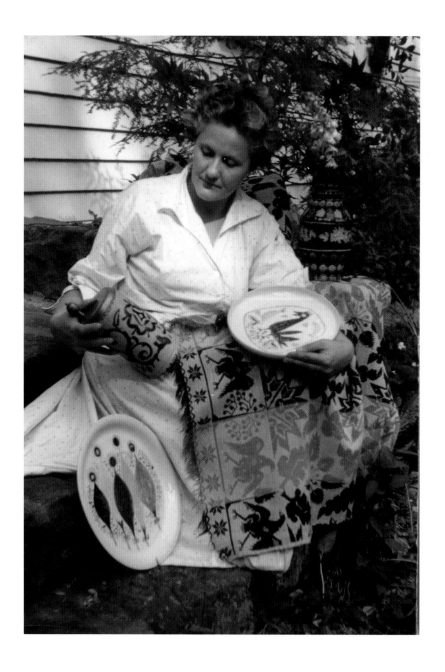

NOTES

1 For more about Eva Zeisel's life and work, see Pat Kirkham, ed., *Eva Zeisel: Life, Design, and Beauty* (San Francisco: Chronicle, 2013); Martin Eidelberg, *Eva Zeisel: Designer for Industry* (Montreal: La Château Dufresne, Musée des arts décoratifs de Montréal, 1984), the catalog for a 1984 traveling retrospective of Zeisel's work to that date; and Ronald T. Labaco, "'The Playful Search for Beauty': Eva Zeisel's Life in Design," in *Women Designers in the USA, 1900-2000*, ed. Pat Kirkham and Ella Howard, special issue, *Studies in the Decorative Arts* 8, no. 1 (Fall-Winter 2000-2001).

2 Eva Zeisel recollection, "About 1950-55," Eva Zeisel Archive (in possession of her daughter, Jean Richards), New City, New York. Cited in Kirkham, *Eva Zeisel*, 16.

3 Jean Richards, telephone conversation with author, June 18, 2017.

4 The phrase became widely associated with Zeisel and was used as the title of an exhibition of her work in 2004 and in the title of a TED Talk she gave in 2008.

5 Cyril Stanley Smith, *From Art to Science: Seventy-Two Objects Illustrating the Nature of Discovery* (Cambridge, MA: MIT Press, 1981), 242.

6 Q&A after TED Talk in 2000. For the talk, see Eva Zeisel, "The Playful Search for Beauty"; https://www.ted.com/talks/eva_zeisel_on_the_playful_search_for_beauty (accessed January 4, 2018). See also *Throwing Curves: Eva Zeisel*, directed by Jyll Johnstone (Tiburon, CA: Canobie Films, 2002).

7 Eva Zeisel in conversation with Pat Kirkham, September 1, 2004.

8 For "soul contact," see Eva Stricker, "Die Künstlerin hat das Wort," *Die Schaulade* 8 (February 1932): 281-296.

9 For more on Zeisel's mother and grandmother, see Judith Szapor, *The Hungarian Pocahontas: The Life and Times of Laura Polanyi Stricker, 1882-1959* (Boulder, CO: East European Monograph, 2005).

10 For the kindergarten movement, see Juliet Kinchin, "The Kindergarten Movement: Building Blocks of Modern Design," in *Century of the Child: Growing by Design, 1900-2000*, ed. Juliet Kinchin and Aidan O'Connor (New York: Museum of Modern Art, 2012), 30-33. See also Norman Brosterman, *Inventing Kindergarten* (New York: Abrams, 1997).

11 Eva Zeisel, "Eva Zeisel — Biography," Eva Zeisel Archive.

12 Cited in Kirkham, *Eva Zeisel*, 17.

13 Ibid., 18-19.

14 For Zeisel and tacit knowledge, see Tanya Harrod, Eva Zeisel obituary, *The Guardian*, January 15, 2012. Michael Polanyi was a noted scientist and philosopher.

15 Tom Tredway, "Design within Reach: *Granit Collection*," in Kirkham, *Eva Zeisel*, 142-145.

16 A piece of pottery made to one of her hand-drawn designs was shown in 1926 in the Hungarian section of the Sesquicentennial International Exposition in Philadelphia, commemorating the 150th anniversary of the signing of the Declaration of Independence. She won an honorable mention. "Eva Zeisel: Designer for Industry," Brooklyn Museum press release, October 6, 1984; Zeisel, "Playful Search for Beauty."

17 Her 1946 exhibition at the Museum of Modern Art, New York, was that museum's first show dedicated to a woman designer. Martin Eidelberg, with Derek Ostergard and Jennifer Toher, "Eva Zeisel: Ceramist in an Industrial Age," in Eidelberg, *Eva Zeisel*, 36, and https://www.moma.org/artists/6556?locale=en (accessed January 4, 2018).

18 Pat Kirkham, "Eva Zeisel: Design Legend 1906-2011," in Kirkham, *Eva Zeisel*, 18-20.

19 Eva Zeisel Archive.

20 For example, Zeisel called the "time alone" sessions she spent with each of her children on an individual basis "tumbalone," presumably because some of that time involved tumbling around. Jean Richards to author, e-mail June 4, 2017.

21 Pat Moore, "Select Chronology," in Kirkham, *Eva Zeisel*, 224.

22 Paula DiPerna, "The Life of Eva Zeisel and the Absurdity of Other People's Rules," *Forbes*, January 13, 2012; https://www.forbes.com/sites/worldviews/2012/01/13/the-life-of-eva-zeisel-and-the-aburdity-of-other-peoples-rules/#1d6d04642cab (accessed January 4, 2018).

23 See Eva Zeisel Fine Stoneware from Monmouth Pottery brochure (Monmouth, IL: Monmouth Pottery, 1953).

24 Kirkham, *Eva Zeisel*, 44. The date of the sketch is early 2000s (Jean Richards to author, e-mail September 17, 2017).

25 The vases were designed for the Zsolnay Porcelain Manufactory, the rug for the London Rug Company, and the lids were part of a service for Kispester-Granit in the 1980s.

26 Cited by Meri Villane, "Red Wing Potteries: Town and Country," in Kirkham, *Eva Zeisel*, 77.

27 See Eva Zeisel Fine Stoneware from Monmouth Pottery brochure, 1953.

28 Mary Roche, "Utility Exhibition Will Start Today," *New York Times*, September 17, 1947.

29 The comment was made in *The Pathfinder*, a weekly newsmagazine. See Villane, "Red Wing Potteries," 77.

30 Quoted in ibid., 76.

31 Scott Vermillion, "Western Stoneware Company: Eva Zeisel Fine Stoneware, 1953," in Kirkham, *Eva Zeisel*, 104.

32 Kirkham, "Eva Zeisel: Design Legend 1906-2011," in Kirkham, *Eva Zeisel*, 11, 22-23.

33 Ibid., 12.

TOYS AS FURNITURE / FURNITURE AS TOYS

ALEXANDRA LANGE

Small fry who have recently been interested by the sight of their elders struggling to construct a table, a chair or a chest may now take a try at it themselves. A child's type of the popular knock-down furniture is called Tyng Toy.

—*New York Times*, February 22, 1950

The Tyng Toy was introduced just in time for Christmas 1949: a life-size construction toy, sold in sets of six, eleven, or twenty-one flat, precut fir plywood pieces shaped to serve as wheels, axles, and platforms; notched for assembly without tools; and promising a renewable play experience. The six-piece set could be made into a chair, a push cart, a stool, or a rocking chair, big enough for a child to sit on and simple enough for a child to assemble herself. The eleven-piece set added longer elements and the ability to fashion a bench or desk. One side of the largest piece, a rough rectangle, was coated with blackboard paint so that, after assembly, a child could further express her creativity through drawing. Though abstract overall, one piece resembled a flat horse head, with a painted mane and cut-out eye and mouth to suggest possibilities for dramatic play (fig. 106). The toy's designer was recently licensed architect Anne Tyng (1920–2011), then twenty-nine. One publicity photo shows her sitting on the floor among her pieces, legs criss-crossed, like a kindergarten teacher about to start a lesson in the 1-2-3s of construction instead of the ABCs (fig. 107).

In the years that followed the introduction of the toy, Tyng would develop her own design for an elementary school for Bucks County, Pennsylvania, with a tetrahedral space-frame roof sheltering triangular classrooms, manipulating adult-size geometry with the same confidence she wanted to inspire in kids (fig. 108). Tyng's tetrahedrons would also appear in two buildings designed by Louis Kahn with her collaboration: the Trenton Bath House and the Yale University Art Gallery. Decades later, Tyng would say, apropos of

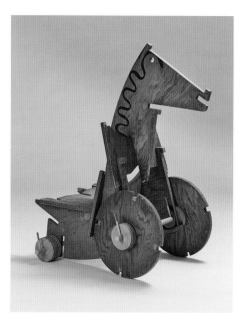

Fig. 106 Anne Tyng, Tyng Toy, 1947. Collection of William Whitaker and Shilpa Mehta. [CAT. 181]

opposite
Fig. 107 Anne Tyng with Tyng Toy, c. 1949

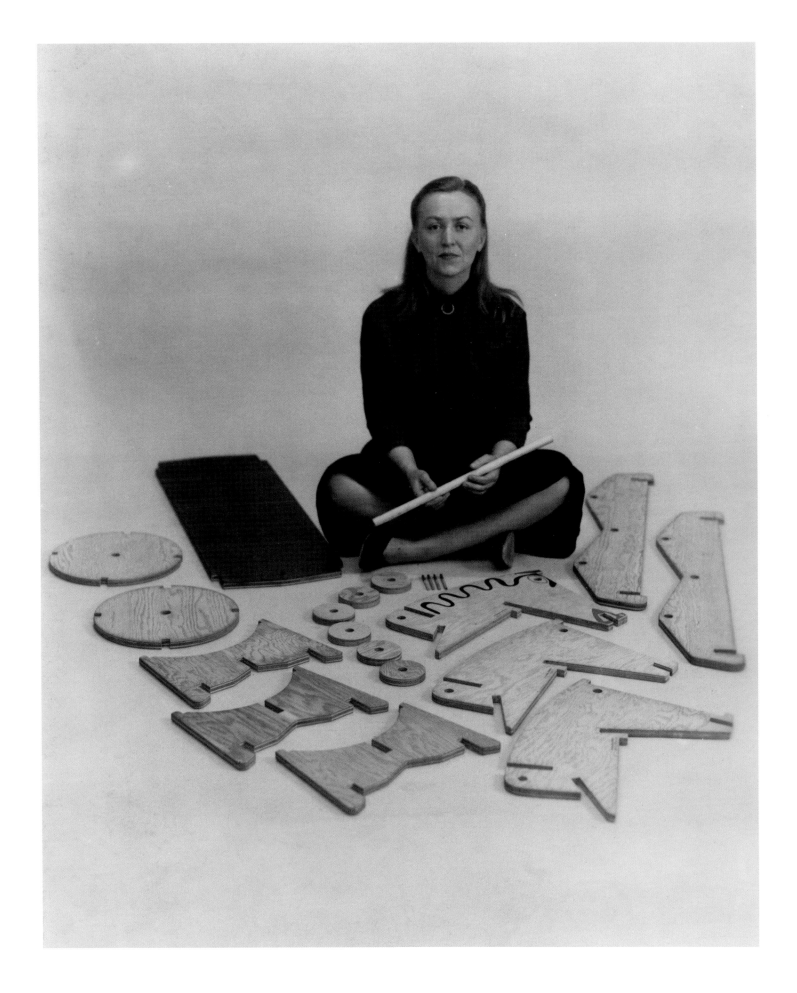

Fig. 108 Anne Tyng, model for a tetrahedral space-frame roof, 1951

starting her independent design career with a toy, "Doing something that's playful is always a great help in developing ideas."[1]

She was not alone in her thinking. The Tyng Toy, which was widely exhibited through the early 1950s, was part of a wave of architect- and designer-made toys that shrunk the process of shaping space and equipment down to child size, even as handbooks, pattern books, and furniture lines encouraged adults to get (back) in touch with their creative side. Hilde Reiss, founding curator of the Everyday Art Gallery at the Walker Art Center in Minneapolis, included the toy in a 1950 exhibition at the American Federation of Arts in Washington, DC, alongside Lincoln Logs, Tinkertoy, Erector Sets, and The Toy (see fig. 54) by Charles and Ray Eames. It was also shown at the Institute of Contemporary Art in Boston and the Children's Museum in Denver; when shown at the Children's Fair at the Walker, the *New York Times* reported that it "survived the energetic curiosity of 20,000 children."[2] America's baby boom, combined with the postwar real estate boom, created many more children to amuse and playrooms to furnish: why not kill two birds with one modernist stone? According to an article on design toys in *Progressive Architecture*, by 1965, retail toy sales exceeded $2.4 billion a year, triple the market in 1950.[3] In marketing materials, the Tyng Toy was described as something "for the whole family to enjoy . . . develop[ing] ingenuity and resourcefulness and stimulat[ing] a child's imagination to create life size equipment for work and play."[4]

As design historian Amy F. Ogata describes in her book *Designing the Creative Child*, postwar parents considered it their "responsibility" to outfit their homes with the same materials found in nursery schools, and a consensus formed around basics like beads and blocks and abstract, hardwood toys.[5] Frank Caplan (1911–1988), founder of Creative Playthings, one of the chief suppliers of such toys after 1946, defined what distributors like him were fighting against: "There is a huge flood of mechanical toys from abroad for the first time in years. Many of them are devoid of real toy value. Young children don't need gadgets. Their own imaginations are enough" (fig. 109).[6] Tyng didn't want children simply to copy her ideas, but to work out some of their own. As she wrote to the headmaster of the Oak Lane Country Day School in Philadelphia in 1950, "One aspect I fear may be lost in the commercialization of the toy is the theory that children may wish to

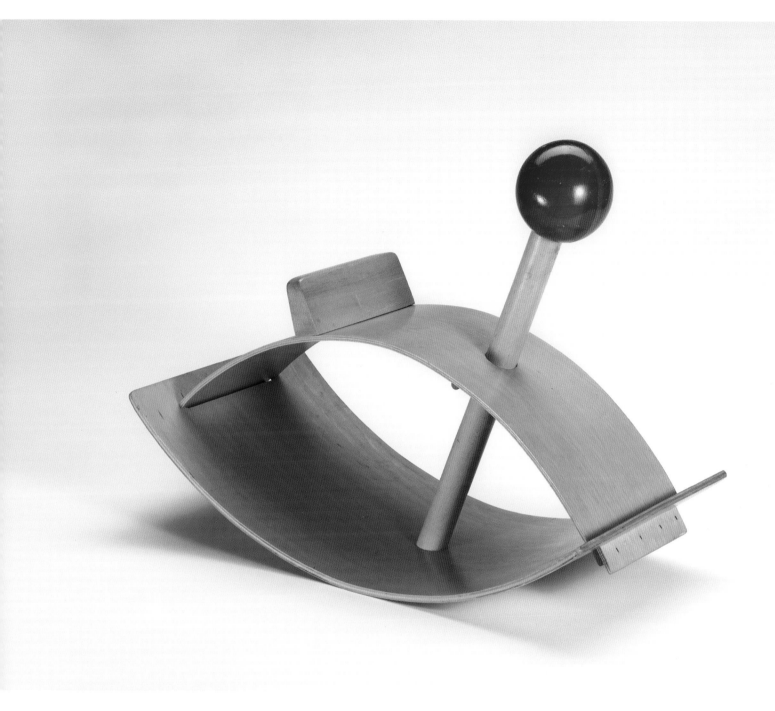

Fig. 109 Gloria Caranica, Rocking Beauty
hobby horse, for Creative Playthings,
1964–66. Collection of Jill A. Wiltse and
H. Kirk Brown III. [CAT. 50]

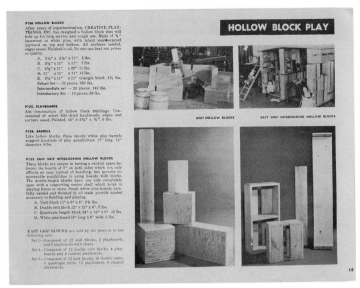

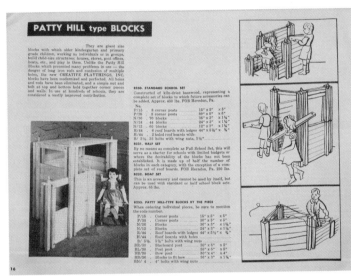

Fig. 110 Charlotte Trowbridge, *Creative Playthings: Tangibles in Early Childhood Education,* c. 1950. Milwaukee Art Museum Research Center. [CAT. 52]

Fig. 111 Frank Caplan and Martha New, Hollow Blocks, in *Creative Playthings* catalog, c. 1950. Milwaukee Art Museum Research Center

Fig. 112 Patty Hill type blocks, in *Creative Playthings* catalog, c. 1950. Milwaukee Art Museum Research Center

Fig. 113 Caroline Pratt's Unit Blocks at City and Country School, New York, photo taken between 1916 and 1921

construct imaginary objects not specifically shown. . . . This approach is really intended rather than 'how to make a chair' in three easy lessons!"[7] Although architecture and design histories have not necessarily treated products made for children with care, as curator Juliet Kinchin argues in *Century of the Child: Growing by Design, 1900–2000,* it is clear that postwar America was a time of great interest in the development of children *and* of the children's market.[8] That designers made child-size versions of objects similar to their own work is not really a surprise: like Tyng, most of them regarded work and play as intertwined.

The Tyng Toy was not a kit, but a kit of parts that, like its contemporaries, was intended for open-ended and creative play. Caplan's Creative Playthings catalogs (fig. 110) provided both summaries of the latest in thinking about early childhood education and the products for parents to follow up: "Because, in our adult-controlled world, first-hand experiences are rarely possible at an early age, we substitute meaningful play experiences," it says in the introduction to one catalog from the early 1950s.[9] No "one best way," as motion study theorists had prescribed for the prewar factory, but the child's best way, learning by manipulating the pieces. Anna Campbell Bliss, editor of a 1963 issue of *Design Quarterly* devoted to children's furniture, wrote,

> Furniture for the young child can offer more than a place to sit, eat or play. In the hands of a creative designer, it will open up new avenues for his imagination. A table may be a chair or a hiding place, a tunnel or a house. With a few simple components, the child has the beginning of a train, a boat or a slide. Well made boxes help him in learning to keep his possessions in order. They may also serve as building blocks, tables, benches or props for creative activities. A number of the designs shown here and on the following pages can be assembled or dismantled by the child at an early age, helping him to develop coordination and an understanding of how things are built.[10]

If the initial idea of the nursery had been to give children freedom of movement by removing their stuff from adult spaces, and to teach them to take care of their things by providing kid-size open shelving, giving them the means to do both simultaneously was too alluring a design problem to ignore.

Creative Playthings' paradigmatic product was the Hollow Block, designed by Frank Caplan and Martha New and introduced in the late 1940s (fig. 111). The Hollow Block was just that: an oil-finished, five-sided wooden block, ranging in size from a 5 $^1/_2$ × 5 $^1/_2$ × 11–inch brick to an 11 × 11 × 11–inch cube. Their modularity was likely inspired by two other sets of blocks designed by female educators in the early part of the century and also sold by Creative Playthings: Patty Smith Hill's (1868–1946) giant blocks (fig. 112), and Unit Blocks, designed by Caroline Pratt (1867–1954) in 1913 and familiar to most people educated in a progressive preschool (fig. 113). Pratt believed children could learn much from blocks through their tweens, starting with counting, comparing, and experiencing gravity and ending with building replica cities out of those same units.[11] But Creative Playthings' Hollow Blocks were bigger, intended for "life size" play rather than miniature play. Their dimensions held other benefits as well: though they were light enough for a small child to lift, the constructions that resulted were big enough for two or three children to inhabit and—no small thing for the parent—could be used for

storage or furniture when not in active use. Hill's earlier design of larger blocks, which combined prebuilt cubes and rectangles with planks, iron rods, and predrilled holes, were intended for cooperative play.[12] The Creative Playthings version eliminated the hardware. With one purchase, a mother could furnish the playroom with both toy and seating, easel and canvas.

Within the confines of the playroom or child's bedroom, the idea of the toy doing double duty as storage proved to be extremely appealing, and a number of designers created what is either furniture inspired by blowing up the block and hollowing it out, or a toy inspired by modular storage systems. The first such experiment was intended as a one-off, designed for the nursery of a 1923 Bauhaus exhibition house, the House am Horn, in Weimar, Germany, by Alma Siedhoff-Buscher (1899–1944), a Bauhaus student and teacher initially confined to the weaving workshop, as was typical for women.[13] Siedhoff-Buscher had a special interest in design for children, however, and designed a series of wooden toys that were successfully sold in the school's Christmas shop, an important source of institutional income. These toys included miniature theaters, spinning tops, and ship-building blocks (cubes, triangles, and trapezoids that stack into small boats and sails). Siedhoff-Buscher believed design for children could have an impact on society at large, and privileged playing with simple, colorful blocks like her own over the narrative play of fairy tales, which, she said, were "an unnecessary burden for small brains."[14] Her success with toys got her access to the furniture design studio, previously the province of men. For the nursery in Weimar, she increased the scale of her wooden

Fig. 114 Alma Siedhoff-Buscher, children's furniture, 1923

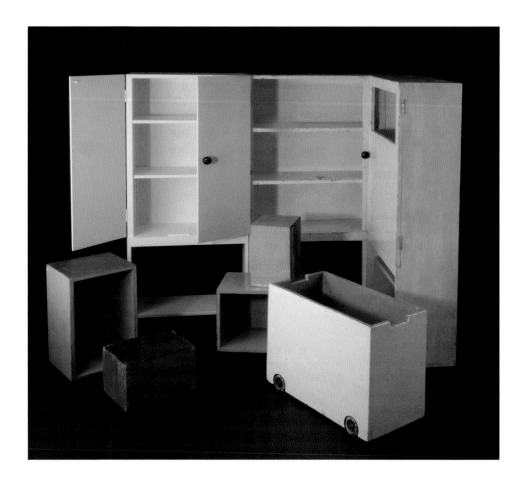

PLATE 22 CHAIR (PLYWOOD)

Figs. 115 and 116 Norman Cherner,
How to Build Children's Toys and Furniture,
first edition © 1954. Cover and plate 22.
Reproduced with permission of McGraw-
Hill Education

pieces, designing a white-painted wooden cupboard with big, black knobs, open shelves, and a series of brightly painted, open-sided boxes that could be used as tables, chairs, and carts (fig. 114). One box has wheels, and one of the doors in the cupboard has a window cut out so that it can be used as a puppet theater. The influential 1938–39 Bauhaus exhibition at the Museum of Modern Art included a number of Siedhoff-Buscher's pieces in the children's section, including the cabinet and a "commode," or changing table, that had a waist-high work surface, a pull-out tray on which to set a bathtub or take a seat, and a low table that pulled out from the center.[15] A modern child would have been able to store her blocks inside Siedhoff-Buscher's blocklike cupboard and, the Bauhaus teachers fervently hoped, install that cupboard inside one of their blocklike houses. The child's play nested neatly inside the architect's dream.

In his 1954 book *How to Build Children's Toys and Furniture,* industrial designer Norman Cherner (1920–1987) provided plans and instructions for both toys and furniture that, once an adult had cut out the pieces, a child might easily put together (fig. 115).[16] Cherner had been an instructor at the Museum of Modern Art in the late 1940s, and in this and his other books he advocated for modernist do-it-yourself homes, furniture, and toys. Today he is best known for a chair it would be impossible to make at home, the swoop-arm molded plywood chair, manufactured by Plycraft, which Norman Rockwell used for an illustration of "The Artist at Work" on a 1961 *Saturday Evening Post* cover.[17] In Cherner's books, the lines are much simpler and curves are few. A child-size chair has four pieces: rectangular back and seat, and two square sides, each with a triangular cut taken out of the bottom to create separate legs. The seat slides into notches part way down the front of the leg pieces, and the back into notches almost at the back of the top, using the same assembly system as the Tyng Toy (fig. 116). All of the outside corners are

Fig. 117 Tri-Tower play structure, c. 1964

rounded to avoid scrapes. Cherner also proposed designs for handmade building blocks and puzzles made from thin, notched pieces of wood. If he had drawn cuts in slightly different locations, the child might have been able to have a dollhouse furnished identically to her playroom.

Landscape architect Douglas Baylis (1915–1971) and his wife, artist and writer Maggie Baylis (1912–1997), are best known for inventing a new style of how-to garden writing published in magazines like *Better Homes & Gardens* and *House Beautiful,* with illustrations by Maggie.[18] They applied the same technique when creating what they termed "Play Projects" in the early 1960s: equipment built from flat, geometric shapes of wood that would challenge children's balance, agility, and strength. The Baylises envisioned at least five different structures that consumers could build, most made from combinations of trapezoidal and triangular plywood pieces: the Flying Saucer, the Tippy-totter, the Freeway, the Climbing Tower, and the Plyform (renamed the Tri-Tower) (figs. 117 and 118).[19] Although all were intended for use in both active and passive play, the most flexible was the Plyform, four nested triangles, the largest 4 feet on a side, that "can be climbed on, crawled through and sat in," as a writer for the *San Francisco Examiner* observed in a 1964 article; "Units are light enough for toddlers to take apart," the story noted, but large enough in scale to make challenging climbing structures for their older siblings.[20] In Maggie's drawings, children leap over the Tippy-totter, clamber up a ladder inside the tower, and roll trucks over the zigzag surface of the Freeway (fig. 119). At least one project, the Plyform, made the leap from concept to commerce; specifications were distributed as plans, under the name Tri-Tower, by the Douglas Fir Plywood Association (DFPA), a trade group that showed modern architecture in its advertisements to promote new uses for its product. During the same period, the DFPA also published booklets with how-tos for simple, stylish vacation homes. The Double-Deck A-Frame shown in the 1960 DFPA publication "Second Homes for Leisure Living" is not far in appearance from another Baylis children's prototype for a wooden tent, open at both ends, with a trapezoidal hatch cut into one of the sloping sides.[21] Handy parents could provide their children with a miniature version of the family's own vacation home; in either case, construction, as well as subsequent use, was seen as a wholesome leisure activity for adults.

When Eleanor Roosevelt visited Marcel Breuer's butterfly-roof House in the Museum Garden, at the Museum of Modern Art in 1949, it was precisely the multifunctional quality of the playroom's toys that caught her eye. "I particularly like the children's playroom with nothing but those hollow blocks which could be made into furniture and still remain toys," she told the *New York World-Telegram*.[22] As photographed by Ezra Stoller through an outside window, the small playroom landscape in the Breuer house is almost entirely made of Hollow Blocks, some with cushioned tops to make them serve as seating, others stacked as a side table for reading (fig. 120).[23] A carpentry set is mounted on the wall and a small loom sits on the floor, suggesting art school–like activities for children. Even the stripes on the curtains seem to echo the form of the blocks. Seventy-six percent of visitors, when polled by the museum, commented on the toys and furnishings of the playroom,[24] which included built-in wall storage with more sliding panels, albeit not the full span of the Storagewall promoted during the mid- to late 1940s by George Nelson and Henry Wright as a means of organizing the toys for the whole family (see "Playful Domesticity" in this volume; see also fig. 19).[25]

Fig. 118 Children constructing a Tri-Tower play structure, c. 1964

Fig. 119 Douglas and Maggie Baylis, Freeway Play Project rendering, c. 1964. Environmental Design Archives, University of California, Berkeley. [CAT. 39]

When Pratt and Hill had created their block sets earlier in the twentieth century, unpainted wood was considered utilitarian, but by the 1940s, the material had taken on another meaning, as modernist style. Russel Wright's American Modern furniture, manufactured by Conant Ball, had popularized blonde wood as the material of casual, contemporary living (Mary Wright was the first to call it "blonde").[26] Model nurseries designed by Gilbert Rohde and by Ilonka Karasz in the late 1920s and 1930s featured child-height shelves and child-size chairs and tables, rendered in the plainest possible materials, with only simple geometric forms as ornament (fig. 121).[27] Wipeable surfaces, including linoleum and plastic-coated wallpaper, along with furniture without nooks and crannies, were recommended for hygiene, while low and open storage was recommended as a means of giving children independence and the ability to pick up after themselves.[28] Lewis Mumford wrote of Rohde's work in the Contemporary American Industrial Art exhibition of 1934, "His nursery for children is a straightforward and intelligent application of the unit principle, and it was free from the singular adult hallucination that children like pictures of Mother Goose and Red Riding Hood on their furniture."[29] The workbenches and desks littered with model airplane parts seen in period issues of *Parents'* magazine carry the same message, as does the boys' bedroom in a 1958 *Popular Mechanics* article, "A House Full of Built-Ins," that includes a chalkboard that folds down from the wall to

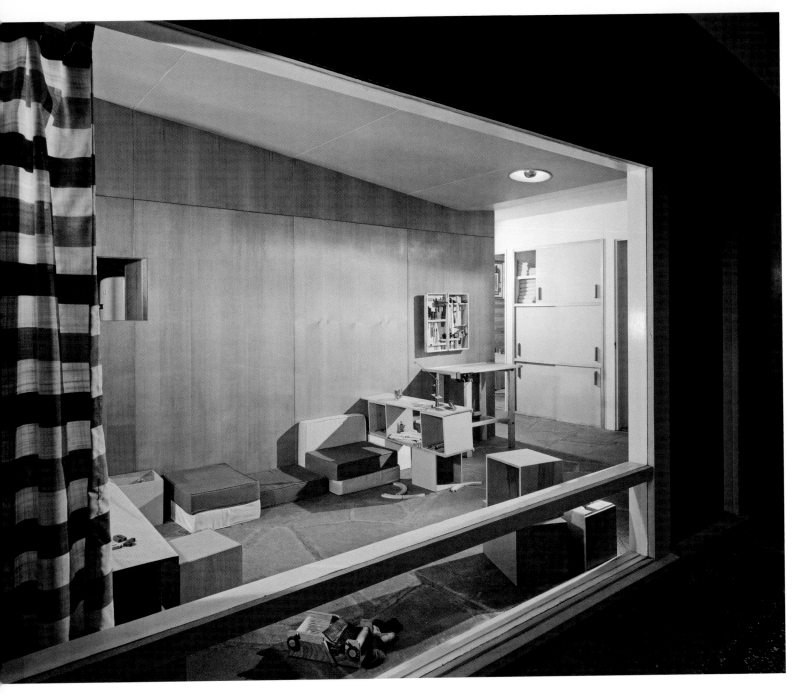

Fig. 120 Marcel Breuer, playroom in the
House in the Museum Garden, Museum
of Modern Art, New York, 1949

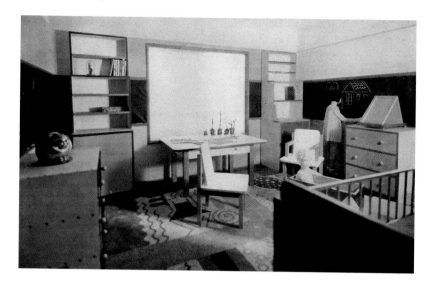
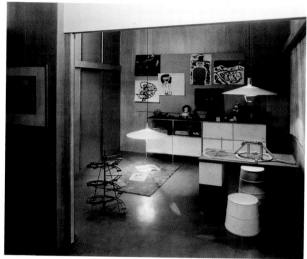

Fig. 121 Ilonka Karasz, nursery for exhibition at American Designers' Gallery, New York, 1928

Fig. 122 Gregory Ain, Woman's Home Companion Exhibition House, Museum of Modern Art, New York, 1950

become a platform for model trains (two kinds of creative play in one piece of furniture).[30] When the Museum of Modern Art built a second, lower-cost house in its garden in 1950, designed by Gregory Ain, Hollow Blocks made a repeat appearance, along with the then brand-new Eames Storage Units, shelving that went together like a construction toy (fig. 122).[31]

The designer who came closest to creating a mass-market version of Siedhoff-Buscher's 1923 suite of building-block furniture was Henry P. Glass (1911–2003), an Austrian émigré who created the award-winning Swing-Line series for the Fleetwood Furniture Company in 1951. Glass, who had worked for both Gilbert Rohde and Russel Wright, combined an interest in new materials like Masonite (from which Swing-Line's pieces were made) with ongoing explorations of the mutable in domestic design. Glass designed inflatable furniture around 1940, nesting furniture in the 1940s, and collapsible furniture in the 1940s and 1950s.[32] His children's pieces were solid, even bulky, resembling neat stacks of colored building blocks; however, unique hinged components allowed them to be manipulated like toys without falling apart.[33] The wardrobe, for example, features a shallow drawer roughly the dimensions of a 11 × 11 × 11–inch Hollow Block over a tall cupboard on one side, and another cupboard on top of a drawer on the other (CAT. 121). Pull on a pair of linear blonde wood handles on the front and the cupboards spring open, revealing dowels that attach the base to the top shelf but let the components swing free. That makes it easy for a child to access anything inside and removes crannies in which socks or stuffed animals might hide. There were low, open bookshelves (fig. 123), which could be arranged in a straight line or a zigzag, and a four-block toy chest (fig. 124). A low, round table was surrounded by four stools, each of which shared a leg with the table, allowing them to swing out for seating or swing under for storage (fig. 125). The colors were intended to make it easy for children to keep things tidy by coding which drawer was for what object.[34] In a 1951 *House Beautiful* article titled "Children's Furniture Faces the Facts of Life," those colors merited particular commendation as "the strong primary colors which children much prefer to the tender pastels beloved by dreamy-eyed mamas."[35] Glass later erroneously claimed he was the first to introduce primary colors to children's furniture, but, as design historian Carma R. Gorman has noted, Siedhoff-Buscher and Karasz were there first.[36]

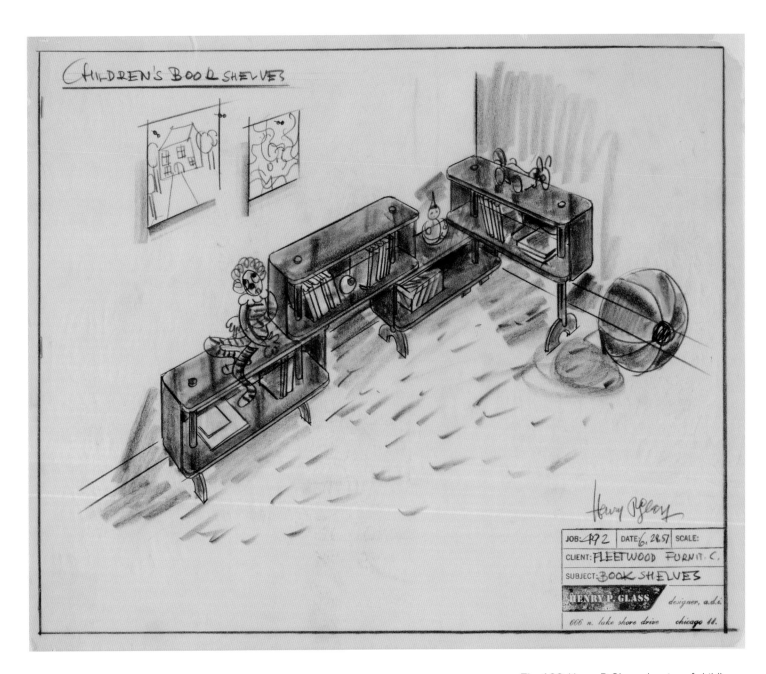

Fig. 123 Henry P. Glass, drawing of child's bookshelves, 1951. Milwaukee Art Museum. [CAT. 119]

Fig. 124 Henry P. Glass, Swing-Line toy chest for Fleetwood Furniture Company, 1952. Milwaukee Art Museum. [CAT. 120]

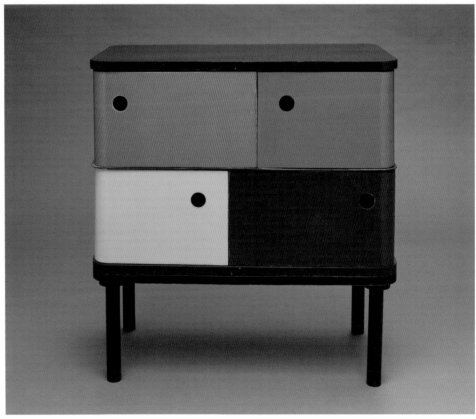

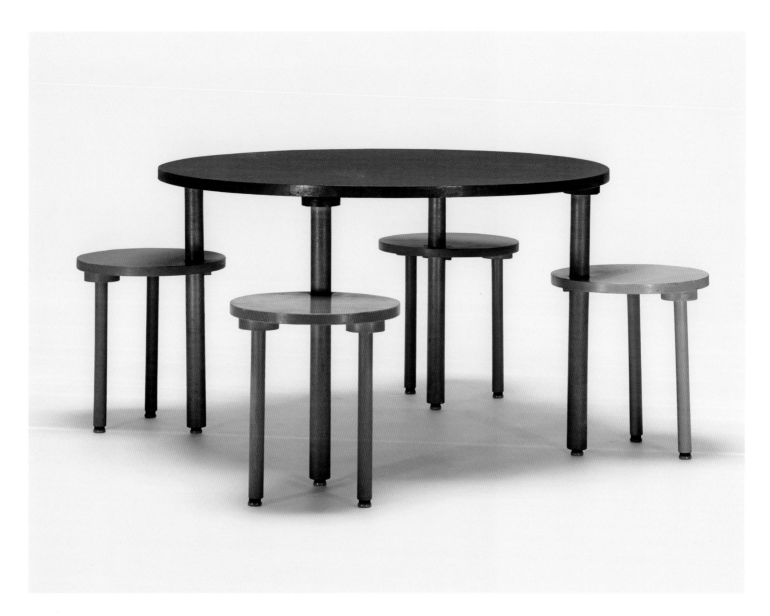

Fig. 125 Henry P. Glass, Swing-Line child's
table and stool set, for Fleetwood Furniture
Company, c. 1955. Private collection.
[CAT. 123]

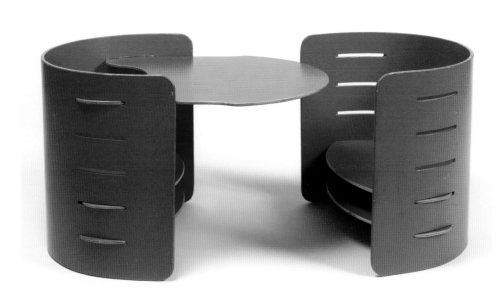

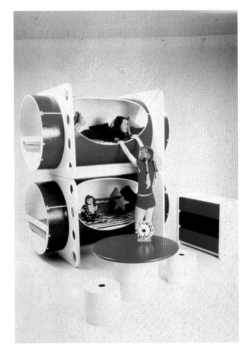

Fig. 126 Kristian Vedel, child's chair with table insert, for Ørskov & Company, c. 1957

Fig. 127 H.U.D.D.L.E., Big Toobs beds, 1972

Designs from the later 1950s and 1960s began to move away from the block form while keeping the ideas of modularity and ease of manipulation. About 1957, Kristian Vedel designed a set of seats and desks, manufactured by Ørskov & Company, that combine half-cylinders of bentwood, notched up the sides (fig. 126). Flat pieces of wood slot into those notches, allowing children to adjust the height of their seat, link two half-cylinders with a larger piece to make a table, or tip the whole thing over to make a rocking cradle or tunnel. In *Design Quarterly,* Anna Campbell Bliss uses one of the seats to illustrate her point about the "avenues for his imagination" opened by playful furniture.[37]

In 1970s California, Jim and Penny Hull founded H.U.D.D.L.E., fashioning cardboard tubes made of recycled newspapers and cardboard boxes into children's furniture that included bunk beds, a toadstool-like circular table, and cylindrical chairs. The tubes, often sold under the brand name Sonotube, were used in construction as molds for concrete columns, but the Hulls saw their potential as a lightweight and inexpensive premade structure. The Big Toobs beds were made by inserting the tubes into square wooden panels, one at each end, into which a series of smaller holes were cut to create a ladder (fig. 127). "The Hulls actually see their design as a play environment, too," wrote the *New York Times* when the set was introduced at the Design Research store on East 57th Street in Manhattan in 1972. "While some [children] crawled in and out of the double-decker tubes, calling them caves and houses, others scaled the unit to the top, straddling the upper cylinders as if they were king of the mountain."[38] Their backgrounds may have had something to do with their inventiveness: Penny Hull was then an elementary school teacher, and Jim Hull an urban designer, and they used their own children as guinea pigs.

A subset of midcentury children's furniture was inspired by nature rather than architecture, more akin to the Tinkertoy, whose branching structure suggests building at the molecular level, than blocks (fig. 128). The most fascinating of these useful toys is Richard Neagle's Bamboozler (c. 1953): a red-and-white striped wooden pole on four protruding

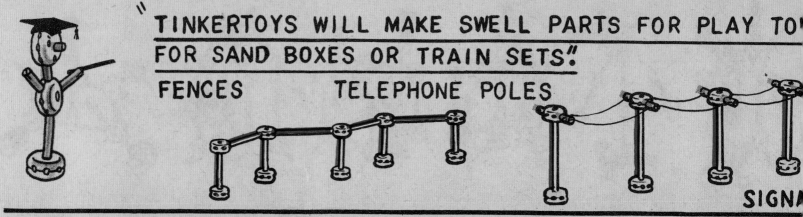

"TINKERTOYS WILL MAKE SWELL PARTS FOR PLAY TO[W]
FOR SAND BOXES OR TRAIN SETS."

FENCES TELEPHONE POLES

SIGNA[L]

ANIMALS — PULL TOYS — FURNITURE — TRAINS — BRIDGES — BUILDI[NG]

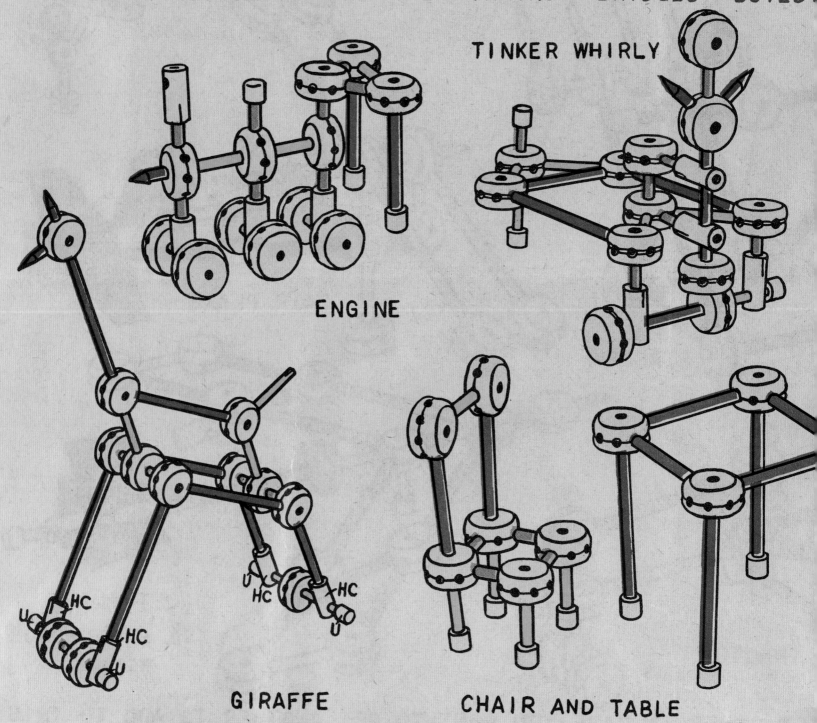

TINKER WHIRLY

ENGINE

GIRAFFE CHAIR AND TABLE

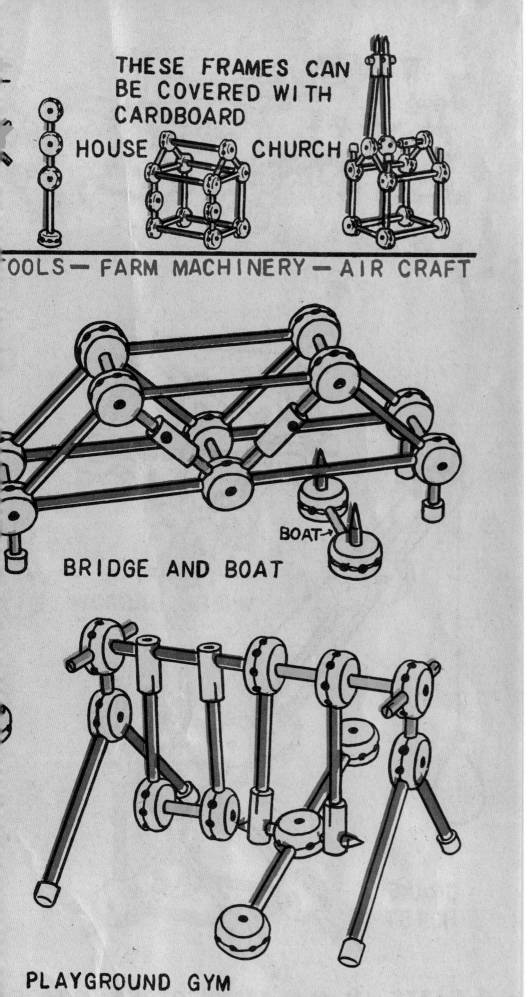

THESE FRAMES CAN BE COVERED WITH CARDBOARD

HOUSE CHURCH

TOOLS — FARM MACHINERY — AIR CRAFT

BOAT→

BRIDGE AND BOAT

PLAYGROUND GYM

Fig. 128 Instructions for Tinkertoy, A. G. Spalding and Brothers, c. 1955. [CAT. 33]

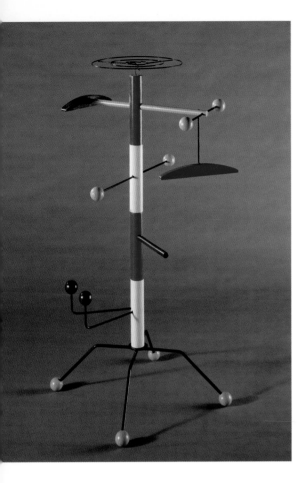

Fig. 129 Richard Neagle, The Bamboozler child's clothes tree, c. 1953. Brooklyn Museum

metal legs ending in colorfully painted balls, with branching pegs, hooks, and poles of various sizes and a set of concentric metal circles on top (fig. 129). The idea was to "bamboozle" kids into hanging up their clothes by making tidying up seem like fun.[39] If open shelving wasn't suggestive enough, trick them with space-age forms and dazzling graphics. On the practical side, it "has been carefully designed so that your range rovers will find it quite a problem to knock over," read the promotional text for the object. The balls and struts and angles are close cousins of geometric building toys, while the Bamboozler's upright carriage (just over 44 inches at its tallest point) suggests a robot companion for a kindergartner.

The Eameses' Hang-It-All (1953; see fig. 61) was premised on the same idea and used almost identical materials: a welded wire rack, made using the same techniques as those for the designers' metal-base chairs and tables, was to be screwed to the wall, with protruding pieces at three angles, which were topped with two different sizes of wooden balls, suggesting a frozen juggling act.[40] The balls on both Neagle's and the Eameses' structures would have made it easier for a child to snag a coat, while the rainbow colors on the latter suggested a game even while teaching the lesson (natural to architects) that getting organized could be fun. The ball-and-pinion structure of these made-for-children pieces was adapted from a more serious model: the atom, as seen in science classrooms and originally adapted for modern design in Irving Harper's Ball clock (see fig. 68). Incorporating atomic structure into the postwar playroom can be seen as of a piece with the constructivist toys that dominated such rooms, nudging children subconsciously toward careers in the growth industries of aerospace and construction. In the 1990s, new toys like the Hoberman Sphere and artist Michael Joaquin Grey's zoob would return to the structure of molecules for inspiration.[41]

Perhaps the most extreme example of making your whole house into the playroom is featured on the cover of Molly and Norman McGrath's cult classic *Children's Spaces* (fig. 130). That book was published in 1978 and covers "environments for the young" by fifty architects and designers. In his foreword, graphic designer Ivan Chermayeff wrote, "The not-so-extraordinary thing about children is that they are people," so in their rooms (now rebranded as "environments"),

> There must be places for heroes and heroines.
> Space to foul; room to move; soft corners to fall asleep in.
> Storage, lots of it, for incredible accumulations.
> Color and light.
> Not a classroom.
> No images that won't erase.
> No one wants to live in someone else's personal expression.
> No invasions of privacy.
> A tabula rasa, because children don't have to be reinvented.[42]

The project on the cover is the Los Angeles house of graphic designer Sheila de Bretteville and her architect husband, Peter. Made of modular steel parts, the house centers on a double-height living space with a concrete floor and glass French doors opening out onto a terrace of the same flooring material. Jason de Bretteville, then seven, can use the

Fig. 130 Molly and Norman McGrath, *Children's Spaces: 50 Architects & Designers Create Environments for the Young,* 1978

whole downstairs as a giant, constructive play yard, thanks to a set of yellow, fake leather Cohide-covered foam cushions in brick and block shapes that make a mountain in the center of the room. In quieter moments, the cushions can be belted together to form a low, sectional sofa for chatting and lounging, but most days Jason and his friends pile, stack, and tunnel through the soft blocks, creating rooms within the room, castles within the castle. The de Brettevilles were inspired to create the cushions by the feeling that "their whole house is as much their child's environment as theirs." "When Jason was very small, he pulled himself to a standing position on them," said Sheila de Bretteville. "I think making our whole environment accessible to him has caused him to be not less, but more respectful of our things as well as his own."[43]

The de Bretteville house is the last link in a chain of design experiments that began with the Haus am Horn in 1923. The child's needs have become the whole purpose of the home—the parents' workspace and sleeping area are secondary and unseen, while the playroom becomes the main event. By the time Charles and Ray Eames built their house in Pacific Palisades, California, in 1949, Charles's daughter Lucia Eames was in her late teens and never lived there full time; many of the other most famous modern houses were for the child-free. Their high-ceilinged living room, with low cushions and storage niches, was a place for the adults to play with arrangement, color, and structure. When the couple entertained, Ray, with help from Eames Office employees, set the house up as a designed sequence of visual delights, from food to flowers to furniture. Jason de Bretteville may have had less discernment but was learning how to perform the same acts of spatial imagination. Though designers' children often turn out to be designers, for most of the recipients of do-it-yourself furniture, the ability to affect the environment was intended as a way station. As anthropologist Margaret Mead explained, in a 1962 book published by the national Children's Bureau, "As creativity is essentially making something new, all those who are busy growing are naturally creative."[44] It is important, she wrote, to let the child discover for himself the relationship between things in the house. Follow the ants from the spilled sugar to figure out where their home is. Take the child to the country to find out the connection between honey, bees, and a sting. Or, in the case of toys-cum–children's furniture, figure out for yourself how it goes together, and how it might be made into something else. Make your room new every day.

NOTES

Epigraph Betty Pepis, "Children Offered a Knockdown Set," *New York Times*, February 22, 1950.

1 Anne Tyng, "Beaux Arts Complexity to Bauhaus Simplicity c. 1940s: Where Is Architecture Going Today?" (lecture, Harvard Graduate School of Design, Cambridge, MA, October 13, 2011).

2 Pepis, "Children Offered."

3 "The Child at Play in a World of Form," *Progressive Architecture* 47, no. 4 (April 1966): 191.

4 Tyng Toy brochure, c. 1950. Anne Griswold Tyng Collection, 1932–2004, Architectural Archives, University of Pennsylvania, Philadelphia.

5 Amy F. Ogata, *Designing the Creative Child: Playthings and Places in Midcentury America* (Minneapolis: University of Minnesota Press, 2013), 44.

6 Frank Caplan, quoted in Ogata, *Designing the Creative Child*, 47.

7 Anne Tyng to John Niemeyer, Oak Lane Country Day School, March 29, 1950. Anne Griswold Tyng Collection, 1932–2004.

8 Juliet Kinchin, "Hide and Seek: Remapping Modern Design and Childhood," in *Century of the Child: Growing by Design, 1900–2000*, ed. Juliet Kinchin and Aidan O'Connor (New York: Museum of Modern Art, 2012), 16.

9 Charlotte Trowbridge, *Creative Playthings: Tangibles in Early Childhood Education* catalog (New York: Creative Playthings, c. 1950), 1.

10 Anna Campbell Bliss, "Children's Furniture," *Design Quarterly* 57 (1963): 13.

11 Jeroen Staring, "Caroline Pratt: Progressive Pedagogy *In Statu Nascendi*," in "Living a Philosophy of Early Childhood Education: A Festschrift for Harriet Cuffaro," ed. Miriam Raider-Roth and Jonathan Silin, special issue, *Bank Street [College of Education] Occasional Paper Series*, no. 32 (October 2014): 46–62.

12 Karen Hewitt, "Blocks as a Tool for Learning: Historical and Contemporary Perspectives," *Young Children* (January 2001): 9.

13 Kinchin and O'Connor, *Century of the Child*, 77.

14 "Bauhaus: Modernist Toy Icons," Maammo blog; https://maammo.com/blogs/stories/bauhaus-modernist-toy-icons (accessed January 4, 2018).

15 *Bauhaus 1919–1928* master checklist, Museum of Modern Art, New York; https://www.moma.org/calendar/exhibitions/2735 (accessed January 4, 2018), 28.

16 Norman Cherner, *How to Build Children's Toys and Furniture* (New York: McGraw-Hill, 1954), pl. 22, "Chair (Plywood)."

17 "Rockwell and Cherner," Design Within Reach blog; http://blog.dwr.com/2012/08/28/rockwell-and-cherner-or-how-a-commercial-illustrator-created-a-mid-century-icon/ (accessed January 4, 2018).

18 Alison Isenberg, *Designing San Francisco: Art, Land, and Urban Renewal in the City by the Bay* (Princeton, NJ: Princeton University Press, 2017), 160–161.

19 Douglas and Maggie Baylis Collection, Collection #1999-4, Box 4. Environmental Design Archives, University of California, Berkeley.

20 Phyllis Seidkin, "It's a Tower, No It's a Boat, It's a Tent," *San Francisco Examiner*, June 7, 1964.

21 *Second Homes for Leisure Living* (Tacoma, WA: Douglas Fir Plywood Association, 1960), 10; http://www.ncmodernist.org/Second-HomesForLeisureLiving.pdf (accessed January 4, 2018).

22 Eleanor Roosevelt, "Museum Model Home Is New But Expensive," *New York World-Telegram*, June 24, 1949, quoted in Amy F. Ogata, "Creative Playthings: Educational Toys and Postwar American Culture," *Winterthur Portfolio* 39, no. 2 (Fall 2004): 151.

23 Peter Blake, *Marcel Breuer: Architect and Designer* (New York: Museum of Modern Art, 1949), 114.

24 "Modern Architecture Favored in Poll," press release, Museum of Modern Art, New York, October 11, 1949.

25 "Storage Wall," *Life*, January 22, 1945, 63–68.

26 William J. Hennessey, *Russel Wright* (Cambridge, MA: MIT Press, 1983), 31–35.

27 Ashley Brown, "Ilonka Karasz: Rediscovering a Modernist Pioneer," *Studies in the Decorative Arts* 8, no. 1 (Fall-Winter 2000–2001): 78–80.

28 Bryn Varley Hollenbeck, "Making Space for Children: The Material Culture of American Childhoods, 1900–1950" (PhD diss., University of Delaware, 2008), 52.

29 Lewis Mumford, "Memorials and Moderns," *New Yorker*, April 14, 1934, reprinted in Robert Wojtowicz, ed., *Mumford on Modern Art in the 1930s* (Berkeley: University of California Press, 2008), 120.

30 "A House Full of Built-Ins," *Popular Mechanics*, November 1958, 113–115.

31 *The Museum of Modern Art — Woman's Home Companion: Exhibition House,* Gregory Ain, architect; Joseph Johnson and Alfred Day, collaborating (New York: Museum of Modern Art, 1950), 15; https://www.moma.org/documents/moma_catalogue_2746_300062079.pdf (accessed January 4, 2018).

32 Carma R. Gorman, "Henry P. Glass and World War II," *Design Issues* 22, no. 4 (Autumn 2006): 4–20.

33 Ibid., 17.

34 Jeffrey Head, "How Things Work: The Inventions of Henry P. Glass," *Modernism* 7, no. 1 (Spring 2004): 84–86.

35 "Children's Furniture Faces the Facts of Life," *House Beautiful*, October 1951, 190, 290.

36 Gorman, "Henry P. Glass," n74.

37 Alexander von Vegesack, ed., *Kid Size: The Material World of Childhood* (Milan: Skira; Vitra Design Museum, 1997), 261; Bliss, "Children's Furniture," 12–13.

38 Rita Reif, "Instead of Ending on Scrap Heap, This Furniture Began There," *New York Times,* December 30, 1972.

39 "The Bamboozler (Child's Clothes Tree)," Richard Neagle, American, born 1922, Brooklyn Museum; https://www.brooklynmuseum.org/opencollection/objects/2161 (accessed January 4, 2018).

40 John Neuhart, Marilyn Neuhart, and Ray Eames, *Eames Design: The Work of the Office of Charles and Ray Eames* (New York: Abrams, 1995), 184.

41 Michael Joaquin Grey, interview with author, June 3, 2016.

42 Molly McGrath and Norman McGrath,

Children's Spaces: 50 Architects & Designers Create Environments for the Young (New York: William Morrow, 1978), 5.

43 Quoted in McGrath and McGrath, *Children's Spaces,* 74–76.

44 Margaret Mead, *A Creative Life for Your Children* (Washington, DC: U.S. Department of Health, Education, and Welfare, Children's Bureau, 1962), 5.

ALEXANDER GIRARD AND PLAY IN THE CORPORATE ENVIRONMENT

MONICA OBNISKI

Fig. 131 Herman Miller Textiles &
Objects shop, 1961

In response to a perceived gap in contemporary design, Alexander Girard (1907-1993) advocated for a "more human, entertaining, colorful and decorative approach."[1] This short essay will highlight two postwar corporate environments designed by the industrious Girard—the Textiles & Objects (T&O) shop (1961) for Herman Miller and the VIP lounge (1965) for the Braniff International airline—as material and visual experiments in color and whimsy that articulate his playful point of view. Herman Miller and Braniff offer two examples of how corporations engaged in serious business while also (where appropriate) using quirky—but appealing—imagery, lightheartedness, and levity.

TEXTILES & OBJECTS SHOP

Girard began his tenure with the Herman Miller Furniture Company (later Herman Miller) in 1951, and directed the textile division until his retirement in 1973. He parlayed his previous experience designing exhibitions and retail settings into an idea for an entirely new venture for the firm—Textiles & Objects, a shop in New York City.[2] Ten years of

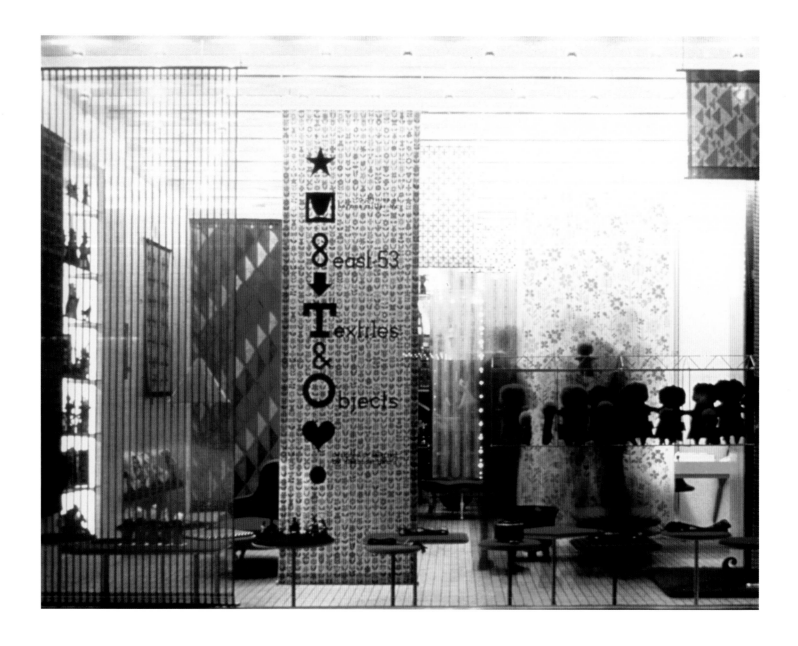

Fig. 132 Alexander Girard, window banner for Textiles & Objects, 1961. The Henry Ford

dreaming by Girard and his wife, Susan, and collaboration with Herman Miller, resulted in the opening of the T&O shop in 1961 as a place for an atypical combination of Girard-designed and Girard-sourced fabrics alongside complementary objects, including folk art found by Girard.[3] The showroom projected the image of Herman Miller as a retailer of modern design enlivened by unique handcrafted items. The legacy of the T&O shop is its contribution to Herman Miller's brand identity and its attempt to interject whimsy into the selling of modern design in the mid-twentieth century.[4]

With previous experience in showroom design for Herman Miller (in Grand Rapids, Michigan, and San Francisco [see fig. 28]) and his own modern design shop (in Grosse Pointe, Michigan), Girard understood the value of making an impression. The glass-walled storefront of the T&O shop exposed a brightly lit jewel-box interior (fig. 131). Girard hung fabric panels from the ceiling to disrupt the long, narrow space and had all the surfaces painted a glossy white to form a noncompetitive architectural framework for the fabrics and objects. Following the principles of German architectural theorist Gottfried Semper, who believed that architecture evolved from handicrafts, Girard's approach incorporated architectural ornament not simply as decoration, but as a symbolic language that embodied the visual expression of a building.[5] The textures and patterns of Girard's textiles (along with the colorful object displays) were the most important aspects of articulating the message of the space.

The window banner (fig. 132) utilized one of Girard's printed textiles, April, with silk-screened graphic lettering announcing the shop and its contents as "designed or selected by Alexander Girard." The opening announcement (fig. 133) proclaimed the T&O shop as a store that offered textiles designed by Girard and manufactured by Herman Miller alongside "unusual and sympathetic decorative objects selected by Alexander Girard."[6] Employing a palette of red, blue, and black design elements on a cream background, the text is centered, but the lines of the announcement are composed of several different colors, fonts, and sizes to produce a varied, yet legible, whole. The announcement reflects Girard's design approach—a modernist typographic structure with playful interludes, such as arrows and hearts that suggest the handcrafted. As part of a midcentury typographic revival, Girard's design (with John Neuhart's assistance) references nineteenth-century wood type through the use of ornamental typefaces.

Historian Regina Lee Blaszczyk notes that most US citizens were chromophobic until the postwar era, when colorists were employed in advertising, architecture, merchandising, and product design to combat the predisposition to muted tones.[7] Girard responded to this call by tapping into the psychological need to experience color. The "air conditioned bazaar," as the shop was called by *Interiors*, resembled a pure white box (a decidedly modernist aesthetic choice that should be understood as a historical construct)[8] into which Girard layered vibrant fabrics with charming and attractive objects.[9] Part of the concept was to interrupt the "monotony of just textiles and give it more . . . context."[10] Unlike previous Herman Miller showrooms that were laid out in room-like settings, here textiles and objects were arranged in various ways, including in a display tower, on shelving, and on low stools and benches, as well as on all-white cupboards faced with textiles. Girard designed all the fixtures—from the small details, such as the cupboard door handles, to the large steel and aluminum display tower with integrated lights (fig. 134)—reminiscent of his project for Alcoa (see fig. 30; see also "Serious Business" in this volume). He also designed the

HERMAN MILLER INC.

announces the opening

OF

Textiles & Objects

AT

8 EAST 53RD. STREET
NEW YORK CITY

a wholesale and retail shop

OFFERING

THE HERMAN MILLER COLLECTION

OF

FABRICS & TEXTILE ITEMS

Designed by Alexander Girard

UNUSUAL & SYMPATHETIC

DECORATIVE OBJECTS

Selected by Alexander Girard

OPEN FOR BUSINESS · MAY · 22ND, 1961

PLAZA 3-5106

opposite

Fig. 133 Alexander Girard and
John Neuhart, Textiles & Objects
announcement, 1961. Herman
Miller Archives. [CAT. 114]

right

Fig. 134 Interior of Textiles &
Objects, 1961

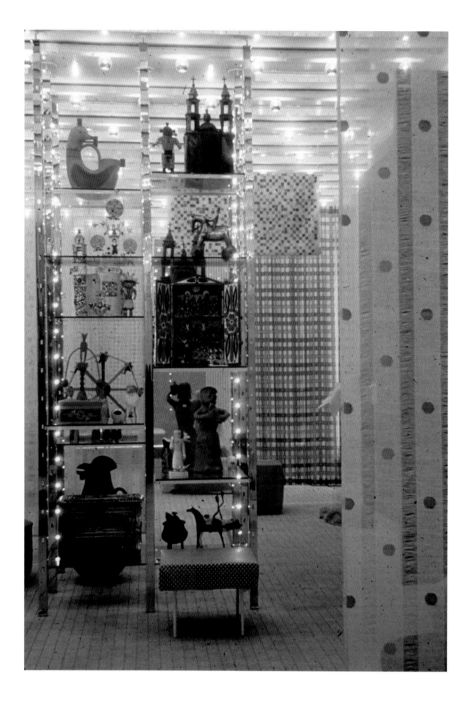

ceiling strips, which utilized a specially manufactured bulb that reflected light toward the
ceiling, helping to create a gleaming white space.

Hung in between the ceiling lighting tracks were many of the ninety-two different
fabrics, from forty-seven series, designed by Girard and manufactured by Herman Miller,
including five new fabrics (Barber Pole, Nastri, Fruit Tree, Alphabet, and Tent) introduced
to coincide with the opening of the shop. Girard proposed another way to expand the
firm's fabric business—"a collection of special 'one' or 'few of a kind' textile items of assorted
types and from assorted places" (fig. 135).[11] The company believed the showroom's
"special attraction" was that its collection of objects was selected by Girard, who was
deemed to have "good judgment and taste."[12] Herman Miller hoped to sell goods to people
whose taste, guided by Girard's curatorial choices, leaned toward interiors full of objects

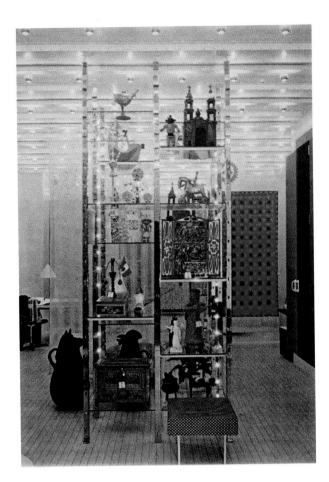

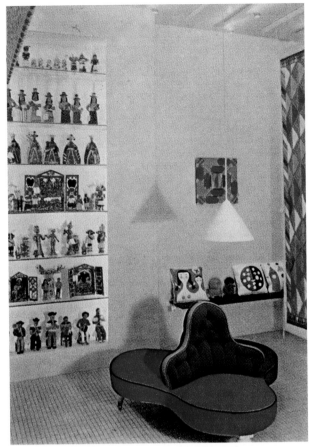

from different cultures—a propensity associated with well-known designers like Girard, the Eameses, and others. By providing a continually changing cache of such objects, Girard and Herman Miller played a role in making such interiors more readily accessible to American consumers.

Girard designed a few new lines for the shop, including a napery (tablecloths, mats, and napkins) collection in Checkerboard, Mosaic, and Cut-Out patterns on printed linen, and Mexicotton, a fabric handwoven in Mexico. He also designed mirrors[13] and an extensive range of pillows in cotton, linen, and wool as part of a proposed Herman Miller objects division, a program that would include many "useful and decorative objects for domestic or public use" (fig. 136).[14] The firm tested a few features of the program with objects that went on sale at T&O, but some objects never made it into production, including a series of screen-printed tray table prototypes (fig. 137). Girard-designed textiles (Triangles, 1952; One-Way, 1952; Small Squares, 1952; and Rain, 1953) were applied to a wooden surface, presumably as experimental samples for a tray table designed by

opposite

Fig. 135 Textiles & Objects shop in *Interiors*, July 1961

right

Fig. 136 Objects designed or selected by Alexander Girard for Textiles & Objects, 1961

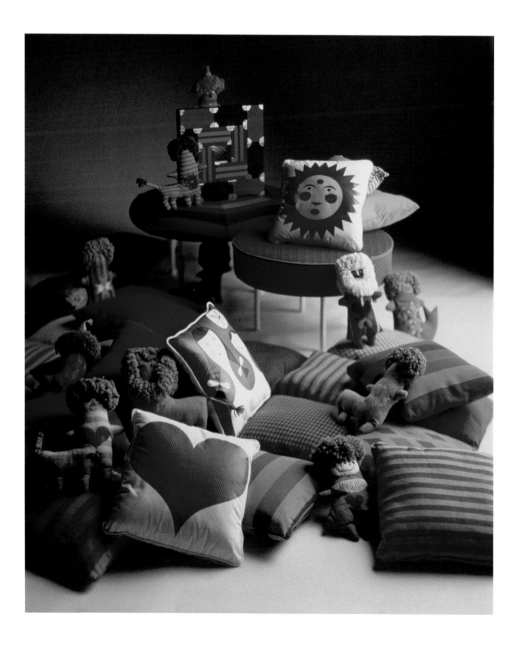

George Nelson & Associates and manufactured by Herman Miller for a few short years in the early 1960s.[15] These unique trays demonstrate product development, company innovation, and how new ideas are generated through experimentation.

Girard's viewpoint that "objects are not incidental to our lives but primary and paramount" was central to the shop's mission.[16] These objects included ceramics made in Italy by his brother Tunsi and embroidered, one-of-a-kind cloth dolls handmade by Marilyn Neuhart and sold exclusively at T&O (fig. 138). Ray Eames introduced Girard to the dolls, which Neuhart began making in the late 1950s for her family.[17] Displayed prominently in the shop's front window, Neuhart's dolls were an inspired choice to advertise the store: contemporary craft that employed a traditional toy type.

In addition to contemporary art objects, the program included folk art that was collected and assembled by Girard, who selected crafts from various parts of the world for their individuality and visual appeal. These objects were part of what Girard called "the delight department of daily use; that is, things used simply for delight."[18] These affordable bibelots could be used in one's home and enjoyed as toys or crafts. Girard's rhetoric in the company's press release proposes that "each object is unique and expresses the spontaneous imagination of the craftsman who fashioned it for his own delight and enjoyment."[19] This statement supports how Herman Miller planned to sell these disparate objects to an American public—as playful interludes to enhance interiors. One example of an object found by Girard is a sculpture made by Mexican ceramist

Fig. 137 Alexander Girard, tray table prototypes, for George Nelson & Associates, c. 1960. Milwaukee Art Museum. [CAT. 113]

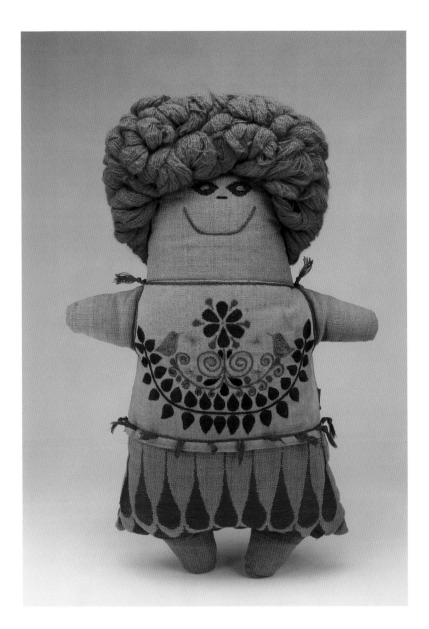

Fig. 138 Marilyn Neuhart, doll, c. 1961. Estate of Marilyn Neuhart. [CAT. 140]

Fig. 139 Teodora Blanco, female figure, c. 1965. Museum of International Folk Art, Santa Fe. [CAT. 213]

Teodora Blanco, who was born into a family of Oaxacan potters (fig. 139). Her unglazed terracotta figures ranged from small figurines to monumental sculpture. These works were framed as a "contrast against the mass produced items typically found in stores."[20] Girard remarked that "we have become so practical that anything that is not functional is overlooked as not worth the doing . . . but people buy folk art because it fills a need that is not satisfied at another level."[21] Not only were these works distinct (from mass-produced objects), but they offered a human connection to the maker. The Blanco sculpture is emblematic of Girard's approach—using handcrafted folk art as a tool for creating whimsy within a space.

The poster celebrating objects sold in the shop is a visual cacophony of many types of folk art, including toys, masks, and ceramics (fig. 140). Reflecting Girard's interest in collecting and in artful arrangements, the poster shows varied handcrafted objects neatly organized in a condensed space, similar to the carefully arranged vignettes within the white cube of the retail space. Internally, it was important for the company to brand

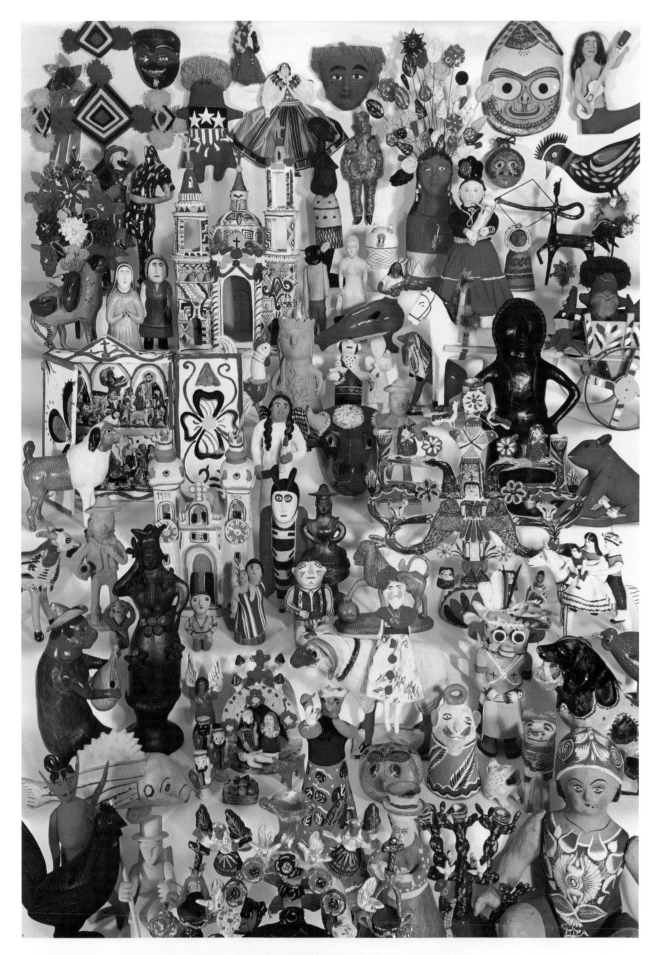

Objects selected by Alexander Girard for Herman Miller, Inc.

Textiles & Objects, 8 E. 53rd St., New York City: 555 Pacific Ave., San Francisco: 8806 Beverly Blvd., Los Angeles: 622 Merchandise Mart, Chicago: 1733 Chestnut St., Philadelphia

opposite

Fig. 140 Alexander Girard, Objects Selected by Alexander Girard for Herman Miller, Inc. poster, c. 1961. Collection of William and Annette Dorsey. [CAT. 96]

below

Fig. 141 Textiles & Objects advertisement in *Interiors*, November 1961

the folk art as "Herman Miller collections of folk art," because the composition, or "juxtaposed collection," was unique — and this was a selling point.[22] Publicly, advertisements communicated the compatibility of textiles and objects (fig. 141), as illustrated by the way the multicolored pottery church blends into the background of the vibrant textile in a 1961 magazine advertisement (the pottery church also made an appearance in figure 140). The ad cleverly incorporates textiles and objects, visually reinforcing the compatibility of these objects as part of the store's operation.

BRANIFF VIP LOUNGE

Girard designed the Braniff International VIP lounge, which incorporated gridded spaces filled with Latin American folk art, to playfully encourage close examination. The lounge mixed the luxury of jet-age air travel with whimsy suggested by the folk art and demonstrated the complex corporate identity that Braniff wished to communicate.

Braniff was a midlevel airline, conservative in its business plan and image, until Harding Lawrence led the company into an era of expansion in the 1960s. Braniff's new owners wanted the dynamic Lawrence, whom they hired away from Continental Airlines, to facilitate a rupture with the past.[23] The airline had been flying internationally to the

Caribbean, South America, and Central America since the mid-1940s, but Lawrence needed to find a "big idea" to transform the then-lackluster airline into an immediate international sensation.[24] Lawrence aspired to a distinctive image that would "add sheer beauty to the exciting technology of flight," and he hired the advertising agency Jack Tinker & Partners, with Mary Wells as creative director for the Braniff account.[25] Undertaking preliminary research for the project, Wells and her team visited airports within Braniff's system to gain greater perspective; what they saw at the facilities elicited the following impressions: "a jail, the army, a prison camp, a ghastly desert and a lot of grey people."[26] Developing out of the military complex, many airlines had not yet entered the consumer-driven modern era. Wells noticed that an important marketing tool—color—was missing from Braniff's image.

Wells's interest in creating the most stylish airline led her to the most relevant designer to deliver a "high-octane color montage of Mexican and modern"—Alexander Girard.[27] Wells was well acquainted with his work, as she had visited the restaurant he famously designed in New York City, La Fonda del Sol. She was impressed by Girard's treatment of the interior of the restaurant and with its graphic and industrial design program.

Girard was hired in 1965 and charged with fashioning a "space-age concept" and plan for everything from a new logo to terminal architecture, as part of a larger total design program.[28] The airline planned to roll out other improvements as well, including new methods for ticketing and baggage handling, improved on-time performance and more flights, enhanced food service, and a high-fashion uniform collection designed by Emilio Pucci. As part of "The End of the Plain Plane" campaign, Wells dreamed up the idea to paint the planes in seven different colors and convinced Braniff to adopt this vision as part of a new corporate identity. For the interior of the planes, Girard selected Herman Miller textiles and unconventional fabrics.

The company also sought to create a distinctive corporate identity. Thus, Girard was tasked with altering the physical appearance of everything "Braniff." Competition in postwar aviation was intense due to booming economic prosperity, which made it possible for more people to travel; cementing a recognizable public image was key to an airline's success. The airline industry understood the significance of a compelling corporate identity—the image a company presents to the public—in order to create perceivable difference for the consumer in a field that was highly regulated by the government. Girard overhauled the design of facilities, equipment, and graphics—from airplanes and lobbies to service utensils and a distinctive font (fig. 142).[29] Girard developed a typeface composed of straight and slanted letters for use on everything from Braniff planes and letterhead to posters. Beginning in the late 1950s, many designers of corporate identities used Helvetica, a new but internationally recognized typeface. To create his type, Girard drew upon some of the most popular elements of Helvetica, such as the dynamism and modernity of the crisp, clear sans serif font. But for the Braniff type (which makes an appearance at the bottom of figure 146), he distorted the shape by inclining and rounding uppercase letters, which suggested forward propulsion or jet-age speed but at the same time implied reclining airplane seats. In keeping with progressive graphic design of the period, the "BI" logo was reductive and modernist. However, the Braniff typeface is also inspired by Girard's penchant for folk art, as the all-caps font was hand-drawn and maintained a folksy, "comfortable" quality, perhaps as a way to assuage fearful passengers.[30]

Fig. 142 Alexander Girard, Braniff International plane and equipment, c. 1965

As he thought about the airline's in-terminal passenger club (its VIP lounge at Love Field in Dallas), Girard noted that passenger clubrooms had historically resembled hotel lobbies—large rooms without much privacy—so he changed this convention for Braniff. Girard created modular rooms within one large space to "break up the room into different activity areas" and to "provide privacy" for individual pursuits (working, playing cards, visiting the bar, and so forth) (fig. 143).[31] In the VIP lounge, Girard designed an open space organized by Herman Miller's Comprehensive Storage System into rational, grid-like sections (fig. 144). The brightly colored, textile-covered partitions provided passengers more privacy and allowed for intimate spaces that could accommodate furniture (also manufactured by Herman Miller). Girard inserted some of the original folk art that was quickly becoming his trademark, set within modular screens to create a harmonious, colorful, and artistic setting. Girard used three different types of fabric in this commission— Herman Miller textiles that emphasized vivid color and tactile strength; shiny, space-age vinyls and plastics; and colorful, handwoven Mexican cottons, which were chosen to "encourage people to fly to Mexico."[32] He designed the original furniture, which functioned "like a chameleon: its character remains intact yet its skin texture and color change to suit the environment" (fig. 145).[33] For the overall design, Girard preserved a low sight

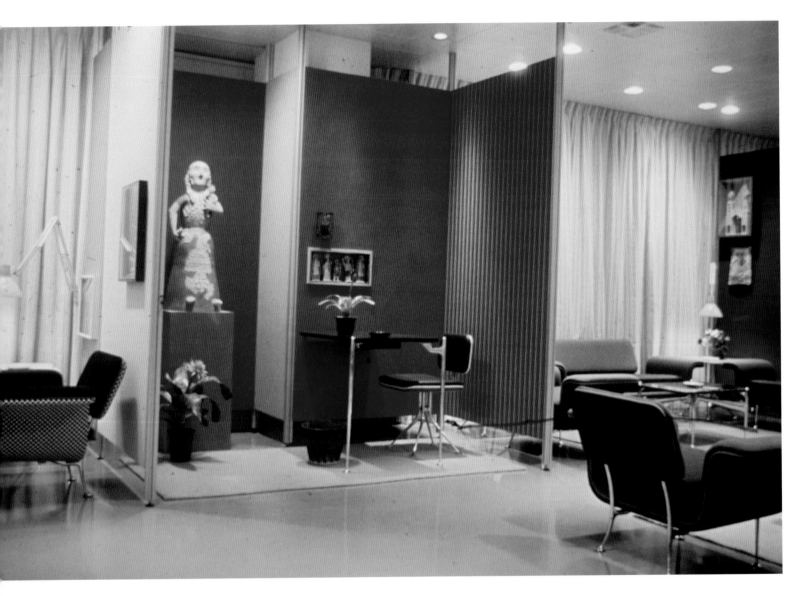

Figs. 143 and 144 Alexander Girard,
Braniff International VIP lounge, c. 1965

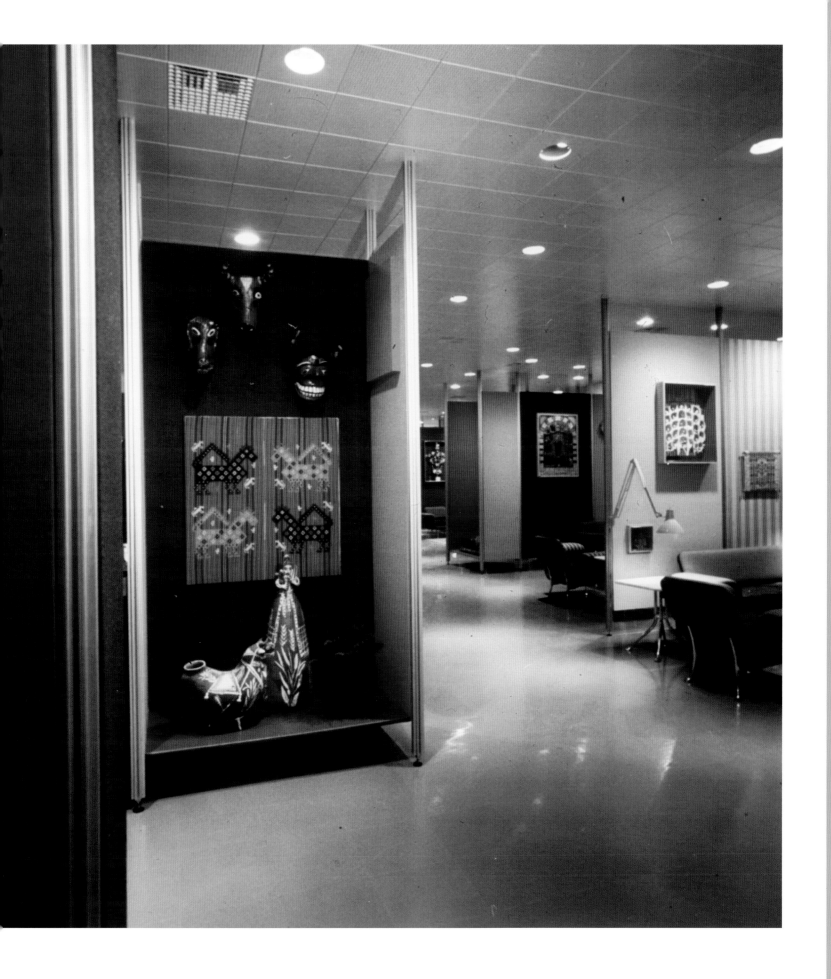

opposite

Fig. 145 Alexander Girard, armchair for Braniff International VIP lounge, c. 1965. Collection of George R. Kravis II. [CAT. 105]

right

Fig. 146 Alexander Girard, Mexico: Braniff International poster, 1968. Private collection. [CAT. 112]

line (26 inches high), which was "highly desirable in contemporary low-ceiling spaces" and created a "feeling of space and repose."[34] The rectilinear structure of the spaces within the VIP lounge provided a straight-edged backdrop for the soft, elegant chairs and sofas with rounded corners. The winglike shape of the furniture (*Progressive Architecture* called it "fly-away furniture"), in tandem with the folk art, visually alluded to airplane travel.[35]

By hiring Girard, Braniff understood that it was going to get a product that was colorful, distinctive, modern, and full of folk art. The VIP lounge demonstrated stimulating juxtapositions, with sleek machine-made furniture and industrial partitions alongside global crafts and textured surfaces. While the former spoke to the firm's commitment to modern luxury, the other indicated a more human-centered approach to travel through its suggestion of souvenirs. To reinforce Braniff's Latin American routes, Girard incorporated textiles and folk art culled from his collection of Latin American artifacts (the same objects that were pictured in the color posters advertising Latin American destinations, such as Brazil and Mexico) (fig. 146). Girard believed that folk art deserved to be seen by many, and part of his legacy is his tenacious perseverance in proposing the relevance of these artifacts by continuing to use them in his modern design projects.

In addition to his dedication to audacious color and his whimsical spirit, Girard's personal imprint was his folk art collection, which he employed to great effect for Braniff and Herman Miller to create a cohesive and playful image. For Girard, folk art ignited his creativity and was also "a way to recapture all the wonderful enthusiasm and the spirit of discovery that we experience as children."[36] In his practice, folk art functioned as more than souvenirs: these objects were valued for their design, storytelling ability, and because they kept culture alive. For both corporate environments, Girard combined designed objects with artist-crafted works, humanizing these settings and adding warmth to the white cube. When all the elements are considered—color, objects, folk art, textiles, and layout of the interiors—Girard's playfulness within corporate settings emerges as a midcentury phenomenon.

NOTES

1 Alexander Girard, "Proposed Herman Miller Objects Division," December 18, 1961, ACCN 3, Folder 15, Herman Miller Archives, Zeeland, Michigan.

2 For more information about Girard's textiles, see Susan Brown, "Alexander Girard, Textile Architect," in *Alexander Girard: A Designer's Universe*, ed. Mateo Kries and Jochen Eisenbrand (Weil am Rhein, Germany: Vitra Design Museum, 2016); for Girard's contribution to the Detroit Institute of Arts' *An Exhibition for Modern Living*, see Monica Obniski, "The Theatrical Art of Displaying 'Good Design,'" in Kries and Eisenbrand, eds., *Alexander Girard*; and for further clarification about the T&O shop, see Monica Obniski, "Selling Folk Art and Modern Design: Alexander Girard and Herman Miller's Textiles and Objects Shop (1961–1967)," *Journal of Design History* 28, no. 3 (September 2015): 254–274.

3 D. J. De Pree (then president of the firm) stated, "The occasion of 'Textiles & Objects' is a culmination of a ten-year dream of Mr. Girard and Herman Miller. Alexander and Susan Girard have put the best of their talented lives into this program. They were the first to see the value of such a showroom." D. J. De Pree letter, May 5, 1961, GITO 8, Herman Miller Archives.

4 After the T&O shop closed, Herman Miller showrooms across the United States absorbed some of the folk art, textiles, and objects in specially designated areas.

5 Gottfried Semper, *The Four Elements of Architecture and Other Writings*, trans. Harry Frances Mallgrave and Wolfgang Herrmann (Cambridge, UK: Cambridge University Press, 1989). Semper linked the four elements of architecture (hearth, platform, roof, and enclosure) to the four crafts (ceramics, masonry, wood, and textiles), of which textiles was the most important of the crafts.

6 Vitra Design Museum's archive (Weil-am-Rhein, Germany) of Alexander Girard includes drawings and sketches for this graphic material.

7 Regina Lee Blaszczyk, *The Color Revolution* (Cambridge, MA: MIT Press, in association with the Lemelson Center, Smithsonian Institution, 2012). Blaszczyk refers to David Batchelor's coining of the term "chromophobia" on page 8.

8 Brian O'Doherty, *Inside the White Cube: The Ideology of the Gallery Space* (Santa Monica, CA: Lapis, 1986).

9 "Girard's Air Conditioned Bazaar," *Interiors*, July 1961, 79.

10 Alexander Girard, interview by Mickey Friedman, transcript, November 9, 1974, ACCN 124, Herman Miller Archives.

11 Alexander Girard to Hugh De Pree (son of Herman Miller founder D. J. De Pree), February 12, 1958, ACCN 3, Folder 15, Herman Miller Archives.

12 D. J. De Pree letter, May 5, 1961.

13 Herman Miller archivist Amy Auscherman confirmed that drawings and paste-ups of Girard mirrors are located at the Henry Ford Museum for American Innovation, Dearborn, Michigan.

14 Girard, "Herman Miller Objects Division," December 18, 1961. To read more about the program, see Obniski, "Selling Folk Art," 254–274.

15 Interestingly, Max De Pree (son of Herman Miller founder D. J. De Pree) noted: "This might even fit into the Textile Division group of accessories rather than be taken on as a furniture item." This comment, alongside the timing, suggests they could have been considering this product for T&O. Max De Pree to Hugh De Pree, November 4, 1960, ACCN 292, Box 8, Folder 4, Herman Miller Archives. According to Amy Auscherman (archivist at Herman Miller), although the tray table (model 1680) was released for production in 1961, it only appeared in the 1964 price list.

16 "Policy Proposal, Herman Miller, Objects Division," November 14, 1962, T&O-03, Herman Miller Archives.

17 According to Marilyn Neuhart, she made one for Ray Eames, who said she must also make one for "Sandro" (Girard's nickname). Neuhart obliged, and Eames delivered the doll to Girard for Christmas (probably 1958). Author interview with Marilyn Neuhart, February 27, 2014, Hermosa Beach, California.

A Neuhart doll is pictured in Girard's living room by early 1959; see "Books Belong in Every Room," *House & Garden*, April 1959, 105.

18 William C. Eckenberg, "Folk Art Is Offered 'Simply for Delight,'" *New York Times*, November 27, 1962.

19 Press release, "Herman Miller's New Textiles and Objects Collection," November 3, 1962, T&O-03, Herman Miller Archives.

20 Press release from Elaine K. Sewell Public Relations for Herman Miller, "New Departure in Marketing," May 22, 1961, T&O-03, Herman Miller Archives.

21 Quoted in Eckenberg, "Folk Art Is Offered," 42.

22 "Marketing Structure, Herman Miller, Folk Arts Program," November 14, 1962, T&O-03, Herman Miller Archives.

23 An abridged history of Braniff Airways, written by Jon Kutner Jr., can be found online at the Texas State Historical Association: http://www.tshaonline.org/handbook/online/articles/epbqm (accessed January 8, 2018).

24 Mary Wells Lawrence, *A Big Life in Advertising* (New York: Knopf, 2002), 33.

25 "Airline Designs for Passengers," *Progressive Architecture* 47, no. 3 (March 1966): 176. After she married Harding Lawrence, she became known as Mary Wells Lawrence.

26 Lawrence, *Big Life in Advertising*, 34.

27 Ibid.

28 "Alexander Girard: Pacesetter of Design," Public Relations Department, Braniff International, Dallas, Texas. General Aviation Collection, McDermott Library, University of Texas, Dallas.

29 "Color Sets Style, Spirit of Braniff International Approach for Air Travel," History of Aviation Collection, University of Texas, Dallas.

30 The author would like to thank Marcia Lausen for her observations about the connections between Girard's graphic design and folk art.

31 "Suggested Remarks by Alexander Girard in the Braniff Club," History of Aviation Collection, University of Texas, Dallas.

32 Ibid.

33 Alexander Girard, "Girard Group
Statement," March 10, 1967, GIF 6,
Herman Miller Archives.
34 Ibid.
35 "Airline Designs for Passengers," 179.
36 Charles Lockwood, "A Perfectionist
at Play," *Connoisseur*, January 1983, 98.

THE PLAY PRINCIPLE

PAUL RAND AND GRAPHIC DESIGN

STEVEN HELLER

No matter how serious the intent of any project, a designer must inevitably begin with the freedom of unfettered exploration; let's call that play. Play is a key element of surprise, and audiences love surprises. When it comes to graphic design, in particular, play underpins and increases its significance as mass communication and popular culture. "Without play, there would be no Picasso." Paul Rand (1914–1996), the influential American advertising, poster, and logo designer, said this in a 1990 interview (with me) about what he dubbed "The Play Instinct." "Without play, there is no experimentation."[1] He added that without experimentation, there is no "quest for answers." Whether working in painting or typography, an artist must continually search for answers to a wide range of problems, including how to have an intimate connection with the receiver of the message: the audience. Synonymous with exploration and invention, play is the power that facilitates this desired relationship between maker and user in surprising and memorable ways (fig. 147).

Rand was a passionate and joyous member of the generation of postwar modern designers who elevated graphic design from a methodical service to an expressively methodical art. From the mid-1940s through the 1960s, the modernists imbued advertising and products, periodicals and books, with a *je ne c'est quoi*, a personal flair that provided the eye- and mind-grabbing powers of attraction—the force to pull audiences directly into a message (fig. 148). Though sometimes seen as a slave to a product message, graphic design is more than routinized hawking and selling through predictable typefaces and staid images. There has long been an element of wit and humor in graphic design; it dates back to before the turn of the twentieth century, when the discipline began as an adjunct to printing, but it was sporadic until the early to mid-twentieth century, when modernism brought to the fore the work of a new crop of dedicated professional designers who believed graphic design's mission was to make the world both a better and happier place in which to live. Play has played no small role in this goal. In his essay "Design and the Play Instinct," Rand espoused Gilbert Highet's assertion that the "best Renaissance teachers, instead of beating their pupils, spurred them on by a number of appeals to the play-principle. They made games out of the chore of learning difficult subjects."[2]

Any graphic designer who says that play is not an essential aspect of the design process is telling a big fat lie. How can anyone so involved in the analog or digital practice of cutting, pasting, and composing letters, pictures, shapes, and patterns reject play as a fundamental behavior? Certainly, designers want to be taken seriously by business and the public, but pointing out that design involves play is not intended to belittle the creative conceiver/producer of printed material that surrounds us every day in every corner of our material world. Graphic design is not a rote activity made on a production line but a series of trials and errors derived from playful investigation.

Bringing order to chaos is, strictly speaking, the definition of design. But the truth is that without play, design is a tight blueprint. Of course, blueprints, templates, schematics, and other guidelines are necessary when designing corporate identities and branding systems. Yet before these graphic standards are carved into tablets, first comes play—a foray into the unknown and unbiased. Design begins as a tabula rasa (fig. 149).

Following rules rarely produces originality; experimentation is essential (even if it fails). Play enters unknown territory. Rand was talking about innovation when he said that "it is the driving force of the creative spirit," but he could just as easily have been expressing

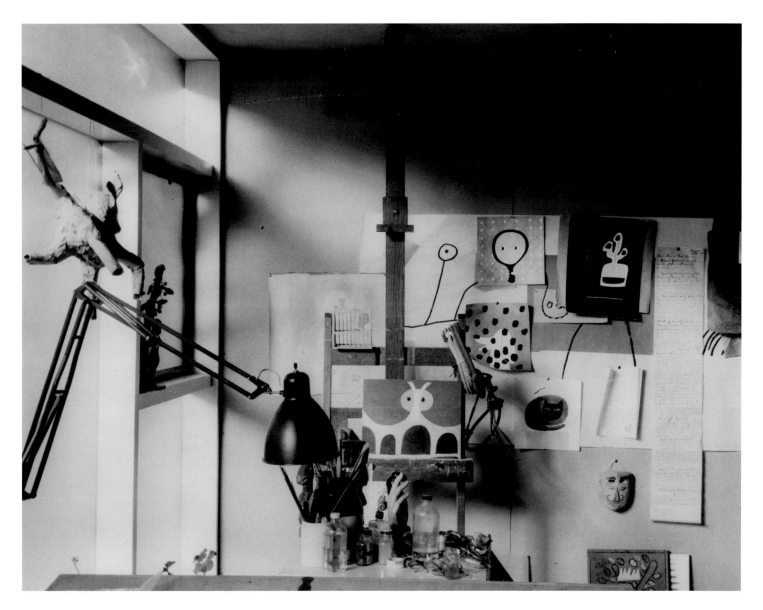

Fig. 147 Paul Rand's studio,
Weston, Connecticut, date unknown.
Photograph by Hans Namuth

subway posters score

24 hours a day
they never miss

Paul Rand

opposite

Fig. 148 Paul Rand, Subway Posters Score, 1947. Collection of Merrill C. Berman. [CAT. 153]

above

Fig. 149 Paul Rand, cover of *IBM Logo Guidelines*, c. 1990

his thoughts about play. "[It] is sensitive to change and the changeless," he continued. "It focuses not only on what is right, but on what is exceptional."[3]

Play is a gateway behavior. It defines children as children, but many adults engage in serious play, too. Professionals in many fields—musicians, actors, artists, and athletes—depend on play. Play and work only appear to be natural dichotomies. The virtuoso and maestro do not reach their levels of expertise through intuitive play alone—or do they? Tinkering, which is another form of play, leads to invention and revelation; in graphic design, playing (in the form of sketching, cutting and pasting, rendering, iterating) is that essential first step toward decision-making. Playing yields the foundation of the idea, which is the crucial outcome of any playful experience.

"I use the term play," Rand explained, "but I mean coping with the problems of form and content, weighing relationships, establishing priorities. Every problem of form and content is different, which dictates that the rules of the game are different too." That said, Rand and others do not engage in play "unwittingly." It is endemic to the design process, and whether it's called play or some other term, "one just does it," he said.[4]

A graphic designer, like any artist or craftsperson, is free to play indefinitely, but the process must have an end point. The role of what is imprecisely known as commercial art (as distinguished from fine art) is to convey and clarify information of various types, using image, typography, and layout as the means. On this playing field, the goal is an idea; and an idea is a combination of visuals and words that resonates with the receiver. Regardless of how artful the outcome is—how much stylish veneer is applied to the final result—graphic design's purpose is to foster understanding. If in the end this is ignored, the design has failed.

It is said that play is a means to an end, the foundation for stronger concepts, never an end in itself. Yet even this rule has exceptions. There are designers, for instance, who may mistake play for something more deliberately formal or tried and true. "The visual message camouflaged as profound or luxurious often boomerangs as mere snobbery and pomposity," Rand warned, noting that when play leads to self-consciousness, it is doomed.[5] His rule of thumb was always simple: "I like things that are happy; I like things that will make the client smile."[6] One role of design is to make consumers feel better about what they consume.

Rand was one among many, but his work provides a valuable example of the "play instinct." Sometimes play is on the surface. In Rand's case, his advertisements and package designs for El Producto cigars, the ones that integrate comic drawings with straight-forward photographs of the product (the cigar), typify his approach (figs. 150 and 151). Sigmund Freud is quoted as observing that "sometimes a cigar is just a cigar." It is not clear that Freud did, in fact, utter these words, but it is a fact that after playing with a few unsatisfying ideas, Rand took the cigar photos and added cartoon drawings of arms, legs, shoes, hats, and so forth that made each one into a particular character, representing all kinds of people—from clowns and kings to laborers and gentlemen.

Rand's approach did not distort or dismiss the product or make it cute, but retained its realism while adding personalities to the inanimate objects. Rand used these cleverly supplemented images in newspaper ads to create a weekly serial or situational comedy starring the variously sized and shaped cigars interacting with one another. Although this was not a child-appropriate product, Rand's lighthearted approach made the campaign

UCTO

he way to a

nan's heart...

Fig. 150 Paul Rand, El Producto, The Way to a Man's Heart, 1953–57. Collection of Merrill C. Berman. [CAT. 162]

opposite

Fig. 151 Paul Rand, El Producto, For Your King of Hearts, 1953–57. Collection of Merrill C. Berman. [CAT. 159]

above

Fig. 152 Paul Rand, El Producto, 25 Bouquet, 1953–57. Collection of Steven Heller. [CAT. 156]

into a comic fantasy world. He engaged the audience in a narrative that, like the best children's stories, increased their anticipation for what came next. This approach extended from the weekly newspaper advertisements to special holiday packaging (fig. 152) adorned with carnivalesque colors and patterns in the shape of cigars. The long-running campaign was a radical departure from stereotypical, formulaic cigar promotion laden with decorative Victorian typefaces and detailed chromolithographic art. This departure was influenced by modern artists like Paul Klee and Joan Miró (fig. 153), who rejected conventionally accepted representational art in favor of a highly tuned and energized, if purposefully naive, abandon.

Fig. 153 Bradbury Thompson, cover
for *Westvaco Inspirations for Printers* 200,
with illustration by Joan Miró, 1955

The common critique of modern art during the 1950s and 1960s was "my five-year-old could have done this." Ha! Could a five-year-old develop a series of playful scenarios that so captivated the consuming public? Although Rand and others of his ilk, designers like Bradbury Thompson (known for giving typefaces distinctive voices), Alvin Lustig, Saul Bass, Leo Lionni (fig. 154), Seymour Chwast, Milton Glaser, Cipe Pineles, and more may have borrowed aspects of their art and design language from children—in truth, they may have never grown up—they still understood how to adapt, transform, and ultimately use these aspects to make complex statements accessible. They understood that rather than blindly accepting the academic rigor of ultraformal art and design, there were other more primal, expressive ways of making images and words jump off the page and into the hearts and minds of audiences.

"There is no creative aspect of graphic design more enjoyable or rewarding than the indulgence in play," Bradbury Thompson wrote in his monograph, "and there are scholarly sources from which to learn more about 'the art of play.' But one must first resolve to provide the time in which to have fun and to record the ideas that will come one's way."[7] Thompson's own design demanded play, and in his own practice he allowed his children to help conceive layouts for his signature publication, *Westvaco Inspirations*, which was devoted to showing other designers how a sense of serious tomfoolery could imbue the printed pages with what can best be described as youthful energy (fig. 155). "The play

there was little yellow!

Happily they hugged each other

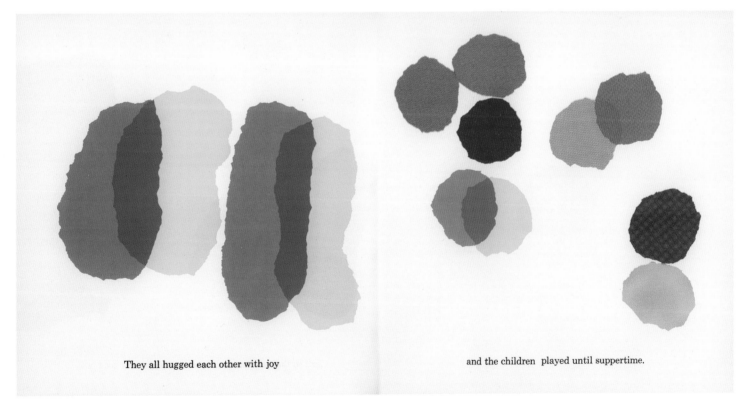

They all hugged each other with joy

and the children played until suppertime.

Fig. 154 Leo Lionni, *Little Blue and Little Yellow*, 1959. Private collection. Used by permission of Alfred A. Knopf. [CAT. 139]

WINK

Quick as a wink,
a typeface can express the
creative mood and spirit of a
photographic idea printed
on fine paper.

Printed by letterpress
on Sterling Letterpress Enamel,
25 x 38-80.

Photograph: Somoroff.
Magazine: *Look*.
Publisher: Cowles Magazines, Inc.
Art Director: Allen Hurlburt.
Engraving: Four-color process, 120 line screen.

4184

WESTVACO

4185

Sunday, September

97

Central Park Mall

All Star Show

PM

Interfaith Day

Vincent R Dmpellitteri, mayor. Harry Hershfield, chairman. Sponsored by Interfaith Movement Inc.

opposite

Fig. 156 Paul Rand, Interfaith Day: Sunday, September 27, 1953. Collection of Merrill C. Berman. [CAT. 155]

below

Fig. 157 Paul Rand, advertisement for Westinghouse, c. 1963

experience was as enriching for the designer as it was vital for the children, who often became collaborators in the process," he added.[8]

Milton Glaser said that "Rand was not like other designers."His play was deliberate but never forced. "Every shape, every element, whether it was cut out of paper or drawn with pen and brush was perfectly executed."[9] Glaser implied that Rand's technical skill and ecstatic spirit were in complete sync. This is exemplified by the series of posters Rand designed for Interfaith Day ceremonies, which, instead of being predictably conservative announcements for the Interfaith Movement in New York, were veritable rays of graphic sunlight. The posters he designed had all the necessary information—time, place, and date—but also were enlivened by expressive shapes and bright hues, as well as impressions of an angel tooting a horn and a jolly little rooster made from roughly cut paper (fig. 156). While his typography was composed with care, his exuberant imagery conveyed a sense of optimism.

Even when Rand was directing design standards for major corporations, like IBM, Westinghouse, and UPS, he never stifled his instinct to make merry—to use playful tools, like rebuses and puzzles, to his advantage. The ribbon atop the UPS logo was done for the joy of it.[10] The more consequential the job, the more unhitched he was to conventional practice. For a serious focus on Westinghouse's undersea technology, he fashioned an exaggerated fish from a photograph of a submersible device (fig. 157).

Fig. 158 Paul Rand, advertisement for *Architectural Forum,* 1945

Fig. 159 Paul Rand, cover for *Jazzways* magazine, 1946

Surprise is power. In a series of advertisements for *Architectural Forum*, not known as a witty magazine, he created a menagerie of graphical animals—a seal balancing drafting tools, a parrot sitting on a hammer, a frog leaping from a box, a fish flying in the air—made from geometric and amorphous shapes, brightly colored and radiant (fig. 158). They were unexpected, yet born of intention: the intention to capture the imagination, to announce that even in precisionist manmade architecture there is natural play.

I once believed modernists marched lockstep to the rigors of the International Style, a Swiss-originated, Bauhaus-inspired view that design should be clear, simple, and unambiguous.[11] From my near-sighted perspective, I saw this style as a rejection of play and improvisation. I was so wrong. Although there are decided similarities between works by and styles of, say, Rand, Lester Beall, Walter Allner, and Herbert Bayer, among his contemporaries, there are significant differences in how they each played with the graphic elements and solved the design problems they were tasked to address. It was clear through the juxtaposition of pictures and words, the colors and overlays, geometries and abstractions, that each of these modernists was playing a variant of visual jazz (fig. 159)—and what is jazz but playful improvisation?

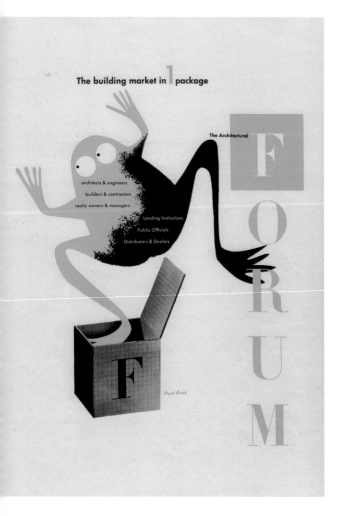

NOTES

1 Steven Heller, "Paul Rand: The Play Instinct," in Steven Heller and Gail Anderson, *Graphic Wit: The Art of Humor in Design* (New York: Watson-Guptill, 1991), 122.

2 Gilbert Highet, *The Art of Teaching* (New York: Knopf, 1950), 194; cited by Paul Rand, "Design and the Play Instinct," in *Education of Vision,* ed. Gyorgy Kepes (New York: George Braziller, 1965), 156.

3 Paul Rand, *Design, Form, and Chaos* (New Haven, CT: Yale University Press, 1993), 146.

4 Heller, "Paul Rand," 122.

5 Paul Rand, *Thoughts on Design* (New York: Wittenborn, Schultz, 1951), 29.

6 Paul Rand, lecture (Cooper Union, New York, October 3, 1996).

7 Bradbury Thompson, *The Art of Graphic Design* (New Haven, CT: Yale University Press, 1988), 52.

8 Ibid., 49.

9 Conversation with the author, 2016.

10 See Heller, "Paul Rand," 123–124.

11 See Steven Heller and Greg D'Onofrio, *The Moderns: Midcentury American Graphic Design* (New York: Abrams, 2017).

SERIOUS BUSINESS

THE WONDERFUL, IMAGINATIVE SPIRIT OF ALCOA'S FORECAST PROGRAM

DARRIN ALFRED

Fig. 160 Herbert Matter, advertisement for Alcoa Forecast, 1956. [CAT. 26]

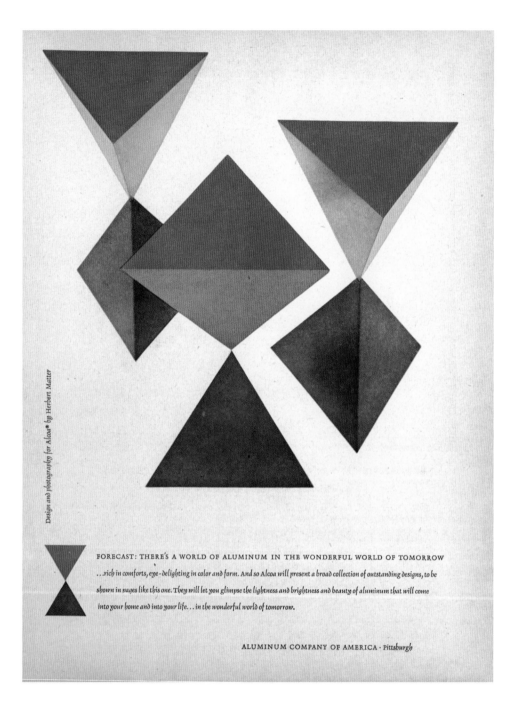

In October 1956, a curious advertisement appeared in several national magazines. It illustrated a three-dimensional interpretation by designer Herbert Matter of Aluminum Company of America's double-triangle symbol. The brief text said: "Forecast: There's a world of aluminum in the wonderful world of tomorrow . . . rich in comforts, eye-delighting in color and form. And so Alcoa will present a broad collection of outstanding designs, to be shown in pages like this one. They will let you glimpse the lightness and brightness and beauty of aluminum that will come into your home and into your life . . . in the wonderful world of tomorrow" (fig. 160).[1] Thus was born Alcoa's Forecast Program, one of several ways in which the company proclaimed its oft-repeated opinion that much of the company's future was in the hands of the designer and, at the same time, expressed its core belief that creativity should be unrestrained and unburdened.

By the mid-1950s, no one in the aluminum industry needed to be told that design had become a vital tool in the competitive race among aluminum suppliers. At the beginning of the decade, the supply of aluminum had caught up with demand and the three biggest producers — Alcoa, Reynolds, and Kaiser — were attempting to develop new product categories and increase their market shares. For the first time, but in different ways, all three directed resources toward design departments and speculative design thinking.[2] Through design, the companies hoped to influence purchasers of aluminum and aluminum products and, of course, increase sales. Alcoa, the biggest of the three, developed an imaginative advertising and promotional program in which leading designers fostered a forward-thinking vision for aluminum to their colleagues and the consuming public: "a design program . . . that puts dream thinking to a new and serious purpose."[3]

Forecast's objective was to investigate new applications of aluminum rooted in home and family life and to report the findings of those investigations so that they would be helpful to others. In announcing the program, Frederick J. Close, the company's manager of market development, said: "Alcoa regards Forecast as a unique opportunity to make significant contributions to our way of life."[4] To achieve that purpose, Alcoa, through the advertising agency Ketchum, MacLeod & Grove, asked more than twenty leading designers between 1956 and 1960 to create a visually captivating prototype that employed one or more of aluminum's many forms in ways that exploited and demonstrated the advantages of the metal. The designers were asked to provide not a product to manufacture but an intriguing concept — for housewares to home furnishings and packaging to playthings — that would generate original, unhindered thinking in others.[5] What Forecast sought was a picture of trends, directions, and possibilities. The results, ranging from the serious to the lighthearted, were captured by prominent photographers for full-page advertisements in nationally distributed magazines, such as *U.S. News & World Report*, *Time*, *Newsweek*, the *New Yorker*, and the *Saturday Evening Post*, as well as design publications, including *Arts & Architecture* and *Industrial Design*.

The second Forecast advertisement appeared as a double-page spread in November and December 1956 and became an immediate sensation. The American model Suzy Parker, whose career reached its peak during the 1950s, posed in an evening gown designed by the French couturier Jean Dessès. Dessès used twenty-eight yards of a shimmering chiffon-soft apricot-gold fabric — made of plastic-laminated aluminum thread — to create the shirred-torso gown with swirling skirt. Richard Avedon photographed Parker posing at the entrance to a chic Parisian restaurant and before the Eiffel Tower (fig. 161). The gown, which was widely exhibited in department stores and at trade shows, was seen by an estimated 100 million people and heightened women's interest in the program.[6]

The Dessès gown was followed by two decorative objects before the program moved into a more product-oriented phase. Ilonka Karasz used aluminum foil to create a wall mosaic that was intended as a decorative focal point in the home. The Hungarian-born artist and designer, known for her brilliant wallpapers, selected bits and pieces of everyday foils, including gift wrapping and candy wrappers. Some were used in their original colors and textures; others were painted or patterned by Karasz. Working entirely with irregular quadrangles and triangles, Karasz assembled the individual pieces into a spectacular wall covering that glittered against a background of heavy-gauge gunmetal foil. "Our tomorrow will be like our today," she said. "Only the surfaces will be different."[7]

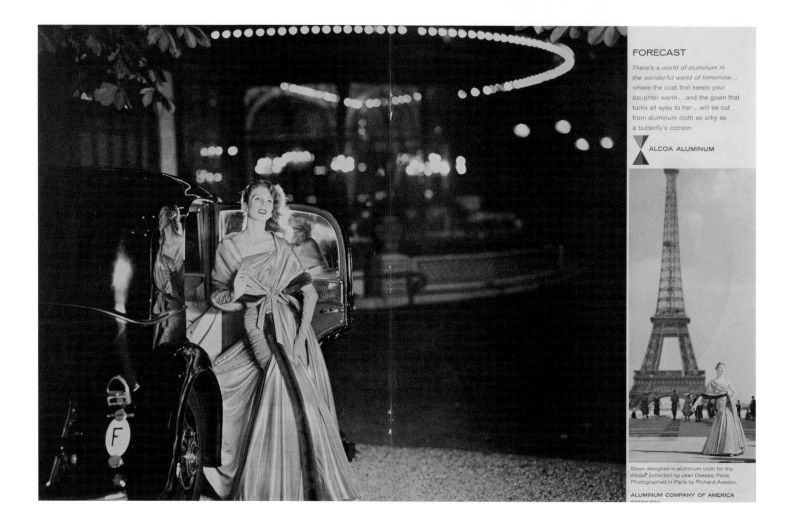

FORECAST

There's a world of aluminum in the wonderful world of tomorrow... where the coat that keeps your daughter warm...and the gown that turns all eyes to her...will be cut from aluminum cloth as silky as a butterfly's cocoon.

▼ ALCOA ALUMINUM

Gown designed in aluminum cloth for the Alcoa® collection by Jean Desses, Paris. Photographed in Paris by Richard Avedon.

ALUMINUM COMPANY OF AMERICA

Fig. 161 Alcoa Forecast advertisement featuring Jean Dessès's gown, 1956. Photographed by Richard Avedon

opposite

Fig. 162 Alcoa Forecast advertisement featuring Marianne Strengell's rug, 1957. Photographed by Leslie Gill. [CAT. 24]

The Finnish-born textile designer Marianne Strengell created a rug woven almost entirely of aluminum thread. Strengell, who collaborated with many prominent architects and designers—including Eero Saarinen on the textiles for General Motors Technical Center—employed her vast expertise in weaving to create a richly colored and textured rug (cat. 11). More than thirty shades of metallic yarn, stranded into nineteen color combinations of Strengell's design, were woven into the approximately 12 × 6-foot work of art.[8] Strengell combined the aluminum thread with wool and viscose for the weft; jute formed the warp. The thick, striped, glimmering rug maintained the brilliant color of the aluminum with the combined softness and texture of the handwoven. Strengell, who often experimented with combinations of synthetic and natural materials, was initially appalled by the slickness of the metallic fibers, but accepted the challenge of working with such an unconventional material.[9] Without consulting a preparatory sketch, as she had characteristically done in the past, Strengell took advantage of the commission to just play and have fun. "It turned out really quite wonderful," she later observed. "It was subtle and it was sturdy, and it draped."[10] For its Forecast advertisement, Strengell's rug was photographed by Leslie Gill cascading over a Chinese-style table alongside a decorative Asian figurine holding a bouquet of flowers (fig. 162). As Barbara Paris Gifford and Leslie S. Edwards have argued, the advertisement conveyed that "the owner of the rug was well travelled and sophisticated, yet down-to-earth and approachable."[11]

FORECAST

There's a world of aluminum in the wonderful world of tomorrow . . . where rugs of aluminum yarn, strong and whisper soft . . . will warm your feet . . . and bring to your floors, year after year, the fabulous colors of sunlight falling through a window of stained glass.

ALCOA ALUMINUM

Rug designed in aluminum yarns for the Alcoa collection by Marianne Strengell. Photographed by Leslie Gill.

ALUMINUM COMPANY OF AMERICA · Pittsburgh

THE LANDSCAPE IN THE LIVING ROOM

No designer was more fascinated with displaying objects in whimsically arranged settings than Alexander Girard. Girard recognized that the "stark" contemporary home, with its spacious, light-filled interiors and open floor plans, was not the generous container it once was. "One thing you had to say for the old four-level house: spatially, it was a more than adequate container. . . . To turn it inside out would have been like emptying the bottomless pockets of some prodigious child."[12] Girard did not mourn the old days. The new ways of living forced many to become more selective and to display what they once concealed. Girard considered this when in 1956 he designed a freestanding aluminum shelving unit for Forecast where "beautiful things will find their perfect setting in endlessly variable interiors of aluminum."[13] The grid-like display system was constructed of an extruded aluminum frame. Its slender, modular components could be easily moved and reassembled into various configurations. Four aluminum posts formed a single shelving unit that stood 8 feet high. Additional pairs of posts could be added to create one continuous storage wall, a corner unit, or a cross (see fig. 30). Thin aluminum and glass shelves could be easily raised or lowered. Textured and anodized aluminum panels could be intermittently fastened to all sides of the framework for decorative or structural purposes. "The divider was devised to not only partition off a room, but also separate layers of vertical space . . . an open receptacle for the orderly arrangement of art works," according to Girard. "Its relationship to these works is exactly as the relationship of a good frame to a good painting."[14] Within Girard's display system, individual objects, each in a sense a piece of sculpture, could be playfully arranged and appreciated from all angles while still maintaining an orderly and unified whole.

Like the possessions on Girard's shelving unit, Isamu Noguchi's origami-inspired sectional tables for Forecast could be appreciated individually or in arrangements "as endless as the patterns of a kaleidoscope."[15] The Japanese-American artist had learned the art of origami as a child in Japan and delighted in bringing a flat sheet of paper to life in three dimensions. "Paper is fascinating because it is workable in ways that other materials are not," Noguchi stated. "Aluminum has that workability. I think sometimes of aluminum as metallic paper. It is the nearest thing to paper on a permanent basis."[16] Noguchi was introduced to Alcoa executives by his friend, the lighting designer Edison Price, who in the late 1950s provided Noguchi with access to sheet aluminum and the machines to bend it. Noguchi respected the flexibility and sculptural qualities inherent in sheet metal. Noguchi's hexagonal tables were constructed out of three diamond-shaped sections of scored and folded sheet aluminum (fig. 163). Each interchangeable section, whose shape was reminiscent of Alcoa's triangular symbol, was intended to be enameled or anodized in different colors. The lightweight tables could have functioned as a modular play system for adults (or children), easily moved into endless arrangements in a kaleidoscope of colors. Irving Penn photographed one table for the advertisement. Placed on the table were a glass of wine, fruit, nuts, bread, and a single rose: the accoutrements for a relaxing, leisurely lifestyle that was newly possible in the postwar era (fig. 164).

In 1957, Alcoa commissioned Paul McCobb to design an entire collection of aluminum furniture that included chairs, an ottoman, a couch, a bed, tables, and a stereo console. McCobb's playful takes on traditional forms would transform the midcentury interior. In particular, the designer's mass-produced and moderately priced furniture fulfilled the

Fig. 163 Isamu Noguchi, Alcoa Forecast Program tables, 1957. Carnegie Museum of Art, Pittsburgh. [CAT. 9]

Fig. 164 Alcoa Forecast advertisement featuring Isamu Noguchi's tables, 1957. Photographed by Irving Penn. Collection of Edgar Orlaineta. [CAT. 28]

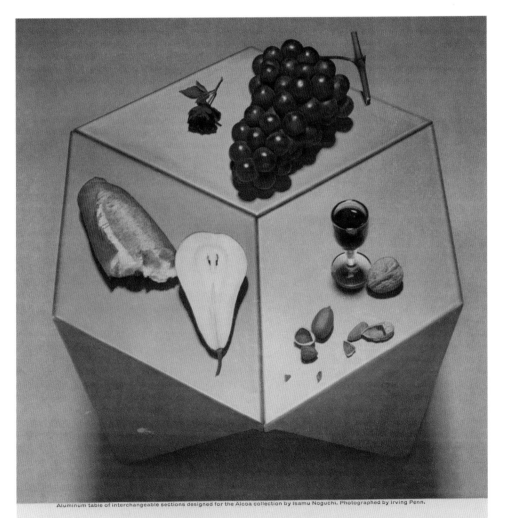

Aluminum table of interchangeable sections designed for the Alcoa collection by Isamu Noguchi. Photographed by Irving Penn.

FORECAST: THERE'S A WORLD OF ALUMINUM IN THE WONDERFUL WORLD OF TOMORROW

...where you will style rooms to your whim of the moment...using sectional aluminum furniture of myriad

textures, colors, finishes and forms...in arrangements as endless as the patterns of a kaleidoscope.

ALCOA ALUMINUM ▲ Aluminum Company of America, Pittsburgh

desires of "young married couples who admired the new 'modern' style, but could not afford its then high prices."[17] A master in the use of new materials, McCobb was enthusiastic about employing aluminum to create his elegant, yet spare, furniture. He stated that "an aluminum chair leg 1/2-inch thick will do the job requiring a wooden leg 1 1/4-inch thick, thus permitting a delicate grace impossible with wood."[18] According to McCobb, aluminum permitted an ease of fabrication that other materials did not, and provided color where it had not been previously available or practical. Supported by splayed cast aluminum legs, McCobb's chairs for Forecast were a natural development of shapes and forms he had been working with and that he felt were identifiably "McCobb."[19] The chairs were photographed by Harold Becker and Irwin Horowitz for the advertisement with a white dove with wings spread, a playful nod to the chairs' graceful, lightweight qualities (fig. 165).

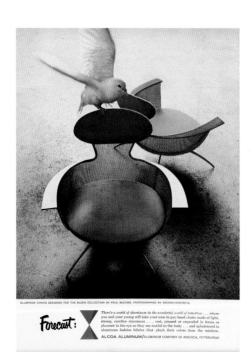

Fig. 165 Alcoa Forecast advertisement featuring Paul McCobb's chairs, 1957. Photographed by Becker-Horowitz. [CAT. 16]

Fig. 166 Alcoa Forecast advertisement featuring Lester Beall's Music Sphere, 1959. Photographed by Richard Rutledge. Collection of Edgar Orlaineta. [CAT. 29]

Fig. 167 Alcoa Forecast advertisement featuring Gene Tepper's game table, chairs, and chess pieces, 1960. Photographed by Albert Gommi. [CAT. 25]

FORECAST: *There's a world of aluminum in the wonderful world of tomorrow* . . . where you will furnish your home for elegant fun with aluminum . . . aluminum that takes so many colors and shapes it turns a table and chairs into an endlessly versatile game center . . . aluminum that can be enameled, brushed, anodized, cast, forged, stamped or extruded in as many moods as there are moves on a chessboard. Aluminum Company of America, Pittsburgh.

CAST ALUMINUM GAME TABLE AND CHAIRS DESIGNED FOR THE ALCOA COLLECTION BY GENE TEPPER. PHOTOGRAPHED BY ALBERT GOMMI.

ALCOA ALUMINUM
ALUMINUM COMPANY OF AMERICA

The American home also became an entertainment zone, not only a place to impress guests with displays of good taste. Lester Beall's Forecast Music Sphere signaled the arrival of in-home high-fidelity stereo systems and displayed the post-Sputnik spirit of the times (fig. 166). Beall's design was an aluminum sphere 3 feet in diameter mounted on a pole that rose from a four-legged base. The globe was composed of two concentric hemispheres. The outer hemisphere rotated to expose the turntable and amplifier controls. It was topped by two telescoping rods, each supporting a cone speaker. The rods could be collapsed or extended and spread apart for true stereophonic effect. The bass speaker was located beneath the turntable. Nothing about the external appearance of existing stereo systems resembled Beall's Music Sphere. Most were concealed within large consoles, displayed on the shelves of storage walls, or disguised within cabinets. Beall's device shimmered like an abstract sculpture and suggested the wondrous world of stereophonic sound that it controlled.

Gene Tepper's game table and chairs were meant to accommodate families who took delight in the rattling of dice, shuffling of cards, or participating in any other game that required seated concentration (fig. 167). Tepper's experimentation in form and investigation

opposite

Fig. 168 Gene Tepper, sketches for Alcoa Forecast game table, c. 1960. Collection of Steve Cabella, Modern i Shop. [CAT. 12]

below

Fig. 169 Harley Earl with Alcoa Forecast packaging designs, c. 1958

of new applications for aluminum, however, made this game table like no other. Sketches convey an array of folds and transitions between the tabletop's varying surfaces, as well as numerous options for its base (fig. 168). Tepper's final design consisted of a multi-planed, compartmentalized tabletop cast in aluminum as a single unit and was one of the most complex castings for a piece of furniture at the time.[20] Its varying levels separated the playing surface from the spaces typically set aside for spare game pieces, cocktail glasses, and elbows. There were three aluminum game boards for playing chess, Chinese checkers, and Go; the reversible checkerboard had a green felt surface for playing cards. When properly housed, the three boards would rest in a niche and lie even with the table-top; beneath was a storage area. The chairs' low backrests reflected Tepper's observation that players display the tendency to continuously lean forward during games. Tepper also designed the chess pieces for his game table, each carved from wood and then set on an anodized aluminum base.

THE BREAKOUT FROM THE KITCHEN

As the dividing lines between the kitchen and the rest of the home became less rigid, food preparation and serving pieces became portable and often combined both aspects into one.[21] Even packaging looked good enough to leave out in plain sight. Harley Earl Associates of Detroit designed a set of aluminum packaging concepts for Forecast that were, according to the *Pittsburgh Post-Gazette*, "As acceptable on the dining table as on the pantry shelf."[22] Made from a poly-foil laminate, the containers came in playful shapes and bright metallic colors meant to attract the consumer's attention (fig. 169).

Hors d'oeuvre tree with arrangeable components, salad service and electric casseroles, all of aluminum, designed for the Alcoa collection by Don Wallance. Photographed by Becker-Horowitz.

FORECAST: THERE'S A WORLD OF ALUMINUM IN THE WONDERFUL WORLD OF TOMORROW...where the loveliest pieces on your festive table will be aluminum ...gay and colorful aluminum...anodized, or porcelainized, or brushed to satiny richness...aluminum tableware so versatile you will cook in it, serve in it, and create table arrangements as original as a Gauguin canvas. Aluminum Company of America, Pittsburgh.

ALCOA ALUMINUM

Drum-shaped containers of varying dimensions were intended to store dry products, such as coffee and flour. Their fluted surfaces of contrasting colors resembled a circus tent. A group of modular pyramidal packages nested to form a cube. Pull-tab, tear-string, or perforated openings provided access to products like cheese or butter. Simple pinched tubes with pull-out spouts could store a variety of liquids. Spun-aluminum pressure packages dispensed liquid through a push-button nozzle. Shaped like a flattened ball, the vessels were designed to be easily held and squeezed.

In a letter to Oscar Shefler at Ketchum, MacLeod & Grove, the industrial designer Don Wallance declared, "A table setting is more than an arrangement for conveniently serving food. It should provide opportunity for decoration, gaiety, and personal expression."[23] In 1957, Wallance contributed a coordinated group of aluminum cook-and-serve ware to Forecast. Designed for table or buffet use, the Forecast Buffet Group consisted of two electric casseroles, a salad service, and an hors d'oeuvre tree (fig. 170). As Wallance wrote to Shefler, "The trend towards cooking and serving from the same utensil has created a need for colorful, attractive cookware."[24] The two-quart and three-quart casseroles had a blue porcelain enamel exterior finish, easily removable hinged covers, and heating elements that were integrally cast into the bottoms, permitting complete immersion and cleaning in water. The salad service consisted of a bowl with a porcelain enamel interior surface and a polished aluminum exterior, in addition to serving utensils of polished aluminum. The most artistic component was the hors d'oeuvre tree, a whimsical do-it-yourself centerpiece and serving unit that could be arranged in multiple ways. Its brightly anodized, multicolored components provided a flexible way of serving hors d'oeuvres, condiments, and relishes. According to Wallance, the modular components could be "assembled with the ease of a 'Tinkertoy'" and offered endless opportunities for arrangements that could be "simple or complex, vertical or horizontal" (fig. 171).[25]

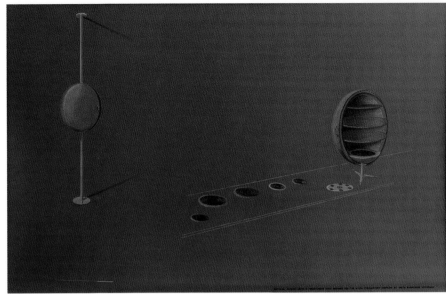

Fig. 172 Portable oven designed by Greta Magnusson Grossman, c. 1957. Photographed by Bernard Gray, Albert Gommi Studios

Fig. 173 Greta Magnusson Grossman, drawing for individual cooking units and freestanding oven, c. 1957. Estate of Greta Magnusson Grossman, R & Company, New York. [CAT. 8]

opposite
Fig. 174 Alcoa Forecast advertisement featuring Harrison & Abramovitz's summer house, 1957. Photographed by Bert Stern. [CAT. 31]

Greta Magnusson Grossman designed a freestanding, portable oven that was "as streamlined as a satellite" (fig. 172). According to "Forecast: Aluminum and the Breakout from the Kitchen," the aluminum oven's marketing brochure, "there is a growing tendency for the cook and the hostess to be the same person, some of the appliances now stationed in the kitchen are going to be adapted to more and more peripatetic patterns of entertaining."[26] Grossman's oven consisted of two rotating hemispheres of spun aluminum—one hemisphere set inside another—that housed aluminum wire shelves.[27] Aimed at the housewife (and hostess), Grossman's oven could be operated directly at the table or carried out of the kitchen to where dinner was to be served—in the living room, poolside, on the patio, or in the recreation room. The same cast aluminum handle employed for opening the oven was used to carry it. Its aluminum exterior could be anodized in several colors to match the kitchen and to make it easy to clean. The oven was photographed on its tetrapod base, but an early drawing by Grossman (fig. 173), as well as an illustration in the *Los Angeles Examiner*, render the oven supported on a pole.[28] According to one cheeky review in 1959, "You can stand it right next to the martinis and not appreciably affect their temperature."[29]

LIVING WHERE THE FUN IS

The first of the Forecast designs to display the art of the architect was a 700-square-foot summer house designed by Robert Fitzpatrick (fig. 174). Alcoa advertising executives acknowledged that "Americans, with even more leisure time than they have today, will devote as much care to the design of their summer residence as they now do to the design of the year-round dwellings."[30] In 1953, Fitzpatrick joined the architectural firm Harrison & Abramovitz, which had designed, among other structures, Alcoa's thirty-story, aluminum-clad headquarters in Pittsburgh.[31] When Alcoa commissioned the firm to design a dwelling suitable for rest and recreation, Harrison & Abramovitz conducted a competition among its staff. Fitzpatrick's winning proposal was a luminous structure of glass and aluminum, which literally rotated—like a merry-go-round—to follow or escape

**FORECAST: There's a world of
aluminum in the wonderful world of tomorrow . . .**
where you will pass your leisure hours at beach
or mountain with all the comforts of home . . .
in a summer house made of aluminum . . . roofed, walled
and screened with aluminum to turn the sun
and welcome the breeze . . . and take any shape or color
to suit the landscape that wears it like a crown jewel.

ALCOA ALUMINUM Aluminum Company of America, Pittsburgh

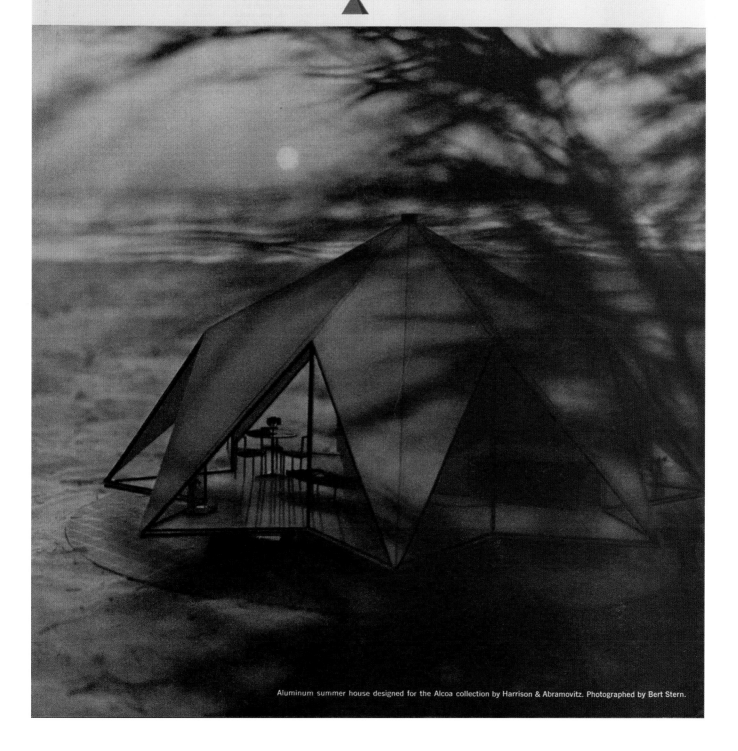

Aluminum summer house designed for the Alcoa collection by Harrison & Abramovitz. Photographed by Bert Stern.

Fig. 175 Alcoa Forecast advertisement featuring John Matthias's View Box, 1959. Photographed by Ted Castle. [CAT. 20]

the sun and alter views as its occupants chose. Fitzpatrick wanted the summer dwelling or year-round home to be "an exciting experience" that would "exploit aluminum to its utmost capacity."[32] Built around a central aluminum column, the beach house featured a peaked aluminum roof and glass walls that swung open to provide access to the outdoors. Its floor plan, in the form of an eight-pointed star, depicted a modern, open-concept dwelling.

The summer house was unveiled as a half-scale model at an Alcoa-organized display of aluminum consumer goods at Macy's New York flagship store, called "Live Light with Aluminum . . . It's Summer." The *New Yorker* described the "gleaming affair" for its readers:

> There is no doubt, the entire "Live Light" exhibit seemed to be saying, that in some special way aluminum is involved with our future. . . . The designers (Harrison & Abramovitz) of the Alcoa beach house—a miniature, in the middle of the floor, constructed on the comparatively generous scale of one-half actual size—seemed to feel that the genius of aluminum lay in its playfulness. The beach house was starfish-shaped, and hinges on the windows showed that they folded up into triangles. The furniture within (by Paul McCobb) suggested mushrooms. . . . The effect was charming, though the residents might have to stoop a little in the corners.[33]

John Matthias, an architect known for a series of experimental houses built in Southern California and the San Francisco Bay Area, designed an 8 × 16 × 16–foot aluminum structure for those who preferred something less permanent than Fitzpatrick's beach house.[34] Unveiled at the 1959 San Francisco Home Show, the demountable and moveable Forecast View Box was composed of weather-resistant structural aluminum channels with simple slide-in joints in 4-foot modules (fig. 175). A kit of parts intended for open-ended composition, the View Box could be used as a playhouse, pool shelter, or guest house; a beach cottage or hunting lodge; a refreshment stand or even a civil defense housing shelter. The unassembled package could be carried by two people and put together by a "woman and a six-year-old child" with ease.[35] The shelter sat on adjustable supports and could be placed anywhere without permanently disturbing the view or site. Side panels could swing, pivot, or stay put and be made of numerous materials. A kind of downsized, generic version of the Eames House, Matthias's View Box provided "a sense of shelter, but little sense of enclosure," and was designed for the nomadic outdoors-loving postwar family.[36]

Chicago industrial designer and architect Henry P. Glass contributed the most portable of all the aluminum shelters to Forecast.[37] Known for his knockdown, foldup furniture designs (Alexandra Lange discusses his experiences, in addition to the colorful Swing-Line children's furniture, in her contribution to this publication), Glass designed for Alcoa a collapsible aluminum and plastic trailer called the Accordium Camp Trailer (fig. 176).[38]

The Accordium was described as "a mobile living enclosure that opens out to a volume of seven hundred cubic feet. It can be folded down to less than one-third that volume, in which condition it can be hauled behind an automobile on its own two wheels."[39] By means of bellows-like sections, the portable shelter operated like the familiar squeeze-box.[40] When fanned open, the unit formed a semicircle measuring 18 feet in diameter. It provided

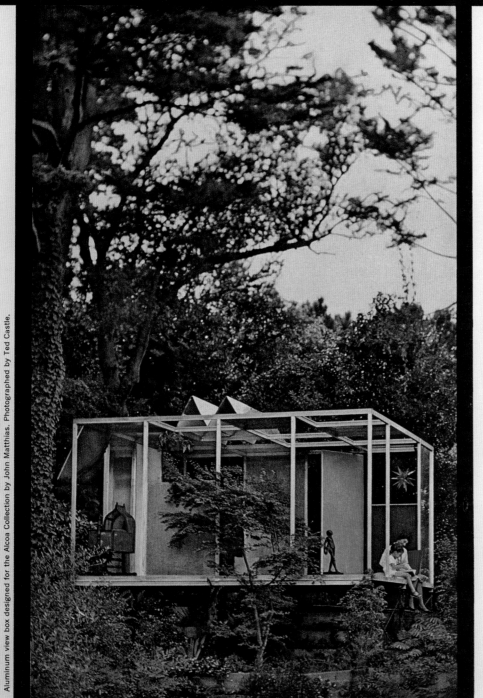

Aluminum view box designed for the Alcoa Collection by John Matthias. Photographed by Ted Castle.

FORECAST:

**There's a world
of aluminum
in the wonderful
world of tomorrow**
. . . where any place that
beckons on mountainside,
meadow or shore will
become your sheltered
retreat . . . because
aluminum will travel with
you . . . standard shapes of
light, strong, weatherproof
aluminum that become
airy, expansible shelters
as kind to the landscape
as sunlight . . . as portable
as the tents of the Arabs.
Aluminum Company
of America, Pittsburgh

 ALCOA ALUMINUM

six pie-shaped sleeping areas, each about 3 feet wide at the outer edge.[41] Squeezed together, to 4 feet wide, the "rolling delight" rode jauntily down the highway. Even Glass's toylike scale model was collapsible (fig. 177). The two swing-around aluminum panels that formed the "front" of the Accordium were teeming with camping conveniences, such as a compartmented storage area for supplies and a fold-down table and benches. Glass saw the Accordium as filling a need somewhere between a house and a tent — offering "a minimum filter between us and the outdoors which we are enjoying more and more."[42] Postwar prosperity — abetted by paid vacation leave, car ownership, and the new interstate highway system — forged the ritual of the family road trip.[43] Across the

Fig. 176 Alcoa Forecast advertisement featuring Henry P. Glass's Accordium Camp Trailer, 1960. Photographed by J. Frederick Smith. [CAT. 30]

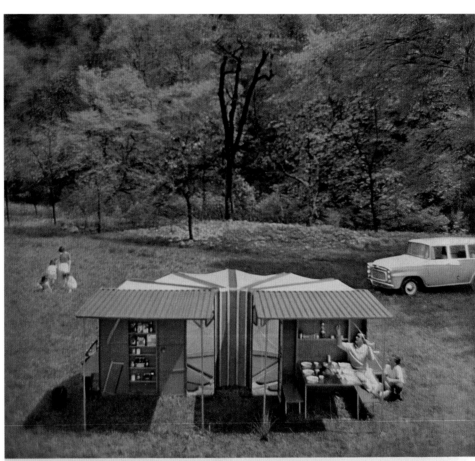

The Forecast Accordium Camp Trailer, designed in aluminum for the Alcoa collection by Henry Glass. Photographed by J. Frederick Smith.

Forecast: There's a world of aluminum in the wonderful world of tomorrow...where shelters of aluminum will fold like an accordion to accompany you anywhere...trailers of light, strong aluminum sections that wed with other materials...carry accouterments of work or leisure... withstand road and storm ...and unfold where you will with peacock glory.

▼ **ALCOA ALUMINUM**

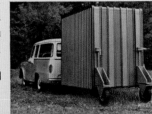

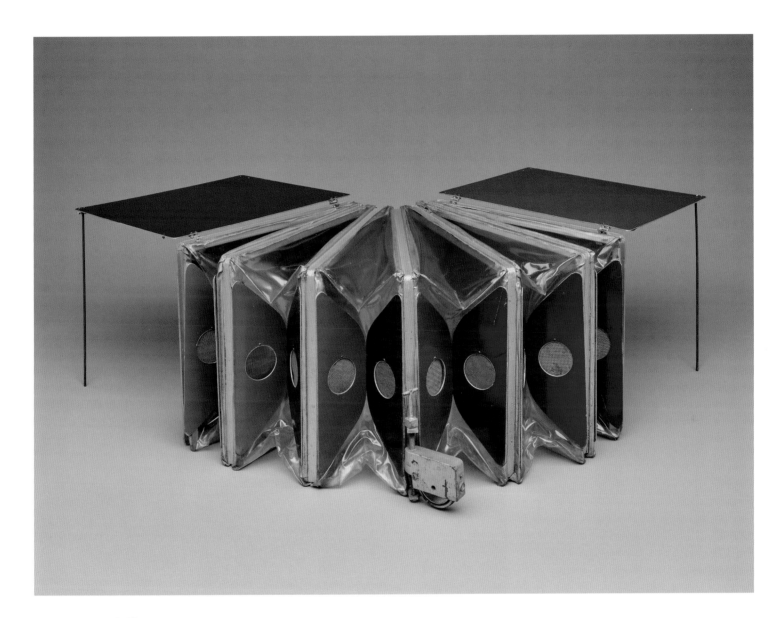

Fig. 177 Henry P. Glass, maquette
for Accordium Camp Trailer, c. 1960.
Collection of Tom Clark and Martha
Torno. [CAT. 7]

nation, Americans were on the move, taking in the sights and scenes of the country. America, to increasing millions of families, became "a land and a heritage that must be seen, be experienced, be felt," and Alcoa's aluminum trailer imagined a better solution for those families cheerfully hauling hundreds of cubic feet of vacant air space behind them in the form of mobile homes.[44]

ALUMINUM IN THE GARDEN

In 1960, industrial designer and educator Jay Doblin created the Forecast Fun Furniture, a collection of whimsical outdoor seating that looked like people (fig. 178; see also fig. 42). Asked why the chairs so closely resembled humans, Doblin replied: "To me, chairs usually look like seated human beings, and I find it hard not to be amused by this aspect of most of them." He continued, "The chair is basically meant to conform to the human shape—and if this is true, why not make a 'human being' so that you can sit on his lap."[45] Behind the whimsy lay some serious ideas. Doblin expressed a desire to design a visually attractive body of a chair out of one piece of material that was impervious to weather, with no waste and a minimum of bends and folds.[46] Some of the People chairs were cut and bent from a single sheet of aluminum (fig. 179). Some have attached legs of aluminum sheet; some of aluminum tubing. Doblin created the illusion of bodily features and brightly colored clothing on the surface of the seating. "The chair is actually an amusing problem," he said. "There is no such thing as a definitive chair. . . . Millions of them have been designed and the problem goes on—with millions of solutions yet to come."[47] As Doblin understood it, designing a chair was about freedom—the freedom to play, to invent, and to discover.

Multidisciplinary artist and designer Herbert Bayer's contribution to Forecast was the Kaleidoscreen, a colorful outdoor screen that could act as a decorative addition to any beautiful setting—or conceal an unattractive view. Standing 7½ feet high and 14 feet long, the screen was made of seven vertical, angularly shaped louvers fashioned

Fig. 178 Jay Doblin with his Fun Furniture, 1960

opposite
Fig. 179 Jay Doblin with prototype for People chair, 1960. Illinois Institute of Technology. [CAT. 3]

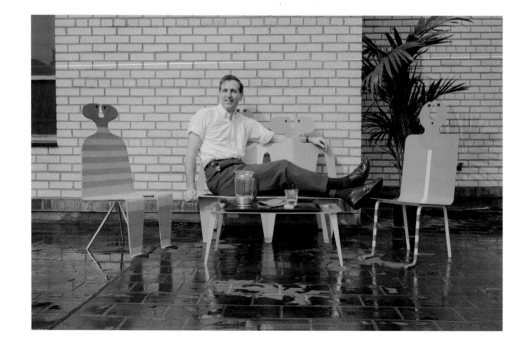

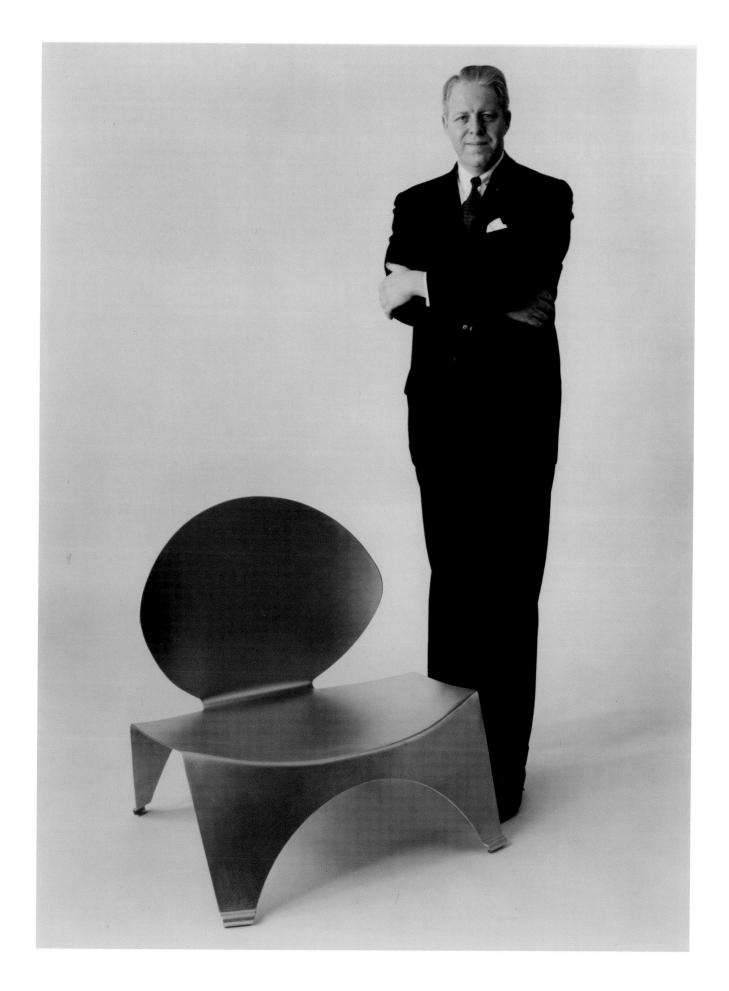

Fig. 180 Herbert Bayer's Kaleidoscreen installed in Aspen, Colorado, c. 1957

opposite

Fig. 181 Alison Eckbo beneath Garrett Eckbo's aluminum mesh garden structure, 1959. Photographed by Julius Shulman

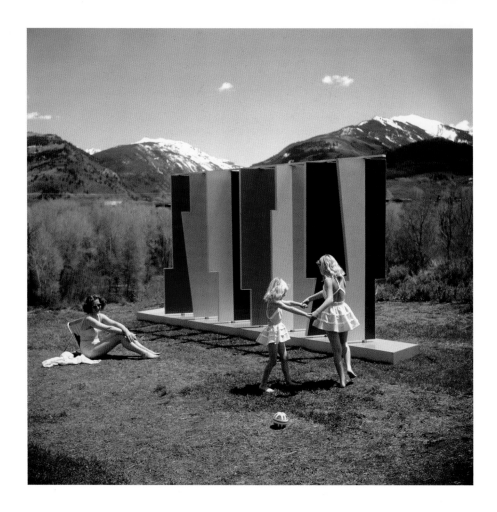

from prefabricated aluminum-faced structural panels. The "leaves" could be rotated 180 degrees by a crank mechanism in the screen's base. When the louvers intersect and form a continuous plane, one side of the screen becomes a multicolored, patterned mural; the reverse, a richly textured, heat-reflecting surface of natural aluminum. The screen's visual patterns changed as the louvers turned. At least as important, the panels could be rotated to adjust exposure to light, temperature, or wind. Bayer's Kaleidoscreen also had applications for inside the home.[48] As a wall, its louvers could be opened to let breezes pass through or its residents step outside onto a patio. As a roof, its panels could open up to make moonlight suppers an indoor possibility. Permanently installed adjacent to the swimming pool at the Aspen Meadows Resort in Aspen, Colorado, the Kaleidoscreen's playful engagement of movement and articulation remains its essential appeal (fig. 180).[49]

Landscape architect Garrett Eckbo also exploited the versatility of aluminum for outdoor living. Historian Marc Treib quotes Eckbo as saying that "gardens must be places of delight, of gayety, of fantasy, of illusion, of imagination, of adventure," before adding his own observation that one could introduce fantasy through form, but also through novel materials such as aluminum.[50] In 1959, Alcoa approached Eckbo to design aluminum garden architecture that would exploit the versatility of its products and, at the same time, extend the limits of the shapes, spaces, and materials widely accepted in garden construction (fig. 181). Installed at his family's Los Angeles home,

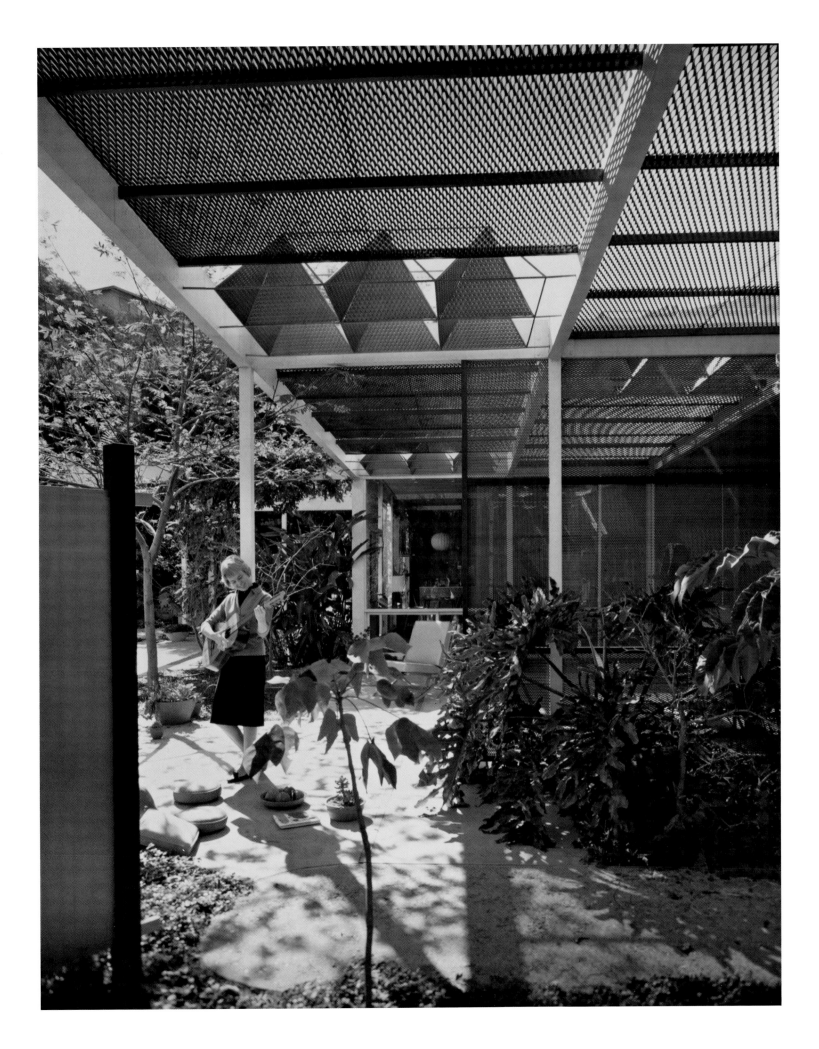

Eckbo's modernist garden employed large quantities of aluminum in wonderful textures and colors to create a sunbreak, screens, a fanciful garden house, and, most spectacularly, a whimsical fountain in the shape of a flower (fig. 182).

FORECAST FANTASYLAND

In 1953, when Creative Playthings added its Play Sculptures division, the term *play sculptures* described sculptural playground equipment designed by artists and industrial designers.[51] The first Forecast contribution to explore the outdoor environment of the playground was an imaginative Play Sculpture designed by David Aaron (fig. 183). Aaron's grouping of four brilliantly colored, free-form play sculptures bore little resemblance to typical playground furniture: it was abstract and unspecific as to both form and function. It was made from lightweight, water-resistant cast aluminum punctuated by holes of

Fig. 182 Garrett Eckbo's flower fountain and pool, 1959. Photographed by Julius Shulman

opposite

Fig. 183 Alcoa Forecast advertisement featuring David Aaron's Play Sculpture, 1957. Photographed by Wingate Paine. [CAT. 27]

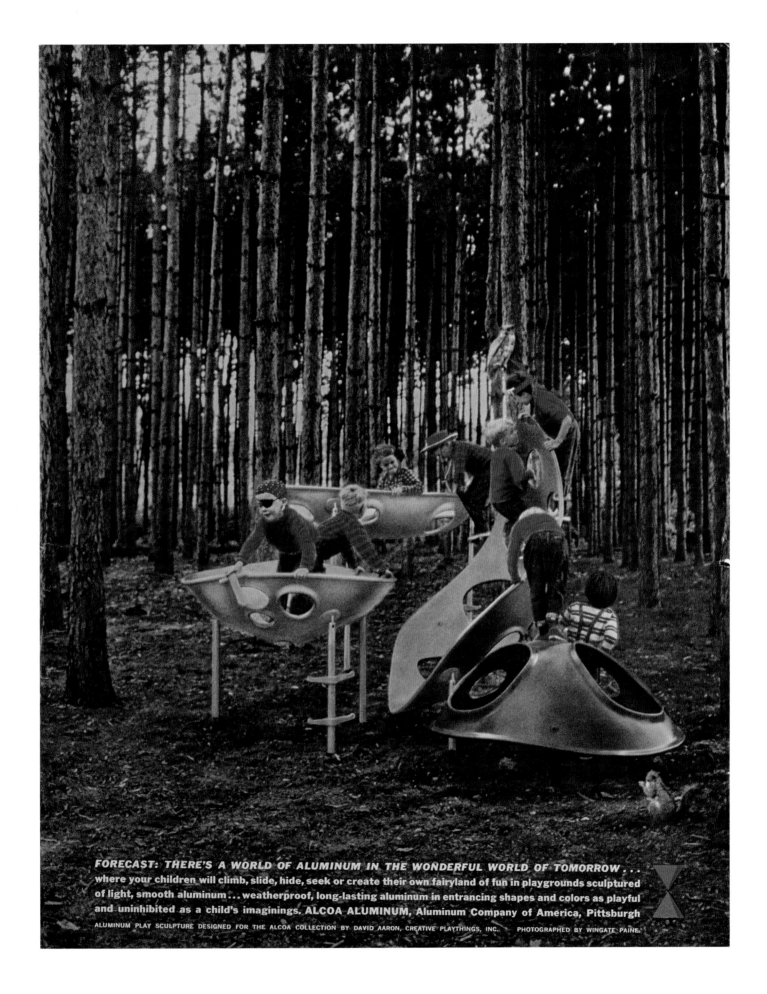

FORECAST: THERE'S A WORLD OF ALUMINUM IN THE WONDERFUL WORLD OF TOMORROW...
where your children will climb, slide, hide, seek or create their own fairyland of fun in playgrounds sculptured
of light, smooth aluminum... weatherproof, long-lasting aluminum in entrancing shapes and colors as playful
and uninhibited as a child's imaginings. ALCOA ALUMINUM, Aluminum Company of America, Pittsburgh

ALUMINUM PLAY SCULPTURE DESIGNED FOR THE ALCOA COLLECTION BY DAVID AARON, CREATIVE PLAYTHINGS, INC. PHOTOGRAPHED BY WINGATE PAINE.

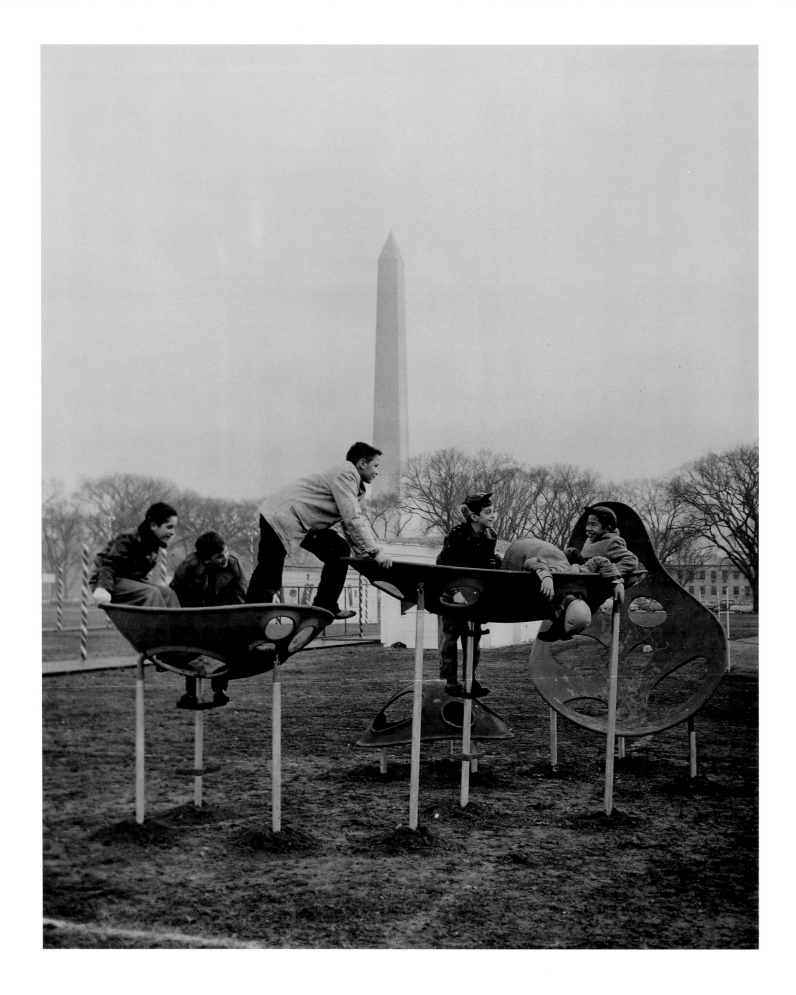

varying sizes. According to Aaron, they "can be used for hiding and seeking, climbing and sliding, and letting imagination run wild."[52] Whatever their inventive minds found in the shapes—a pirate ship or flying saucer—children of different ages, sizes, and levels of skill and confidence could find new ways to express their dynamic spirits in Aaron's Play Sculpture. As a consultant and designer of play materials and playgrounds for children, Aaron was a specialist in how children play, think, grow, and learn. "Play is important to kids," he explained. "Play is important to adults, too, but it's a respite, a release, an escape from the principal business of life."[53] In Aaron's mind, children's games were their most *serious* business. The first public showing of the Forecast Play Sculpture was at the Pageant of Peace in Washington, DC (December 23, 1957–January 1, 1958), across from the White House (fig. 184).[54]

According to an article in *Industrial Design* in July 1957, Martin Rosenzweig and Harold Krisel were working on a children's playground design, a commission for Forecast that was planned for 1958. Rosenzweig, an illustrator and graphic designer, and Krisel, an architect and fine artist, were a logical choice for designing a playground for tomorrow. The designers were joint recipients of a special citation at the Museum of Modern Art's competition for new playground structures in 1954, sponsored by Creative Playthings and *Parents'* magazine. Rosenzweig and Krisel's submission, a "ferrophone" fence, consisted of graduated brass or steel pipes meant to replace conventional fencing. Children could strike the pipes like a xylophone to make sounds while running or walking by. Rosenzweig and Krisel's playground proposal for Alcoa featured six "child-delighting aluminum elements," including the Alumophone, an updated version of their "ferrophone" fence to be made of color-anodized aluminum pipes. A 6-foot-diameter aluminum sundial divided into twelve wedges of contrasting colors would encourage children to tell time in a simpler fashion. The Climbing Rings, which were patented, would encourage children to move diagonally, a freer and more enjoyable type of climbing than the conventional up-and-down. A tactile hopscotch board was designed for shoeless playing. An undulating landscape was composed of convex and concave hemispheres made of 4-foot-round cast aluminum units, which were modular and rearrangeable. The lightweight aluminum Giant Blocks were king-size building blocks in various colors and patterns, edged in rubber. However, a Forecast advertisement does not appear to exist or have been released. A photo of Rosenzweig and Krisel with a model of their "Forecast Fantasyland" does appear in a September 1961 issue of *Interiors* magazine. It is possible that the Forecast Program came to an end before the fantasy playground was publicly launched by Alcoa.

Perhaps the most spectacular of all the Forecast creations was a whimsical toylike sculpture designed by Charles and Ray Eames (fig. 185). Asked to design an aluminum toy, the Eameses at first declined to participate, citing too many modern problems that had been left unresolved. It soon occurred to them that there were important ideas worth promoting through Forecast, and the Eames Office proceeded to create a marvelous toy: the Solar Do-Nothing Machine. Its objective was to playfully shed light on solar energy as a practical source of power in combination with the lightweight, reflective properties of aluminum. The machine accomplished nothing, but it demonstrated—as it spun, fluttered, and danced in a poetry of motion, drawing its power from 93 million miles away—that the world was soaking in the sun's energy (fig. 186).

Fig. 185 Charles Eames with the Solar
Do-Nothing Machine, 1957

The solar machine consisted of an elliptical aluminum platform supporting moving displays of differing heights. Each was topped with circles, pinwheels, and other flower-like shapes cut out of brilliant, jewel-like anodized aluminum. Close to the platform, a highly polished aluminum sheet reflector tracked the sun all day and focused it onto photovoltaic cells that transformed its ceaseless energy into electricity. Motors turned wheels, drove pulleys, and spun crankshafts, creating a delightful display of color, motion, and sound. Its purpose was pure pleasure, but it also happened to draw attention to a modern problem: the need to conserve natural resources (fig. 187).[55] Like many of the prototypes in Alcoa's Forecast Program, the Solar Do-Nothing Machine at once embodied and evoked the spirit of pure, unadulterated originality. Its lack of any specific function freed it from the burden of meeting expectations, while its intrinsic playfulness subtly challenged others to free their own imaginations — in the wonderful world of tomorrow.

Fig. 186 Charles and Ray Eames, sketch
for Alcoa Solar Do-Nothing Machine, c. 1957.
Library of Congress. [CAT. 4]

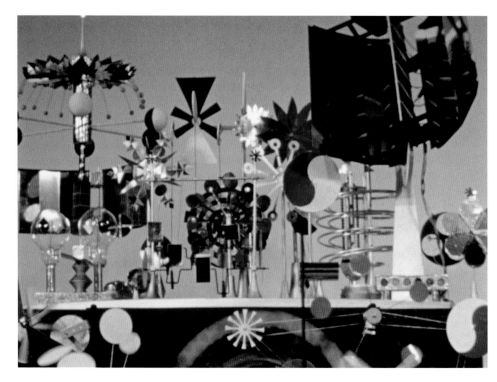

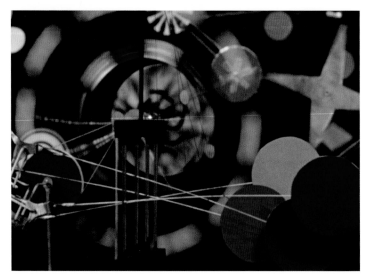

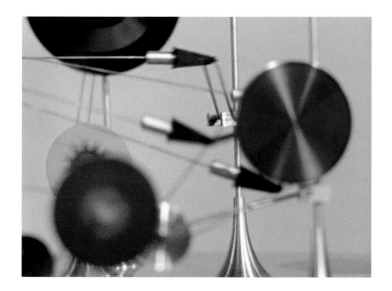

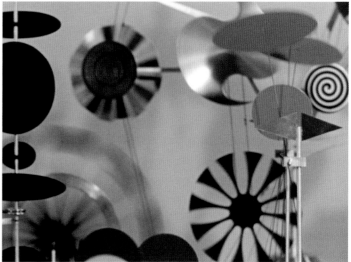

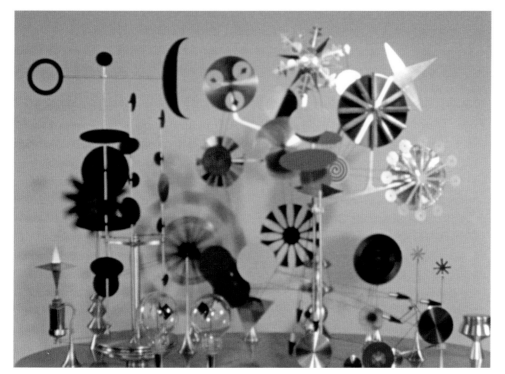

NOTES

1 Ketchum, MacLeod & Grove, Forecast Program report/scrapbook, 1959, on loan from Torrence Hunt, Acct. #L98.011, Alcoa Archives, Library and Archives Division, Historical Society of Western Pennsylvania, Pittsburgh.

2 See Dennis P. Doordan, "Promoting Aluminum: Designers and the American Aluminum Industry," *Design Issues* 9, no. 2 (Autumn 1993): 44–50.

3 "Alcoa Ventures a *Forecast,*" *Industrial Design* 4, no. 7 (July 1957): 74.

4 "Alcoa Forecast: There's a Wonderful World of Aluminum in the Wonderful World of Tomorrow," *Alcoa News* (Pittsburgh, PA: Aluminum Company of America, December 1956), 8–9. Alcoa Archives. Close was elected a vice president in 1958, executive vice president and a director in 1963, and chairman of the board in 1965. He retired from Alcoa in 1970.

5 John M. Clampitt (advertising program manager, Alcoa), interim mailing piece on Forecast summer house, June 6, 1957, Oscar Shefler Papers; and Don Wallance to Oscar Shefler, September 27, 1958, Oscar Shefler Papers. Oscar Shefler was an account supervisor in the Public Relations Department at Ketchum, MacLeod & Grove, a leading advertising and public relations agency in Pittsburgh. I am deeply grateful to W. Douglas McCombs, Chief Curator, Albany Institute of History & Art, for his generosity in sharing Shefler's papers with me.

6 "Design for Success," *Alcoa News* (Pittsburgh, PA: Aluminum Company of America, January 1959), 9. Alcoa Archives. According to the *Alcoa News,* the dress continued to travel until December 1958 (it is now part of the collection of the Metropolitan Museum of Art). Alcoa's objective was to expand the uses of aluminum beyond "pots and airplanes" by targeting women to purchase clothing and home furnishings made of aluminum. See Barbara Paris Gifford and Leslie S. Edwards, "Feminizing Alcoa Aluminum: Marianne Strengell and the *Forecast Rug* (1957)," special issue, "Women in Art, Craft and Design, Midcentury and Today," *Journal of Modern Craft* 8, no. 2 (July 2015): 167–179.

7 Quoted in report from Oscar Shefler to Blair R. Gettig (advertising manager, Alcoa) on March 5, 1958, interview of Ilonka Karasz, Oscar Shefler Papers.

8 The rug was woven by Gerda Nyberg, a Swedish weaver who worked with Marianne Strengell for many years. See Gifford and Edwards, "Feminizing Alcoa Aluminum," 168, 170.

9 Oral history interview with Marianne Strengell, January 8–December 16, 1982. Archives of American Art, Smithsonian Institution; https://www.aaa.si.edu/collections/interviews/oral-history-interview-marianne-strengell-12411 (accessed on January 5, 2018).

10 Ibid.

11 Gifford and Edwards, "Feminizing Alcoa Aluminum," 174. I thank Leslie S. Edwards, Head Archivist, Cranbrook Archives, Cranbrook Center for Collections and Research, for her assistance.

12 "Alexander Girard: The Containers We Live In: The Pungent Designer," *Design Forecast* 2 (Pittsburgh, PA: Aluminum Company of America, 1960), 51. In 1959, Alcoa produced *Design Forecast*, an extension of the Forecast Program. Edited by the company's in-house chief industrial designer, Samuel L. Fahnestock, *Design Forecast* was "by and about designers, and about design in general and aluminum in particular." Originally conceived as a serial publication with subscribers, *Design Forecast* ended in 1960 after two issues.

13 Alcoa Forecast advertisement featuring Alexander Girard's shelving unit, Forecast Program report/scrapbook, July 1957, Alcoa Archives.

14 Oscar Shefler, undated draft for "We Live in Containers," Oscar Shefler Papers.

15 Alcoa Forecast advertisement featuring Isamu Noguchi's table, Forecast Program report/scrapbook, April/May 1957, Alcoa Archives.

16 Draft of "The Landscape in the Living Room," interview with Isamu Noguchi conducted by Oscar Shefler on May 25, 1959, Oscar Shefler Papers.

17 Cynthia Kellogg, "Store Gives Paul M'Cobb 15 Settings," *New York Times*, October 30, 1957.

18 Ketchum, MacLeod & Grove, Forecast Program report/scrapbook, 1959, Alcoa Archives.

19 Report from Oscar Shefler to Blair R. Gettig on March 6, 1958, interview of Paul McCobb, Oscar Shefler Papers.

20 "Forecast: All-Star Casting for Players" (cast aluminum game table and chairs marketing brochure) (Pittsburgh, PA: Aluminum Company of America, undated [possibly late 1960]). Collection of Steve Cabella.

21 W. Douglas McCombs, "Music Spheres, People Chairs, and Solar Do-Nothings: Designing for Tomorrow with Alcoa's Forecast Program, 1956–1960" (unpublished notes for presentation at a symposium held at Carnegie Museum of Art, Pittsburgh, in conjunction with the exhibition *Aluminum by Design: Jewelry to Jets,* November 11, 2000).

22 *Pittsburgh Post-Gazette*, March 13, 1958.

23 Don Wallance to Oscar Shefler, September 27, 1958, Oscar Shefler Papers.

24 Ibid.

25 Don Wallance to Oscar Shefler, October 3, 1958, Oscar Shefler Papers.

26 "Forecast: Aluminum and the Breakout from the Kitchen" (portable aluminum oven marketing brochure) (Pittsburgh, PA: Aluminum Company of America, undated [possibly early 1959]). Greta Magnusson Grossman Archives at R & Company, New York.

27 The oven's spherical form recalled Russel Wright's sophisticatedly simple informal serving accessories, which were designed in the mid-1930s and also made of spun aluminum. See Sarah Nichols, *Aluminum by Design* (Pittsburgh: Carnegie Museum of Art, 2000), 226–227.

28 Dan MacMasters, "Culinary Sphere . . . the Oven Gets a Fresh New Form," *Los Angeles Examiner*, March 8, 1959.

29 *Iron Age*, June 25, 1959, 13.

30 Oscar Shefler to Edwin B. Morris Jr. (assistant to executive director of the American Institute of Architects), March 21, 1957 [may have never been sent], Oscar Shefler Papers.

31 For more on Alcoa's office tower, see Dennis P. Doordan, "From Precious to Pervasive: Aluminum and Architecture," in Nichols, *Aluminum by Design,* 104.

32 Oscar Shefler, undated draft for "The Home That Is Not a Home," Oscar Shefler Papers.

33 A. Gomberg and John Updike, "The Eight Virtues," Talk of the Town, *New Yorker,* June 1, 1957, 19. The promotional display was on view at Macy's from May to June 1957. Besides the magazine advertisements, Alcoa exhibited many of the Forecast objects at locations around the country, including trade shows and department stores, such as Macy's and Horne's department stores in Pittsburgh.

34 John Matthias designed the Stinson Beach home of Maggie Baylis and her husband, Douglas Baylis, a leading landscape architect in the San Francisco Bay Area. See Alexandra Lange's essay in this volume.

35 "Forecast: A Box with a View!" (View Box marketing brochure) (Pittsburgh, PA: Aluminum Company of America, undated [possibly October or November 1959]). Collection of Steve Cabella.

36 Ibid.

37 McCombs, "Music Spheres, People Chairs."

38 See Jeffrey Head, "How Things Work: The Inventions of Henry P. Glass," *Modernism* 7, no. 1 (Spring 2004): 80–86.

39 "Forecast: Living Where the Fun Is," (Accordium marketing brochure) (Pittsburgh, PA: Aluminum Company of America, undated [possibly September 1959]). Henry P. Glass Papers, Ryerson and Burnham Libraries, Art Institute of Chicago.

40 Henry P. Glass, Collapsible shelter using bellows-like sections. US Patent 2,999,507, filed May 27, 1960, and issued September 12, 1961.

41 "The Accordium has six compartments, which would take care of a typical carload of people (and of most families), and which is the number of Boy Scouts in a squad." Oscar Shefler, notes from April 29, 1960, interview with Henry P. Glass, Oscar Shefler Papers.

42 "Forecast: Living Where the Fun Is."

43 See Susan Sessions Rugh, *Are We There Yet? The Golden Age of American Family Vacations* (Lawrence: University Press of Kansas, 2008).

44 "Forecast: Living Where the Fun Is."

45 "Jay Doblin: The Chair: The Pungent Designer," *Design Forecast 2* (Pittsburgh, PA: Aluminum Company of America, 1960), 49.

46 "Forecast: Some Chairs You Can Sit in the Laps Of" (Fun Furniture marketing brochure) (Pittsburgh, PA: Aluminum Company of America, undated [possibly April or May 1960]). Oscar Shefler Papers.

47 "Jay Doblin," 49.

48 Herbert Bayer, Multiple-panel space-divider structure. US Patent 3,049,203, filed April 13, 1959, and issued August 14, 1962.

49 Report from Oscar Shefler to Blair R. Gettig on June 28, 1958, interview of Herbert Bayer, Oscar Shefler Papers.

50 Garrett Eckbo quoted in Marc Treib, *The Donnell and Eckbo Gardens: Modern California Masterworks* (San Francisco: William Stout, 2005), 103.

51 Amy F. Ogata, *Designing the Creative Child: Playthings and Places in Midcentury America* (Minneapolis: University of Minnesota Press, 2013), 60–61.

52 David Aaron and Bonnie P. Winawer, *Child's Play: A Creative Approach to Playspaces for Today's Children* (New York: Harper & Row, 1965), 76.

53 Robert Creamer, "New Look at the Sandbox," *Sports Illustrated,* July 2, 1962, 34–42.

54 Ketchum, MacLeod & Grove, Forecast Program report/scrapbook, 1959, Alcoa Archives.

55 In the 1990s, the couple's grandson, Eames Demetrios, discovered raw footage of the Solar Do-Nothing Machine and edited it: http://www.eamesoffice.com/the-work/solar-do-nothing-machine (accessed January 16, 2018).

CHECKLIST

Objects are listed alphabetically by designer. For designers with multiple objects, those objects are grouped by manufacturers or collaborators and listed chronologically within each group. Model and style numbers, when known, appear after the name of the object. The date specified for each work is the design date. Height precedes width precedes depth. A checklist of the ephemera included in the exhibition begins on page 232.

David Aaron (d. 1984)
See Alcoa

Aluminum Company of America (Alcoa) (1888–present, Pittsburgh, Pennsylvania)
Design Forecast 1 publication, 1959
Design Forecast 2 publication, 1960
 Ink, paper
 Each: 11 1/4 × 8 3/4 in. (28.6 × 22.2 cm)
 Private collection
 Cat. 1

Herbert Bayer (1900–1985, b. Austria)
Model for Kaleidoscreen, 1957
 Aluminum, wood, paint
 12 7/8 × 24 × 5 1/2 in.
 (32.7 × 61 × 13.8 cm)
 Denver Art Museum: Gift of the Estate of Herbert Bayer, 1986.1988
 Cat. 2

Jay Doblin (1920–1989)
Prototype for People chair, 1960
 Aluminum
 27 1/2 × 30 × 24 in. (69.9 × 76.2 × 61 cm)
 University Archives and Special Collections, Paul V. Galvin Library, Illinois Institute of Technology
 Cat. 3

Charles Eames (1907–1978)
Ray Eames (1912–1988)
Eames Office (1941–1988, Venice, California)
Sketch for Alcoa Solar Do-Nothing Machine, c. 1957
 Graphite on tracing paper
 11 5/8 × 13 3/8 in. (29.5 × 34.3 cm)
 Prints and Photographs Division, Library of Congress, Washington, DC
 Cat. 4

Alcoa Solar Do-Nothing Machine, 1957
(unfinished; edited 1990s)
 Film
 Duration: 8 minutes
 Eames Collection, LLC
 Cat. 5

Charles Eames, photographer
Billy Mure (1915–2013), recording artist
Supersonic Guitars Volume II
(album cover featuring Alcoa Solar Do-Nothing Machine), 1960
 Offset lithograph
 12 1/4 × 12 1/4 in. (31.1 × 31.1 cm)
 Denver Art Museum
 Cat. 6

Henry P. Glass (1911–2003, b. Austria)
Maquette for Accordium Camp Trailer, c. 1960
 Metal, plastic
 Approximately 9 1/2 × 16 1/2 × 12 in.
 (24.1 × 41.9 × 30.5 cm)
 Collection of Tom Clark and Martha Torno
 Cat. 7

Greta Magnusson Grossman (1906–1999, Swedish)
Design drawing for an oven and individual cooking units, c. 1957
 Pastel and graphite on paper
 19 1/4 × 30 1/4 in. (48.9 × 76.8 cm)
 Estate of Greta Magnusson Grossman, R & Company, New York
 Cat. 8

Isamu Noguchi (1904–1988)

Alcoa Forecast Program Table, 1957
 Painted aluminum
 Two, each: 14³/₄ × 18¹/₂ × 16 in.
 (37.5 × 47 × 40.6 cm)
 Carnegie Museum of Art, Pittsburgh:
 Gift of Torrence M. Hunt Sr., 2004.9.1
 and 2004.9.2
 Cat. 9

Richard Rutledge (1923–1985),
photographer
Music from Monitor
(album cover featuring Alcoa Forecast
Music Sphere), 1960
 Offset lithograph
 12¹/₄ × 12¹/₄ in. (31.1 × 31.1 cm)
 Collection of Edgar Orlaineta
 Cat. 10

Marianne Strengell
(1909–1998, b. Finland)
Alcoa Forecast Rug, 1957
 Aluminum thread, jute, wool, viscose
 147 × 66 in. (373.4 × 167.6 cm)
 Senator John Heinz History Center:
 Gift of Alcoa Inc.
 Cat. 11

Gene Tepper (1919–2013)
Sketches for Alcoa Forecast Game Table,
c. 1960
 Graphite and colored pencil on paper
 Five, each: 10 × 8 in.
 (25.4 × 20.3 cm)
 Collection of Steve Cabella,
 Modern i Shop
 Cat. 12

Sketch for Alcoa Forecast Game Table
Chair, c. 1960
 Graphite and colored pencil on paper
 10 × 8 in. (25.4 × 20.3 cm)
 Collection of Steve Cabella,
 Modern i Shop
 Cat. 13

Prototype for Alcoa Forecast Game Table
Top, c. 1960
 Wood
 3 × 28 × 28 in. (7.6 × 71.1 × 71.1 cm)
 Collection of Steve Cabella, Modern i Shop
 Cat. 14

Prototype for Alcoa Forecast Game Board,
c. 1960
 Aluminum
 ¹/₈ × 18 × 18 in. (0.3 × 45.7 × 45.7 cm)
 Collection of Steve Cabella,
 Modern i Shop
 Cat. 15

Alcoa Forecast Program Advertisements
Becker-Horowitz (active mid-20th century)
Harold Becker (b. 1928), photographer
Irwin Horowitz (active mid-20th century),
photographer
Alcoa Forecast Chairs by Paul McCobb,
1957
 Offset lithograph
 11¹/₂ × 8¹/₄ in. (29.2 × 21 cm)
 Denver Art Museum
 Cat. 16

Alcoa Forecast Buffet Group
by Don Wallance, 1958
 Offset lithograph
 13⁵/₈ × 10¹/₂ in. (34.6 × 26.7 cm)
 Denver Art Museum
 Cat. 17

Ferenc Berko (1916–2000, b. Hungary),
photographer
Alcoa Forecast Kaleidoscreen
by Herbert Bayer, 1958
 Offset lithograph
 13⁵/₈ × 10⁵/₈ in. (34.6 × 27 cm)
 Denver Art Museum
 Cat. 18

Lester Bookbinder (1929–2017),
photographer
Alcoa Forecast Fun Furniture

by Jay Doblin, 1960
 Offset lithograph
 11¹/₂ × 8⁷/₈ in. (29.2 × 22.5 cm)
 Denver Art Museum
 Cat. 19

Ted Castle (active 1950s–1990s),
photographer
Alcoa Forecast View Box
by John Matthias, 1959
 Offset lithograph
 13¹/₂ × 10³/₈ in. (34.3 × 26.4 cm)
 Denver Art Museum
 Cat. 20

Edgar De Evia (1910–2003, b. Mexico),
photographer
Alcoa Forecast Portable Oven
by Greta Magnusson Grossman, 1959
 Offset lithograph
 13⁵/₈ × 10³/₈ in. (34.6 × 26.4 cm)
 Denver Art Museum
 Cat. 21

Charles Eames, photographer
Alcoa Forecast Shelving Unit
by Alexander Girard, 1956
 Offset lithograph
 13³/₈ × 10¹/₄ in. (34 × 26 cm)
 Denver Art Museum
 Cat. 22

Alcoa Forecast Solar Energy Toy
by Charles and Ray Eames, 1957
 Offset lithograph
 11¹/₂ × 8³/₈ in. (29.1 × 21.3 cm)
 Denver Art Museum
 Cat. 23

Leslie Gill (1908–1958), photographer
Alcoa Forecast Rug
by Marianne Strengell, 1957
 Offset lithograph
 11³/₈ × 8¹/₄ in. (28.9 × 21 cm)
 Denver Art Museum
 Cat. 24

Albert Gommi (1919-1976), photographer
Alcoa Forecast Game Table and Chairs
by Gene Tepper, 1960
　Offset lithograph
　11³/₈ × 8³/₈ in. (29.1 × 21.3 cm)
　Denver Art Museum
　Cat. 25

Herbert Matter (1907-1984,
b. Switzerland)
Alcoa Forecast Program Advertisement,
1956
　Offset lithograph
　11 × 7⁷/₈ in. (27.9 × 20.2 cm)
　Denver Art Museum
　Cat. 26

Wingate Paine (1915-1987),
photographer
Alcoa Forecast Play Sculpture
by David Aaron, 1957
　Offset lithograph
　13¹/₂ × 10¹/₂ in. (34.3 × 26.7 cm)
　Denver Art Museum
　Cat. 27

Irving Penn (1917-2009), photographer
Alcoa Forecast Tables by Isamu Noguchi,
1957
　Offset lithograph
　11¹/₄ × 7⁷/₈ in. (28.6 × 20 cm)
　Collection of Edgar Orlaineta
　Cat. 28

Richard Rutledge (1923-1985),
photographer
Alcoa Forecast Music Sphere
by Lester Beall, 1959
　Offset lithograph
　11¹/₄ × 8¹/₄ in. (28.5 × 21 cm)
　Collection of Edgar Orlaineta
　Cat. 29

J. Frederick Smith (1917-2006),
photographer
Alcoa Forecast Accordium Camp Trailer

by Henry P. Glass, 1960
　Offset lithograph
　11³/₈ × 8³/₈ in. (29.1 × 21.3 cm)
　Denver Art Museum
　Cat. 30

Bert Stern (1929-2013), photographer
Alcoa Forecast Summer House
by Harrison & Abramovitz, 1957
　Offset lithograph
　11 × 8 in. (27.9 × 20.3 cm)
　Denver Art Museum
　Cat. 31

A. F. Arnold (active mid-20th century)
The Builder toy, 1953
　Cardboard box, plywood, paper
　1 × 16 × 6 in. (2.5 × 40.6 × 15.2 cm)
　Collection of Steve Cabella,
　Modern i Shop
　Cat. 32

A. G. Spalding and Brothers, Toy
Tinkers Division (active mid-20th
century, Evanston, Illinois)
Tinkertoy, c. 1955
　Wood, metal, cardboard, paper instructions
　Container: 13 × 3¹/₂ × 3¹/₂ in.
　(33 × 8.9 × 8.9 cm); instructions:
　7 × 10¹/₄ in. (17.8 × 26 cm)
　Denver Art Museum
　Cat. 33

Eileen J. Aureli (active mid-20th
century)
Six interior renderings for Monsanto
House of the Future, c. 1958
　Gouache on tissue
　Each: 18 × 24 in. (45.7 × 61 cm)
　Collection of Jill A. Wiltse and
　H. Kirk Brown III
　Cat. 34

Barton's Bonbonniere (1938-2009,
Brooklyn, New York)
Barton's B Almond Kisses tin, c. 1952

Tin
5¹/₄ × 3¹/₂ × 3¹/₂ in. (13.3 × 8.9 × 8.9 cm)
Private collection
Cat. 35

Box, c. 1952
　Cardboard
　1 × 12 × 5 in. (2.5 × 30.5 × 12.7 cm)
　Private collection
　Cat. 36

Chocolate tin, c. 1952
　Tin
　Height: 2³/₄ in. (7 cm); diameter: 7¹/₂ in.
　(19.1 cm)
　Private collection
　Cat. 37

Fred Bassetti (1917-2013)
Forde Corporation (active mid-20th
century, Tacoma, Washington)
　Flexagons toy, c. 1960
　Cardboard box, paper, rubber bands
　2 × 16 × 13 in. (5.1 × 40.6 × 33 cm)
　Collection of Steve Cabella,
　Modern i Shop
　Cat. 38

Herbert Bayer (1960-1985,
b. Austria)
See Alcoa

Douglas Baylis (1915-1971)
Maggie Baylis (1912-1997)
Play Project renderings: Climbing Tower,
Freeway, Plyform, Tippy-totter, c. 1964
　Ink and watercolor on paper
　Four, each: 8 × 12¹/₂ in.
　(20.3 × 31.8 cm)
　Douglas and Maggie Baylis Collection,
　Environmental Design Archives,
　University of California, Berkeley
　Cat. 39

Lester Beall (1903-1969)
See Alcoa

Harry Bertoia (1915–1978, b. Italy)

Knoll International (1938–present, also known as Knoll Associates, New York)

Side chair (no. 420), 1952
Rubber-coated metal, metal, vinyl
$28^3/_4 \times 21^3/_4 \times 19^3/_4$ in.
(73 × 55.3 × 50.2 cm)
Collection of Jody and Dick Goisman
Cat. 40

Small diamond chair (no. 421), 1952
Painted steel, foam, upholstery
$31^1/_4 \times 34 \times 32^3/_4$ in.
(79.4 × 86.4 × 83.2 cm)
Denver Art Museum: Bequest of
Jean C. Graham, 1997.197
Cat. 41

High-backed chair (no. 423) and ottoman
(no. 424), 1952
Chrome-plated steel, rubber, urethane,
upholstery
Chair: $40^1/_4 \times 38^1/_2 \times 33$ in.
(102.2 × 97.8 × 83.8 cm);
ottoman: $14^1/_2 \times 23^1/_2 \times 17^1/_4$ in.
(36.8 × 59.7 × 43.8 cm)
Denver Art Museum: Gift of Seal Furniture
and Systems, 1992.557A–B
Cat. 42

Child's chair (no. 425), 1955
Painted steel and Naugahyde
$23^5/_8 \times 15^5/_8 \times 16$ in. (60 × 39.7 × 40.6 cm)
Collection of Jody and Dick Goisman
Cat. 43

Child's chair (no. 426), 1955
Painted steel and Naugahyde
$19^7/_8 \times 13 \times 12^1/_2$ in.
(50.3 × 33 × 31.8 cm)
Denver Art Museum: Gift of Mrs. Wayne
Stacey, by exchange, 1995.378A–B
Cat. 44

Gloria Caranica (b. 1931)

See Creative Playthings

Arthur A. Carrara (1910–1991)

Magnet Master 400 toy, 1947
Cardboard, steel plates and rods,
magnets
$2^5/_8 \times 10^3/_8 \times 6^1/_4$ in.
(6.7 × 26.4 × 15.9 cm)
Milwaukee Art Museum: Purchase with
funds from the Demmer Charitable Trust,
M2016.153
Cat. 45

Magnet Master 900 toy, 1947
Cardboard, steel plates and rods,
magnets
$2^1/_8 \times 20^1/_4 \times 10^1/_4$ in.
(5.4 × 51.4 × 26 cm)
Milwaukee Art Museum: Purchase with
funds from the Demmer Charitable Trust,
M2016.152
Cat. 46

Alan Colby (active mid-20th century)

See Creative Playthings

**Creative Playthings (1945–present,
Princeton, New Jersey)**

See-Inside Puzzle, 1958
Plywood, Masonite
$^3/_4 \times 11 \times 9^1/_2$ in.
(1.9 × 27.9 × 24.1 cm)
Private collection
Cat. 47

Totem Pole toy, c. 1965
Wood
17 × 4 × 4 in. (43.2 × 10.2 × 10.2 cm)
Private collection
Cat. 48

The Power of Play catalog, 1967
Offset lithograph
$11 \times 8^3/_8$ in. (28 × 21.3 cm)
Milwaukee Art Museum Research Center:
Purchase with funds from the
Alice and Lucia Stern Library Fund
Cat. 49

Gloria Caranica (b. 1931)

Rocking Beauty hobby horse, 1964–66
Plywood, solid wood, pigment
$20^1/_4 \times 25^1/_4 \times 11^3/_4$ in.
(51.4 × 64.1 × 29.8 cm)
Collection of Jill A. Wiltse and H. Kirk
Brown III
Cat. 50

Alan Colby (active mid-20th century)

*Creative Playthings, Inc.: A Climate of
Creativity for New World Builders* catalog,
1960
Offset lithograph
$11 \times 8^1/_2$ in. (28 × 21.6 cm)
Milwaukee Art Museum Research Center:
Purchase with funds from the
Alice and Lucia Stern Library Fund
Cat. 51

**Charlotte Trowbridge
(active mid-20th century)**

*Creative Playthings: Tangibles in Early
Childhood Education* catalog, c. 1950
Offset lithograph
$8^1/_4 \times 10^7/_8$ in. (21 × 27.6 cm)
Milwaukee Art Museum Research Center:
Purchase with funds from the
Alice and Lucia Stern Library Fund
Cat. 52

Lucia DeRespinis (b. 1927)

See George Nelson & Associates

Jay Doblin (1920–1989)

See Alcoa

**Charles Eames (1907–1978)
Ray Eames (1912–1988)**

Eames Office (1941–1988, Venice,
California); see also Alcoa
Parade, 1952
Film
Duration: 5:30 minutes
Eames Collection, LLC
Cat. 53

Prototypes and mock-ups for House
of Cards, c. 1952
 Photographs, cardboard
 Twenty-seven cards and two jigs,
 each: 3 1/2 × 2 1/4 in. (8.9 × 5.7 cm)
 Eames Collection, LLC
 Cat. 54

Prototypes for House of Cards
packaging, c. 1952
 Paper, foil
 Four, each: 2 3/8 × 4 1/2 × 3 3/4 in.
 (6 × 11.4 × 9.5 cm)
 Eames Collection, LLC
 Cat. 55

Toccata for Toy Trains, 1957
 Film
 Duration: 13:30 minutes
 Eames Collection, LLC
 Cat. 56

Tops, 1969
 Film
 Duration: 7:40 minutes
 Eames Collection, LLC
 Cat. 57

Evans Products Company, Molded
Plywood Division (1943–1949,
Venice, California)
Child's chair, c. 1944
 Molded plywood
 14 1/2 × 14 1/2 × 11 in.
 (36.8 × 36.8 × 27.9 cm)
 Denver Art Museum: Gift of Suzanne
 Farver and George J. Berky,
 1992.130
 Cat. 58

Child's chair, c. 1944
 Aniline-dyed molded birch plywood
 14 1/2 × 14 1/2 × 11 in.
 (36.8 × 36.8 × 27.9 cm)
 Private collection
 Cat. 59

Child's stool, c. 1944
 Molded plywood
 8 1/2 × 14 1/2 × 10 1/2 in.
 (21.6 × 36.8 × 26.7 cm)
 Eames Collection, LLC
 Cat. 60

Evans Products Company, Molded
Plywood Division
Herman Miller (1923–present, Zeeland,
Michigan)
LCM (Lounge Chair Metal), 1946
 Aniline-dyed plywood, steel, rubber
 26 1/2 × 22 × 19 in.
 (67.3 × 55.9 × 48.3 cm)
 Collection of Jody and Dick Goisman
 Cat. 61

Herman Miller
Eames Storage Unit (ESU), 100 series,
c. 1949
 Zinc-plated steel, birch-faced and
 plastic-coated plywood, enameled
 Masonite, rubber
 20 1/2 × 47 × 16 in.
 (52.1 × 119.4 × 40.6 cm)
 Collection of Mark McDonald
 Cat. 62

Eames Storage Unit (ESU), 150 series,
c. 1949
 Zinc-plated steel, birch-faced and
 plastic-coated plywood, enameled
 Masonite, rubber
 20 1/2 × 24 1/2 × 16 in.
 (52.1 × 62.2 × 40.6 cm)
 Collection of Mark McDonald
 Cat. 63

Eames Storage Unit (ESU), 400 series,
first edition, c. 1949
 Zinc-plated steel, birch-faced and
 plastic-coated plywood, enameled
 Masonite, rubber
 59 × 47 × 17 in.
 (149.9 × 119.4 × 43.2 cm)

Denver Art Museum: Funds, by exchange,
from Mr. and Mrs. John C. Mitchell II,
Calvina Morse Vaupel in memory of Calvin
Henry Morse, Mrs. George Cranmer,
Charles E. Stanton, Charles Bayly Jr.
Collection, Mrs. Claude Boettcher,
Dr. Charles F. Shollenberger, Mr. Ronald S.
Kane, Frances Charsky, Dorothy Retallack,
Mrs. Alfred B. Bell, Charles William Brand,
Doris W. Pritchard, Mrs. F. H. Douglas,
Mrs. Calista Struby Rees, and Jane Garnsey
O'Donnell, 2017.208
Cat. 64

Elliptical Table Rod Base (ETR), 1951
 Plastic laminate, plywood,
 galvanized steel
 10 1/4 × 89 × 29 in.
 (26 × 226.1 × 73.7 cm)
 Denver Art Museum: Funds from
 Florence R. and Ralph L. Burgess trusts
 and Design Council of the Denver Art
 Museum, 1992.8
 Cat. 65

Sofa Compact with Colorado
Plaid textile designed by Alexander Girard,
1954
 Wool upholstery, urethane,
 chrome-plated steel, enameled steel
 34 3/4 × 71 3/4 × 32 1/4 in.
 (88.3 × 182.3 × 81.9 cm)
 Denver Art Museum: Gift of P. R. D.
 Roberts in memory of his mother,
 Marie Ponzi Roberts, 1995.43
 Cat. 66

Tigrett Enterprises,
Playhouse Division (1930s–1961,
Jackson, Tennessee)
The Toy, 1951
 Paper, cardboard, wood dowels
 Seven sets, each box length: 30 in.
 (76.2 cm); diameter: 3/4 in. (1.9 cm)
 Collection of John Kishel
 Cat. 67

House of Cards, 1952
 Plastic, paper
 Fifty-four cards, each: 3 1/2 × 2 1/8 in.
 (8.9 × 5.4 cm)
 Denver Art Museum: Neusteter Textile
 Collection, Bequest of Myron B. (Lee)
 Hochstetler, 1971.112
 Cat. 68

Instruction sheets for House of Cards, 1952
 Paper
 Two: 10 7/8 × 3 3/4 in. (27.6 × 9.5 cm);
 11 × 7 5/8 in. (27.9 × 19.4 cm)
 Eames Collection, LLC
 Cat. 69

The Little Toy, 1952
 Tekwood, metal wire, paper, cardboard
 Five sets, each box: 9 1/2 × 9 1/2 × 1 1/2 in.
 (24.1 × 24.1 × 3.8 cm)
 Four sets from the collection of
 John Kishel, one set from the collection
 of Jody and Dick Goisman
 Cat. 70

Hang-It-All wall rack, 1953
 Enameled steel, wood
 15 1/4 × 19 3/4 × 6 1/2 in.
 (38.7 × 50.2 × 16.5 cm)
 Milwaukee Art Museum:
 Gift of Marianne and Sheldon B. Lubar,
 M2017.52
 Cat. 71

Giant House of Cards, 1953
 Cardboard
 Twenty cards, each: 11 × 7 in.
 (27.9 × 17.8 cm)
 Collection of Jody and Dick Goisman
 Cat. 72

The Coloring Toy, 1955
 Cardboard, paper, crayons
 7 1/2 × 21 × 1 1/4 in. (19.1 × 53.3 × 3.2 cm)
 Eames Collection, LLC
 Cat. 73

Lester Geis
(active mid-20th century)
Heifetz Manufacturing Company
(1938–1960s, New York)
Table lamp, model T-5-G, 1951
 Enameled metal, brass
 22 1/2 × 14 × 14 1/2 in.
 (57.2 × 35.6 × 36.8 cm)
 Collection of George R. Kravis II
 Cat. 74

George Nelson & Associates
(1946–1986, known as
George Nelson & Company,
mid-1950s–1980, New York)
Herman Miller (1923–present,
Zeeland, Michigan)
Irving Harper (1916–2015)
Marshmallow sofa, 1956
 Chrome-plated and enameled steel, fabric
 32 1/2 × 53 × 33 in.
 (82.6 × 134.6 × 83.8 cm)
 Milwaukee Art Museum: Purchase with
 funds from the Demmer Charitable Trust
 and Wayne and Kristine Lueders,
 M2017.53
 Cat. 75

Howard Miller Clock Company
(1926–present, Zeeland, Michigan)
Lucia DeRespinis (b. 1927)
Eye wall clock (model 2238), 1957
 Walnut, lacquered wood, brass,
 enameled steel, enameled aluminum
 15 × 29 1/2 × 3 1/4 in.
 (38.1 × 74.9 × 8.3 cm)
 Collection of Jay Dandy and Melissa Weber
 Cat. 76

Irving Harper (1916–2015)
Ball wall clock (model 4755), 1949
 Wood, steel
 Diameter: 13 1/2 (34.3 cm);
 depth: 2 3/4 in. (7 cm)
 Collection of Jody and Dick Goisman
 Cat. 77

Carousel weather vane, 1954–55
 Enameled steel and aluminum, brass
 Height: 25 in. (63.5 cm);
 diameter: 24 in. (61 cm)
 Vitra Design Museum
 Cat. 78

Drawing for Sunburst #1, 1955
 Graphite on paper
 21 1/4 × 28 1/4 in. (54 × 71.8 cm)
 Herman Miller Archives
 Cat. 79

Drawing for Sunburst #2, 1955
 Graphite on paper
 18 1/2 × 24 5/8 in. (47 × 62.6 cm)
 Herman Miller Archives
 Cat. 80

Drawing for Sunflower wall clock, 1958
 Graphite on paper
 21 × 34 1/4 in. (53.3 × 87 cm)
 Herman Miller Archives
 Cat. 81

Drawing for Ophelia's Hair wall clock, 1959
 Graphite on paper
 21 × 33 7/8 in. (53.3 × 86 cm)
 Herman Miller Archives
 Cat. 82

Drawing for Platter wall clock, 1959
 Graphite on paper
 20 7/8 × 24 3/4 in. (53 × 62.9 cm)
 Herman Miller Archives
 Cat. 83

Kite wall clock (model 2201A), 1953
 Enameled metal, painted wood
 16 1/2 × 22 1/2 × 4 1/2 in.
 (41.9 × 57.2 × 11.4 cm)
 Collection of Jay Dandy and Melissa Weber
 Cat. 84

Pleated Star wall clock (model 2224), 1955
 Lacquered wood, enameled aluminum

Diameter: 18 in. (45.7 cm);
depth: 3 1/2 in. (8.9 cm)
Collection of Jay Dandy and Melissa Weber
Cat. 85

Paddle wall clock (model 7513), 1957
 Lacquered Masonite, lacquered wood,
 enameled aluminum, brass
 Diameter: 17 3/4 in. (45.1 cm);
 depth: 2 1/4 in. (5.7 cm)
 Collection of Jay Dandy and Melissa Weber
 Cat. 86

Sunflower wall clock (model 2261A), 1958
 Lacquered wood, enameled aluminum,
 enameled brass
 Diameter: 29 3/4 in (75.6 cm);
 depth: 3 in. (7.6 cm)
 Collection of William and Annette Dorsey
 Cat. 87

Compass wall clock (model 2278),
from the Motion Notion series, 1959
 Enameled aluminum, acrylic,
 lacquered wood, string, brass
 Diameter: 9 3/4 in. (24.8 cm);
 depth: 4 in. (10.2 cm)
 Collection of William and Annette Dorsey
 Cat. 88

Kaleidoscope wall clock (model 2277),
from the Motion Notion series, 1959
 Lacquered wood, chrome-plated steel,
 transfer-print on acrylic, enameled
 aluminum
 11 3/4 × 13 1/2 × 7 1/4 in.
 (29.9 × 34.3 × 18.4 cm)
 Collection of William and Annette Dorsey
 Cat. 89

Platter wall clock (model 2274A),
1959
 Enameled aluminum, chrome-plated
 brass, acrylic, string
 Diameter: 14 in. (35.6 cm);
 depth: 3 in. (7.6 cm)

Collection of William and Annette Dorsey
Cat. 90

Birdcage wall clock (model 2292A), 1961
 Walnut, enameled steel, lacquered wood,
 enameled aluminum
 Diameter: 18 1/2 in. (47 cm),
 depth: 7 in. (17.8 cm)
 Collection of Jay Dandy and Melissa Weber
 Cat. 91

Alexander Girard (1907-1993)

Village textile, 1945
 Screenprint on linen
 91 3/4 × 35 7/8 in. (233.1 × 91.1 cm)
 Cooper Hewitt, Smithsonian Design
 Museum: Gift of Alexander H. Girard,
 1969-165-59
 Cat. 92

Centerpiece for Georg Jensen exhibition,
1955-56
 Wood, metal, paint
 29 7/8 × 11 × 11 in. (76 × 27.9 × 27.9 cm)
 Museum of International Folk Art,
 Santa Fe: Gift of the Girard Foundation
 Collection, A.2016.26.2ab
 Cat. 93

Mirror, c. 1961
 Fabric, wood, brass, mirrored glass
 18 1/2 × 18 1/2 × 1 1/2 in. (47 × 47 × 3.8 cm)
 Herman Miller Archives
 Cat. 94

Pillows (Castle and Sun), c. 1961
 Screenprint on fabric
 Two, each: 14 × 13 × 4 in.
 (35.6 × 33 × 10.2 cm)
 Herman Miller Archives
 Cat. 95

Objects Selected by Alexander Girard
for Herman Miller, Inc. poster, c. 1961
 Offset lithograph
 37 × 23 1/2 in. (94 × 59.7 cm)

Collection of William and Annette Dorsey
Cat. 96

Textiles & Objects advertisement, 1961
 Offset lithograph
 14 1/2 × 11 1/2 in. (36.8 × 29.2 cm)
 Herman Miller Archives
 Cat. 97

Textiles & Objects invitation, 1961
 Screenprint
 5 1/2 × 6 in. (14 × 15.2 cm)
 Herman Miller Archives
 Cat. 98

Herman Miller (1923-present, Zeeland, Michigan)

Drawing for Multiform textile,
series #648, 1954
 Graphite and colored pencil on
 tracing paper
 30 1/8 × 51 1/2 in. (76.5 × 130.8 cm)
 Cooper Hewitt, Smithsonian Design
 Museum: Gift of Alexander H. Girard,
 1969-165-225
 Cat. 99

Collage for Cutout textile, series #640,
1954
 Brush and gouache, graphite on
 cut tissue paper mounted on white
 tracing paper mounted on cardboard
 17 1/4 × 15 1/8 in. (43.8 × 38.4 cm)
 Cooper Hewitt, Smithsonian Design
 Museum: Gift of Alexander H. Girard,
 1969-165-234
 Cat. 100

Cutout textile, 1954
 Screenprint on cotton
 45 1/4 × 50 3/8 in. (114.9 × 128 cm)
 Cooper Hewitt,
 Smithsonian Design Museum:
 Gift of Mr. and Mrs. J. Irwin Miller,
 1993-41-1
 Cat. 101

Tablecloth (Cut Out pattern), 1961
 Screenprint on fabric
 52 × 50 in. (132.1 × 127 cm)
 Herman Miller Archives
 Cat. 102

End table for Braniff International
VIP lounge, c. 1965
 Cast aluminum, marble
 20 1/2 × 20 × 20 in. (52.1 × 50.8 × 50.8 cm)
 Minneapolis Institute of Art: Gift of
 Della Patrick Rothermel in memory
 of John Patrick Rothermel
 Cat. 103

Sofa (model 66303) with Checker textile by
Alexander Girard, for Braniff International
VIP lounge, c. 1965
 Cast aluminum and cotton upholstery
 25 1/2 × 72 × 30 in.
 (64.8 × 182.9 × 76.2 cm)
 Minneapolis Institute of Art: Gift of
 Della Patrick Rothermel in memory
 of John Patrick Rothermel
 Cat. 104

Armchair (model 66310) with Checker
textile by Alexander Girard, for Braniff
International VIP lounge, c. 1965
 Vinyl, urethane foam, latex foam, molded
 plywood, cast aluminum, woven textile
 upholstery of cotton (46%), wool (33%),
 and nylon (21%)
 26 × 40 1/2 × 29 in. (66 × 102.9 × 73.7 cm)
 Collection of George R. Kravis II
 Cat. 105

**Hutschenreuther (1814–present,
Selb, Germany)**
Four dinner plates (Carolus Magnus pattern),
c. 1956
 Glazed porcelain with applied decoration
 Each, diameter: 10 3/4 in. (37.3 cm)
 Milwaukee Art Museum: Purchase with
 funds from the Demmer Charitable Trust,
 M2017.21.1-2; Denver Art Museum:

Funds from Design Council of the
Denver Art Museum, 2017.209.1-2
Cat. 106

**Alexander Girard
Harvey Lloyd (b. 1926), photographer**
Bolivia, Braniff International poster,
c. 1965
 Photography, offset lithograph
 17 7/8 × 22 in. (45.5 × 55.9 cm)
 Vitra Design Museum
 Cat. 107

Colombia, Braniff International poster,
c. 1965
 Photography, offset lithograph
 17 7/8 × 22 in. (45.5 × 55.9 cm)
 Vitra Design Museum
 Cat. 108

Ecuador, Braniff International poster,
c. 1965
 Photography, offset lithograph
 17 7/8 × 22 in. (45.5 × 55.9 cm)
 Vitra Design Museum
 Cat. 109

Mexico, Braniff International poster,
c. 1965
 Photography, offset lithograph
 17 7/8 × 22 in. (45.5 × 55.9 cm)
 Vitra Design Museum
 Cat. 110

Panama, Braniff International poster, c. 1965
 Photography, offset lithograph
 17 1/2 × 22 in. (44.5 × 55.9 cm)
 Vitra Design Museum
 Cat. 111

Mexico, Braniff International poster,
1968
 Photography, offset lithograph
 17 1/2 × 22 in. (44.5 × 55.9 cm)
 Private collection
 Cat. 112

Alexander Girard
George Nelson & Associates
(1946-1986, known as George Nelson &
Company, mid-1950s-1980, New York)
Tray table prototypes (One-Way, Rain,
Small Squares, and Triangles patterns),
c. 1960
 Screenprinted and molded walnut
 plywood
 Four, each, height: 7/8 in. (2.2 cm);
 diameter: 18 1/8 in. (46 cm)
 Milwaukee Art Museum: Purchase
 with funds from the 1919 Investment
 Council, M2017.2.1-4
 Cat. 113

**Alexander Girard
John Neuhart (1928-2011)**
Herman Miller (1923-present,
Zeeland, Mchigan)
Textiles & Objects announcement, 1961
 Screenprint on textured off-white paper
 26 1/4 × 20 1/8 in. (66.5 × 51 cm)
 Herman Miller Archives
 Cat. 114

**Henry P. Glass (1911-2003,
b. Austria)**
See also Alcoa

Drawing of child's desk and armchair,
1949
 Graphite, colored pencil, and pastel
 on tissue
 16 5/8 × 13 7/8 in. (42.2 × 35.2 cm)
 Milwaukee Art Museum:
 Purchase with funds from the Demmer
 Charitable Trust, M2015.38
 Cat. 115

Drawing of child's table and chairs, 1949
 Graphite, colored pencil, and
 pastel on tissue
 16 3/4 × 13 3/4 in. (42.4 × 34.9 cm)
 Milwaukee Art Museum:
 Purchase with funds from the Demmer

Charitable Trust, M2015.41

Cat. 116

Drawing of child's cabinet, 1951
 Graphite, colored pencil, and
 pastel on tissue
 16 × 11 in. (40.6 × 27.9 cm)
 Collection of Michael Jefferson
 and Heidi Mucha
 Cat. 117

Drawing of child's table and stool set,
1951
 Graphite, colored pencil, and
 pastel on tissue
 14 1/8 × 14 in. (35.9 × 35.6 cm)
 Milwaukee Art Museum: Purchase
 with funds from the Demmer
 Charitable Trust, M2015.40
 Cat. 118

Drawing of child's bookshelves, 1951
 Graphite, colored pencil, and
 pastel on tissue
 14 1/8 × 17 1/8 in. (35.9 × 43.5 cm)
 Milwaukee Art Museum: Purchase
 with funds from the Demmer
 Charitable Trust, M2015.39
 Cat. 119

**Fleetwood Furniture Company
(1955-present, Holland, Michigan)**
Swing-Line toy chest, 1952
 Lacquered Masonite, birch
 31 3/4 × 33 × 17 1/2 in.
 (80.7 × 83.8 × 44.5 cm)
 Milwaukee Art Museum: Purchase
 with funds from the Demmer
 Charitable Trust, M2015.85a,b
 Cat. 120

Swing-Line child's wardrobe, 1952
 Painted Masonite, wood
 42 3/8 × 31 3/4 × 17 1/2 in.
 (107.6 × 80.7 × 44.5 cm)
 Art Institute of Chicago:

Gift of Henry P. Glass, 2000.133
Cat. 121

Swing-Line bookshelves, 1952
 Lacquered wood, walnut, plywood
 Two, each: 28 1/2 × 32 × 10 1/4 in.
 (72.4 × 81.3 × 26 cm)
 Private collection, New York
 Cat. 122

Swing-Line child's table and stool set,
c. 1955
 Masonite, lacquered wood, walnut
 25 1/2 × 35 × 35 in.
 (64.8 × 88.9 × 88.9 cm)
 Private collection
 Cat. 123

**Greta Magnusson Grossman
(1906-1999, Swedish)**
See Alcoa

Victor Gruen (1903-1980, b. Austria)
Ceiling light for Barton's Bonbonniere,
c. 1952
 Painted metal (iron, steel, copper alloy,
 aluminum)
 41 × 36 × 40 in. (104.1 × 91.4 × 101.6 cm)
 Brooklyn Museum: Marie Bernice
 Bitzer Fund, 2005.22
 Cat. 124

Irving Harper (1916-2015)
See George Nelson & Associates

**Harrison & Abramovitz
(active 1945-76, New York)**
See Alcoa

Gere Kavanaugh (b. 1929)
Prototype for city planning toy, c. 1965
 Painted wood, canvas
 Mat: 24 × 24 in. (61 × 61 cm)
 Los Angeles County Museum of Art:
 Gift of Gere Kavanaugh
 Cat. 125

Tammis Keefe (1913-1960)
Birdcages tea towel, 1950s
 Printed linen
 29 × 16 in. (73.7 × 40.6 cm)
 Collection of Jill A. Wiltse and
 H. Kirk Brown III
 Cat. 126

Catch of the Day tea towel, 1950s
 Printed linen
 28 1/4 × 16 in. (71.8 × 40.6 cm)
 Collection of Jill A. Wiltse and
 H. Kirk Brown III
 Cat. 127

Chairs tea towel, 1950s
 Printed linen
 19 × 15 1/2 in.
 (48.3 × 39.4 cm)
 Collection of Jill A. Wiltse and
 H. Kirk Brown III
 Cat. 128

Choo Choo tea towel, 1950s
 Printed linen
 29 × 16 in. (73.7 × 40.6 cm)
 Private collection
 Cat. 129

Ray Komai (1918-2010)
Craft Horizons magazine cover,
Spring 1949
 Offset lithograph
 11 3/4 × 8 1/2 in.
 (29.9 × 21.6 cm)
 Collection of Edgar Orlaineta
 Cat. 130

**Laverne Originals (1938-1960s,
also known as Laverne and
Laverne International, New York)**
Masks textile, 1948-49
 Screenprint on cotton
 50 3/8 × 52 in. (128 × 132 cm)
 Collection of Edgar Orlaineta
 Cat. 131

JG Furniture Company (c. 1930-1970s, Brooklyn, New York)
Side chair, 1949
 Molded mahogany plywood, chrome-plated steel, stainless steel, aluminum, rubber
 29 1/2 × 21 × 22 in.
 (74.9 × 53.3 × 55.9 cm)
 Denver Art Museum: Funds from Design Council of the Denver Art Museum, 2014.197
 Cat. 132

Erwine Laverne (1909-2003)
Estelle Laverne (1915-1997)
Laverne Originals (1938-1960s, also known as Laverne and Laverne International, New York)
Tulip chair (model 120-LF) with portrait of a girl, 1959
 Fiberglass, steel, paint
 50 × 45 3/4 × 29 1/2 in.
 (127 × 116.2 × 75 cm)
 Collection of Randy P. Roberts
 Cat. 133

Jonquil chair (model 85-LI), 1960
 Lucite
 24 1/2 × 31 × 29 in.
 (62.2 × 78.7 × 73.7 cm)
 Private collection
 Cat. 134

Golliwog (Ebony), 1961
 Hand-painted aluminum, cast iron
 Height: 62 1/2 in. (158.8 cm);
 diameter: 9 in. (22.9 cm)
 Collection of Lawrence Converso
 Cat. 135

Golliwog (Esquire), 1961
 Hand-painted aluminum, cast iron
 Height: 37 in. (94 cm);
 diameter: 13 in. (33 cm)
 Collection of Benjamin Storck,
 Galerie XX, Los Angeles
 Cat. 136

Golliwog (Vogue), 1961
 Hand-painted aluminum, cast iron
 Height: 41 1/2 in. (105.4 cm);
 diameter: 14 in. (35.6 cm)
 Collection of Benjamin Storck,
 Galerie XX, Los Angeles
 Cat. 137

Estelle Laverne (1915-1997)
Laverne Originals (1938-1960s, also known as Laverne and Laverne International, New York)
Fun to Run textile, 1947
 Screenprint on cotton, rayon, nylon, cellulose acetate film
 84 3/4 × 68 3/4 in. (215.3 × 174.6 cm)
 Art Institute of Chicago: Alexander Demond Fund, Textile Purchase Fund, 1992.381
 Cat. 138

Leo Lionni (1910-1999, b. Netherlands)
Little Blue and Little Yellow book, 1959
 Offset lithograph
 8 1/4 × 8 1/4 × 3/8 in. (21 × 21 × 1 cm)
 Private collection
 Cat. 139

John Matthias (active mid-20th century)
See Alcoa

Paul McCobb (1917-1969)
See Alcoa

Marilyn Neuhart (1930-2017)
Dolls, c. 1961–85
 Fabric, embroidery, yarn, stuffing
 Five: Varying dimensions
 Estate of Marilyn Neuhart
 Cat. 140

Isamu Noguchi (1904-1988)
See also Alcoa

United Nations Playground model, 1952 (cast 1964)
 Bronze
 3 × 19 1/2 × 27 in. (7.6 × 49.5 × 68.6 cm)
 The Isamu Noguchi Foundation and Garden Museum, New York
 Cat. 141

Schematic drawings for play sculptures, c. 1965-68
 Graphite on vellum
 Two, each: 21 x 30 in. (53.3 × 76.2 cm)
 The Isamu Noguchi Foundation and Garden Museum, New York
 Cat. 142

Study model for *Play Cubes (4-Cube element)*, c. 1965-68
 Plaster
 1 × 1 × 1 in. (2.5 × 2.5 × 2.5 cm)
 The Isamu Noguchi Foundation and Garden Museum, New York
 Cat. 143

Study model for Play Module A, c. 1965-68
 Plaster
 1 3/8 × 1 3/8 × 1 3/8 in. (3.5 × 3.5 × 3.5 cm)
 The Isamu Noguchi Foundation and Garden Museum, New York
 Cat. 144

Study model for Play Module B, c. 1965-68
 Plaster
 5/8 × 1 1/4 × 7/8 in. (1.6 × 3.2 × 2.2 cm)
 The Isamu Noguchi Foundation and Garden Museum, New York
 Cat. 145

Study model for *Play Sculpture*, c. 1965-68
 Plastic
 3/4 × 2 1/2 × 2 1/2 in. (1.9 × 6.4 × 5.4 cm)
 The Isamu Noguchi Foundation and Garden Museum, New York
 Cat. 146

Slide Mantra Maquette, 1985
 Marble
 27$^1/_4$ × 24$^1/_4$ × 27$^3/_4$ in.
 (69.2 × 61.6 × 70.5 cm)
 The Isamu Noguchi Foundation and
 Garden Museum, New York
 Cat. 147

Play Sculpture, c. 1965-68
(fabricated 2017)
 Steel
 Height: 44 in. (111.8 cm);
 diameter: 103 in. (261.6 cm)
 The Isamu Noguchi Foundation and
 Garden Museum, New York
 Cat. 148

Model for *Playscapes*, Piedmont Park,
Atlanta, Georgia, 1975-76
 Basswood
 10$^1/_2$ × 47 × 34$^1/_2$ in.
 (26.7 × 119.4 × 87.6 cm)
 The Isamu Noguchi Foundation and
 Garden Museum, New York
 Cat. 149

**Knoll International (1938-present, also
known as Knoll Associates, New York)**
Child's table (model 87), 1953
 Laminate, plywood, enameled steel, birch
 20 × 24 × 24 in.
 (50.8 × 61 × 61 cm)
 Milwaukee Art Museum: Purchase
 with funds from the Demmer
 Charitable Trust, M2016.31
 Cat. 150

**Jens Quistgaard
(1919-2008, Danish)**
Dansk Designs
(1954-present, New York)
Dansk Variations IV flatware, 1955
 Stainless steel
 Knife: 8$^5/_8$ in. (21.9 cm)
 Collection of Dung Ngo
 Cat. 151

**Ann Rand (1918-2007)
Paul Rand (1914-1996)**
I Know a Lot of Things book, 1956
 Offset lithograph
 10$^1/_4$ × 8$^3/_4$ in. (26 × 22.2 cm)
 Collection of Danny Lewandowski
 Cat. 152

Paul Rand (1914-1996)
Subway Posters Score poster, 1947
 Lithograph on paper
 45$^3/_8$ × 29$^3/_8$ in.
 (115.3 × 74.6 cm)
 Collection of Merrill C. Berman
 Cat. 153

Interfaith Day: Sunday, September 23
poster, 1951
 Lithograph on paper
 45$^1/_8$ x 29$^1/_4$ inches (104.3 x 74.8 cm)
 Collection of Merrill C. Berman
 Cat. 154

Interfaith Day: Sunday, September 27
poster, 1953
 Lithograph on paper
 45$^1/_8$ × 29$^1/_4$ in.
 (114.6 × 74.3 cm)
 Collection of Merrill C. Berman
 Cat. 155

El Producto, 25 Bouquet packaging,
1953-57
 Offset lithograph on cardboard
 5 × 3$^1/_2$ × 3$^1/_2$ in.
 (12.7 × 8.9 × 8.9 cm)
 Collection of Steven Heller
 Cat. 156

El Producto, 25 Queens packaging,
1953-57
 Offset lithograph on cardboard
 3 × 7$^1/_2$ × 8$^1/_2$ in.
 (7.6 × 19.1 × 21.6 cm)
 Collection of Steven Heller
 Cat. 157

El Producto, Every Cigar Says Merry
Christmas advertisement, 1953-57
 Lithograph on paper
 27$^3/_4$ × 41$^1/_2$ in.
 (70.5 × 105.4 cm)
 Collection of Merrill C. Berman
 Cat. 158

El Producto, For Your King of Hearts
advertisement, 1953-57
 Lithograph on paper
 27$^1/_4$ × 18$^1/_2$ in.
 (69.2 × 47 cm)
 Collection of Merrill C. Berman
 Cat. 159

El Producto, It's a Boy! tin, 1953-57
 Tin
 Height: 5$^3/_8$ in. (13.7 cm);
 diameter: 4 in. (10.2 cm)
 Collection of Danny Lewandowski
 Cat. 160

El Producto, It's a Girl! tin, 1953-57
 Tin
 Height: 5$^3/_8$ in. (13.7 cm);
 diameter: 4 in. (10.2 cm)
 Collection of Danny Lewandowski
 Cat. 161

El Producto, The Way to a Man's Heart
advertisement, 1953-57
 Lithograph on paper
 27$^7/_8$ × 42$^7/_8$ in.
 (70.8 × 108.9 cm)
 Collection of Merrill C. Berman
 Cat. 162

**Colorforms Corp.
(1951-present, New York)**
The Colorforms Toy, c. 1959
 Cardboard box, vinyl
 1$^1/_2$ × 15 × 15 in.
 (3.8 × 38.1 × 38.1 cm)
 Collection of Danny Lewandowski
 Cat. 163

John Risley (1919–2002)

Raymor/Richards Morgenthau & Company
(1936–1980, known as Russel Wright Inc.
1936–1941, New York)

Woman chair, 1960s
Steel
56³/₄ × 19 × 19¹/₂ in.
(144.1 × 48.3 × 49.5 cm)
Kirkland Museum of Fine & Decorative
Art, Denver
Cat. 164

Woman and Man bench, 1960s
Steel
50¹/₂ × 36¹/₄ × 23¹/₄ in.
(128.3 × 92.1 × 59.1 cm)
Kirkland Museum of Fine & Decorative
Art, Denver
Cat. 165

**Eero Saarinen (1910–1961,
b. Finland)**

Knoll International (1938–present, also
known as Knoll Associates, New York)

Womb chair, 1947–48
Chrome-plated steel, fiberglass, plastic,
wood particle shell, latex foam, original
fabric upholstery
36 × 39 × 30 in. (91.4 × 99.1 × 76.2 cm)
Collection of Jody and Dick Goisman
Cat. 166

**Zahara Schatz
(1916–1999, Israeli)**

Heifetz Manufacturing Company
(1938–1960s, New York)

Table lamp, 1951
Aluminum, enameled brass
29 × 13 × 14 in. (73.7 × 33 × 35.6 cm)
Collection of George R. Kravis II
Cat. 167

**Ruth Adler Schnee
(b. 1923, b. Germany)**

Adler-Schnee Associates (1947–1976,
Detroit, Michigan)

Humpty Dumpty furnishing fabric, 1949
Screenprint on cotton
44 × 35 in. (111.8 × 88.9 cm)
Collection of Ruth Adler Schnee
Cat. 168

Pins and Needles furnishing fabric,
1949
Screenprint on linen
50 × 52 in. (127 × 132.1 cm)
Collection of Ruth Adler Schnee
Cat. 169

Wireworks furnishing fabric, 1950
Screenprint on cotton
36 × 50 in. (91.4 × 127 cm)
Collection of Ruth Adler Schnee
Cat. 170

Seedy Weeds furnishing fabric, 1953
Screenprint on cotton
50 × 36 in. (127 × 91.4 cm)
Collection of Ruth Adler Schnee
Cat. 171

Richard Schultz (b. 1926)

Knoll International (1938–present, also
known as Knoll Associates, New York)

Petal table, 1960
Redwood, powder-coated aluminum
Height: 19¹/₄ in. (48.9 cm);
diameter: 16¹/₈ in. (41 cm)
Denver Art Museum: Funds from
Design Council of the Denver Art
Museum, 2017.64
Cat. 172

**Marianne Strengell (1909–1998,
b. Finland)**

See Alcoa

Deborah Sussman (1931–2014)

Textiles & Objects Sale announcement,
c. 1964
Screenprint
12 × 12 in. (30.5 × 30.5 cm)

Herman Miller Archives
Cat. 173

Gene Tepper (1919–2013)

See Alcoa

Bradbury Thompson (1911–1995)

Westvaco Inspirations for Printers 171
periodical, 1948
Lithograph
12 × 18 in. (30.5 × 45.7 cm)
Cary Graphic Arts Collection,
Rochester Institute of Technology
Cat. 174

Westvaco Inspirations for Printers 177
periodical, 1949
Lithograph
12 × 18 in. (30.5 × 45.7 cm)
Cary Graphic Arts Collection,
Rochester Institute of Technology
Cat. 175

Westvaco Inspirations for Printers 188
periodical, 1952
Lithograph
12 × 18 in. (30.5 × 45.7 cm)
Cary Graphic Arts Collection,
Rochester Institute of Technology
Cat. 176

Westvaco Inspirations for Printers 194
periodical, 1953
Lithograph
12 × 18 in. (30.5 × 45.7 cm)
Cary Graphic Arts Collection,
Rochester Institute of Technology
Cat. 177

Westvaco Inspirations for Printers 202
periodical, 1955
Lithograph
12 × 18 in. (30.5 × 45.7 cm)
Cary Graphic Arts Collection,
Rochester Institute of Technology
Cat. 178

Westvaco Inspirations for Printers 210
periodical, 1958
 Lithograph
 12 × 18 in. (30.5 × 45.7 cm)
 Cary Graphic Arts Collection,
 Rochester Institute of Technology
 Cat. 179

Westvaco Inspirations for Printers 216
periodical, 1961
 Lithograph
 12 × 18 in. (30.5 × 45.7 cm)
 Cary Graphic Arts Collection,
 Rochester Institute of Technology
 Cat. 180

Charlotte Trowbridge (active mid-20th century)

See Creative Playthings

Anne Tyng (1920-2011, b. China)

Tyng Toy, 1947
 Plywood, paint, wooden dowels
 32 × 19 × 30 in.
 (81.3 × 48.3 × 76.2 cm)
 Collection of William Whitaker and
 Shilpa Mehta
 Cat. 181

Maquette for Tyng Toy, c. 1947
 Graphite and colored pencil on cardboard
 Approximately 20 × 20 in.
 (50.8 × 50.8 cm)
 Architectural Archives, University
 of Pennsylvania by the gift of
 Anne Griswold Tyng
 Cat. 182

Tyng Toy brochure, 1949
 Printed matter
 9 × 23^3/$_4$ in. (22.9 × 60.3 cm)
 Architectural Archives, University
 of Pennsylvania by the gift of Anne
 Griswold Tyng
 Cat. 183

Don Wallance (1909-1990)

See Alcoa

Russel Wright (1904-1976)

Morgantown Glassware Guild
(1899-1965, Morgantown,
West Virginia)
American Modern Glassware
(chartreuse), c. 1951
 Molded glass
 Four luncheon glasses,
 each: height: 4^1/$_2$ in. (11.4 cm);
 four tumblers, each: height:
 3^1/$_2$ in. (8.9 cm)
 Collection of Jill A. Wiltse and
 H. Kirk Brown III
 Cat. 184

Simtex Mills, a division of
Simmons Company
(active mid-20th century,
New York)
Napkins, c. 1949
 Rayon and cotton
 Four, each: 15 × 15 in.
 (38.1 × 38.1 cm)
 Collection of Jill A. Wiltse and
 H. Kirk Brown III
 Cat. 185

Eva Zeisel (1906-2011, b. Hungary)

Prototype for Eva's Aminals:
Anteater, 1950s
 Plywood
 8 1/$_2$ × 12 3/$_4$ x 2 in.
 (21.6 × 32.4 × 5.1 cm)
 Eva Zeisel Archive
 Cat. 186

Prototypes for Eva's Aminals:
Doubles, 1950s
 Plywood
 Two: 8 3/$_4$ × 13 × 3/$_4$ in.
 (22.2 × 33 × 1.9 cm);
 9 × 11 1/$_2$ × 3/$_4$ in.

(22.9 × 29.2 × 1.9 cm)
 Eva Zeisel Archive
 Cat. 187

Prototype for duck pull toy, 1950s
 Plywood
 8 × 12 × 3 in. (20.3 × 30.5 × 7.6 cm)
 Eva Zeisel Archive
 Cat. 188

Goss China (active mid-20th century,
Chatham, New Jersey)
Two-handled mug
(Wee Modern pattern), 1953
 Porcelain
 3^1/$_2$ × 4^3/$_4$ × 3 in.
 (8.9 × 12.1 × 7.6 cm)
 Denver Art Museum: Funds from
 George and Betty Woodman
 by exchange, 2018.1
 Cat. 189

Porringer (Wee Modern pattern),
1953
 Porcelain
 2 × 6^1/$_4$ × 6^1/$_8$ in.
 (5.1 × 15.9 × 15.6 cm)
 Denver Art Museum: Funds, by exchange,
 from the Walter C. Mead Collection,
 Dr. and Mrs. Byron Cohn, and, in memory
 of Janice C. Kranz, from Bertram Saul and
 Harriet Youngclaus, 2018.2
 Cat. 190

Loop-handled dish
(Wee Modern pattern), 1953
 Porcelain
 2 × 8^1/$_2$ × 7^7/$_8$ in. (5.1 × 21.6 × 20 cm)
 Denver Art Museum: Funds, by
 exchange, from the bequests of
 Lloyd W. Rule, Camille Ferret Cummings,
 Dr. Emily M. Frisby,James H. Mills
 Estate, and Myron B. (Lee) Hochstetler,
 2018.3
 Cat. 191

Monmouth Pottery, a division
of Western Stoneware Company
(1892–present, Monmouth, Illinois)
Coasters, Eva Zeisel Fine Stoneware
(Pals, Horses, Feathered Friends,
and Colonial patterns), 1953
 Stoneware
 Four, each, diameter: 4$^1/_8$ in. (10.5 cm)
 Collection of Scott Vermillion
 Cat. 192

Dinner plate, Eva Zeisel Fine Stoneware
(Feathered Friends pattern), 1953
 Stoneware
 Diameter: 8 $^3/_4$ in. (22.2 cm)
 Collection of Scott Vermillion
 Cat. 193

Dinner plate, Eva Zeisel Fine Stoneware
(Pals pattern), 1953
 Stoneware
 Diameter: 11 $^1/_4$ in. (28.6 cm)
 Collection of Scott Vermillion
 Cat. 194

Salad plate, Eva Zeisel Fine Stoneware
(Pals pattern), 1953
 Stoneware
 Diameter: 7 in. (17.8 cm)
 Collection of Scott Vermillion
 Cat. 195

Bowl with ladle, Eva Zeisel Fine Stoneware
(Pals pattern), 1953
 Stoneware
 Bowl: 4$^5/_8$ × 8$^1/_4$ × 6$^1/_2$ in. (11.8 × 21
 × 16.5 cm); ladle: 11$^1/_2$ in. (29.2 cm)
 Collection of Scott Vermillion
 Cat. 196

Teapot, creamer, and sugar, Eva Zeisel
Fine Stoneware (Blueberry glaze), 1953
 Stoneware
 Teapot: 7 × 8$^1/_2$ × 7$^1/_2$ in.
 (17.8 × 21.6 × 19.1 cm);

creamer: 4$^1/_2$ × 4 $^1/_4$ × 4 $^1/_8$ in.
(11.4 × 10.8 × 10.5 cm);
sugar: 5 $^1/_4$ × 4 $^1/_4$ × 4 $^1/_4$ in.
(13.3 × 10.8 × 10.8 cm)
Collection of Scott Vermillion
Cat. 197

Marmite bowl, Eva Zeisel Fine Stoneware
(Colonial pattern), 1953
 Stoneware
 5 $^1/_4$ × 7 $^5/_8$ × 6$^1/_4$ in. (13.3 × 19.4 × 15.9 cm)
 Collection of Scott Vermillion
 Cat. 198

Salt and pepper, Eva Zeisel Fine Stoneware
(Colonial pattern), 1953
 Stoneware
 Salt: 3 × 2 $^3/_4$ × 2 $^5/_8$ in. (7.6 × 7 × 6.7 cm);
 pepper: 1 $^1/_2$ × 4 $^7/_8$ × 2 $^3/_4$ in.
 (3.8 × 12.4 × 7 cm)
 Collection of Scott Vermillion
 Cat. 199

Nihon Koshitsu Toki Company (founded
1908, known as Nikko Ceramics Company
1950–present, Kanazawa, Japan)
Gravy boat with ladle, Schmid Ironstone
(Stratford pattern), 1964
 Earthenware
 Gravy boat: 4$^5/_8$ × 5 $^3/_4$ in. (11.7 × 14.6 cm);
 ladle: 6$^1/_4$ × 1$^5/_8$ in. (15.9 × 4.1 cm)
 Collection of Scott Vermillion
 Cat. 200

Oil/vinegar bottle, Schmid Ironstone
(Stratford pattern), 1964
 Earthenware
 8$^1/_4$ × 4 $^3/_8$ in. (21 × 11.1 cm)
 Collection of Scott Vermillion
 Cat. 201

Red Wing Potteries
(1861–present, Red Wing, Minnesota)
Salt and pepper, Town and Country, 1947
 Earthenware
 Salt, height: 3$^1/_2$ in. (8.9 cm);

pepper, height: 4$^1/_2$ in. (11.4 cm)
Collection of Jody and Dick Goisman
Cat. 202

Ephemera
Objects from the Personal Collection
of Charles and Ray Eames
Unknown
Richter's Anchor Blocks no. 206,
The Bungalow Box, c. 1910
 Stone blocks, wooden box,
 paper brochure
 Box: 1$^7/_8$ × 12$^3/_4$ × 8$^3/_4$ in.
 (4.8 × 32.4 × 22.2 cm);
 brochure: 7$^3/_4$ × 11$^1/_8$ × $^1/_4$ in.
 (19.7 × 28.3 × 0.6 cm); blocks:
 varying dimensions
 Eames Collection, LLC
 Cat. 203

Unknown
Butterfly kites, dates unknown
 Ink, paper, string, bamboo
 Two: 22 × 24 × $^1/_2$ in. (55.9 × 61 × 1.3 cm);
 15 × 20 × $^1/_2$ in. (38.1 × 50.8 × 1.3 cm)
 Eames Collection, LLC
 Cat. 204

Unknown
Japanese fish kite, date unknown
 Ink, paper, string, bamboo
 22 × 14 × $^1/_2$ in. (55.9 × 35.6 × 1.3 cm)
 Eames Collection, LLC
 Cat. 205

Unknown
Tops, dates unknown
 Varying materials
 Sixty-eight; varying dimensions
 Eames Collection, LLC
 Cat. 206

Unknown
Penny cars pictured in House of Cards,
dates unknown
 Painted tin

Eight; varying dimensions
Eames Collection, LLC
Cat. 207

Unknown
Ives train pictured in House of Cards,
date unknown
 Painted metal
 $11^1/_2 \times 21 \times 7$ in. (29.2 × 53.3 × 17.8 cm)
 Eames Collection, LLC
 Cat. 208

Unknown
Japanese fish on a string pictured
in House of Cards, date unknown
 Wire, metal, painted tin
 Six, each: $9 \times 2^3/_4$ in. (22.9 × 7 cm)
 Eames Collection, LLC
 Cat. 209

Unknown
Ceramic balls pictured in House of Cards,
date unknown
 Ceramic
 Varying dimensions
 Eames Collection, LLC
 Cat. 210

Unknown
Sheets of marbleized paper pictured
in House of Cards, date unknown
 Paper
 Six; varying dimensions
 Eames Collection, LLC
 Cat. 211

Folk Art from the Personal Collection of Alexander Girard

Aguilar family (active 1930s-present,
Zapotec)
Standing women candlesticks, c. 1960
 Ceramic
 Five, each approximately:
 $10^1/_2 \times 4 \times 4$ in. (26.7 × 10.2 × 10.2 cm)
 Museum of International Folk Art,
 Santa Fe: Gift of the Girard Foundation

Collection, A.1979.44.359x,
A.1979.44.376x, A.1979.44.392x
Cat. 212

Teodora Blanco
(1925-1980, Zapotec)
Female figure, c. 1965
 Ceramic
 $20^3/_4 \times 7^1/_2 \times 7^1/_8$ in.
 (52.6 × 19.1 × 17.9 cm)
 Museum of International Folk Art,
 Santa Fe: Gift of the Girard Foundation
 Collection, A.1979.3.333
 Cat. 213

Pedro Abilio Gonzales Flores
(1912-2006, Peruvian)
Musician, c. 1958
 Wood, fiber, gypsum, paint
 $5 \times 2^3/_8 \times 4^3/_4$ in. (12.5 × 6 × 12.1 cm)
 Museum of International Folk Art,
 Santa Fe: Gift of the Girard Foundation
 Collection, A.1979.32.610
 Cat. 214

Musician, c. 1958
 Wood, gypsum, paper
 $6^3/_8 \times 3^5/_8 \times 3$ in. (16 × 9 × 7.5 cm)
 Museum of International Folk Art,
 Santa Fe: Gift of the Girard Foundation
 Collection, A1979.32.665x
 Cat. 215

Pedro Abilio Gonzales Flores
Felipe Gonzales
(active 1950s, Peruvian)
Musician, c. 1958
 Wood, fiber, gypsum
 $5^7/_8 \times 2^3/_4 \times 2^1/_4$ in.
 (14.9 × 6.8 × 5.6 cm)
 Museum of International Folk Art,
 Santa Fe: Gift of the Girard Foundation
 Collection, A.1979.32.549v
 Cat. 216

Musician, c. 1958
 Wood, gypsum, cardboard, paint
 $6^1/_8 \times 3 \times 3^3/_8$ in.
 (15.6 × 7.5 × 8.6 cm)
 Museum of International Folk Art,
 Santa Fe: Gift of the Girard Foundation
 Collection, A.1979.32.581x
 Cat. 217

Musician, c. 1958
 Wood, fiber, gypsum, cardboard
 $6^1/_8 \times 3^1/_8 \times 2^3/_4$ in.
 (15.6 × 7.8 × 7 cm)
 Museum of International Folk Art,
 Santa Fe: Gift of the Girard Foundation
 Collection, A.1979.32.579x
 Cat. 218

Herón Martínez Mendoza
(1918-1990, Mexican)
Candlesticks, c. 1960
 Ceramic, paint
 Two: $9^5/_8 \times 4^1/_2 \times 5$ in.
 (24.5 × 11.4 × 12.5 cm);
 $9^7/_8 \times 4^3/_4 \times 5^1/_8$ in.
 (24.9 × 12.1 × 13 cm)
 Museum of International Folk Art,
 Santa Fe: Gift of the Girard Foundation
 Collection, A.1979.3.825x
 Cat. 219

Double-headed bird, c. 1965
 Ceramic
 $18^1/_8 \times 17 \times 8^3/_8$ in.
 (46 × 43 × 21.4 cm)
 Museum of International Folk Art,
 Santa Fe: Gift of the Girard Foundation
 Collection, A.1979.5.32
 Cat. 220

Horse, c. 1965
 Ceramic
 $13^1/_4 \times 10^1/_4 \times 7^1/_8$ in.
 (33.5 × 26 × 17.9 cm)
 Museum of International Folk Art,
 Santa Fe: Gift of the Girard Foundation

Collection, A.1979.3.841
Cat. 221

Cathedral, c. 1965
 Ceramic
 $23^1/_2 \times 11^7/_8 \times 11$ in.
 $(59.5 \times 30 \times 27.9$ cm)
 Museum of International Folk Art,
 Santa Fe: Gift of the Girard Foundation
 Collection, A.1979.3.866
 Cat. 222

Unknown, Guatemala
Napkin, c. 1930
 Cotton
 $36^1/_4 \times 31^1/_2$ in. $(92 \times 80$ cm)
 Museum of International Folk Art,
 Santa Fe: IFAF Collection,
 FA.1971.9.125
 Cat. 223

Unknown, India
Nandi, 19th century
 Bronze
 $9^1/_2 \times 10^1/_8 \times 5^1/_2$ in. $(24 \times 25.6 \times 14$ cm)
 Museum of International Folk Art,
 Santa Fe: Gift of the Girard Foundation
 Collection, A.1981.22.991
 Cat. 224

Unknown, Mexico
Bull mask, c. 1960
 Wood, paint, paper, leather
 $11^1/_2 \times 12^3/_8 \times 6^3/_8$ in.
 $(29.1 \times 31.4 \times 16$ cm)
 Museum of International Folk Art,
 Santa Fe: Gift of the Girard Foundation
 Collection, A.1979.6.422
 Cat. 225

Unknown, Mexico
Deer, c. 1960
 Ceramic
 $30 \times 14^1/_8 \times 15^3/_8$ in.
 $(76 \times 36 \times 39.1$ cm)
 Museum of International Folk Art,

Santa Fe: Gift of the Girard Foundation
Collection, A.1979.17.258
Cat. 226

Unknown, Mexico
Mermaid bottle, c. 1960
 Ceramic
 $13^5/_8 \times 9^1/_8 \times 4^3/_4$ in.
 $(34.5 \times 23 \times 12.1$ cm)
 Museum of International Folk Art,
 Santa Fe: Gift of the Girard Foundation
 Collection, A.1979.3.554
 Cat. 227

Unknown, Peru
Flask, c. 1958
 Ceramic
 $15^1/_8 \times 5^1/_8 \times 5^1/_2$ in.
 $(38.6 \times 13 \times 14$ cm)
 Museum of International Folk Art,
 Santa Fe: Gift of the Girard Foundation
 Collection, A.1979.32.379
 Cat. 228

Unknown, Peru
Retablo, c. 1958
 Potato paste, wood, paint
 Open: $14^3/_8 \times 10^1/_8 \times 6^3/_4$ in.
 $(36.5 \times 25.6 \times 17$ cm)
 Museum of International Folk Art,
 Santa Fe: Gift of the Girard Foundation
 Collection, A.1979.32.895
 Cat. 229

Unknown, Peru
Retablo, c. 1958
 Wood, potato paste, leather, paint
 Open: $22^1/_8 \times 23^5/_8 \times 6^3/_4$ in.
 $(56 \times 60 \times 17$ cm)
 Museum of International Folk Art,
 Santa Fe: Gift of the Girard Foundation
 Collection, A.1979.32.899
 Cat. 230

Unknown, Peru
Roof ornament, c. 1958
 Ceramic
 $11^1/_4 \times 5^1/_2 \times 4^3/_4$ in.
 $(28.6 \times 14 \times 12.1$ cm)
 Museum of International Folk Art,
 Santa Fe: Gift of the Girard Foundation
 Collection, A.1979.32.430
 Cat. 231

Unknown
Group of musicians, c. 1961
 Ceramic
 $8^1/_2 \times 10 \times 4$ in.
 $(21.6 \times 25.4 \times 10.2$ cm)
 Herman Miller Archives
 Cat. 232

CONTRIBUTORS

Darrin Alfred is Curator of Architecture, Design, and Graphics, Denver Art Museum

Amy Auscherman is Corporate Archivist at Herman Miller, Zeeland, Michigan

Steven Heller is Co-chair, MFA Design/ Designer as Author + Entrepreneur program at School of Visual Arts, New York

Pat Kirkham is Professor of Design History, Kingston University, UK, and Professor Emerita, Bard Graduate Center, New York

Alexandra Lange is an architecture and design critic based in New York

Monica Obniski is Demmer Curator of Twentieth and Twenty-First Century Design, Milwaukee Art Museum

ILLUSTRATION CREDITS

Frontispiece: Cooper Hewitt, Smithsonian Design Museum/Art Resource, NY.

Chapter openers (details): Page 1, © Eames Office LLC (eamesoffice.com); Page 22, The Art Institute of Chicago/Art Resource, NY; Page 52, © Eames Office LLC (eamesoffice.com); Page 80, Photograph by John R. Glembin; Page 102, Photograph by Brent C. Brolin, courtesy of Eva Zeisel Archive; Page 120, Photograph by Ernest Braun, Douglas and Maggie Baylis Collection. Environmental Design Archives, University of California, Berkeley; Page 146, © Vitra Design Museum, Alexander Girard Estate; Page 166, © and courtesy of International Business Machines Corporation. Image courtesy of Steven Heller; Page 184, Photograph courtesy of Denver Art Museum.

Figs. 1, 3, 5-6, 24, 26, 46-48, 50-60, 62-65, 185, 187: © Eames Office LLC (eamesoffice.com).

Figs. 2, 7-8, 11-12, 40, 68, 71, 78-81, 84-86, 110-112, 123-124, 137, 177: Photographs by John R. Glembin.

Figs. 4, 69, 120: © Ezra Stoller/Esto

Figs. 9, 23: © Eames Office LLC (eamesoffice.com). Photograph © Denver Art Museum.

Fig. 10: Courtesy of Ruth Adler Schnee. Photograph courtesy of The Kresge Foundation. © Julie Pincus.

Fig. 13: © 2018 The Isamu Noguchi Foundation and Garden Museum, New York/ Artists Rights Society (ARS), New York.

Figs. 14, 28, 77, 83, 134, 142-144: © Vitra Design Museum.

Fig. 15: Photograph by Robert Damora. © Damora Archive, all rights reserved.

Fig. 16: Photograph © Brooklyn Museum.

Figs. 17, 27, 29, 30, 32, 36, 42, 121, 128, 135, 141, 151, 160, 162, 165-168, 170, 174-176, 183: Photographs courtesy Denver Art Museum.

Fig. 18: Photograph courtesy of Cary Graphic Design Archives, Rochester Institute of Technology.

Fig. 19: Photograph by Herbert Gehr/The LIFE Picture Collection/Getty Images.

Fig. 20: HB-12065-B, Chicago History Museum: Hedrich-Blessing Collection. © Chicago Historical Society, published on or before 2018, all rights reserved.

Figs. 21, 22, 66-67, 70, 74-76, 82, 87, 131, 133, 136: Courtesy of Herman Miller Archives.

Fig. 25: Image courtesy Vitra Design Museum, © Eames Office LLC (eamesoffice.com).

Fig. 31: Courtesy Museum of International Folk Art, Santa Fe. Photograph by Linda Dillman and Karen Fowler.

Fig. 33: Photograph by Virginia Roehl, reproduced with permission from Girard Studio, LLC.

Figs. 34, 39, 43, 109, 152: Photographs © Denver Art Museum.

Fig. 35: Photograph by Elaine Petschek, courtesy Museum of International Folk Art, Santa Fe.

Fig. 37: The Art Institute of Chicago/ Art Resource, NY.

Figs. 38, 166: Photographs by Edgar Orlaineta.

Fig. 41: Photograph © 2017 Mario de Lopez.

Fig. 44: Courtesy Kirkland Museum of Fine & Decorative Art, Denver. Photograph © Denver Art Museum.

Fig. 45: Phillip Harrington/Alamy Stock Photo.

Fig. 49: Digital Image © The Museum of Modern Art/Licensed by SCALA/Art Resource, NY.

Fig. 61: © Eames Office LLC (eamesoffice. com). Photograph by John R. Glembin.

Fig. 72: © 2018 Estate of Pablo Picasso/ Artists Rights Society (ARS), New York: Digital Image © The Museum of Modern Art/Licensed by SCALA/Art Resource, NY.

Fig. 73: Courtesy of Herman Miller Archives. Image courtesy Vitra Design Museum.

Fig. 87: Courtesy of Herman Miller Archives. Image courtesy of Wright.

Fig. 88: Photograph © D. James Dee.

Figs. 89-91, 95, 99-100, 105: Courtesy of Eva Zeisel Archive.

Figs. 92, 96, 101: Courtesy of Eva Zeisel Archive. Photographs by Brent C. Brolin.

Fig. 93: Courtesy of Eva Zeisel Archive. Photograph © Denver Art Museum.

Figs. 94, 97-98, 102, 104: Photographs by Scott Vermillion.

Fig. 103: Courtesy of Eva Zeisel Archive. Photograph by John R. Glembin.

Fig. 106: Photograph by Joseph Hu, © is retained by Joseph Hu.

Figs. 107-108: Anne Griswold Tyng Collection, The Architectural Archives, University of Pennsylvania.

Fig. 113: Photograph by George W. Harting, courtesy of City and Country School Archives.

Fig. 114: Image courtesy of Quittenbaum.

Fig. 115: Image courtesy Hennepin County Library.

Fig. 116: Image courtesy of Milwaukee Art Museum.

Figs. 117-118: Photographs by Ernest Braun. Douglas and Maggie Baylis Collection. Environmental Design Archives, University of California, Berkeley.

Fig. 119: Courtesy of Douglas and Maggie Baylis Collection. Environmental Design Archives, University of California, Berkeley.

Fig. 122: Gregory Ain papers, Architecture and Design Collection. Art, Design, & Architecture Museum, UC, Santa Barbara.

Figs. 125, 145: Courtesy of Wright.

Figs. 126, 171: Cooper Hewitt, Smithsonian Design Museum/Art Resource, NY.

Fig. 127: Courtesy Environmental Communications Online Archive, California. Image courtesy Design Library Image Collection, North Carolina State University Libraries.

Fig. 129: Brooklyn Museum: Alfred T. and Caroline S. Zoebisch Fund, 1993.6; Photograph © Brooklyn Museum.

Fig. 130: © 1972 Norman McGrath— All Rights Reserved. Photograph courtesy of Denver Art Museum.

Fig. 132: Image courtesy from the collections of The Henry Ford.

Fig. 138: Photograph © 2017 by Andrew Neuhart.

Fig. 139: Courtesy Museum of International Folk Art, Santa Fe. Photograph by Ernst Luthi and Ellen Wilde.

Fig. 140: Courtesy of Herman Miller Archives. Photograph by Katherine du Tiel.

Fig. 146: Photograph by John R. Glembin. Original photograph © Harvey Lloyd.

Fig. 147: © 1991 Hans Namuth Estate. Courtesy Center for Creative Photography.

Figs. 148, 150, 156: Images courtesy Merrill C. Berman.

Fig. 149: © and courtesy of International Business Machines Corporation. Image courtesy of Steven Heller.

Fig. 153: © Successió Miró/Artists Rights Society (ARS), New York/ADAGP, Paris 2018. Image courtesy of Denver Art Museum.

Fig. 154: Excerpts from *Little Blue and Little Yellow*, Leo Lionni, © 1959, copyright renewed 1987 by NORAELEO LLC. Used by permission of Alfred A. Knopf, an imprint of Random House Children's Books, a division of Penguin Random House LLC. All rights reserved. Any third party use of this material, outside of this publication, is prohibited. Interested parties must apply directly to Penguin Random House LLC for permission. Image courtesy of Milwaukee Art Museum.

Fig. 155: Courtesy Cary Graphic Arts

Collection, Rochester Institute of Technology. Image courtesy of Mark Thompson.

Figs. 157-159: Images courtesy of Steven Heller.

Fig. 161: Carnegie Museum of Art, Pittsburgh: FIC.2016.2. Photograph by Tom Little. Photograph © Carnegie Museum of Art.

Fig. 163: © 2018 The Isamu Noguchi Foundation and Garden Museum, New York/ Artists Rights Society (ARS), New York. Photograph by Tom Little. Photograph © Carnegie Museum of Art, Pittsburgh.

Fig. 164: © 2018 The Isamu Noguchi Foundation and Garden Museum, New York/ Artists Rights Society (ARS), New York. Photograph courtesy of Denver Art Museum.

Fig. 169: Image courtesy GM Design Archive & Special Collections, General Motors LLC.

Figs. 172-173: Courtesy of the Estate of Greta Magnusson Grossman, R & Company, New York.

Fig. 178: *Look* Magazine Photograph Collection, Library of Congress, Prints & Photographs Division [Reproduction number LC-L9-60-8770-E, frame 22].

Fig. 179: Image courtesy University Archives and Special Collections, Paul V. Galvin Library, Illinois Institute of Technology.

Fig. 180: Herbert Bayer Collection and Archive, Denver Art Museum. Photograph courtesy Denver Art Museum.

Figs. 181-182: © J. Paul Getty Trust. Getty Research Institute, Los Angeles (2004.R.10).

Fig. 184: Carnegie Museum of Art, Pittsburgh: Director's Discretionary Fund, 2001.47.2.1. Photograph © Carnegie Museum of Art, Pittsburgh.

Fig. 186: © Image courtesy of The Work of Charles and Ray Eames, Library of Congress, Prints & Photographs Division [LC-DIG-ppmsca-53517]. © Eames Office LLC (eamesoffice.com).

INDEX

Published on the occasion of the exhibition
Serious Play: Design in Midcentury America.

Milwaukee Art Museum
September 28, 2018–January 6, 2019
Denver Art Museum
May 5–August 25, 2019

Serious Play: Design in Midcentury America
is co-organized by the Milwaukee Art
Museum and the Denver Art Museum.

It is generously funded by the National
Endowment for the Arts, the donors to the
Annual Fund Leadership Campaign, and
the citizens who support the Scientific and
Cultural Facilities District (SCFD). The
catalog was published with assistance from
Furthermore: a program of the J. M. Kaplan
Fund. We regret the omission of sponsors
confirmed after May 1, 2018.

Copyright © 2018 by the Milwaukee Art
Museum and the Denver Art Museum.
All rights reserved. This book may not be
reproduced, in whole or in part, including
illustrations, in any form (beyond that
copying permitted by Sections 107 and
108 of the U.S. Copyright Law and except
by reviewers for the public press), without
written permission from the publishers.

Denver Art Museum
Director of Publications: Laura Caruso
Senior Curatorial Assistant, Department
of Architecture, Design, and Graphics:
Kati Woock
Rights and Reproductions Coordinator:
Renée B. Miller

Milwaukee Art Museum
Curatorial Assistant: Hannah Pivo
Rights and Reproductions Coordinator:
Rebekah Morin

Yale University Press
Publisher, Art and Architecture:
Patricia Fidler
Senior Editor, Art and Architecture:
Katherine Boller
Production Manager: Mary Mayer
Project Manager: Heidi Downey

Designed by Jena Sher Graphic Design
Set in Galaxie Polaris, Champion,
Eames Century Modern, Leviathan,
and Swiss 721 BT type by Jena Sher
Printed in China by 1010 Printing
International Limited

Library of Congress Control Number:
2017961775
ISBN 978-0-300-23422-0

A catalog record for this book is available
from the British Library.

The paper in this book meets the require-
ments of ANSI/NISO Z 39.48-1992
(Permanence of Paper).

10 9 8 7 6 5 4 3 2 1

Frontispiece: Alexander Girard, Village
textile, 1945 (detail). Cooper Hewitt,
Smithsonian Design Museum: Gift of
Alexander H. Girard, 1969-165-59.
[CAT. 92]